MODERN ART
PRACTICES AND DEBATES

Modernism in Dispute

MODERN ART
PRACTICES AND DEBATES

Modernism in Dispute
Art since the Forties

Paul Wood Francis Frascina Jonathan Harris Charles Harrison

YALE UNIVERSITY PRESS, NEW HAVEN & LONDON
IN ASSOCIATION WITH THE OPEN UNIVERSITY

Library of Congress Cataloging-in-Publication Data
Modernism in Dispute: Art since the Forties/
Paul Wood ... [et al.].
p. cm. – (Modern art – practices and debates)
includes bibliographical references and index
ISBN 0–300–05521–8 (cloth)
0–300–05522–6 (paper)
1. Modernism (Art) – United States 2. Art, American
3. Art, Modern – 20th century – United States 4. Art – Political aspects – United States
5. Art and society – United States – History – 20th century
I. Wood, Paul II. Series
N6512.5.M63M63 1993 709′.73′09045–dc20 93-10674

Edited, designed and typeset by The Open University
Printed in Hong Kong by Kwong Fat Offset Printing Co. Ltd

CONTENTS

PREFACE

This is the final volume in a series of four books about art and its interpretation from the mid-nineteenth century to the end of the twentieth. Each of the books is self-sufficient and accessible to the general reader. As a series, they form the main texts of an Open University course, *Modern Art: Practices and Debates*. They represent a range of approaches and methods characteristic of contemporary art-historical debate. The present book focuses on art since the 1930s, the main emphasis being on the period since the Second World War.

The first chapter, 'Modernism and culture in the USA, 1930–1960', examines the ideological interests that governed the predominant Modernist account of the period. In contrast to this account, Jonathan Harris considers the connection between 'historical' and 'theoretical' debates in terms of the relationships between art, culture and society in the USA. Although the two focal points are the 1930s and the years after the Second World War, questions of cultural value and power in capitalist societies are also discussed in the context of parallels to be found in conditions during the 1990s.

In Chapter 2, 'The politics of representation', Francis Frascina examines debates about the practices of art, criticism and curatorial validation since the 1940s. He considers these practices as representations of ideas, values and beliefs that were produced in a period dominated by the Cold War consensus. A major issue is whether this consensus was ruptured during the late 1960s by a counter-culture characterized by, for example, feminism and the anti-Vietnam War movement. While questions about the function of 'art and culture' are mostly located in the specific social and political conditions existing between the 1940s and the early 1970s, issues about the legacy of this period are also considered.

In the final chapter, 'Modernity and Modernism reconsidered', Charles Harrison and Paul Wood examine the high Modernism of the 1960s and go on to review its continuation or contestation by movements such as Minimal Art, Land Art and Conceptual Art. They also discuss various practices of the 1980s and the apparent revival of interest in painting. The chapter closes with an inquiry into the implications of the postmodernism debate for the practice of art today.

Open University texts undergo several stages of drafting and review. The authors would like to thank those who commented on the drafts, notably Lynn Baldwin and Professor Thomas Crow. Abigail Croydon and John Pettit were the editors. Picture research was carried out by Tony Coulson; Alison Clarke and Sophie White keyed in the text. Richard Hoyle was the graphic designer, Roberta Glave the course administrator.

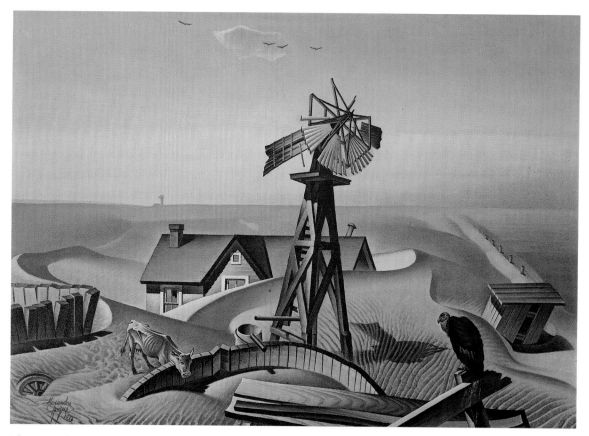

Plate 1 Alexandre Hogue, *Drouth-stricken Area*, 1934, oil on canvas, 76 x 108 cm. Dallas Museum of Fine Arts; Dallas Art Association Purchase, 1945.6.

CHAPTER 1
MODERNISM AND CULTURE IN THE USA, 1930–1960

by Jonathan Harris

Introduction

Questions of 'history' and 'theory'

In this chapter I consider the history of art in the USA between about 1930 and the early 1960s. In particular, I want to examine the shift from the type of painting illustrated by Plates 1 and 2 to the very different style of Plates 3–5. How can we account for this move from an art of 'naturalism' or 'social realism' to what became celebrated after 1945 as 'Abstract Expressionism' or '"American-type" Painting'? An adequate account of this shift, which involved a dramatic change in artists' interests and priorities, should also examine the role of particular critics and historians whose interpretation of art, artists and the wider historical circumstances was not a mere *supplement* to that development, but actually a defining feature of it. Within the dominant history of US art in the twentieth century, it is clear that certain critics and historians writing during the 1950s and 1960s – particularly Clement Greenberg – have held sway. While it may be true to some extent that these accounts have been criticized and revised over the last two decades, it is important to recognize that the legacy of specific accounts and judgements, as to the relevance and quality of works of art produced during the period, is still active and powerful in many quarters.

The chapter provides two main historical accounts and two theoretical discussions. In Part 1, I consider the history of 'Depression America' art, which is normally described as 'naturalist' or 'social realist'. This discussion will attempt to link these specific artistic products and practices to the wider economic, political and ideological circumstances of US society in the period 1930–1941, i.e. up to the entry of the USA into the Second World War. Part 2 deals with the reconstruction of US art after the war, when 'Abstract Expressionism', along with a number of other terms, was coined to describe the art associated with Jackson Pollock, Mark Rothko, Barnett Newman and others. For Greenberg, an active supporter of Pollock and other Abstract Expressionists working during the late 1940s and 1950s, the 'look' of these paintings *was* their most significant feature, in sharp contrast to the social and political intentions of artists who had worked during the Depression, for whom art was part of the intense ideological struggles over the crisis in US capitalism and over the possibility of an alternative, socialist future in that country. It will be necessary to point out, however, that such a rigid division between 'art of the 1930s' and 'art of the 1950s' is itself part of the critical legacy associated with Greenberg and other critics and historians, who would like to drive a wedge between the politics and practices of art and criticism before and after the Second World War. Many of the so-called Abstract Expressionists had been active artistically and politically during the Depression, and their work after the war was by no means unrelated – in terms of intentions, interests and values – to the concerns they had developed during the 1930s.

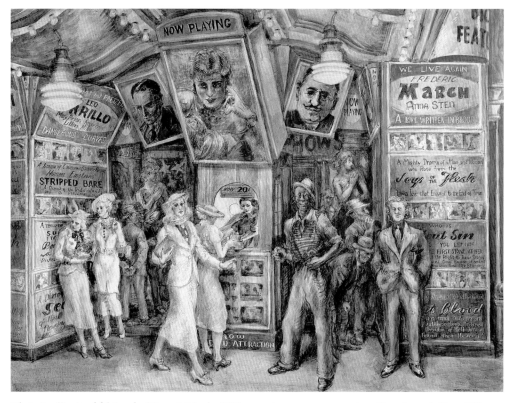

Plate 2 Reginald Marsh, *20-cent Movie*, 1936, egg tempera on composition board, 76 x 102 cm. Collection of the Whitney Museum of American Art, New York; purchase 37.43. Photograph: Geoffrey Clements.

The first theoretical discussion (see Part 2) presents an account of the nature and significance of Greenberg's art criticism as it impinged on art practice in the USA during the middle decades of the century *and* as it influenced and shaped later historical descriptions and explanations of US art. This dominant version, or historical and critical orthodoxy, presents US art as only really 'flowering' or becoming 'authentic' after 1945, while art of the Depression, in large part, is regarded as merely 'illustrational' and 'anecdotal'. We can describe such an orthodoxy of selection, explanation and evaluation as 'Modernist' in that it relies on specific notions of formal and technical innovation, conceptions of art's uniqueness as a medium, and the assumption that art is, in its most significant respects, autonomous from social and historical circumstances. Greenberg's two key essays in this respect are 'Avant-garde and kitsch' (1939) and 'Modernist painting' (1961).

The second theoretical discussion (in the conclusion) attempts to relate issues about art, culture and society during the 1930s in the USA to the situation in the early 1990s when monopoly capitalism is in 'recession'. I shall attempt to show that the 1930s debates and struggles in the USA over the role of art and culture within a capitalist society in crisis have a direct parallel in the conditions faced by people living in capitalist societies during the 1990s. The art-historical questions, then, I would propose, have distinct relevance to social life generally, and many of the features of the discussion about art practice and critical practice current in the period 1930–60 have continuing resonance. 'Modernist' accounts have attempted to *suppress* these wider social and historical issues and, by so doing, have made it harder for people to understand the situation in which they find themselves and their societies.

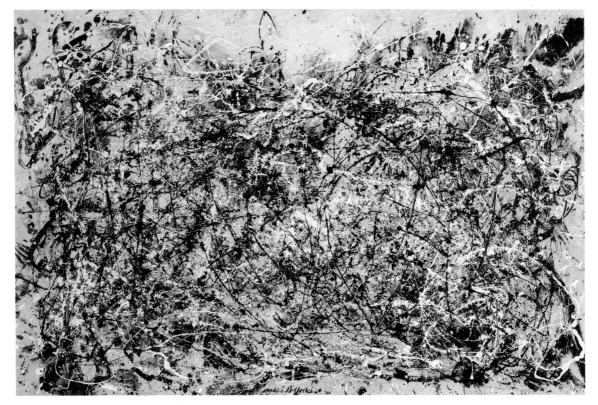

Plate 3 Jackson Pollock, *Number 1 (1948)*, 1948, oil and enamel on unprimed canvas, 173 x 264 cm. Collection, The Museum of Modern Art, New York; purchase. © 1992 The Pollock-Krasner Foundation/ARS, New York.

It should become obvious that the distinction between 'historical' and 'theoretical' debates and positions is, in an important sense, untenable. Whatever the analytic value in separating 'descriptions' and 'selections' from 'explanatory principles' and 'evaluations', the writing of history – the production of accounts of past acts, events, products and processes – involves assumptions and presuppositions if a perspective or focus is to be achieved at all. This is irrespective of whether particular critics or historians believe they are writing 'objectively'. The attempt to present a description or interpretation as unrelated to a set of personal or social interests *itself* reveals a very particular interest that needs interrogation. In what follows, therefore, the interaction of 'history' and 'theory', of 'descriptions' and 'judgements', should be acknowledged as a necessary and inevitable feature of writing, whatever the claims of those doing the writing.

Part 1: Capitalist crisis and artistic culture during the 1930s

Description and explanation

Consider these works: Alexandre Hogue's *Drouth-stricken Area*, Reginald Marsh's *20-cent Movie*, Jackson Pollock's *Number 1 (1948)*, Mark Rothko's *Number 7* and Barnett Newman's *Covenant* (Plates 1–5). The contrast between the first two paintings and the other three is obvious. It can stand for the difference, the schism, between 'work of the 1930s' and 'work of the 1950s' (this is a descriptive and conceptual division, rather than one based on precisely *when* a painting was produced). The works by Pollock, Rothko and Newman have canonical status within the body of Abstract Expressionist painting and within most histories of twentieth-century Modernist art. As art historian Barbara Rose wrote:

> In Abstract Expressionism, then, American artists were at last able to realize their long maturing ambition for an art both of formal grandeur as well as spiritual significance. The literalism that limited American art for centuries was but a small portion of Abstract Expressionism; it was largely confined to making literal the flatness of the painting, and asserting the real qualities of the medium (i.e. that paint was fluid and surface was palpable). In all other respects, Abstract Expressionism was an art dedicated, above all, to transcending the mundane, the banal and the material through the use of metaphor and symbol.
>
> (B. Rose, *American Painting*, p.70)

It may not be clear at this stage whether Rose's statement clarifies or obscures what these three paintings may be said to mean or represent. Part 2 includes a discussion of the ideas, intentions, interests and values of artists and critics active at the time of Abstract Expressionism. Rose's account, produced at the end of the 1960s, may not have much in common with an account that we might give if we simply try to 'describe' what we see. If we are unfamiliar with these paintings, we might be tentative, searching, unsure of what precise words are adequate to the experience of looking. Rose's words are confident, stronger, surer: she presents *concepts* rather than a stumbling list of colours, shapes, patterns or lines. Her terms – 'Expressionism', 'Abstract', 'formal grandeur', 'literal', 'fluid', 'surface' – appear certain of their place within a system that constitutes an explanation. Her terms and phrases may *appear* to be descriptive, but at the same time they have a conceptual weight, as part of what could be called a critical discourse or argument. And what about 'spiritual significance', 'the mundane', 'the banal', 'the material', as well as 'metaphor' and 'symbol'? Is it clear what objects or events or values she is referring to? What sense are we to make of these works and this kind of critical account?

We might begin by recognizing, and then trying to articulate, the sense of strangeness or unfamiliarity of these works of art. Without a knowledge of twentieth-century art up to 1945 (and perhaps even with it), we are unlikely to find signs of 'life' or 'the world' in these paintings: no people, or landscape or objects are depicted. Yet, for Rose, these absences don't add up to nothing: it appears that, for her, the tangibility of paint, the surface of the canvas, is made possible because of the absence of depiction. Perhaps 'depiction' is what Rose has in mind when she refers to 'the mundane' and 'the banal'. And it might be that the palpability of paint on canvas (in terms of texture, hue, pattern and 'line') is necessary if the paintings are to attain what she calls 'formal grandeur' and a 'spiritual significance'. Setting aside the task of description for a moment, we might well want to ask: where have Rose's notions of value and significance come from, and why have they been so invested in paintings such as these? Could these notions of value and significance be clarified simply through the act of looking at the works, as if Rose herself

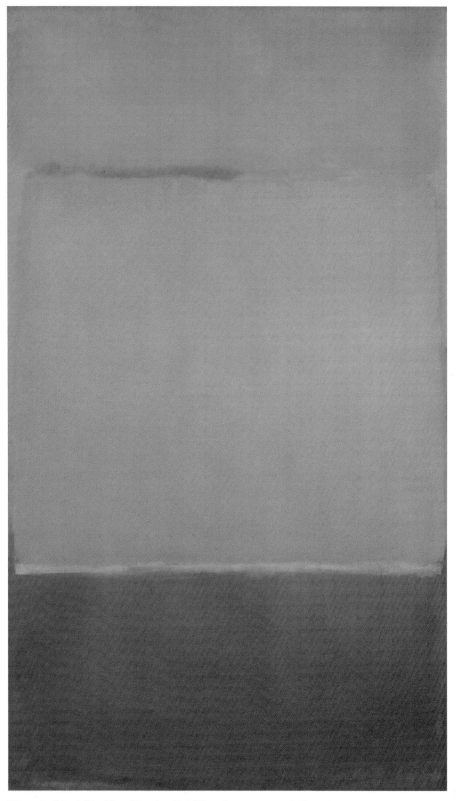

Plate 4 Mark Rothko, *Number 7*, 1951, oil on canvas, 239 x 138 cm. Private collection. Courtesy of Thomas Ammann Fine Art, Zurich.

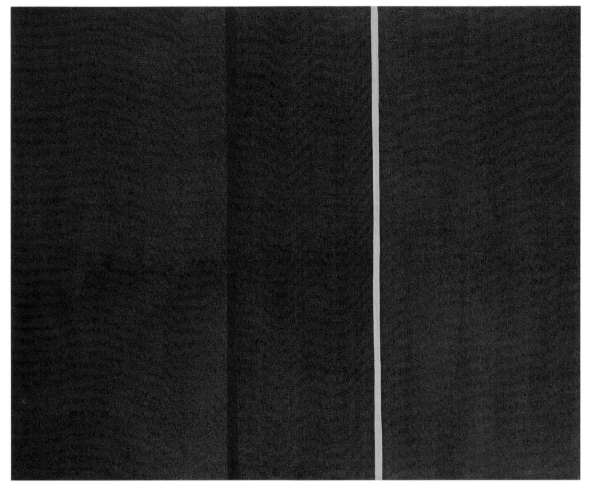

Plate 5 Barnett Newman, *Covenant*, 1949, oil on canvas, 121 x 151 cm. Hirshhorn Museum and Sculpture Garden, Smithsonian Institution, Washington; gift of Joseph H. Hirshhorn, 1972. Photograph: Lee Stalworth. Reproduced courtesy of Annalee Newman in so far as her rights are concerned.

had arrived at these notions merely by 'looking'? This seems doubtful. I shall return in Part 2 to the issue of how/where these values and assumptions may have been formed.

Now consider Hogue's *Drouth-stricken Area* and Marsh's *20-cent Movie*. Both were produced during the 1930s. In 1934, the year in which the former painting was made, the US art critic Thomas Craven wrote:

> We can no longer turn away from the significance of the subject-matter of art. America lies before us, stricken with economic pains, but eager for the voice of criticism, and in desperate need of spiritual consolations. Shall we face the situation like honest workmen; or shall we hide in the dark tower and paint evasive arabesques on an ivory wall? Again and again, with all the temper at my command, I have exhorted our artists to remain at home in a familiar background, to enter emotionally into strong native tendencies, to have done with alien cultural fetishes. And at this critical moment, I repeat the exhortation.
>
> (T. Craven, *Modern Art*, p.260)

These two paintings may be said to respond to Craven's exhortation, though in differing ways. Hogue's painting apparently pictures something of the 'economic pains' of the USA – a dilapidated farm in the Midwest, with skeletal cow and expectant vulture. The warping of wooden structures is echoed in the pictorial 'warping' of the perspectival devices: the outhouse to the right tips precariously, preventing the scene from appearing centred and

ordered. Both the painting and what is pictured within it appear on the point of collapse. Marsh's canvas represents, perhaps, Americans 'at home in a familiar background' – going to the movies. Yet the scratchiness of the mode of depiction, its harsh contrasts between light and dark, and the angularity of composition inflect the mood of the scene in a powerful way: something of the dowdiness and general 'poverty of life' appears to be expressed. Neither painting offers much in terms of 'spiritual consolation'. Both, on the other hand, seem to have little in common with European Modernist art, except in the sense of borrowing a general 'expressionistic' and non-naturalistic use of line. To apply a blanket label such as 'naturalism' to all the varying types of 'socially committed' art produced during the 1930s would be a crude misrepresentation.

It would also be wrong to conclude that Craven's exhortation in some way encapsulates *all* the art produced in the Depression, although it is true that later Modernist histories of that period – including Rose's – saw the vast majority of that art as tainted with the crude nationalist sentiments that Craven displays. I shall indicate something of the variety of works produced in this period by artists and groups of artists who saw their art as part of a number of *differing* social, political and ideological struggles and projects, on both the left and right of US society.

Whatever the differences in subject-matter, mode of depiction or intent, it is clear that the works by Hogue, Marsh and many others share a commitment to the realm of 'depiction' that was later to be dismissed by Rose as 'mundane' and 'banal'. These pictures are also much smaller: they are more like 'illustrations', diminutive and manageable in a way – unlike the Abstract Expressionist paintings, whose size lends them the quality that Rose describes as 'formal grandeur'. We can recognize the depiction of people, events and physical and social environments: we may be able to say that there is an immediate familiarity that allows us to be confident in describing what we see.

Attempting to describe these works of art simply by looking at them will get us only so far. Rose's account, as I've said, seems to depend on a complex conceptual language, used to value the Abstract Expressionist works above what she condemns as 'the banal' and 'the mundane' in art. We know (*American Painting*, p.36) that Rose *was* comparing the post-Second World War artists with some 1930s counterparts, the so-called 'naturalists' or 'realists', and deciding that the latter were mere illustrators. How might a knowledge of the history of the USA from the 1930s to the 1960s enable us to explain the differences and changes that characterize that four-decade period, in terms of artists' styles, intentions, values and interests? The change from 1930s 'realism' to 1950s 'abstraction' *seems* particularly abrupt. How might it be explained in relation to economic, political and ideological factors?

Depression, the New Deal and the Federal Art Project

In the 1930s many critics and artists in New York (including Pollock, Rothko and Newman) were committed to socialist politics and a vision of a non-capitalist USA. 'Naturalistic' or 'realist' representational practices dominated, and were seen as a cultural necessity for those affiliated to socialist and communist politics. With the slump in stock-market prices in 1929 came a rapid collapse of the US economy. Between 1929 and the election of Franklin D. Roosevelt in 1932, the US Gross National Product fell from 104 billion dollars to 56 billion. Unemployment rose to at least one-quarter of the entire workforce in 1933. Urban workers received an average wage-cut of 40 per cent between 1929 and 1933. The recession was so long and deep that, for the first time, accurate official figures on national unemployment were gathered, and these were published in *Recent Social Trends* in 1933. Estimates of unemployment range from eight and a half million to seventeen million during the 1930s. In 1931 the Soviet Union advertised in the USA for 6,000 skilled workers and received 100,000 applications.[1]

[1] D. Smith and J. Siracusa, *The Testing of America*, p.129.

The New Deal government under Roosevelt established huge welfare programmes and work-relief schemes during 1933, which were designed both to regenerate the capitalist economy and to enable people to maintain themselves above the breadline. Included within the work-relief programmes was a series of projects intended to enable artists to work, in return for a standard weekly wage of about twenty-one dollars. On the largest of these schemes, the Federal Art Project (1935–1943), artists found themselves engaged collectively – employed by the state – as producers for public clients (schools, hospitals, prisons and other institutions that wished to receive art works for display). 'Naturalistic' or 'realist' representational styles were generally encouraged and were predominant, and most artists worked on projects for public buildings and sites other than art galleries or museums. An important exception to this was the Easel Section of the Federal Art Project, which was based in New York. Administered by the abstract painter Burgoyne Diller, this part of the project tolerated and encouraged the increasingly abstract work produced by Pollock, Rothko, de Kooning and other contemporary painters. Consider, for example, Pollock's *Going West* (1934–35) and Rothko's *Subway* (1930s). In most accounts, these paintings merely figure as 'early works' in the careers of artists who only became 'mature' after 1945, as Abstract Expressionists. *Going West*, from the standpoint of artists active in the 1930s, is related to the work by Hogue discussed earlier, and to that of Pollock's teacher during the period, Thomas Hart Benton (Plates 6, 1 and 7). A comparatively small painting, *Going West* also mobilizes the expressionistic contours that feature, in a more restrained way, in *Drouth-stricken Area*. Reference to the crises of US

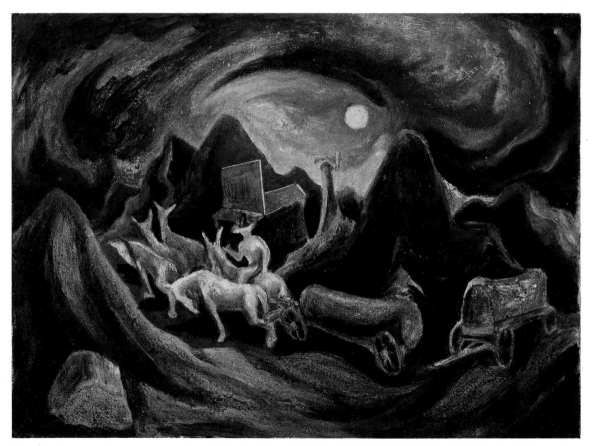

Plate 6 Jackson Pollock, *Going West*, 1934–35, oil on fibre board, 38 x 53 cm. National Museum of American Art, Smithsonian Institution, Washington; gift of Thomas Hart Benton, 1973, 149.1. © 1992 The Pollock-Krasner Foundation/ARS, New York.

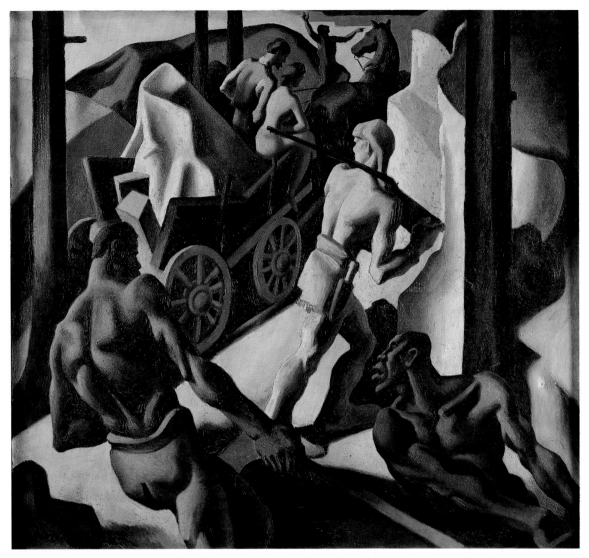

Plate 7 Thomas Hart Benton, *Over the Mountains (American Historical Epic)*, 1924–26, oil on linen on aluminium honeycomb panel, 167 x 183 cm. Collection, the Nelson Atkins Museum of Art, Kansas City; bequest of the Artist F75.21/7. © Thomas Hart Benton, DACS, London and VAGA, New York, 1993.

economic life, both in terms of the effects of drought on the land and unemployment forcing migration within the country, are evident in the painting and title. Stylistic and thematic links can be made between this painting and Benton's *Over the Mountains*, from the *American Historical Epic* series produced in 1924–26 (Plate 7). Pollock had studied with Benton for three years, between 1930 and 1933, at the Art Students' League in New York. According to Benton, Pollock was:

> … treated as one of the family and encouraged to participate in all gatherings of people at our house. These were always highly talkative and were mostly directed, as the major interests of the time dictated, to the social and political problems of America or, because of a number of teachers in our set, to the questions of American education, which was then much affected by the struggles between John Deweyites, Marxist radicals, and extreme conservatives.
>
> (T.H. Benton, 'And still after', quoted in E. Doss, *Benton, Pollock and the Politics of Modernism*, pp.321–2)

Plate 8 Mark Rothko, *Subway*, 1936–39, oil on canvas, 87 x 118 cm. National Gallery of Art, Washington; Rothko no.3261.30, gift of the Mark Rothko Foundation. © 1992 Kate Rothko-Prizel and Christopher Rothko/ARS, New York.

Rothko's *Subway* (Plate 8), although roughly four times the size of *Going West*, is another 'easel' painting, small and unassuming when set beside his *Number 7* from 1951. The theme of New York's underground railway is common within 1930s painting, though Rothko's concentration on people on a platform, depicted in a 'stretched' expressionistic mode, is unlike most paintings within the genre. He also concentrates on the sense of separateness of figures within this pictorial *and* depicted physical space. The theme of social alienation within urban-industrial capitalist society recurs throughout Depression paintings, and to this extent Rothko's painting may be identified as 'socially critical'. Accounts that discuss Pollock's and Rothko's works from the 1930s simply in relation to their work as Abstract Expressionists are not 'wrong' in any absolute sense, but their emphasis tends (and, in some cases, intends) to obscure the relation of those works to the 1930s and the place of the artists within those social and political circumstances.

The Easel Section in New York was in most respects unlike the other programmes run by the Federal Art Project, and it would be a misrepresentation to say that works produced on it by Pollock, Rothko and others were 'typical' of Federal Art. It certainly *is* true to say, however, that later Modernist histories of the period have claimed, and continue to claim, that it is only (or primarily) the works produced by those who came to be known as Abstract Expressionists that have any aesthetic value, as opposed to any historical or social significance. Any exemplification will be partial, but it may be useful to say that Cesare Stea's *Sculptural Relief for the Bowery Bay Sewage Disposal Plant*, produced

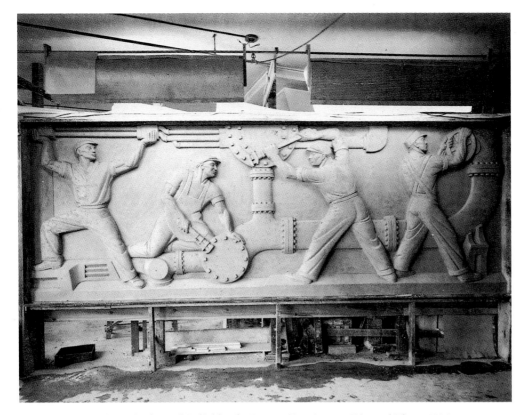

Plate 9 Cesare Stea, *Sculptural Relief for the Bowery Bay Sewage Disposal Plant*, 1936, approx. 20 sq. m. Photograph: Archives of American Art, reproduced from F.V. O'Connor (ed.), *Art for the Millions*, Boston, New York Graphic Society, 1975 by permission of F.V. O'Connor.

on the Federal Art Project in 1936, is indicative of the kind of 'social-realist' conventions encouraged on the public projects. It shares elements of style and iconography with contemporary Soviet Socialist-Realist sculpture, such as Vera Mukhina's *The Worker and the Collective Farm Woman* of 1937 (Plates 9 and 10). Although on a considerably smaller scale, Stea's relief uses the conventions of 'monumentality' to signify the grandeur of the 'state worker' as symbolic of the nation's mission to rebuild itself. This symbolic abstraction, the personified 'worker', was a key ideological emblem in the USSR and USA during the 1930s. Both putatively Communist (USSR) and Democratic (USA) states mobilized the rhetoric of economic and social transformation within their official ideological missions – the supposed creation of Socialism in the USSR, and the reorganization of capitalism into a managed, morally defensible democratic system in the USA.

This brief review of the variety of works from the Depression period in the USA, along with the conditions of economic and ideological production, indicates the difficulty in trying to reduce the practices and debates to a single dominant theme or style. By turns 'expressionistic', 'stylized' or even 'cartoon-like', these works all nevertheless contained narrative, socially symbolic meanings and a concern to represent their visions of contemporary Depression America – be it the alienated metropolitan life in New York, or the crisis on the land, or the Federal Art Project's 'capitalist-democratic realism' representing the US proletarian-citizen set to work by Roosevelt's New Deal.

It's noticeable that Modernist art historians writing after the Second World War are very critical of 1930s realism (of whatever kind). Typical of the comments is Rose's judgement that most of the state-funded art works were 'mediocre compromises with academicism in a heavy-handed, dull illustrational style that had neither the authority of

Plate 10 Vera Mukhina, *The Worker and the Collective Farm Woman*, 1937, bronze, height *c*.12m, for the USSR pavilion, Universal Exhibition, Paris, 1937. Photograph: Society for Co-operation in Russian and Soviet Studies, London.

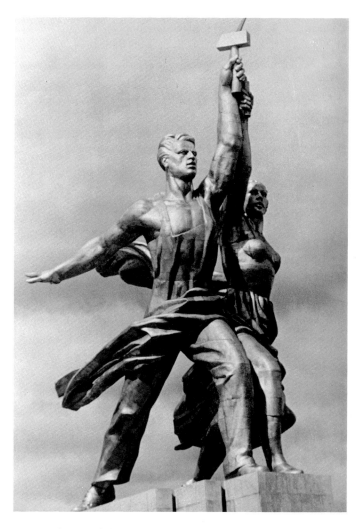

academic art nor the unpretentious charm of the illustration' (*American Painting*, p.36). In some cases the history and significance of the Federal Art Project are written out of Modernist accounts altogether. Is it possible to see this as a repression, both of the general questions and issues relating to culture and democracy in the 1930s, and of the earlier history of many artists who later became famous as Abstract Expressionists? Perhaps it is best understood as an attempt to forget a social, political and ideological conjuncture that by the 1950s, because of the Cold War and anti-Communism in the US, had come to be seen as a 'proto-socialist' or even actual socialist aberration in US history.[2]

Plate 11 shows Pollock preparing for May Day celebrations in 1936. Along with Rothko, Robert Motherwell and other Abstract Expressionists, he became involved with left-wing politics as a member of the Artists' Union, which was set up in 1934 to enable artists employed by the state to bargain for better conditions and to press for extended periods of work on state projects (see Plate 12). In addition, artists and critics on the left became involved in both national and international political issues and debates, such as the Popular Front against Fascism established in 1935, and against the Spanish Civil War in 1936. Pablo Picasso's *Guernica*, completed in 1937 (Plate 13), became both a symbol of opposition to the Fascist bombing of the Spanish town, and a symbol of an attempt to make a politically cogent artistic intervention that did not rely on the conventions of

[2] But see B.J. Bernstein, 'The conservative achievements of liberal reform'.

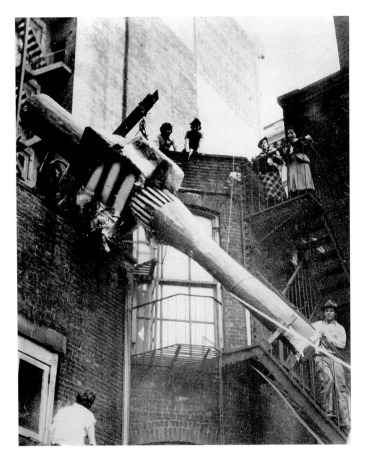

Plate 11 Jackson Pollock (lower right) helps carry a section of a 1936 May Day float down a fire-escape from David Siqueiros's workshop, Union Square, New York. Photograph in the Siqueiros Archive, Mexico City.

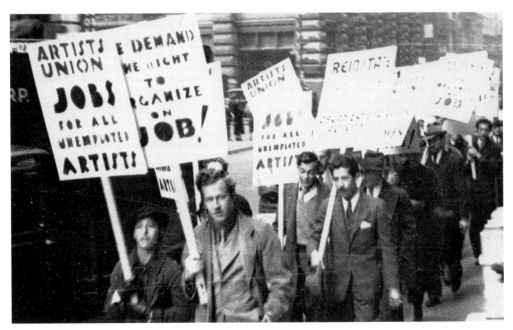

Plate 12 Artists in a picket line. Photograph by Irving Marantz, reproduced from F.V. O'Connor (ed.), *Art for the Millions*, Boston, New York Graphic Society, 1975 by permission of F.V. O'Connor.

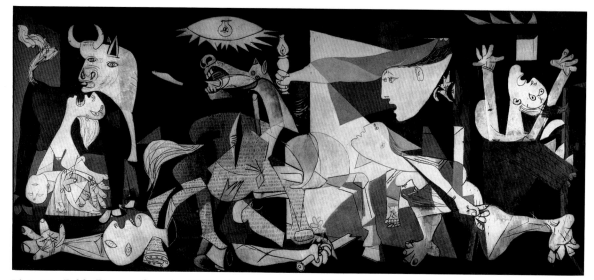

Plate 13 Pablo Picasso, *Guernica*, 1937, oil on canvas, 349 x 777 cm. Museo del Prado, Madrid. © DACS, London, 1993.

'naturalism' or 'social realism' then predominant in the USA. The formal qualities of *Guernica* – which was painted as part of what was regarded as a continuance of the Cubist idiom established by Picasso and Georges Braque before the First World War – became the subject of an intense debate within magazines based in New York, such as *Art Front, Art Digest* and the *Magazine of Art*. The organization of left-wing and liberal artists opposed to Fascism and the war in Spain reached a formal state in the setting up of the American Artists' Congress in 1936. The following year Picasso sent his regards and best wishes, via a transatlantic telephone link. Opinion was divided, however, over how appropriate abstract art was for communicating to a mass public not familiar with it. Further, was it suitable for the needs of political activism? Pollock's response to *Guernica*, and to the range of issues it raised about politics and representation, is part of the history of the transformation that takes place within his work between the late 1930s and the late 1940s. It was also a situation that faced Rothko, and to which I shall return. This conjuncture – in which art and politics, and what were often called the 'social responsibilities' of artists to society and culture as a whole, seemed unavoidably interlinked – stands in sharp contrast (as an antithesis, perhaps) to the situation after the Second World War, in which Modernist accounts and values were dominant.

The director of the Federal Art Project, Holger Cahill, made explicit the relationship between culture and democracy in the USA during the 1930s. Their interconnection was a key element within the project's organizational philosophy, and in a speech given at the opening of a show of government-sponsored art at the Museum of Modern Art in New York in 1936, he argued that the project partly aimed to undermine both imported nineteenth-century European academic traditions *and* the newly arrived conventions of Modernist art. In this sense the project's agenda, based on domestic cultural and political issues, differed from the agenda of left-wing artists who, although wishing to see a socialist revolution in the USA, also had an internationalist perspective. According to Cahill, the Federal Art Project offered

> the upsetting spirit of frontier democracy ... one might say that American art was renewing itself through new contacts with the American art and the American people ... If their taste was not always of the best, it was an honest taste, a genuine reflection of community interests and of community experience.
>
> (H. Cahill, *New Horizons in American Art*, p.11)

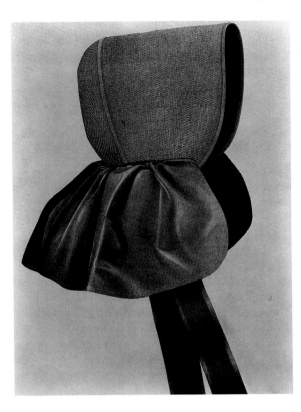

Plate 14 Orville A. Carroll, *Shakertown Bonnet (Kentucky Project)*, 1935–42, watercolour, graphite and gouache on paperboard, 46 x 34 cm. National Gallery of Art, Washington; Index of American Design I-16810.

Cahill's rhetoric may seem similar to Craven's discussed earlier, though Cahill saw himself as a 'New Dealer' through and through, committed to creating a 'managed capitalism' within which social democracy might flourish, offsetting the exploitative structures of a capitalist economy. Yet his language and sentiment included the bucolic vision characteristic of Craven's prose. Cahill spoke of a 'fresh poetry of the soil' (p.35), and the recurrence of rural metaphors in his arguments betrays exactly the sense in which the New Deal's concepts of culture and community invested hopes in a return to a mythical pre-industrial, pre-urban and pre-capitalist past. The Federal Art Project set up what was called the Index of American Design, a programme devoted to producing a drawn and photographic record of American folk-cultural objects. This was intended to document and celebrate the cultural remnants of such a mythic past (Plate 14). Shaker community and cultural artefacts, for instance, were seen as representing the 'organic' and authentic culture and society before the effects of industrialism, which brought with it an alienating division of labour and the regimes of mass production. 'American art', Cahill said, 'is declaring a moratorium on its debts to Europe and returning to cultivate its own garden' (quoted in Rose, *Readings in American Art since 1900*, p.47). The federal nature of the art projects, which covered the whole country, was intended to enable artists to remain in their home towns; it was thus aimed at retarding what was seen as the destructive emigration of artists to the metropolitan centres on the east coast. In this and other respects, the philosophy of the Federal Art Project was explicitly anti-Modernist.

Cahill attacked avant-garde Modernism *and* traditional academic art because he saw both as essentially 'alien' imports from a still semi-feudal European civilization that was about to embroil itself and the rest of the world in another war. Returning a 'social role' to the artists in US society in the 1930s was thus seen as the urgent task of the Federal Art Project, and in so doing the project would remove both the reactionary power of the nineteenth-century academic art establishment and halt the further inroads of what was perceived as an élitist Modernism. Many critics during the 1920s and 1930s, in addition to

Craven and Cahill, were vociferously against Modernism – Kenyon Cox, Royal Cortissoz and John Alexander – though some painters, such as Benton, who had been a Modernist for a number of years before the First World War, also turned chauvinistically against it. According to Benton:

> Modern art became, especially in its American derivations, a simple smearing and pouring of materials, good for nothing but to release neurotic tensions. Here, finally, it became like a bowel movement or a vomiting smell.

Benton went on to diagnose a form of what he called 'aesthetic colonialism', identifying Modernism as a form of international, un-American conspiracy:

> The United States is invaded by aliens, thousands of whom constitute so many acute perils to the health of the body politic ... these movements have been promoted by types not yet fitted for the first papers in aesthetic naturalization – the makers of true Ellis Island art.
>
> (Benton, quoted in Rose, *Readings in American Art since 1900*, pp.27, 54)

This form of racist polemic was a component of the New Deal nationalism which propelled some government art administrators into an attack on the dominance of European art in general in the USA, and which envisaged, through the Federal Art Project, a state intervention into the national culture in the cause of saving and nurturing an indigenous American art. This was conceived as being produced *by* Americans *for* all the American people; hence the funding aimed not only to arrest European and US Modernism, but also radically to democratize the experience and intelligibility of an 'authentic' art produced by Americans. The existence and influence of a small but active Modernist avant-garde – largely based in New York and patronized by an exclusive intelligentsia – was anathema to the populism of the Federal Art Project.

The tradition of 'naturalistic' or 'realist' representational art in the USA, and a corresponding 'art-for-life's-sake' populism, can be traced as far back as the American Revolution; it may be seen as analogous to the political and legal egalitarianism enshrined in the US constitution. Indeed, US art up to the start of the twentieth century, and the beginnings of the large-scale and direct influence of European Modernist art following the Armory Show of 1913 in New York, was dominated by varying 'realistic' practices and ideas. I shall use the term 'realist' to denote the attempt to represent some aspect of social and historical reality, rather than to imply the use of any particular style or formal convention. Nor should the term be taken to involve only *one* political position.

The 'vernacular' tradition

Terms such as 'naïve', 'topographical', 'folk' and 'romantic' have been used to identify works produced within this broad American 'realist' tradition. Consider, for example, Edward Hicks's *The Residence of David Twining* (1846–47), Thomas Cole's *Schroon Mountain, Adirondacks* (1838) and Frederic Remington's *A Dash for the Timber* (1889) (Plates 15–17). All three paintings belong to what has been called a 'vernacular' tradition of visual representation in the USA. 'Vernacular' when used in relation to art in North America refers to two parallel movements and approaches, which can be traced through to art produced in the 1930s as well as after the Second World War within the work of the Pop Artists. 'Vernacular' used as an adjective implies 'native' or 'indigenous', and includes the types of subject-matter found in these three paintings, i.e. agricultural settlement and farming of land that had been either uninhabited (the 'wilderness') or the habitat of Native Americans. This settlement by waves of European immigrants gives an indication of the connected sense of 'vernacular' when it's used as a noun, i.e. 'the native speech or dialect of a people, as opposed to a literary, learned or obsolete language' (*Penguin English Dictionary*, 1979). Stylistic labels such as 'naïve', 'topographical' or 'folk', when used about art produced in the USA, carry the particular meaning that the works have been made

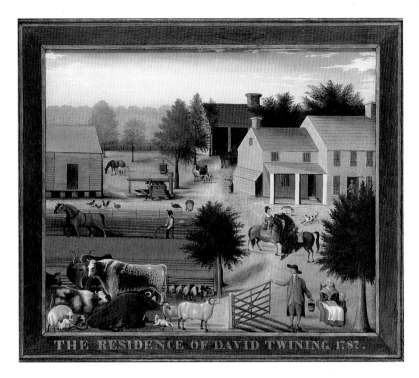

Plate 15 (attributed to) Edward Hicks, *The Residence of David Twining, Bucks County, Pennsylvania*, 1846–47, oil on canvas, 67 x 89 cm. Colonial Williamsburg Foundation, Virginia 33.101.1.

outside the parameters of *European* artistic culture, both in terms of the institutions for training and exhibition (the Academy system in France and Britain, for example) and the conventions developed within European art since the Renaissance. Although the USA was 'settled', this term hardly carries the sense of the struggle and exploitation that were involved in the process of colonization: the developing 'otherness' of these immigrant populations when contrasted with European culture and society quickly became a feature of historical accounts of the USA produced *both* in Europe and in the US. Cahill's defence of what 'is specifically American', outlined in his introductory essay for the New Horizons in American Art show in 1936, is one version of a celebration of 'vernacular' culture. Modernist accounts of US art downplay the value of such 'indigenous' work produced before the Second World War precisely because it is seen as synonymous with 'parochial', and as ignorant of the development and qualities of European Modernist art.

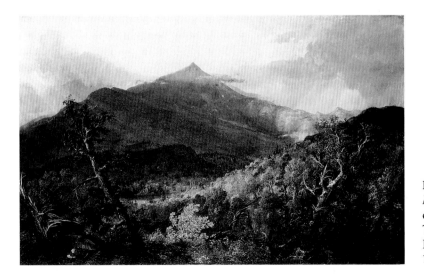

Plate 16 Thomas Cole, *Schroon Mountain, Adirondacks*, 1838, oil on canvas, 100 x 160 cm. The Cleveland Museum of Art, Hinman B. Hurlbut Collection, 1335.17.

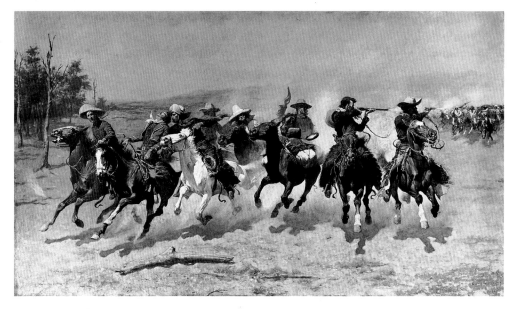

Plate 17 Frederic Remington, *A Dash for the Timber*, 1889, oil on canvas, 123 x 214 cm. Amon Carter Museum, Fort Worth, 1961.381.

At the start of the twentieth century in the USA, the traditions of vernacular representation were re-articulated within the writings of populists such as Oliver Wendell Holmes and Walt Whitman, and in the statements of artists and writers including Robert Henri and the 'Ash Can School'. Two statements exemplify the yearnings for a rich vernacular culture at the end of the nineteenth century and the beginning of the twentieth:

> America has yet morally and artistically originated nothing. She seems singularly unaware that the models of persons, books, manners, etc., appropriate for former conditions and for European lands, are but exiles and exotics here.
> (W. Whitman, *Democratic Vistas*, quoted in Rose, *Readings in American Art since 1900*, p.11)

> If anything can be done to bring the public to a greater consciousness of the relation between art and life, of the part each person plays by exercising and developing his own personal taste and judgement and not depending on outside 'authority', it would be well.
> (R. Henri, *The Art Spirit*, quoted in Doss, *Benton, Pollock and the Politics of Modernism*, p.45)

Henri's book *The Art Spirit* became influential on a group of artists including John Sloan, George Luks, Everett Shinn, William Glackens and George Bellows, active especially during the first two decades of the twentieth century. Henri urged artists to engage with the 'vernacular modernity' of urban life in the USA, and the term 'urban vernacular' may be a useful way of describing the genre dominant in the USA until the Second World War, as most artists were concentrated on the Eastern Seaboard and especially in New York. The 'outside "authority"' Henri cites as a block on 'indigenous' development referred to European civilization and the codes of representation within both European academic and Modernist art.

John Sloan's *Sixth Avenue at 30th Street (New York)* (Plate 18) is part of the 'subway' painting tradition to which Rothko contributed in the 1930s. Sloan is concerned with the representation of the life of people as part of the material fabric of urban life in New York; and he uses an obscure but nevertheless quite extensive narrative to depict social relations within the city's structures of roads, overhead railways and buildings. The woman in the foreground appears distressed and physically 'alienated' (i.e. separated) from other groups, including the two women who, in passing, appear to mock her demeanour.

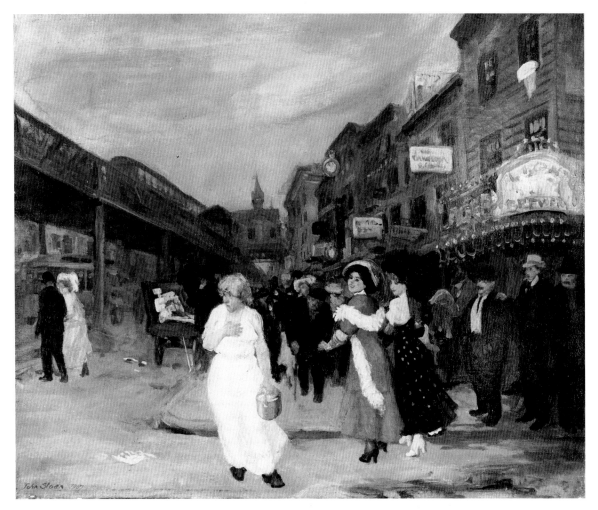

Plate 18 John Sloan, *Sixth Avenue at 30th Street (New York)*, 1907, oil on canvas, 64 x 90 cm. Collection of Mr and Mrs Meyer Potamkin, USA.

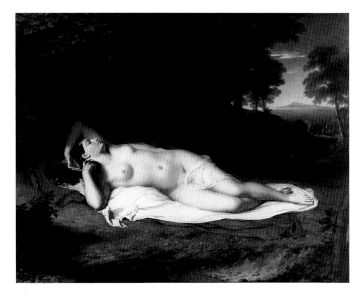

Plate 19 John Vanderlyn, *Ariadne asleep on the Island of Naxos*, 1809–14, oil on canvas, 174 x 221 cm. Courtesy of the Pennsylvania Academy of the Fine Arts, Philadelphia; gift of Mrs Sarah Harrison (The Joseph Harrison jr Collection).

Plate 20 William J. Glackens,
Hammerstein's Roof Garden,
c.1901, oil on canvas, 76 x 64 cm.
Collection of the Whitney
Museum of American Art,
New York.

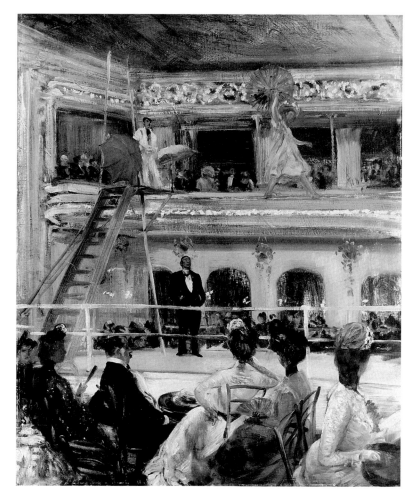

William Glackens's *Hammerstein's Roof Garden* and George Bellows's *Dempsey and Firpo* (Plates 20 and 21) are examples of how US artists depicted contemporary mass leisure pursuits in the commercial capitalist culture of urban life. The tightrope act and the boxing match are both portrayed as spectacles within urban cultures founded on exchange-relations, within which the work activity of one person or group is consumed as part of the leisure activity of another group. Display, in terms of the daring circus act and the boxing 'exhibition', is mirrored by the display of the audience's dress codes, indicative of their location within other social groups present in the urban milieu. Both this choice of subject-matter and the sketchy, 'illustrational' or 'impressionistic' means of depiction suggest antipathy to the traditional values and practices of nineteenth-century academic painting in the USA (contrast Glackens's and Bellows's paintings with, for example, John Vanderlyn's *Ariadne asleep on the Island of Naxos*, Plate 19).

 Such a concentration on the 'urban vernacular' also contrasts sharply with paintings produced by the 'Regionalist' artists active during the 1920s and 1930s. While Benton's work contains scenes of *both* rural and urban life (Plates 7 and 23), the artists John Curry and Grant Wood are primarily regarded as painters of an agrarian America. Consider, for example, Benton's *City Activities with Subway*, part of the *America Today* cycle, along with Curry's *Baptism in Kansas* and Wood's *American Gothic* (Plates 22–24). Benton projects an almost kaleidoscopic montage of scenes to be found within urban life, including the familiar themes of boxing and burlesque night-life, along with the perennial modern

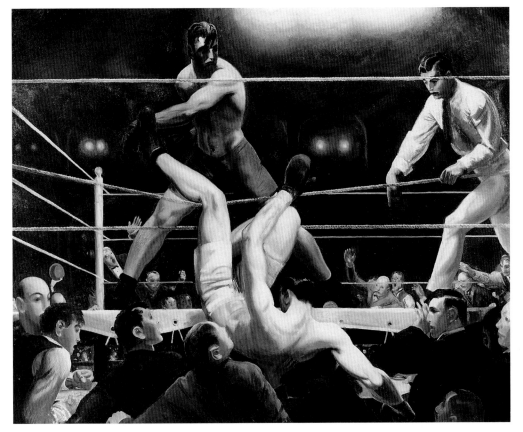

Plate 21 George Bellows, *Dempsey and Firpo*, 1924, oil on canvas, 124 x 161 cm. Collection of the Whitney Museum of American Art, New York; purchased with funds from Gertrude V. Whitney. Photograph: Geoffrey Clements.

Plate 22 John Steuart Curry, *Baptism in Kansas*, 1928, oil on canvas, 102 x 127 cm. Collection of the Whitney Museum of American Art, New York; gift of Gertrude V. Whitney.

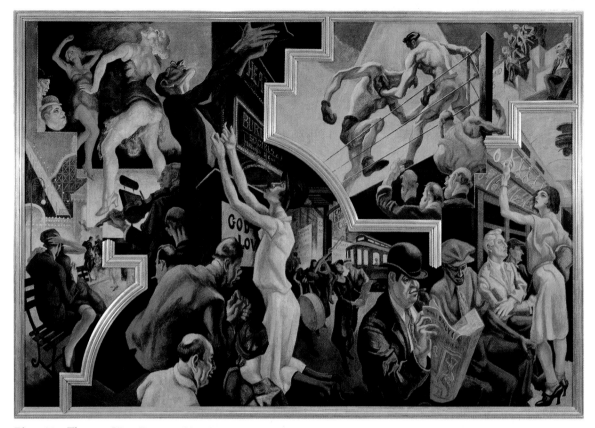

Plate 23 Thomas Hart Benton, *City Activities with Subway (America Today)*, 1930–31, distemper and egg tempera with oil glaze on gessoed linen, 236 x 341 cm. Collection, The Equitable Life Assurance Society, New York. © Thomas Hart Benton, DACS, London and VAGA, New York, 1993.

experience of travelling on the subway. The sexual seediness of modernity also preoccupies Benton, who pictures women as objects of consumption within the masculine spaces of the music-hall, the newspaper and the underground railway car. Benton's sense of the city as a site of apparent contradiction is represented in the depiction of religion and prayer, though the sign 'God is Love' appears as simply another form of advertising and display characteristic of the city as a whole. His caricatural, expressionist formal treatment emphasizes through line and compositional pattern what might be described as the pervading 'rhythm' of the network of urban economic and social relations. The quasi-mural size of the panel, which was of interest to Jackson Pollock during their relationship in the early 1930s, creates the sense of a kind of 'monumentality' characteristic of the city for Benton: cities (especially New York) were the 'building' of the USA. In contrast, Curry's and Wood's representations seem tied into a nineteenth-century 'naïve' or 'folk' tradition, equally 'vernacular' but oriented to a set of social relations and values denied by the realities of urban industrial capitalist society. The beginning of the Depression in the early 1930s exacerbates this sense of a tension between a perceived, perhaps imagined, form of communal life (the Midwest idyll) and the transformations wrought within a capitalist social order apparently brought to its knees. The Federal Art Project, as part of the New Deal, was to offer US artists the opportunity to work within a government agency that, rhetorically at least, wished to see the country's economic and political life reordered as part of a 'New Deal Democratic Revolution'.

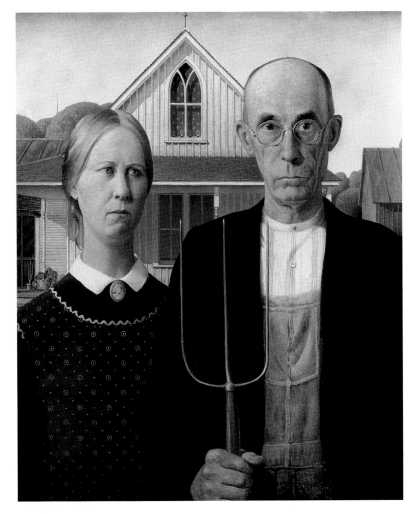

New Deal 'democratic realism'

It was also in the early 1930s that the Mexican mural artists began to achieve widespread popularity and acclaim – for their work in Mexico under the revolutionary-nationalist government of Alvaro Obregon, and then in the USA. Murals by Diego Rivera, José Orozco and David Siqueiros were admired by many in the USA who had no commitment to the Mexicans' socialist and communist beliefs. Rather, the work was seen as valuable in the USA because it represented 'a paradigm of socially-conscious wallpainting'.[3] American artists including George Biddle, Philip Guston and Grace and Marion Greenwood went to Mexico to paint murals, and later worked in the USA on public art programmes sponsored by the government's art projects. Ben Shahn helped Rivera on a series of ill-fated murals at the Rockefeller Center, New York, in 1933–34, including a panel entitled *Man at the Crossroads* (Plate 25). This depicted a history of the development of human technological and social development and included a portrait of Lenin, symbolic of the choice available between a continuing capitalist system of production and the possibility of a socialist revolution. John Rockefeller, the US corporate capitalist with paternalist leanings, ordered the portrait to be removed from the mural. Rivera refused and the mural series was whitewashed over. Rivera had painted other, successful mural cycles, such as the 1932–33

[3] George Biddle, letter to Roosevelt in May 1933, quoted in K.A. Marling, *Wall-to-Wall America*, p.31; see also
G. Berman, *The Lost Years*.

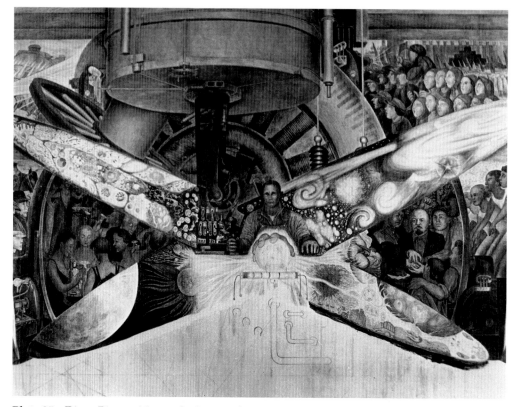

Plate 25 Diego Rivera, *Man at the Crossroads*, 1933–34, fresco (now destroyed), 582 x 1246 cm. Photograph: Lucienne Bloch.

Detroit Industry series (another corporate commission) in the Inner Garden Court of the Detroit Institute of Arts, based on drawings and photographs of the Ford Rouge Plant (Plate 26). As with Stea's *Sculptural Relief for the Bowery Bay Sewage Disposal Plant* (Plate 9), the theme of work and technological dynamism is central – although, unlike *Man at the Crossroads*, the Detroit panels are not obviously critical of capitalist economic and technological transformations.

Whatever the politics in the work of the Mexican muralists in either Mexico or the USA, the appropriation of their skills and monumentalist conventions by the US government involved an effective draining out of any specific ideological convictions. George Biddle wrote to Roosevelt, praising the example of the Mexican muralists and calling for a government scheme to employ artists in the USA:

> The young artists of America are conscious as they have never been before of the social revolution that our country and civilization are going through, and they would be very eager indeed to express their ideals in a permanent art form if they were given the government's co-operation … I am convinced that our mural art, with a little impetus can soon result, for the first time, in a vital national expression.
>
> (Biddle, letter to Roosevelt in May 1933, quoted in K.A. Marling, *Wall-to-Wall America*, p.31)

Three murals produced by US artists on the Federal Art Project may be seen as representative of the work that Biddle envisaged. These are: Lucienne Bloch's mural *Childhood*, painted in a women's prison in Manhattan in 1936; Marion Greenwood's *Blueprint for Living*, painted at the Red Hook Housing Project in Brooklyn in 1939–40; and Philip Guston's *Work and Play*, painted in the lobby of the community centre at

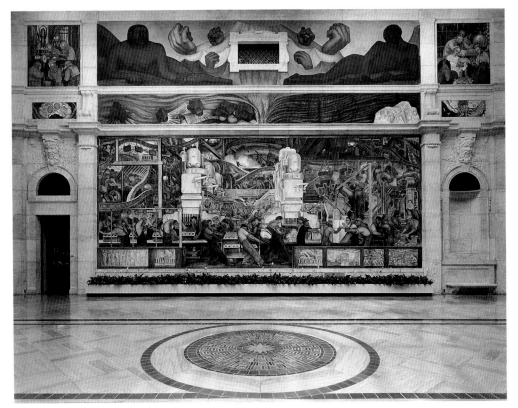

Plate 26 Diego Rivera, *Detroit Industry*, 1932–33, fresco; North Wall and (below) detail of the centre of the North Wall. The Detroit Institute of Arts; Founders' Society Purchase, Edsel B. Ford Fund and gift of Edsel B. Ford.

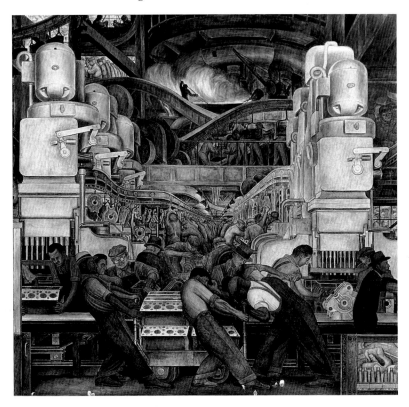

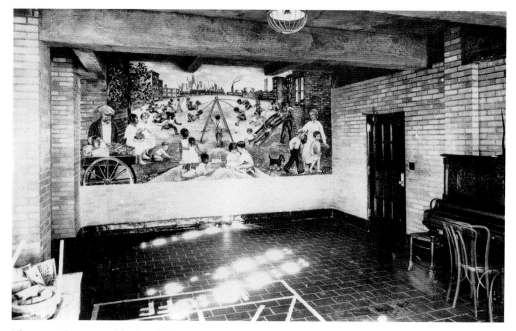

Plate 27 Lucienne Bloch, *Childhood*, 1936, fresco (now destroyed), approx. 22.3 sq. m, in the recreation room of the Women's House of Detention, Manhattan, New York.
Photograph: Lucienne Bloch.

Queensbridge Housing Project, Queens, in 1940–41 (Plates 27–29). All three were intended for public sites, within institutions inherited by the New Deal government or created by it as part of their social welfare programmes inaugurated in 1933. Consciously associated by the artists with the examples of Mexican muralist art, the panels were intended to revive Italian Renaissance traditions of fresco painting in spaces where people congregated, away from the art gallery and the 'art-for-art's-sake' ethos of European Modernism.

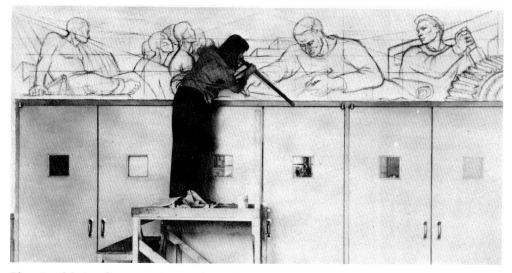

Plate 28 Marion Greenwood at work on *Blueprint for Living*, 1939–40, fresco (now painted over) in the lobby of the community centre, Red Hook Housing Project, Brooklyn, New York.
Photograph: WPA/FAP Photograph Collection, Smithsonian Institution, Washington, courtesy of Robert Plate.

Plate 29 Philip Guston, *Work and Play*, 1940–41, casein-resin emulsion on gesso, approx. 1.8 x 27.4 m, in the lobby of the community centre, Queensbridge Housing Project, Queens, New York City (disavowed by the artist after the work was extensively restored by unknown hand). Photograph: WPA Photograph Collection, Archives of American Art, Smithsonian Institution, Washington.

Bloch's panel was part of an unfinished series. This was to have been called *Cycle of a Woman's Life*, aiming to represent to women prisoners the possibility of a harmonious communal life outside the prison. It presented a vision of a society in which women, suitably improved by their period of incarceration, could rejoin the community. The mural itself was intended to function as a 'corrective' visual diatribe – although rehabilitation, rather than punishment for its own sake, informed the discussions between artist and prison authorities when they negotiated the mural.[4] Whatever the reformist zeal invested in the representation, the opportunities for women outside the prison were shown as highly limited and traditional – mothering (conceived as a form of 'natural' self-fulfilment, or as teaching children for their own entry into the adult social realm).

Greenwood's *Blueprint for Living* also offered a series of narratives for the proper social activity of Americans within the new corporate state. 'Planning' became a central theme in New Deal political and managerial discourse, opposed to the apparent chaos of the free market that had led, in the early 1930s, to a near economic and social collapse. *Blueprint for Living* consisted of three panels on three walls of the entrance hall to the housing centre auditorium. The right-hand panel showed labourers at work on a housing project while a small family group stood by and watched its new house being built. The left-hand panel showed a group of youths studying, playing ball and in general profiting from 'clean living', according to the artist's own statement. The third panel, a thin strip over the doors (see plate), presented an image of the future planned for the youth of the USA and included a man holding blueprints and another operating a machine, while others stood by and looked hopefully into the distance. The New Deal government once again appeared, symbolically portrayed as workers, as the beneficent arbiter of the lives of the people of the USA, empowered to reconcile the 'various needs of the individual' with 'accepted social needs'.[5] The state's task was seen in terms of harnessing economic production to social ends and thereby abolishing the anarchy of the market and replacing it with a state-defined moral economy of needs and 'rightful desires'. Red Hook Housing Project, along with the murals within it, may be seen as a material encapsulation of the New Deal's vision of the future US society. The buildings and murals functioned as signs of the state's fidelity to the concept of a planned, ordered and regulated nation.

Guston's *Work and Play* also had as its theme the family group, claimed as 'symbolic of the basis on which any community must build'. The Federal Art Project produced a commemorative statement explaining the significance of the Guston panels and of works by other artists, both painters and sculptors. Queensbridge Housing Project included a community centre, a children's centre, stores, a playground, spacious interior courts and garden walks, along with the fifteen-acre park. The actual houses provided homes for 3,149 families. Guston's mural, of which only parts survive, narrated the story of Queensbridge. The symbolic family anchors a side panel representing a group of young

4 See J. Harris, 'State power and cultural discourse', pp.37–8.
5 See G.E. Markowitz and M. Park, *New Deal for Art*, p.54.

children playing near slum buildings in the process of demolition. Workmen appear in the foreground, again symbolic of physical and social rebuilding. Represented alongside them are three basketball players over the left doorway of the lobby who, according to the statement, represent 'one phase of community recreation', while a 'related trio of musicians and dancers' is shown above the right doorway. As a whole, therefore, the mural articulated scenes of recreation, reproduction, labour and learning. The statement continued:

> The figure of the doctor and child at the right of this scene indicates the importance of public health, and at the far right are shown a group of youngsters engaged in various activities typical of community life – painting, reading, building model aeroplanes and learning carpentry.
>
> (Federal Art Project statement, Archives of American Art (FVO'C 1089))

All three murals were painted in what may be called 'realist' styles (following my earlier definition), although Greenwood's and Guston's forms owed more to the conventions of monumentalism they found in Mexican mural painting: figures were inflated, made massive and bulging, though they were also located in perspectival schemes *and* narrative episodes. Such formal and narrative devices held the depicted figures in place as symbolic abstractions, personifications of state power and energy, directed towards reconstructive ends in accordance with New Deal ideology.

In one sense these murals embodied the version of technocratic modernity espoused by the professional and managerial élites that allied themselves with Roosevelt's political mission during the 1930s: scientists, engineers, educators and specialists of all kinds were presented as a key to the properly managed development of US society following the failure of an anarchic, capitalist, free market. Yet in terms of style, or the deployment of

Plate 30 Charles Demuth, *Buildings, Lancaster*, 1930, oil on composition board, 61 x 51 cm. Collection of the Whitney Museum of American Art, New York; gift of an anonymous donor 58.63. Photograph: Geoffrey Clements.

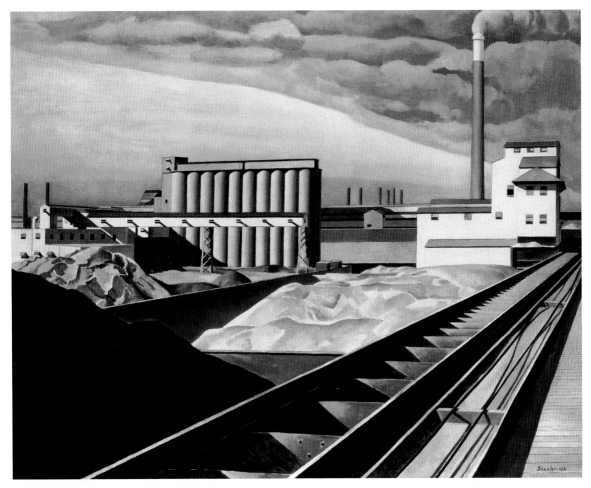

Plate 31 Charles Sheeler, *Classic Landscape*, 1931, oil on canvas, 64 x 83 cm. From the collection of Mr and Mrs Barney A. Ebsworth Foundation.

formal conventions, the murals recapitulated the varying forms of vernacular depiction inherited from the nineteenth century and artists such as Benton and the Mexican muralists. They may be described as 'modern' in terms of subject-matter, but very 'unmodern' in the sense of owing little to the conventions of European Modernist art. In the 1930s, however, this was generally a cause for approbation (remember Whitman, Henri and Cahill) rather than the castigation that became the critical norm after the Second World War.

Artists concerned with vernacular subject-matter, though also with mobilizing a neo- or pseudo- 'Modernist' mode of representation, included Charles Demuth and Charles Sheeler, members of the 'Precisionist' group. Works such as Demuth's *Buildings, Lancaster* or Sheeler's *Classic Landscape* (Plates 30 and 31) exhibit a kind of attention to the flatness of the canvas, and a lack of modelling depth associated with authentic Modernist art. An emphasis on abstract forms, such as the cylinders in Sheeler's painting, has also led some critics and historians to see these works as related, if only very tenuously, to the European Modernist tradition. Similarly a work such as Morgan Russell's *Synchromy in Orange* (Plate 32), composed of a flat pattern of interlocking colours, depicting no objects from the world, has been taken to have attenuated and derivative links with European artists

Plate 32 Morgan Russell, *Synchromy in Orange: to form*, 1913–14, oil on canvas, 312 x 309 cm. Albright-Knox Art Gallery, Buffalo, New York; gift of Seymour H. Knox, 1958.

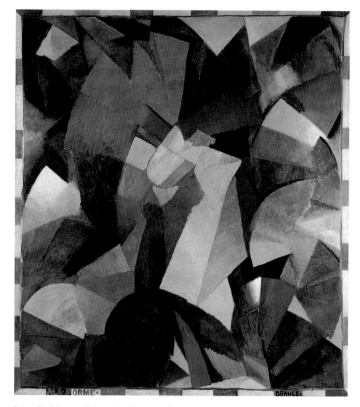

associated with so-called Orphic Cubism. Charles Demuth's *My Egypt* (Plate 33) has also been seen, by Modernist historians writing since the Second World War, as really only an 'illustration', although there is the suggestion of a reference to authentic Cubist linear form and compositional construction based not on perspectival conventions but on the painting's internal formal structure.

 In historical accounts of twentieth-century art in the USA, constructed during the 1960s and 1970s from a Modernist perspective, the period before the Second World War and the period afterwards appear to be 'two different countries'. One, that of the '1930s USA', is a society and culture rooted in an inward-looking, 'domestic' self-regard, with forms of artistic production based on, and derivative of, 'realist' concerns and perspectives. These may be diverse, both stylistically and politically, but they share an attachment to a specific sense of art's function as an element in a society's self-definition and introspection. On the other hand, the '1950s USA' (which will be discussed in detail in Part 2) is a society and culture turned outward, 'international' and shunning the 'parochial' (a key Modernist term of abuse aimed at works that appear to be *merely* 'local' or 'regional'). Art of the '1950s USA' is resolutely 'abstract', tending towards the 'universal', and is not tied down (a negative sense of 'rootedness') to the preoccupations of the society as a whole. This, at least, is the Modernist account of the disjunction between '1930s USA' and '1950s USA'.

Rothko, Davis and the politics of Modernism

Before 1945, most US art institutions showed comparatively little interest in modern American art (the Federal Art Project and other programmes, and the Whitney Museum, being the most important exceptions). The vernacular tradition in any of its variants – 'illustrational', 'anti-Modernist', 'pseudo-Modernist', etc. – was held as secondary to European Modernist artists and movements. The 'circles' of art appreciation established by Arthur Steiglitz and Walter Arensberg in New York had provided a small but wealthy

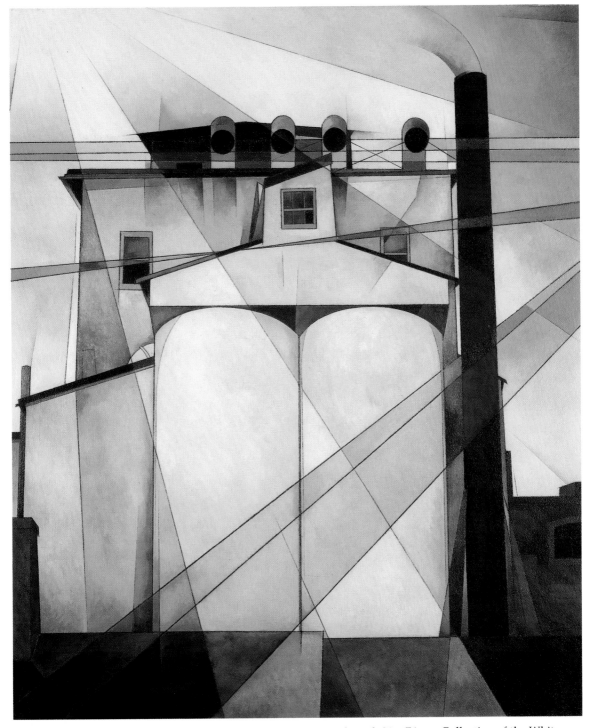

Plate 33 Charles Demuth, *My Egypt*, 1927, oil on composition board, 91 x 76 cm. Collection of the Whitney Museum of American Art, New York; purchased with funds from Gertrude V. Whitney, 31.172. Photograph by Sheldon C. Collins, New York.

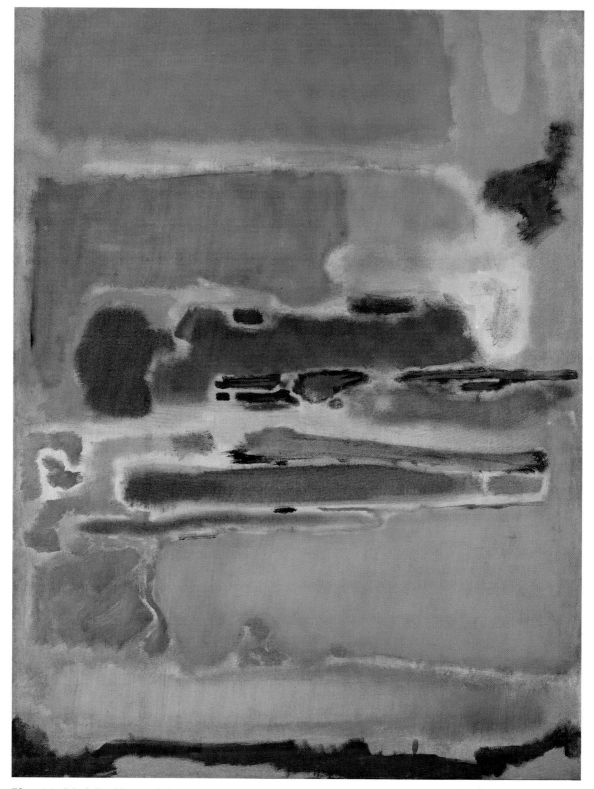

Plate 34 Mark Rothko, *Multiform*, 1948, oil on canvas, 154 x 118 cm. Estate of Mark Rothko; Rothko no.3014.48. Photograph: Pace Gallery. © 1992 Kate Rothko-Prizel and Christopher Rothko/ARS, New York.

public for European artists before the First World War; galleries such as those of Daniel, Bourgeois, Carroll and the Modern, which had been started after the First World War, led to the development of a small market and platform for mainly European artists. Admittedly towards the end of the First World War there developed an interest in a 'national-Modernism', indicated by the 1916 and 1917 Independent Exhibitions of American Art held in New York, and by the opening of The Intimate Gallery (1925–29) and An American Place (1929–46) by Steiglitz, both of which were reserved for American artists. But this interest was small compared with what came after the Second World War.

The 1920s in the USA are conventionally represented as a time of cultural and economic isolationism, growing nationalism and political reaction (owing in part to the defeat, by an isolationist Congress, of President Wilson's plans for the League of Nations, and in part to the subsequent election of successive Republican administrations). And, in terms of the development of art institutions, this representation is generally valid: the American Wing of the Metropolitan Museum was opened in 1924, and the Whitney Museum of American Art opened in 1930–31, with biennials of contemporary American art beginning in the following year. For the Modernist historian Rose, the opening of these galleries and their growth throughout the years after the Armory Show, along with the development of a market and public for both a European and an American Modernism, demonstrated that American art was not necessarily limited to its vernacular forms predominant during the 1930s.

Between about 1938 and 1948 in New York, the work of Rothko and Pollock, and of others who were to become famous as Abstract Expressionists, shifted from the concerns we can characterize as '1930s Realism' to those that are recognized as '1950s Abstraction'. In the period between Rothko's 'Subway' series of paintings (see Plate 8) and the emergence of his paradigmatic 'abstract' paintings from 1948 onwards, beginning with *Multiform* and including *Number 7* discussed earlier (Plates 34 and 4), there is a series of paintings where he begins increasingly to obliterate the social iconography that was present – if only ambiguously – in his 1930s works. Paintings such as *Antigone* and *Aquatic Drama* (Plates 35 and 36) represent a diminution in obvious and accessible socially-symbolic meaning and a turn to shapes in nature, to biomorphic 'hieroglyphs', and reference to ancient myths of gods and origins. Pollock's series of works produced in the early 1940s also resorted to a Surrealist-influenced biomorphism and interest in mythic themes. This was related to the Jungian psychoanalysis he was undergoing at the time (see, for instance, *Male and Female*, Plate 37).

In these works, artists who were later to be identified as the first generation of the post-war New York School may be seen as retreating from the political and aesthetic ideologies prevalent within the organized Left in the 1930s. Rothko said later that he found 'the figure could not serve my purpose … a time came when none of us could use the figure without mutilating it' (speaking at the Pratt Institute, New York, quoted in an article by Dore Ashton in the *New York Times*, 31 October 1958).

This sense of 'destruction', which Rothko apparently felt about his work from the early 1940s onwards (as well as his own continued emphasis in statements about his paintings as 'tragic' or about 'tragedy'), indicates that his career, and those of the other Abstract Expressionists in the 1940s and 1950s, should perhaps be understood as partly a retreat from the ruins of the Socialist and Communist opposition in the USA in the late 1930s brought about by the rise of Fascism, the failure of the Popular Front, the revelations about Soviet Stalinism and the collapse of the New Deal coalition in the USA. Between about 1937 and 1940–41, many partisans became repulsed by Stalin's rule in the USSR and the enforcement of Socialist Realism as the official state cultural ideology. By the early 1940s, social realist painting in the USA had also become discredited, seen as associated with, or even controlled by, Stalinist Communists active in the USSR or operating through US left-wing organizations such as the American Communist Party. One more 'tragedy',

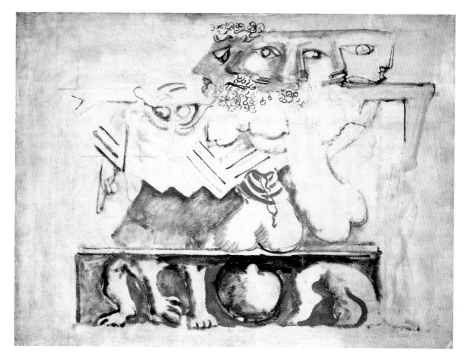

Plate 35 Mark Rothko, *Antigone, c.*1941, oil on canvas, 86 x 116 cm. National Gallery of Art, Washington; Rothko no.3240.38, gift of the Mark Rothko Foundation. © 1992 Kate Rothko-Prizel and Christopher Rothko/ARS, New York.

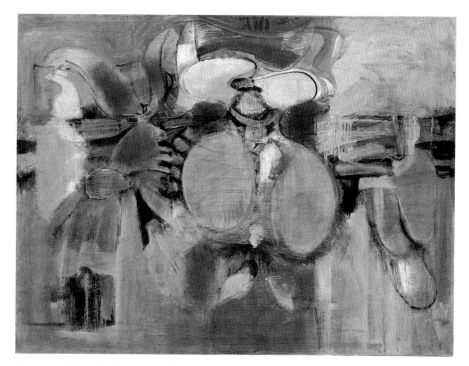

Plate 36 Mark Rothko, *Aquatic Drama*, 1946–47, oil on canvas, 92 x 123 cm. National Gallery of Art, Washington; Rothko no.3029.46, gift of the Mark Rothko Foundation. © 1992 Kate Rothko-Prizel and Christopher Rothko/ARS, New York.

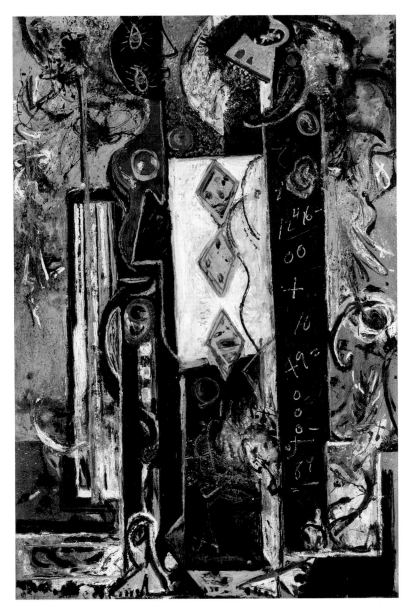

Plate 37 Jackson Pollock, *Male and Female*, *c.*1942, oil on canvas, 185 x 121 cm. Philadelphia Museum of Art; gift of Mr and Mrs H. Gates Lloyd, 74.2321. © The Pollock-Krasner Foundation/ARS, New York.

arguably, was the fact that by 1948 the paintings and statements of the Abstract Expressionists were beginning to be assimilated into the anti-Communist rhetoric characteristic of the Cold War, despite the persistently anti-nationalist and anti-capitalist statements made by Pollock, Rothko and Newman.

If we can recover the actual politics of the conjuncture, from the late 1930s to the late 1940s, and relate the culture and politics of the Depression to those of the incipient Cold War, we may be able to understand why the idea and dream of an art *unconnected* to social and political realities became so appealing to artists who had previously been committed to the transformation of US society.

The break from a recognized and positive social realism – historically specific, politically engaged, and a collective endeavour in the 1930s – to the adoption of 'abstraction' as a new paradigm of practice and critical value, is intelligible as a *strategy* for Rothko. It enabled him to leave behind the increasingly oppressive contemporary political and ideological context of war-time nationalism (which replaced New Deal

ideology in 1940–41) *and* the developing anti-Communism in the USA, what he called 'a matter of ending this silence and solitude, of breathing and stretching one's arms again' ('The Romantics were prompted').

Although active in the Artists' Union and a member of the American Artists' Congress (an organization loyal to the Popular Front adopted by the world's Communist parties associated with the USSR), Rothko had consistently attacked Stalinist political and cultural policies as they were propagated in *Art Front*, the artists' newspaper. His socialist-anarchist beliefs led him by early 1940 to leave the American Artists' Congress in protest at its defence of Stalin's show trials and the Nazi–Soviet Pact of 1939. Rothko, along with Meyer Schapiro, the Trotskyite art historian then teaching at Columbia University in New York, and other artists such as Milton Avery, Adolph Gottlieb, José de Creft and Ilya Bolotowsky, formed a breakaway group which they called the Federation of Modern Painters and Sculptors; the group's inaugural statement condemned any artistic nationalism as detrimental to the development of modern art.[6] A few weeks later, on 4 April 1940, the American Artists' Congress passed a motion supporting the USSR's invasion of Finland. Large groups of artists and writers, both inside and outside the Communist Party, resigned from the Congress. The support for social and socialist realist painting came under persistent and severe attack: the political and artistic orthodoxies established by the Comintern, controlled by Moscow, were assailed both by the right wing and by the followers of Trotsky (the 'Left Opposition') in the USA.

Peyton Boswell, the editor of *Art Digest* magazine, called for the 'return to the aesthetic' and for the artist to produce without constraining reference or adherence to politics, ideology or nationalism (*Art Digest*, editorial, May 1940). Between 1937 and 1940 *Partisan Review*, a left-wing cultural journal published in New York, disaffiliated itself from Soviet Marxism, publishing articles by Trotsky who, in 1938, called for attacks on the 'betrayed revolution' in the USSR. In August 1938 Leon Trotsky, Diego Rivera and André Breton produced the manifesto 'Towards a free revolutionary art', which called for artists to liberate themselves from the constraints of Soviet Socialist Realist dogma. In the USA this was taken to include the constraints on artists who worked on the Federal Art Project, or belonged to the American Artists' Congress and the American Communist Party (all three organizations were represented, to varying degrees, as lackeys of Stalinism by the right-wing press in the USA).

In the period between about 1940 and 1947/48, the space left by those previously committed to 'realist' practices – artists or critics – was filled, *not* by an immediate leap to a defence of abstraction as the only viable means of 'going on', but by an eclecticism of critical values. This was seemingly a parallel to the liberalism in politics urged by Peyton Boswell and by Forbes Watson, editor of the *Magazine of Art* in the late 1930s. Boswell had said:

> The air these days is clearer and considerably more healthy around New York since the Communazis have been driven into the open and can no longer hide beneath the robes of 'Peace', 'Democracy' and 'Culture' … Remember, the 'Communist Front' label was not placed there and sealed by sniping Tories: it was placed there and sealed, by liberals within the Congress's own membership; artists who were on the inside and should know whereof they speak. All the counter-charges of the remaining Congress Leaders – Jerome Klein, Lyn War, Hugo Gallert, Yasuo Kuniyoshi, Louis Lozowick, Phil Evergood, Williams Gropper, Joe Jones, H. Glinken Kamp – will not make reactionaries out of Dr Meyer Schapiro, Ralph M. Pearson, Lewis Mumford or William Zorach.
> (P. Boswell, editorial, *Art Digest*, May 1940)

In the following month, the critic Nathaniel Pousette-Dart, writing in the magazine *Art and Artists of Today*, associated political liberalism (that is, anti-Communism and anti-Fascism) with a stylistic eclecticism: 'The pure abstractionist, the bitter urban commentator, the

[6] letter by Rothko and Gottlieb to *The New York Times*, quoted in *Mark Rothko, 1903–1970*.

man who goes back to the farm, may all be equally good or bad as artists.' He went on to argue that the critical defence of any *single* practice over any other would reduce the USA to the condition of Germany or the USSR:

> America is at the moment in a very healthy condition for the very good reason that it has no one individual or group dominating it. In America, the artists still have freedom of expression and it is the one thing we must fight to retain.
>
> (Pousette-Dart, 'Freedom of expression')

Two years later the City Art Museum in St Louis, Missouri, organized an exhibition of contemporary American art. The catalogue author, P.T. Rathbone, claimed to be able to identify no fewer than six styles in American art – 'realism', 'expressionism', 'fantasy', 'surrealism', 'abstraction' and 'primitivism'. This diversity, the author claimed, was the defining feature of American art, and the 'inescapable' truth about American painting, relating directly to the 'individuality' of the artist. It is striking to note the contrast between criticism and art before and after the crises of the late 1930s and early 1940s: only three years after the effective abolition of the Federal Art Project as a *national* organization in 1939, we hear that the artist 'creates for his own sake and for those who follow him, but he does not paint for society's sake' (Rathbone, *Trends in American Painting Today*).

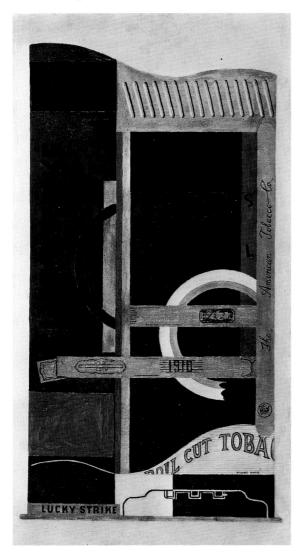

Plate 38 Stuart Davis, *Lucky Strike*, 1921, oil on canvas, 85 x 46 cm. Collection, The Museum of Modern Art, New York; gift of the American Tobacco Company Inc.
© Stuart Davis, DACS, London and VAGA, New York, 1993.

How far is abstraction in painting, dominant during the 1950s in the USA, related to liberal-individualist ideology? Consider the case of Stuart Davis. Executive chair of the American Artists' Congress, involved in the Artists' Union, active as a socialist militant, and possibly a member of the American Communist Party during the later 1930s, Davis was nevertheless committed to what he regarded as an 'abstract' art practice. At the same time, he regarded this practice as a form of *realism*. Works such as *Lucky Strike, House and Street* and *Swing Landscape* (Plates 38–40), although consisting of 'abstracted' forms and colours, were nevertheless for Davis evocations of – and, in fact, themselves part of – the contemporary 'American reality'. Attacking what he called the 'domestic naturalism' of 1930s art as idealistic and sentimental, Davis regarded his own practice as

> … a genuine contemporary expression … it has created a new reality. Abstract art is an integral part of the changing contemporary reality, and it is an active agent in that objective process. The brains, arms, materials, and democratic purpose of abstract artists have literally changed the face of our physical world in the last thirty years. And it must be noted that the changes they have made were constructive and progressive, which puts abstract painting in direct opposition to the destructive forces of totalitarianism and reaction.
>
> (S. Davis, quoted in F.V. O'Connor, *Art for the Millions*, p.126)

Such a view, now as much as then, challenges many of the orthodoxies and closures of Modernist criticism and its political and ideological emergence after the Second World War. Although he was vilified in the late 1930s as a Stalinist stooge by critics developing the new 'common sense' of associating abstract art with political liberal-individualism (the ideology of corporate capitalism in the USA), Davis attacked what he called the 'cultural monopoly' in the USA dominated by 'trustees and museums, with their directors, the critics, the dealers and supporters … and the publications which are subsidized directly and indirectly by the museum-trustee unit' (*Art for the Millions*, p.122). He called for a permanent Bureau of Fine Arts to be established to democratize the production,

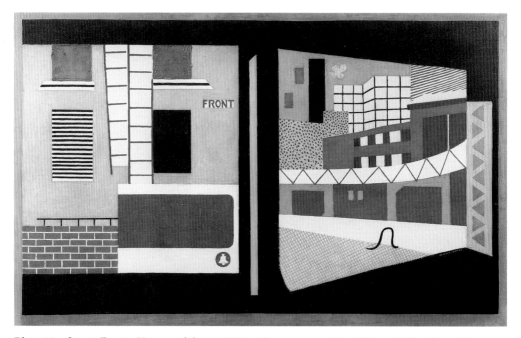

Plate 39 Stuart Davis, *House and Street*, 1931, oil on canvas, 66 x 107 cm. Collection of the Whitney Museum of American Art, New York. Photograph: Geoffrey Clements.
© Stuart Davis, DACS, London and VAGA, New York, 1993.

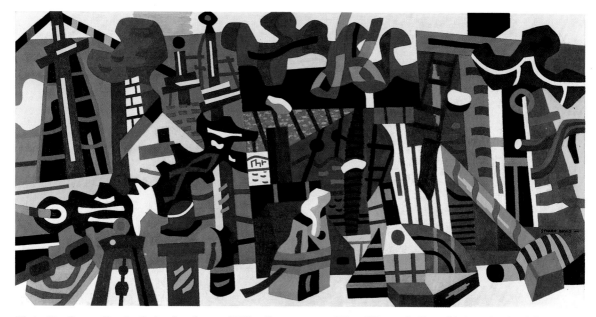

Plate 40 Stuart Davis, *Swing Landscape*, 1938, oil on canvas, 220 x 439 cm. Indiana University Art Museum, Bloomington. Photograph by Michael Cavanagh, Kevin Montague. © Stuart Davis, DACS, London and VAGA, New York, 1993.

distribution, exchange and consumption of art. His position in the late 1930s was one that saw the relationship of culture and art to social and political democracy as crucial to the formulation of critical values and interests.

He and others recognized the interconnection and interdetermination of social and artistic values. At a time when the survival (and the very definition) of democracy and its relationship to culture was threatened both in the nation itself and by the forces of Fascism and Stalinist Communism in Europe, they understood that critical values *necessarily* involve social and political interests and values. In Part 2, I shall consider the mutation of interests and values after the Second World War in relation to both the artists and the critics associated with Abstract Expressionism. What relation might *that* set of positions and interests have to those concerned with art, culture and society in the 1990s?

Part 2: Abstract Expressionism and the politics of criticism

Clement Greenberg and the ascendance of the New York School

Writing in 1940, at about the time that Pousette-Dart commended the eclecticism of US art as a healthy comparison with the strait-jacket in Germany and the USSR, the critic Clement Greenberg speculated:

> Abstract art cannot be disposed of by a simple-minded evasion. Or by negation. We can only dispose of abstract art by assimilating it, by fighting our way through it. Where to? I do not know. Yet it seems to me that the wish to return to the imitation of nature in art has been given no more justification than the desire of certain partisans of abstract art to legislate it into permanency.
> (C. Greenberg, 'Towards a newer Laocoon', p.45)

In that essay, Greenberg's approval is reserved for the artists who now occupy central positions within the canon of Modernist art – Van Gogh, Picasso, Klee, Miró and Arp. Their work, Greenberg said, contributed

> importantly to the development of modern painting ... with the desire to exploit the break with imitative realism for a more powerful expressiveness, but so inexorable was the logic of the development that in the end their work constituted but another step towards abstract art.
> (Greenberg, p.45)

Eight years later, in a more declarative mood, Greenberg stated:

> If artists as great as Picasso, Braque, and Léger have declined so grievously, it can only be because the general social premises that used to guarantee their functioning have disappeared in Europe. And when one sees, on the other hand, how much the level of American art has risen in the last five years, with the emergence of new talents so full of energy and content as Arshile Gorky, Jackson Pollock, David Smith ... then the conclusion forces itself, much to our own surprise, that the main premises of Western art have at last migrated to the United States, along with the center of gravity of industrial production and political power.
> (Greenberg, 'The decline of Cubism', p.369)

We are reminded here of the passage by Rose that I quoted on page 6, where she judges that the art of the Abstract Expressionists constituted a 'formal grandeur' in continuity with the European Modernists of the interwar period, transcending 'the mundane, the banal and the material' that was characteristic of 1930s illustrationism. And as Greenberg says in 'The decline of Cubism', this state of affairs, in which 'the main premises of Western art have at last migrated to the United States', was connected to the rise of the USA as *the* global power in economic and political terms after the Second World War. How might this critical judgement, and the development of the critical consensus regarding the value of the Abstract Expressionists, be assessed? How might the work of the Abstract Expressionists produced in the late 1940s and 1950s, along with the influential criticism of Greenberg and others, be linked to the new status of the USA as the prime superpower within the Cold War?

Consider again Pollock's *Number 1*, Rothko's *Number 7*, Newman's *Covenant*, along with Gorky's *The Betrothal, II*, de Kooning's *Excavation* and Still's *Painting* (Plates 3–5 and 41–43). These paintings may stand as examples of what is usually called 'Abstract Expressionism'. The name itself was first used by the critic Robert Coates in 1946 to describe paintings by the German artist Hans Hofmann on show at the Mortimer Brandt

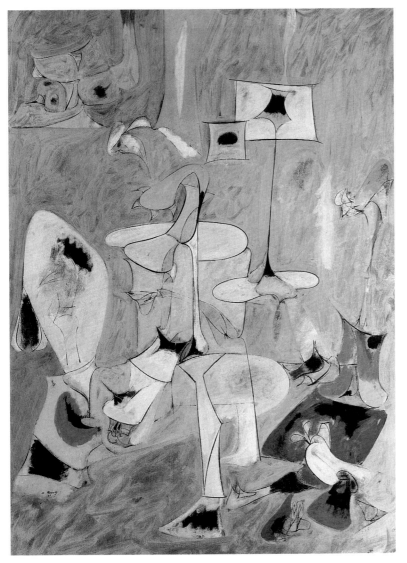

Plate 41 Arshile Gorky, *The Betrothal, II*, 1947, oil on canvas, 129 x 97 cm. Collection of the Whitney Museum of American Art, New York; purchase. © 1992 Agnes Fielding-Gorky/ARS, New York.

Gallery in New York. Hofmann's painting *Effervescence* (Plate 44) may have led Coates to apply the term – which had previously been used, with lower-case letters and adjectivally, in relation to works by Kandinsky, such as *Sketch for Composition IV (Battle)* (Plate 45). Hofmann had moved to the USA during the 1930s, and has generally been understood as a 'transitional' artist whose work in the early 1940s synthesized the formal and expressive conventions of inter-war European Modernist art while adding new features seen as unique to the Abstract Expressionists.[7] Unlike Hofmann's paintings, those by Pollock, Rothko, Newman, Gorky, de Kooning and Still were constructed on a scale beyond what has been called 'the easel tradition'. The mural or quasi-mural size of work by the Abstract Expressionists has also been regarded as signifying, or embodying, a particular American element – using European Modernist forms but transposing them within a new overall form of pictorial organization. Greenberg later described this altered 'situational field' of decisions, preferences and choices within the work of these artists as '"American-type" Painting' (see his article of the same name, where he states that their work had sometimes been given this label in London).

7 For instance, see C. Goodman's *Hans Hofmann*, where she claims that in the early 1940s Hofmann developed the 'drip technique' before Pollock.

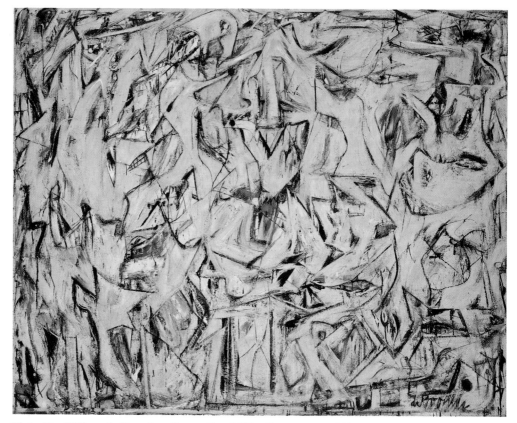

Plate 42 Willem de Kooning, *Excavation*, 1950, oil on canvas, 203 x 254 cm. © 1992 The Art Institute of Chicago, all rights reserved; gift of Mr and Mrs Noah Goldowsky and Edgar Kaufmann jr and Mr and Mrs Frank G. Logan Prize Fund, 1952.1. © 1992 Willem de Kooning/ARS, New York.

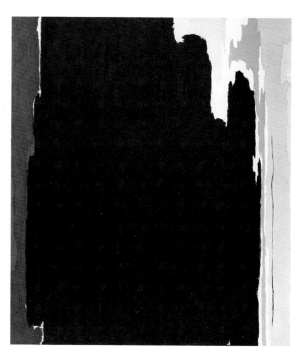

Plate 43 Clyfford Still, *Painting*, 1951, oil on canvas, 237 x 192 cm. © The Detroit Institute of Arts; Founders' Society Purchase, W. Hawkins Ferry Fund.

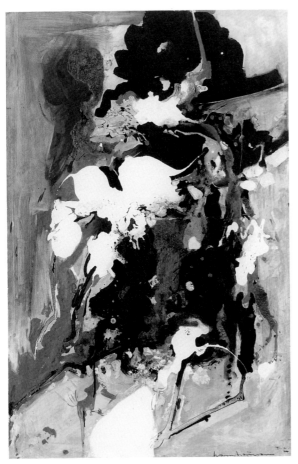

Plate 44 Hans Hofmann, *Effervescence*, 1944, oil, indian ink, casein and enamel on plywood panel, 138 x 91 cm. University Art Museum, University of California, Berkeley; gift of the artist.

Plate 45 Vasily Kandinsky, *Sketch for Composition IV (Battle*, also known as *Cossacks)*, 1910, oil on canvas, 95 x 132 cm. Tate Gallery, London. © ADAGP, Paris and DACS, London, 1993.

Tendentious as both labels are, given that neither was used or adopted by the artists within their own accounts of their work, 'Abstract Expressionism' and '"American-type" Painting' are terms that enable us to begin to investigate the paintings to which they refer. We can explore the works both in formal terms (how we might describe the way the paintings look, or the technical way in which they were made) and, beyond that, in terms of how their 'Americanness' might relate to the wider economic, political and ideological circumstances of the post-war period. *Any* account of their work, however, inevitably involves certain principles of selection, interpretation, emphasis and judgement; and the conditions within which *these* principles are formed should not be cancelled out of the inquiry.

If we compare our selection of Abstract Expressionist paintings with works produced in the USA during the 1930s (discussed in Part 1), there are clearly great differences. The paintings by Pollock, Rothko, Newman and the others are *much* larger, in some cases dozens of times larger. This is also to say, therefore, that Pollock and Rothko left behind the small, easel-painting conventions that they themselves had used during the mid- and late 1930s (see Plates 6 and 8). Representation through conventions of 'resemblance' or traditional iconography has seemingly been abandoned by 1948. Paintings by Gorky, de Kooning, Still and Hofmann are similarly bereft of the forms of 'socially-symbolic' meaning regarded as necessary for authentic artistic communication by US painters working in the Depression. Technically, in terms of the means with which paint is applied to the surface, dramatic changes have been made, and these may be seen as related to the rejection of the narrative and realist means used ten years earlier. This is most evident in the work of Pollock produced between 1948 and about 1951, when the 'drip technique', along with other methods of applying paint, was developed and elaborated.

Although Pollock had a definite sense of the canvas as a picture, which had to be hung and viewed in the traditional manner – vertically, attached to a support and then fixed to a wall – the 'drip-paintings' were made with the unstretched and even uncut canvas laid on the floor. He would work around the surface on all four sides, applying paint through a variety of means. These included dripping the paint from cans and splattering it from the

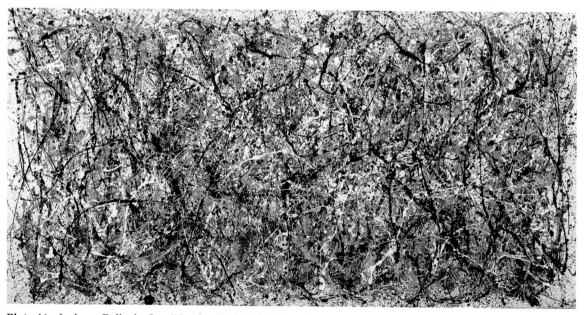

Plate 46 Jackson Pollock, *One (Number 31, 1950)*, 1950, oil and enamel on unprimed canvas, 270 x 531 cm. Collection, The Museum of Modern Art, New York; Sidney and Harriet Janis Collection Fund (by exchange). © 1992 The Pollock-Krasner Foundation/ARS, New York.

end of a brush, in a process that built up, layer upon layer, the dense skeins and veils of paint that are visible within *Number 1 (1948)* and *One (Number 31, 1950)* (Plates 3 and 46). Pollock also used new kinds of industrial paint (including an aluminium composite), and the texture and gloss of these substances contrast markedly with traditional oil-paint effects. *Number 1* and *One* contain highly intricate, 'linear' patterns of marking; in a sense, Pollock has 'drawn' with the paint, although not with the intention or effect of constructing illusions or allusions to objects or events in the world. The dense, though variegated, 'webbing' of compositional form, with its chromatic and linear elements, creates a kind of 'image' or 'presence' on the canvas though it refers to nothing iconically (for example, a person or landscape). Spatial illusions *are* created through the interplay of actual skeins of paint lying on the surface and upon each other, as well as through the viewer's perception of the paint's chromatic and tonal variations. In addition to this, the webbing of paint that constitutes the compositional form recedes and diminishes towards the four sides of the canvas, and the contrast between the canvas underneath and the form upon it also creates a sense of depth and recession.

The sense of movement and rhythm within the painting – which, in one sense, *is* a record of Pollock's movement around the canvas in the process of making the composition – has led critics and historians to designate this type of Abstract Expressionist painting, including work by de Kooning and Kline, as 'gestural'. Despite this label, it's clear that de Kooning's *Excavation* and Kline's *New York, N.Y.* (Plates 42 and 47) share little with Pollock in terms of how their paintings were physically made. De Kooning's work, more so than Kline's, does share with Pollock's canvas that sense of 'all-over' compositional

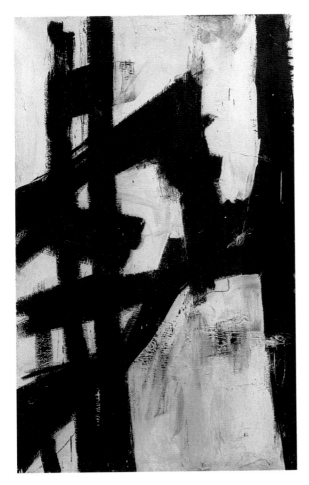

Plate 47 Franz Kline, *New York, N.Y.*, 1953, oil on canvas, 201 x 130 cm. Albright-Knox Art Gallery, Buffalo, New York; gift of Seymour H. Knox, 1956.

Plate 48 Willem de Kooning, *Woman, I*, 1950–52, oil on canvas, 193 x 147 cm. Collection, The Museum of Modern Art, New York; purchase. © 1992 Willem de Kooning/ARS, New York.

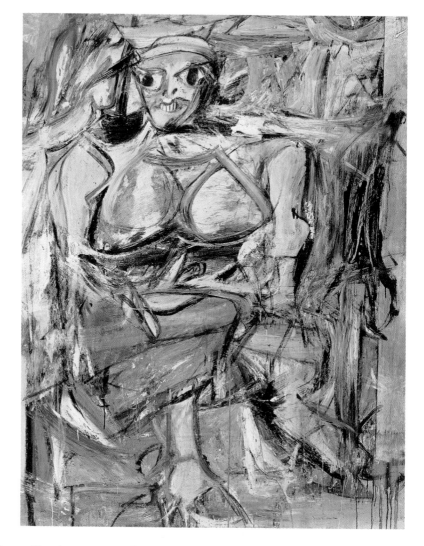

spread, with no focus. But the creating of specific shapes with allusive properties, in both *Excavation* and *New York, N.Y.*, is very unlike Pollock's radically 'decentred' webbing of paint. Kline's configuration of paint is evocative of shapes and structures found in a city such as New York (bridges, buildings, roads even), while de Kooning never lost interest in figuring parts of human bodies within his post-war style. If *Excavation* may be said to contain allusions to faces, eyes, ears and fingers, then his *Woman, I* (Plate 48) reinstates the tradition of representing the human female body (the genre of 'the nude'), articulating figuration within his fractured, 'gestural' mode of composition. De Kooning and Kline also differ from Pollock in that they still apply paint with the brush laid onto the surface of the canvas, in 'easel-painting' mode.

This 'gestural' painting has been seen as a major facet of Abstract Expressionism. Other painters had different concerns – for example, to produce a highly 'static' effect, again based on very different technical means of production. This has been called 'chromatic abstraction' or 'colour-field' painting, seen as having an important point of development in the work of Mark Rothko during the 1950s and being taken up in the early 1960s by a later generation of painters including Morris Louis, Kenneth Noland and Jules Olitski.

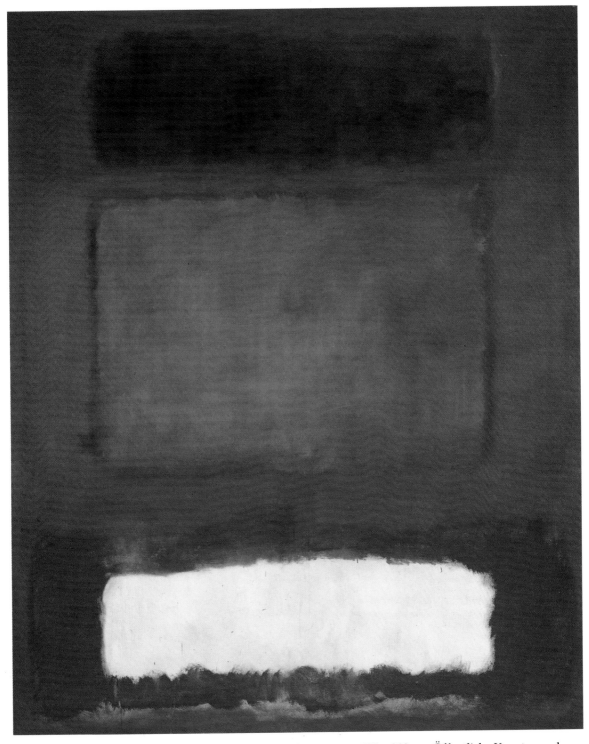

Plate 49 Mark Rothko, *Red, White and Brown*, 1957, oil on canvas, 253 x 208 cm. Öffentliche Kunstsammlung, Kunstmuseum Basel. Inv. G1959.17. Colorphoto: Hans Hinz. © 1992 Kate Rothko-Prizel and Christopher Rothko/ARS, New York.

In contrast to Pollock's work, Rothko's paintings from about 1947 onwards have been described as containing 'floating fields of colour', still and unagitated compared with Pollock's drip-painting. There is little 'incident' or sense of movement within works such as Rothko's *Number 7* or his *Red, White and Brown* (Plates 4 and 49). Paint has been applied with a large, broad brush, and although it is possible to detect quite a number of subtle shifts in tone, intensity and saturation within these works (along with a deliberately 'rough' edging, showing the point of contact between brush and canvas), the spreading of paint 'all over' the canvas again prevents the viewer from being attracted to a single point within the composition. Contrasting areas of colour 'stand out' or 'lie behind' other areas, as if floating in space, but the 'all-over' quality of the painting as a whole is preserved. Still's *Painting* (Plate 43) contains broad areas of paint applied in a similar manner, although more 'agitated' pictorial incident exists towards the top and both sides of Still's canvas, and the rather harsher contrasts in colour create a different effect within the viewer's apprehension of the painting as a whole. While Rothko's 'fields of colour' appear to float together as part of a single form, there is a kind of 'ripping' effect within Still's chromatic contrasts, as if a 'peeling off' of layers of paint is achieved.

This examination of the terms 'gestural' and 'colour field' or 'chromatic abstraction' in relation to four or five actual paintings suggests that such labels should be used carefully. They constitute 'ideal types' of different kinds of Abstract Expressionist work, and thus

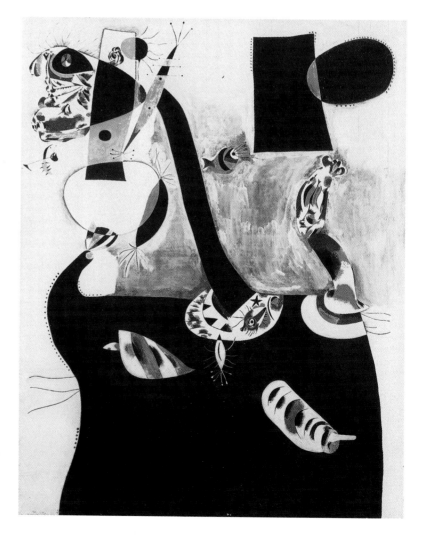

Plate 50 Joan Miró, *Femme assise, II* (*Seated Woman, II*), 1939, oil on canvas, 162 x 130 cm. Peggy Guggenheim Collection, Venice. Photograph © 1991 The Solomon R. Guggenheim Foundation. © ADAGP, Paris and DACS, London, 1993.

cannot capture the differing complexities of particular paintings. If Pollock's and Rothko's paintings come closest to these two typifications, then it may be that Hofmann's *Effervescence* and Gorky's *The Betrothal, II,* from the early years of Abstract Expressionism, combine features of both types. In this sense, they embody and represent the formal inheritance from inter-war European Modernism that is then adopted and built upon by Pollock, Rothko, Newman and others. I shall return to Newman, and *his* conception of what his practice may have been about. For, if a description of the 'look' of Abstract Expressionist paintings is a necessary part of an account of how they were made, then the issue of 'why' they were made, and within what circumstances, is also important.

Modernist accounts stress that Abstract Expressionism mobilized the formal conventions of European Modernist art from the inter-war period – especially the work of Miró, Masson and Mondrian – along with the continuing and shaping influence of Picasso's and Braque's Cubist paintings from before the First World War. The 'all-over' quality of Abstract Expressionist paintings is typically related to Cubist collage, to Mondrian's colour-grids and to Miró's own 'decentred' compositions from the late 1920s and 1930s. In these works, pictorial elements, seemingly unrelated to any important iconic or 'realist' purpose, simply constitute chromatic and linear patterns (see Plate 50, for example). The biomorphic forms of Surrealist painting – in the work of Masson, of Miró and also of Arp – are taken from their symbolic role within Surrealist theories of the unconscious, and are deployed by Gorky, Newman and Pollock in their works of 'the break' during the early and mid-1940s. Rothko's *Aquatic Drama,* Pollock's *Male and Female* and Newman's *Euclidean Abyss* are examples of this 'mid' stage between art 'of the 1930s' and art 'of the 1950s' (Plates 36, 37, 51). It is clear that the titles at this time also indicate the symbolic, 'mythic' values that the artists wished to invest in these works. 'Male' and 'female', 'abyss', 'drama', etc. all suggest allusion and symbolic reference. Contrast this with the types of title favoured by the Abstract Expressionists during the late 1940s and 1950s. Again, though, generalization should be avoided: while Pollock and Rothko often use numbers and colours, and thereby *close down* one source of connotational reading, some

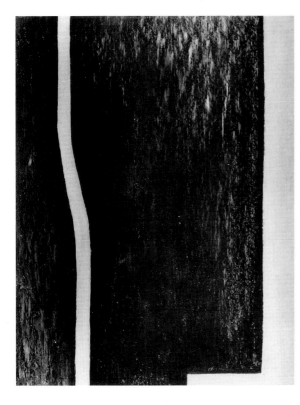

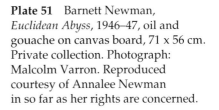

Plate 51 Barnett Newman, *Euclidean Abyss*, 1946–47, oil and gouache on canvas board, 71 x 56 cm. Private collection. Photograph: Malcolm Varron. Reproduced courtesy of Annalee Newman in so far as her rights are concerned.

Plate 52 Jackson Pollock, *Mural*, 1943, oil on canvas, 247 x 605 cm. The University of Iowa Museum of Art; gift of Peggy Guggenheim. © 1992 The Pollock-Krasner Foundation/ARS, New York.

titles still obviously invite it. *Autumn Rhythm*, *Lavender Mist* and *Cathedral* are all titles used by Pollock, while Newman, for instance, persists in using obviously symbolic titles (such as *Adam, Eve, Covenant*) in the 1940s and 1950s. The influence of the Surrealists on the Abstract Expressionists is therefore not without dispute, in terms of how the former's ideological and social interests, as well as their formal and conventional devices, may have been used by the latter. Pollock's interest in both psychoanalysis and the unconscious is a case in point, and is useful in indicating how the concerns of the 1930s are not simply *eradicated* within post-1945 art, but are transmuted and reordered during the Cold War.

Pollock's interest in the mural form had roots both in the work of the Mexican muralists *and* in the radical technical and political meanings that during the 1930s became associated with Picasso's *Guernica*. Pollock's own *Mural* of 1943 may be taken as an attempt to devise a scale and compositional form capable of transcending the conventions of 1930s 'social realism' and yet constituting a 'public', rather than 'private' (easel-painting), expression (Plate 52). It is as well to bear in mind, though, that the mural was commissioned by Peggy Guggenheim, art collector and New York socialite attached to the avant-garde that was present during the war and was composed of European Modernists and Americans such as Pollock. The conditions of production of Pollock's *Mural*, therefore, were very different from those active within revolutionary Mexico. Anti-Communism was emerging during the Second World War as it became clear to the USA that, after the defeat of Fascism, the USSR would be a major world power, with an anti-capitalist ideology. But however much their political commitment was eroded by this, and by revelations about Stalinism, Pollock and many others still invested hopes and aspirations in an art that would not be merely 'private' and 'personal', but would have a *social* function. Although the symbolism in Pollock's works between about 1941 and 1945 may appear intensely *private* and *personal* (bound up with his own period of Jungian psychoanalysis and interest in the 'unconscious' as the source of art), the mural or 'quasi-mural' form may have held out, for him, the possibility of developing a new kind of 'history painting' – mobilizing the conventions of Modernist representation that he had inherited and adapted, yet also capable, at some future point perhaps, of being tied into a realm of public meanings. In leaving behind the forms of 1930s 'social realism', Pollock may have agreed with Newman that the canvases of the Abstract Expressionists consisted of 'images whose reality is self-evident and which are devoid of the props and crutches that evoke associations with outmoded images, both sublime and beautiful' (B. Newman, 'The sublime is now').

Post-war US painting developed out of this period of political and ideological reorganization, with the protocols of socialism and communism (along with realist pictorial codes) being challenged and then replaced with what is usually called US 'political liberalism'. This is *triumphalist*, in that it sees the USA as the most advanced and free nation economically and politically (following the destruction in Europe), and *confrontational*, in that the US regards the USSR as a threat to its own power and interests throughout the world. Arguments and struggles over positions and frontiers, boundaries and exclusion zones, took place within US–USSR political and ideological exchanges, but also within debates about the future and value of art within Cold War culture.

Artists and critics, Greenberg recognized in 1948, found themselves in a situation in which they were both 'isolated' and 'alienated' (see Greenberg's 'The situation at the moment'). Their withdrawal from active social and political involvement after the Second World War became a condition that Greenberg saw as necessary, if not desirable, for the production of what he called 'any ambitious art'. Only alienation and isolation allowed the experience of the 'true reality of our age' (p.82). It was then necessary to experience this reality to produce great art. We have here the complication that Greenberg is celebrating this 'ambitious art' while being decidedly ambivalent about the social, political and ideological conditions within which it was produced, i.e. within a monopoly capitalist society suppressing socialist opposition within it and waging Cold War against the USSR.

To understand the importance of Greenberg's criticism within a history of the shift of US art from the concerns of the 1930s to those of the 1950s, it is necessary to trace the manner in which Greenberg's *own* development as a writer itself went through a dramatic reorientation within the same period. The work of the Abstract Expressionists produced around 1947 or 1948 came to be represented as the new style born *after* the final eradication of the politics and artistic commitments characteristic of the Depression. Greenberg's writing between 1948 and 1960 became highly significant as a Modernist account and defence of that art. Two major tasks confront us: (a) to explain the development and nature of the principles and values underpinning this Modernist criticism, and (b) to relate this elaborate conceptual system to the institutional contexts and forces that enabled Abstract Expressionist painting (and its various critical proponents) to appear as both essentially 'American' and yet as an internationally recognized and dominant art – to be seen as the authentic inheritor of Parisian inter-war Modernism and the new embodiment of the avant-garde.

While it is true that Greenberg was not the only critic actively involved in examining and influencing the work of the Abstract Expressionists during the 1940s and 1950s, it would be difficult to claim that his role was *not* the most important, both in terms of the radicalism of his position and the extent to which his version of the history of Modernist art became disseminated within the critical and art-pedagogic culture of North America and Western Europe during the 1960s (B. Reise, 'Greenberg and the group'). For these reasons, a case study of his role within the 1950s art-critical culture in the USA is valuable, as well as integral to an adequate historical account of the Abstract Expressionists.

From 'Avant-garde and kitsch' to 'Modernist painting'

... all values are human values, relative values, in art as well as elsewhere.

Greenberg made this judgement in his essay 'Avant-garde and kitsch', published in *Partisan Review* in 1939. At this time Greenberg appears committed to a Marxist analysis of capitalist society. Written on the brink of the Second World War, 'Avant-garde and kitsch' contains a vigorous argument about the relations between art, culture, Fascism and the prospects for socialist revolution in Europe and the USA in the mid-decades of the twentieth century. After the end of that war, it may be argued, Greenberg jettisoned any commitment to socialism and began to cling instead to avant-garde Modernist art as itself a salvation – or perhaps a holding operation – from a world capitalist system that had

turned culture into commodities and the noblest human values into a crude instrumental and utilitarian rationality. Whether or not we agree with this account of Greenberg's shift of view from the late 1930s to the 1960s, I wish to propose that his concerns assembled in 'Avant-garde and kitsch' are still the ones that are most important for us now – irrespective of whether Greenberg's specific judgements and interests as an art critic are still relevant or significant. These concerns – modernity, culture, society, and the processes through which values are formulated – are the problems and stakes in *our* culture and society. These concepts, and their use in argument and debate, form the core of decisive reasoning about social and historical reality at the end of the twentieth century.

In 'Avant-garde and kitsch', Greenberg is concerned to talk about not just art but 'the culture of the masses' as well. This would have been a necessary element of any *socialist* discussion interested in the society as a whole. Art and 'mass culture', Greenberg argues, exist and are produced in the same capitalist society, apparently as elements in a single culture. He continues:

> One and the same civilization produces simultaneously two such different things as a poem by T.S. Eliot and a Tin Pan Alley song, or a painting by Braque and a *Saturday Evening Post* cover [see Plates 53 and 54]. All four are on the order of culture and, ostensibly, parts of the same culture and products of the same society. Here, however, their connection seems to end.
>
> (Greenberg, 'Avant-garde and kitsch', p.21)

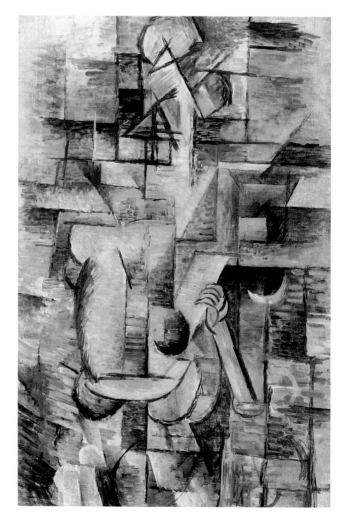

Plate 53　Georges Braque, *Femme tenant une mandoline* (*Woman with a Mandolin*), 1910, oil on canvas, 81 x 54 cm. Thyssen-Bornemisza Collection, Castagnola. © ADAGP, Paris and DACS, London, 1993.

Plate 54 Norman Rockwell, *Rosie the Riveter*, cover of *Saturday Evening Post*, 29 May 1943. Photograph by courtesy of the Curtis Archive, printed by permission of the Norman Rockwell Family Trust. © 1943 The Norman Rockwell Family Trust.

Greenberg's 'seems' here is an important qualifier. He recognizes difference, he will certainly want to say what is good and what is bad, and yet he is also aware that his descriptions, analyses and evaluations are *relative*: they are made between elements in a single culture or way of life. As such, judgements and values related to art, or more strongly to 'fine' or 'high' art (having the 'formal grandeur' Rose talked about), might reasonably be related to a judgement on the 'mass culture'. This was the position Greenberg started from in 'Avant-garde and kitsch', when he attacked what he saw as the 'kitsch' of his day – popular music, magazine illustration and academic art (though his list is more extensive). Although Greenberg certainly condemns kitsch, he is prepared to see and discuss its emergence alongside avant-garde art; and, as he says, both can be viewed as elements of culture in a single society. By the early 1960s, and the publication of his essay 'Modernist painting', he has seemingly lost any interest in the culture as a whole and spends no time on 'mass culture'. 'Avant-garde and kitsch', in contrast, may be read as a sustained piece of cultural criticism, as part of New York socialist debate, with an important historical dimension concerned with the development and consequences of industrial capitalism. 'Modernist painting' (1961, although presented earlier in another form) reads much more like 'art criticism'. This 'specialization' may, in fact, be seen as a *reduction* of interests from those set out in 'Avant-garde and kitsch', and could be related to the idea that a professional art critic (which Greenberg had become after the Second World War) should be concerned with art rather than 'the culture as a whole' or the nature of 'mass culture'.

When Greenberg wrote 'Avant-garde and kitsch', notions of 'mass culture', language about 'the masses', and arguments about 'mass culture' were attempts to come to terms with the reality and consequences of social, rather than individual, patterns of production and consumption. Both ideas, of 'social' and of 'individual' production, need examination because they actually involve already-formed values and discriminations – about types of

media, conditions of production and the social relations of consumption. Paintings may in a sense be said to be produced by individuals physically (though even this case is complicated: for instance, consider the circumstances of Renaissance painting or nineteenth-century history painting). But the enabling and structuring *relations* of patronage, economic exchange, exhibition and critical reception are fully social. The social relations within a society, such as in the USA during the late 1930s, have serious consequences for the forms and practices of art, as cultural elements produced *within* that society. Capitalist social relations particularly influence and shape the development of the culture as a whole.

Taste and social crisis

The opposition made by Greenberg between 'mass culture' and a threatened minority civilization (or one already eroded by 'mass culture') was comparable to judgements made by other cultural critics. Compare, for example, Greenberg in 'The plight of culture' with T.S. Eliot in his *Notes toward the Definition of Culture* (1948):

> … our culture, on its lower and popular levels, has plumbed abysses of vulgarity and falsehood unknown in the discoverable past; not in Rome, not in the Far East or anywhere has daily life undergone such rapid and radical change as it has in the West in the last century and a half.
>
> (Greenberg, 'The plight of culture', p.28)

> We can assert with some confidence that our own period is one of decline: that the standards of culture are lower than they were fifty years ago … I see no reason why the decay of culture should not proceed much further, and why we may not even anticipate a period, of some duration, of which it is possible to say that it will have no culture.
>
> (T.S. Eliot, *Notes toward the Definition of Culture*, quoted in Greenberg, 'The plight of culture', p.24)

Notice that both Greenberg's and Eliot's conceptions of culture are intrinsically evaluative – a question of 'good' and 'bad'. In both there is a kind of apocalyptic vision of the 'bad' driving out the 'good'.[8] In 'Avant-garde and kitsch', Greenberg's 'idealist' culture (this is not meant as a pejorative judgement on him) consists of the work of the authentic Modernist avant-garde, along with the recognized 'masterpieces' from earlier, pre-industrial capitalist centuries in Western Europe. Together these items of culture are represented as the only repositories of real 'high art' in an epoch dominated by the threat of kitsch. They constitute a fragile barrier, however, rather than forming assured elements of a new and general future direction for the culture as a whole.

Greenberg's argument in 'Avant-garde and kitsch' was a powerful statement defending a sphere of 'high art' against the encroachment of 'mass culture', kitsch and vulgarized civilization. After the Second World War, Modernist historical and critical accounts of past and present art made the issue of 'quality' central to the definition of 'relevant' discussion and evaluation of visual art. However, the attempt (as in 'Avant-garde and kitsch') explicitly to relate evaluative statements about art and culture to a wider social and historical analysis of particular societies may be said to have given way to a set of assumptions and implicit judgements that were no longer articulated openly or considered as still arguable.

Greenberg's essays such as 'Master Léger' (1954), '"American-type" Painting' (1955), 'Collage' (1958) and 'Modernist painting' (1961) are what we recognize now as straightforward 'art criticism' – difficult perhaps, but quite unproblematically concerned with 'art' rather than 'culture' or 'society'. What literally 'goes without saying' in these

8 At the same time it should be stated that Greenberg is critical of Eliot's position. However, they do agree on this central point. Greenberg claims at the end of the article that 'only socialism' can transform the culture as a whole, but this stipulation seems peripheral to the main force of his argument and is 'tacked on' as a saving clause. T.J. Clark described Greenberg's position as an 'Eliotic Trotskyism'; see his 'Clement Greenberg's theory of art'.

articles is the closed judgement – a sort of critical 'common sense' – that the culture at large, the society that has engendered kitsch, is now set in opposition to the values and practices of the authentic avant-garde, which after 1945 is synonymous with Abstract Expressionism. Though unspoken, that wider analysis and judgement of the whole culture and society structures the themes and values propelling Greenberg's writing.

Greenberg's criticism after 1945 elaborated a theory of Modernist practice in the visual arts and was inseparable from his defence and acclaim for particular artists working in New York in the 1940s and 1950s. The emergence of the New York School – and in particular the work of Pollock, Rothko, Newman and de Kooning – was thus closely related to the shift in the production of Modernist art from Paris to the USA. We cannot fully understand the 'forms' of this proclaimed avant-garde practice without also understanding the economic, political and ideological conditions with which they were bound up. In the same way, the forms of criticism associated with Greenberg (the paradigmatic text of which is 'Modernist painting') may also be understood as inseparable from the social and historical conditions after the Second World War.

As we have seen, by 1948 Greenberg is sure that US art produced by Gorky, Pollock and others has emerged as superior to that being produced in Europe (see the quotation from 'The decline of Cubism', p.42 above). He also notes that this is related to US economic and political supremacy after the war. Unlike in 'Avant-garde and kitsch', however, Greenberg does not go on to attempt an analysis of the relations between art and industrial production and political power. The significance of this relationship is recorded (as a 'surprise') but not considered. Greenberg's turn away from a social critique towards a 'specialization' in art criticism may be seen as actually a product of the wider pressures and limits active in the context of McCarthyism and Cold War politics. Modernist criticism elaborated by Greenberg and his adherents in the 1950s and 1960s became an increasingly appropriated, institutionalized and 'official' practice, in effect complicit in an ideological representation of US abstract art. In this representation – exemplified by, for example, Alfred H. Barr's introduction in the catalogue of the show New American Painting, which was organized by the Museum of Modern Art in New York in 1959 – Abstract Expressionist paintings were portrayed as simultaneously 'autonomous' from the brute determinations of actual economic and political life in the Cold War, and yet also as symbolic of a kind of 'free', 'creative' cultural practice, as characteristic of a 'free America' standing up against the threat of the Soviet Union to the Western capitalist democracies. René d'Harnoncourt, vice-president of the Museum of Modern Art and in charge of the museum's foreign activities, spoke in 'Challenge and promise' of modern art as the 'foremost symbol' of a 'democratic' society (i.e. the USA). It is important to examine both the developing logic within Greenberg's criticism during the 1940s and 1950s and the ways in which this criticism became a part of the use of Abstract Expressionism as a 'weapon of the Cold War'.

Greenberg's essay 'Towards a newer Laocoon', written during 1940, continued his examination of the question in contemporary art. In this essay he made a tentative defence of abstract art, in an argument notable for its firm, yet undoctrinaire, tone. The discussion is part interrogative, part declarative, and its own uncertainty is displayed as a value:

> My own experience of art has forced me to accept most of the standards of taste from which abstract art has derived, but I do not maintain that they are the only valid standards through eternity. I find them simply the most valid ones at this given moment. I have no doubt that they will be replaced in the future by other standards, which will be perhaps more inclusive than any possible now.
> (Greenberg, 'Towards a newer Laocoon', p.45)

Equally, however, there is present in Greenberg's thinking the ethical imperative that will dominate his anti-relativist stance in 'Modernist painting', which will be discussed shortly. In 'Towards a newer Laocoon' he defends 'purism' in writing about art because of the values he sees it as representing – 'the translation of an extreme solicitude, an

anxiousness as to the fate of art, a concern for its identity' (p.35). The 'advanced' or 'ambitious' Art – made by the Post-Impressionists, the Fauves, the Cubists and Mondrian, according to Greenberg – is an art that can 'test society's capacity for high art'; and those called 'purists', who defend abstract art as the only defence against kitsch and the decline in culture, are the ones who value art more than anyone else. Or rather, 'usually', Greenberg says. This qualification is important, as it indicates how 'Towards a newer Laocoon' still pursues an open inquiry, though it contains the hardening of certain concepts and assumptions into certainties. These certainties are yet to form a systematic doctrine. How are we to explain Greenberg's 'long-march' from a putative 'Trotskyite socialism' in 1939 ('Avant-garde and kitsch') to his position in 'Modernist painting' (1961), an essay in which 'the problem of culture' (and politics) has apparently disappeared, replaced by the purism of art criticism's 'specialized' interests?

'Modernist painting' retains the rhetoric of moral urgency present in his earlier writings: 'Modernism includes more than just art and literature. By now it includes almost the whole of what is truly alive in our culture' (p.5). This reference to 'culture' harks back to 'Avant-garde and kitsch', but it is now little more than an alienated reference point. What now concerns Greenberg is an art that stands out against its general context of production, against what for Greenberg is the kitsch of contemporary society. For Greenberg the value of Modernist art is the 'capacity' and 'ambition' that it shares with all that remains 'self-critical' in contemporary society. 'Modernism', therefore, is not simply a practice, or set of practices, but a principled and coherent effort or project of self-criticism – a self-criticism operative, he believes, in a variety of practices that are unique and irreducible to any other (painting as a practice being Greenberg's own particular concern). Greenberg traces this tendency in what he calls 'Western Civilization' to the philosopher Immanuel Kant and the Enlightenment, and proposes that Kant's critique of logic, which attempted to establish the true nature and limits of logical reasoning, is the model and basis for all authentic Modernist projects – to establish and maintain the intrinsic capacities and limits of particular practices.

Painting, Greenberg goes on to argue, is 'Modernist' in the sense that 'it' too (though the nature of this 'it' is slippery) is a unique and irreducible practice, can 'act upon itself' to discover 'its' own 'characteristic methods' – not, as he says, to subvert the practice, but 'to entrench it more firmly in its area of competence' ('Modernist painting', p.5). This is a process of 'internal' criticism, which Greenberg regards as 'a more rational justification' for 'every formal social activity' (p.5), though he concedes that this process in painting is distant from the origins of self-criticism in philosophy: 'Kantian self-criticism was called on eventually to meet and interpret this demand [for 'a more rational justification'] in areas that lay far from philosophy' (p.5).

At the same time Greenberg is anxious to point out, in fact to emphatically conclude his essay by saying, that Modernism in painting has not led to anything like 'a break with the past' (p.9) or with artists before Manet – who, he claims, is the first to paint Modernist pictures 'by virtue of the frankness with which [his works] declared the surfaces on which they were painted' (p.6). Greenberg says that there may have been a 'devolution', or 'an unravelling of earlier traditions', but nothing 'like a break with the past': art is, for Greenberg, among other things, 'continuity'. This continuity, rather than any rupture, is characteristic of art's history, a 'history' whose development and consistency are raised as values to be recognized and defended.

This stress on artistic continuity was also a necessary component of Greenberg's argument that US post-war artists had both absorbed and surpassed earlier European work. Read in conjunction with his 1955 essay '"American-type" Painting', 'Modernist painting' can be seen as a theoretical ratification of more particular judgements about specific artists and their continuities with earlier art and artists. Greenberg's dictum in the latter essay (p.8), that 'visual art should confine itself exclusively to that which is given in visual experience and make no reference to anything given in other orders of experience',

is an argument that may be seen as illustrated in his discussion of paintings by Gorky, Gottlieb, de Kooning, Hofmann, Newman and Rothko. However, for 'visual experience' (a rather amorphous and problematic notion) read 'Modernist formal judgement'. Gorky's *Painting*, Greenberg says in '"American-type" Painting' (p.95), may 'ease the pressure of Picassoid space', but he 'remain[s] a late Cubist to the end' (Plate 55). De Kooning proposes, in *Woman, I* (Plate 48), 'a synthesis of Modernism and tradition ... in a grand style equivalent to that of the past'. And Still, with *Untitled* (Plate 56), 'has resumed Monet – and Pissarro', as 'the Cubists had resumed Cézanne' (p.95).

This 'specialization' (the concerns of the 'Modernist critic'), which as I've suggested may be seen rather as an actual reduction of both interests and values, is codified in 'Modernist painting' as the self-critical process of Modernist painting practice. It is a practice that Greenberg argues is based on the cumulative 'narrowing' or concentration of artists on the unique constituents of their chosen medium, which is, in painting, the two-dimensional surface and space of the canvas and its enclosing frame. This is what he calls 'the ineluctable flatness of the support' (p.6). But 'ineluctable' ('that against which struggle is useless or worthless') can have a subjective element. We might not all agree about what is ineluctable: it would depend on our values. Although Greenberg recognizes that *any* mark on a canvas creates some illusion of depth, of three-dimensional space, this illusory capacity is

> the province of sculpture, and for the sake of its own autonomy painting has had above all to divest itself of everything it might share with sculpture. And it is in the course of its effort to do this, and not so much – I repeat – to exclude the representational or the 'literary', that painting has made itself abstract.
>
> ('Modernist painting', p.7)

Plate 55 Arshile Gorky, *Painting*, 1947, oil on canvas, 96 x 127 cm. Private collection. © 1992 Agnes Fielding-Gorky/ARS, New York.

Plate 56 Clyfford Still, *Untitled*, 1953, oil on canvas, 236 x 174 cm. Tate Gallery, London.

The use of personification in this passage ('its own autonomy', 'to divest itself', 'everything it might share', 'made itself abstract'), and in the essay as a whole, is significant. 'Modernism' – personified, given human agency – does this or that; it appears to think and judge, to contain its own 'alertness', to make its own 'declarations'. What the essay actually excludes is an active investigation of the whole question of historical intentions, motivations, artists' accounts of their own work, and the circumstances in which decisions were made. These are silences in Greenberg's argument.

In his 1947 review of paintings by Hedda Sterne and Adolph Gottlieb, however, Greenberg was more forthcoming. He praised the work of the Abstract Expressionist Gottlieb as 'ambitious' and 'serious', but dismissed the artist's own stated symbolic and metaphysical intentions, arguing that there was something 'half-baked and revivalist, in a familiar American way' about these claims (consider Gottlieb's *The Oracle*, Plate 57). Dismissing the relevance of artists' own accounts of their work, he went on to argue in 'Modernist painting' (p.9) that Modernist art 'does not offer theoretical demonstrations'. This discounting of any authorial primacy actually requires Greenberg to specify the nature of the critical activity operative 'in painting': '[it] has never been carried on in any but a spontaneous and subliminal way. It has been altogether a question of practice, immanent to practice and never a topic of theory.'

This assertion, absolutist in its formulation ('altogether', 'never'), ratifies Greenberg's argument that he is indifferent to what artists state as their intentions, and to wider forms of explanation and argument about meanings and values. It also allows him effectively to

Plate 57 Adolph Gottlieb, *The Oracle*, *c*.1946, oil on canvas, 152 x 118 cm. Collection of Donald and Barbara Zucker. © 1979 Adolph and Esther Gottlieb Foundation, New York.

render his own account, and his own evaluations, themselves simply the 'observation' of tendencies that he can claim are intrinsic to the practice 'itself'. In this, Greenberg shifts from the rhetoric of personification (giving art objects the qualities and capacities of people) to the rhetoric of objectivism (implying that art objects have innate qualities and values).

Yet this refusal to see artists' stated intentions as either relevant explanations of paintings, or even as relevant evidence *towards* any adequate explanation, is often undermined by his actual judgements on particular paintings, which often collapse together artist as agent and painting as object. Hence, for example, he says 'Gorky found his way', 'de Kooning proposes a synthesis', and Hofmann 'stated and won successful paintings' ('"American-type" Painting', pp.96–7). One of the most salient examples of this is Greenberg's account of Pollock, which suggests that Greenberg believed himself to have special knowledge of Pollock's intentions and motives:

> One of the unconscious motives for Pollock's 'all-over' departure [Plate 58] was the desire to achieve a more immediate, denser and more decorative impact than his later Cubist manner had permitted … he wanted to control the oscillation between an emphatic physical surface and the suggestion of depth.
>
> ('"American-type" Painting', p.97)

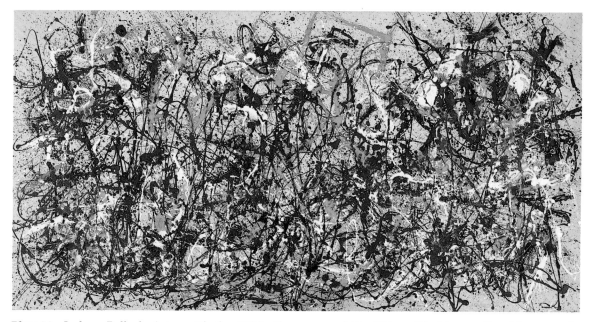

Plate 58 Jackson Pollock, *Autumn Rhythm*, 1950, oil on canvas, 267 x 526 cm. The Metropolitan Museum of Art, New York; George A. Hearn Fund, 1957 (57.92). © 1992 The Pollock-Krasner Foundation/ARS, New York.

The question of agency in relation to production and evaluation is thus implicit in Greenberg's adjudications of meaning and value, but it is not systematically addressed as a problematic issue (in fact, it doesn't exist for Greenberg as an 'issue' at all). When in the mid-1960s critics and others started to condemn Greenberg's approach and his defence of certain abstract artists, and when Pop Art's success was seen as undermining his status as 'prophet of future trends', they particularly attacked his lack of interest in agency and intentions. What I wish to defend is *not* the belief that intentions, motivations or retrospective accounts should be considered as primary within explanation, but that any argument that refuses to engage with the question of their relevance (and of other kinds of material) is inadequate. This would be equally true of some kinds of 'social histories of art', which Greenberg and other art critics had condemned as secondary and supplementary to the primary tasks of description and formal evaluation.

The 'Americanization of Modernism'

Greenberg's support for the Abstract Expressionists in the 1940s and 1950s, from their early exhibition as a nascent New York School in the mid-1940s to their institutionalization as the 'official' avant-garde orthodoxy by the late 1950s, also raises wider questions about the 'purity' of his concerns, about the appropriation of his ideas by others, about the validity of his account of their paintings, and about the role of institutions – such as the Museum of Modern Art – in promoting and installing a new canon of works. By the early 1960s, both artists and critics who had once been considered dissident found themselves in the Establishment pantheon. Within this wider context and history, Greenberg's critical activity may be seen as part of a particular political and ideological formation, in which the rhetoric of 'purity' and 'autonomy' also has Cold War connotations. Within these conditions, art and culture in general were seen, and used, as part of a 'cultural offensive' against the Warsaw Pact.

Within the 'Americanization of Modernism' in the post-war period, Greenberg's writings and curatorial activities may be seen as components of the institutional enshrinement of Abstract Expressionism. This culminated in the Museum of Modern Art's

show The New American Painting, which toured eight European capitals in 1958 and 1959. According to Alfred H. Barr jr, curator of modern painting and sculpture at the museum, this official recognition came at the end of a 'long struggle' and represented their 'present triumph'. Related to this judgement was the critic Porter McCray's verdict that this 'triumph' was that of a 'unique and indigenous ... kind of painting' (quoted in Barr, *The New American Painting*, pp.19 and 7). Greenberg had been among the first (though not the first) to recommend paintings by Pollock back in the early 1940s, and had been instrumental, along with others, in arranging the contracts that gave Pollock, Hofmann, Baziotes, Motherwell, Rothko and Still their first one-man shows with Peggy Guggenheim's gallery in 1943 and 1944. By 1948, and after articles by Greenberg on the Abstract Expressionists in magazines such as *The Nation*, the reputations of the group and their international significance were beginning to be established. De Kooning, Pollock and Gorky showed at the Venice Biennial in 1950, sales of Abstract Expressionist paintings rose at galleries such as Betty Parsons, and coveted art prizes were awarded to Abstract Expressionists.

It is important to register that Greenberg's own critical rhetoric, increasingly 'specialized' or 'reduced' to his identified 'Modernist' concerns during the 1940s and 1950s, always coexisted with a wider, eclectic, celebratory set of accounts by other authors extolling the virtues and values of Abstract Expressionist painting. These accounts consisted, in part, of the kind of humanist and psycho-biographical prose that Greenberg had explicitly attacked in his review of Gottlieb's work in 1947. Constituting what may be called a 'humanist Modernism' (in distinction to what may be called 'Greenbergian Modernism'), they continue to be written; and, in quantitive terms, they have been the predominant form of explanation of Abstract Expressionist painting. Like much pre-Modernist art history, this discourse is centred on the primacy of authorial (artists') intentions, motivations and meanings. Such accounts fuse biography, chronology and creative intent into the kind of anecdotal commentary that Greenberg despised in both painting and art criticism. The following can stand as exemplary:

> In January 1946, a fire in Gorky's studio destroyed much of his work: drawings, sketches, books, were reduced to ashes. In February of the same year he underwent an operation for cancer. Perhaps sensing that he had little time left to live, he began working even more compulsively ... He was, as William Rubin has noted, a painter of poetic allusion. He was a painter of nature filtered through memory and fantasy who moved from representation towards abstractions, from the realm of the exterior world to the inner imagination.
>
> (D. Waldman, *Arshile Gorky*, p.58)

It is important to note that whatever we conclude about the value of such accounts (which exhibit the monograph's rambling form, cataloguing 'great works' and 'significant events' in the lives of artists), propositions about agency, motivation and wider circumstances of production are represented as keys to explanation. Greenberg's so-called 'formalism', as I've tried to show, is actually suffused with metaphors of intent and will. To give an adequate historical account of the Abstract Expressionists, we must consider (and, beyond that, evaluate) the artists' stated aims, intentions, motivations and retrospective accounts, along with the circumstances within which all these were produced. All these elements should be recognized as legitimate evidence within a proper historical inquiry.

The historian Irving Sandler accused such 'formalist writers' as Greenberg of narrowing their interests to such a degree that they represented artists as solely concerned with formal issues. Sandler's work on Abstract Expressionism represents an amalgamation of historical methods and critical positions. Although it draws on analysis of the formal components of composition in Abstract Expressionist painting, it also articulates elements of artists' statements into the overall account. What Pollock or Rothko *thought* they were doing, or what they *intended* to do, thus became pivotal aspects of Sandler's explanation of the artists' works as historical phenomena in a broader social context. Greenberg's 'essentialism' of formal issues is thus a type of misrepresentation.

Sandler proposed, rather, that 'the Abstract Expressionists faced what they referred to repeatedly as "a crisis in subject-matter". As the phrase indicates, their preoccupation was with meaning – with what to paint rather than how to paint' (*The Triumph of American Painting*, p.31).

This returns us directly to the question of values, and the contexts in which they are formulated. I have attempted to show that, to understand this 'crisis in subject-matter', we must recognize the shift from the concerns 'of the 1930s' to the situation in which these artists found themselves during the late 1940s and 1950s. Given this history, it is difficult to accept the Modernist explanations given by Greenberg and others of the virtue and success of their abstract art in the post-war period.

In his introduction (p.15) to the catalogue for The New American Painting exhibition, Barr presented the Abstract Expressionists as a group of artists committed to the values of a principled individualism. He described them and their painting as 'a stubborn, difficult, even desperate effort to discover the "self" or "reality", an effort to which the whole personality should be recklessly committed: I paint, therefore I am'. Such a critical judgement – as absolutist in its way as Greenberg's formulations were to become – was, it may be argued, exactly the kind of closure on explanation that Still had anticipated when he wrote to his dealer Betty Parsons in 1948:

> Please – and this is important, show [the paintings] only [to] those who have some insight into the values involved, and allow no one to write about them. NO ONE. My contempt for the intelligence of the scribblers I have read is so complete that I cannot tolerate their imbecilities, particularly when they attempt to deal with my canvases. Men like Soby, Greenberg, Barr, etc. ... are to be categorically rejected.
>
> (Still, quoted in S. Guilbaut, *How New York Stole the Idea of Modern Art*, p.201)

Such an (again) absolutist refusal, this time of any critical judgement, may be seen mirrored in the difficulties many people have felt when looking at Abstract Expressionist paintings: the works 'resist' readings or, alternatively, admit so many differing interpretative readings and modes of explanation (Greenberg's, Barr's, Waldman's, etc.). The paintings could be (and were) represented as essentially to do with being 'American', or 'essentially individualistic' – in fact, as both at the same time, so that the former implied the latter. The 'triumph' of American painting – proclaimed by Sandler in 1970, and coming after what was seen by Modernists as the dross of 1930s social realist and Regionalist art (connected to the equally shoddy ideologies of socialism and ruralism) – was a triumph that Greenberg had earlier signalled, though less polemically, in '"American-type" Painting' and in other articles published in journals such as *Horizon* and *The Nation*.

While the Abstract Expressionists had 'set out to paint good pictures, and advance[d] in pursuit of qualities analogous to those they admire[d] in the art of the past' ('"American-type" Painting', p.93), their break out of 'provinciality' (a code word for 1930s art) was, according to Greenberg, to do with being American. Jackson Pollock's art contained feelings that he said were 'radically American. Faulkner and Melville can be called in as witness to the nativeness of such violence, exasperation and stridency' (Greenberg, 'The present prospects of American painting and sculpture', p.166). Compared with Jean Dubuffet, Pollock is 'American and rougher and more brutal' ('Review of exhibitions of Jean Dubuffet and Jackson Pollock', pp.138–9). These comments seem far removed from his tone and formal concerns in both '"American-type" Painting' and 'Modernist painting'. Arguably, however, this 'Americanization' of painting was instrumental in raising the status and value of a group of artists (many of them European by birth or ethnicity) as part of a new, distinctively *American* 'high art' – the successor to French Modernism.

By the 1970s this historical development had become an orthodoxy of conventional art-historical accounts of the New York School. Sandler tells us that between 1947 and 1951 'more than a dozen Abstract Expressionists achieved breakthroughs to independent

styles' (*The New York School*, p.ix). Yet these styles are also, he says, recognizably both 'New York' and 'American'. Further, 'American vanguard painting came to be considered the primary source of creative ideas and energies in the world' (p.ix).[9]

Newman offered a different explanation of his own work. Consider *Covenant* (Plate 5), along with the following statement:

> Harold Rosenberg challenged me to explain what one of my paintings could possibly mean to the world. My answer was that if he and others could read it properly, it would mean the end of all state capitalism and totalitarianism.
>
> (Newman, 'The sublime is now')

Conclusion

Newman's sentiments return us, directly, to questions about art *in* society, and about culture *and* democracy, within the shaping (and changing) orders of post-Second World War monopoly capitalism and state socialism. These questions, evidently, were as relevant to Newman in the 1950s as they had been during the 1930s. If the classic Abstract Expressionist paintings by Pollock, Rothko, Newman and others signified a negation of the subject-matter typical of Depression realism, along with a rejection of Stalinist cultural ideology, then it is also possible that, as Newman's statement indicates, the same canvases were intended to negate the sights and signs of the monopoly capitalist system of economic production 'triumphant' in the USA during the 1950s. The 'tragedy' that Rothko talked about could be interpreted as that of the victory of corporate capitalism over Nazism and then Soviet Communism. After 1945, the rhetoric of the New Deal and its reformist mission is discarded, along with any ideology seen as alien to the interests of the US state and to the demands of a massively expanded capitalist economy, whose dynamic becomes, once again, the motor of US social and historical development.

From 'art history' to 'cultural studies'

Within a traditional history of art in the USA, it would be a simple step to move to the USA of the 1960s and to show how a new generation of artists rejected the codes and conventions of the Abstract Expressionists and turned to represent exactly the icons of US commodity culture, whether in complicity with it or in obscure attempts to provide a form of critique. Andy Warhol's soup tins and Marilyns, Claes Oldenburg's giant hamburgers, and Roy Lichtenstein's cartoon-format warplanes depict and process the forms and narratives of that imperializing, consuming empire (Plates 59–63). Jasper Johns's 'Flag' paintings exemplify the ambiguities of this 'modernized' vernacular tradition – picturings of the Stars and Stripes, mobilizing and mutating the conventions characteristic of that 'essentially' *American* avant-garde, the Abstract Expressionists (Plate 64).

However, from Greenberg's perspective in the late 1930s to *our* situation in the 1990s, there is a direct, though problematic, continuity. Its ramifications go far beyond art history and art criticism. Debates about 'high art', the status of 'mass culture', and their relation to social and political organization and power have persisted from the 1950s onwards. More recently, the notion of 'postmodernist' art, culture and society has developed, unsettling the orthodoxies inherited from the late 1940s and 1950s about 'High Modernism' and the value or status of avant-garde art. While the cluster of issues and arguments around both Modernism and postmodernism is complex and multifaceted, it is possible to indicate

[9] For an account of the political use made of Abstract Expressionist painting during the 1950s and 1960s, see E. Cockcroft, 'Abstract Expressionism', pp.39–41, and S. Guilbaut, *How New York Stole the Idea of Modern Art*.

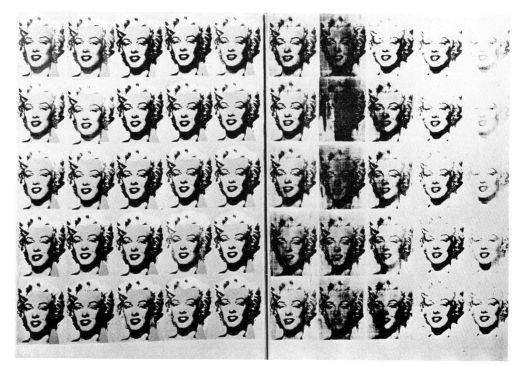

Plate 59 Andy Warhol, *Marilyn Monroe (diptych)*, 1962, silkscreen ink on canvas, 208 x 290 cm. Collection of Mr and Mrs Burton Tremaine, Meriden. © 1992 The Andy Warhol Art Foundation, New York.

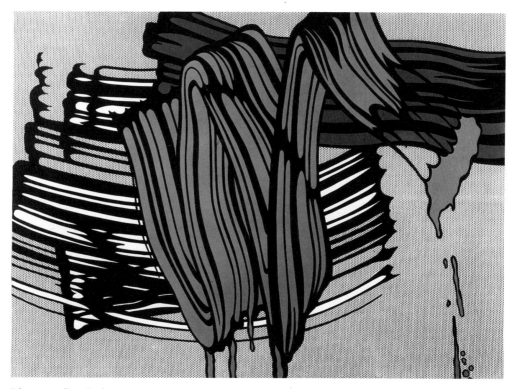

Plate 60 Roy Lichtenstein, *Big Painting no.6*, 1965, oil and magna on canvas, 233 x 328 cm. Kunstsammlung Nordrhein-Westfalen, Dusseldorf. Photograph: Walter Klein. © Roy Lichtenstein, DACS, London and VAGA, New York, 1993.

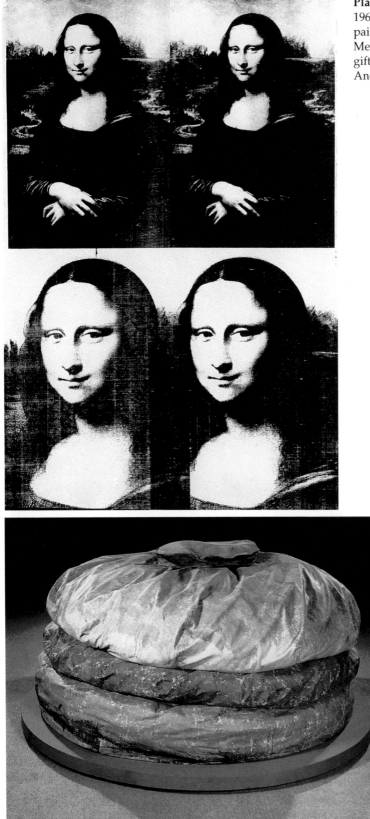

Plate 61 Andy Warhol, *Four Mona Lisas*, 1963, silkscreen ink on synthetic polymer paint on canvas, 112 x 74 cm. The Metropolitan Museum of Art, New York; gift of Henry Geldzahler, 1965. © 1992 The Andy Warhol Art Foundation, New York.

Plate 62 Claes Oldenburg, *Giant Hamburger*, 1962, painted sailcloth stuffed with foam, 132 x 213 cm. Art Gallery of Ontario, Toronto.

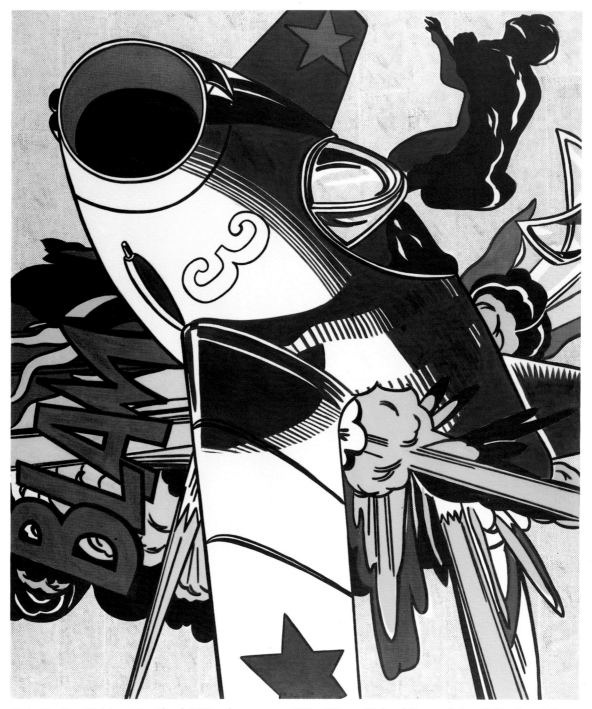

Plate 63 Roy Lichtenstein, *Blam!*, 1962, oil on canvas, 200 x 170 cm. Richard Brown Baker Collection. © Roy Lichtenstein, DACS, London and VAGA, New York, 1993. Photograph courtesy of Yale University Art Gallery.

some important components of this debate that relate directly to the main themes and values present in Greenberg's 'Avant-garde and kitsch'. What follows is an attempt to 'radicalize' this debate and to situate it within the context of the 1990s. From this perspective, Greenberg's dismissive interest in kitsch may be transformed into an attempt fully to understand all aspects of the culture, in their specificity and interrelationships.

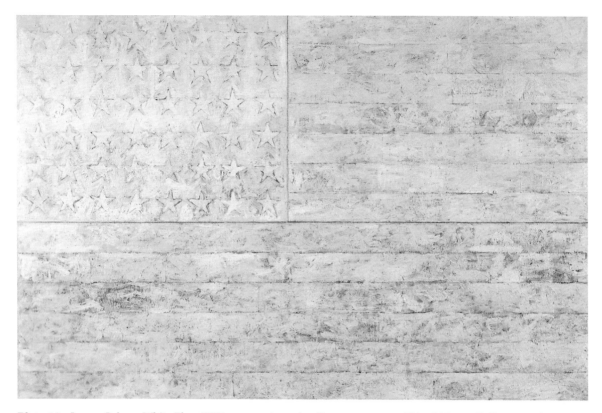

Plate 64 Jasper Johns, *White Flag*, 1955, encaustic and collage on canvas, 200 x 307 cm. Collection of the artist, courtesy of the Leo Castelli Gallery, New York. © Jasper Johns, DACS, London and VAGA, New York, 1993.

Three major sets of problems can be set out:

1 The status and value of Modernist art understood as a kind of 'refusal' or 'resistance' or even 'negation' of monopoly capitalist society. This is usually allied to a claim about the 'autonomy' or 'relative autonomy' of avant-garde art (and sometimes of art criticism) from that society.

2 The status and value of 'mass culture', and its relation to maintaining social order in monopoly capitalist (and state socialist) societies.

3 The possibility or desirability of a politically engaged realist art opposed to the organization and values of present monopoly capitalist or state socialist societies. A related question here is what 'realism' would mean or look like *now*, and how this could be related to particular conditions of production (material, technical, social and ideological).

Beginning to understand how values are formed involves asking questions about *who* believes *what*, in *which* historical and social circumstances, and in relation to what other kinds of human activity and value. This to say that all critical and theoretical arguments and accounts have developed historically, in specifiable – though obviously complex and different – human societies. How we arrive at an evaluation of values, and of the terms in which they are posed (we may want to say, for example, that a 'Modernist' value involves a 'social' judgement), includes our knowledge and understanding of relevant historical and social circumstances, and of the kinds of pressure and limit that have led people to formulate, or adopt, particular values.

If magazine covers and posters were 'kitsch' for Greenberg in the late 1930s, then we might agree that television occupies that position in the 1990s. As an extension of the

technology of photography developed in the first half of the century, and as a medium developed to enable the simultaneous broadcasting of sound and pictures, television may be said to constitute a massively propagated reservoir of disposable (i.e. impermanent) 'image-narratives' akin to the production of nineteenth-century academic and sentimental painting. Television technology and institutional direction over the past fifty years have been largely within the control of private and capitalist interests in North America and Western Europe – with the important exception of the BBC in the UK, and of other government-run channels in continental Europe. The priorities of capitalist broadcasting, centred on higher ratings leading to higher profits, have dictated the types of programme most often transmitted and sponsored by corporate advertising. Soap operas, 'human interest' stories, sport, thrillers, etc. dominate television output and reproduce, within a different medium, many of the narrative forms that previously reached a 'mass' public through magazines and films. 'Western television' is also likely to predominate within the development of the medium in the central and eastern European nations committed to capitalist 'free enterprise' on the US model. A further 'encroachment' of kitsch, via television's international extension as a vehicle for capitalist advertising, suggests that we may be in a similar (or worse) position to the one that Greenberg diagnosed during the late 1930s.

From this analysis, it is possible to see how a certain dominant kind of art history and art criticism wants to see art – or great art – as a form of opposition to this, showing what might be called a 'Utopic face' in contrast to the dire products of contemporary electronic kitsch. Art could be represented as like a

> sacred island systematically and ostentatiously opposed to the profane, everyday world of production, a sanctuary for gratuitous, disinterested activity in a universe given over to money and self-interest, [which] offers, like theology in a past epoch, an imaginary anthropology obtained by a denial of all the negations really brought by the economy.
>
> (P. Bourdieu, *Outline of a Theory of Practice*, p.197)

The notion that art had a special 'presence' and effect, 'liberatory' or 'transcendental' in a variety of obscure ways depending on the particular argument, was examined by the critic and historian Walter Benjamin writing in the 1930s. He believed that, in an age of mechanical reproduction (soon to be extended into electronic forms of image-production and dissemination, via broadcasting from both earth and, later, satellite), the security of Art's status as 'special' or 'sacred' was *threatened*, rather than entrenched, by the mechanization of forms of production. The revolution of mechanical image-making, he thought, was analogous to the revolution that socialism seemed to promise:

> The uniqueness of a work of art is inseparable from its being embedded in the fabric of tradition ... Originally the contextual integration of art in tradition found its expression in the cult. We know that the earliest art works originated in the service of ritual – first the magical, then the religious kind ... This ritualistic basis, however remote, is still recognized as secularized ritual even in the most profane forms of the cult of beauty ... With the advent of the first truly revolutionary means of production, photography, simultaneously with the rise of socialism, art sensed the approaching crisis which has become evident a century later. At the time, art reacted with the doctrine of *l'art pour l'art*, that is, with a theology of art ... An analysis of art in the age of mechanical reproduction ... lead[s] us to an all-important insight: for the first time in the world, mechanical reproduction emancipates the work of art from its parasitical dependence on ritual. To an ever greater degree, the work of art reproduced becomes the work of art designed for reproducibility. From a photographic negative, for example, one can make any number of prints; to ask for the 'authentic' print makes no sense. But the instant the criterion of authenticity ceases to be applicable to artistic production, the total function of art is reversed. Instead of being based on ritual, it begins to be based on another practice – politics.
>
> (W. Benjamin, 'The work of art in the age of mechanical reproduction')

It is clear from the history of television, however, that reproducibility in *itself* is no guarantee of anything: the conditions of control active on a particular medium or technology can determine the way in which it is developed and deployed. The capitalist ordering of television has shaped, limited, influenced and directed the use of the form and its likely development in the future. Its political role in Western societies has largely been to validate and entrench the monopoly capitalist control over the economy and social and political life. This has not been an *inevitable* or *necessary* process, but an outcome within a society such as the USA that was prepared to grant this enormous amount of power and resources to a set of interests beyond the control of the political state that putatively represents the interests of the people.

Many artists became interested in the opportunities afforded by the medium of television (and the attendant technology of video) during the late 1960s and early 1970s. Pop artists, as we have seen, began to show a special interest in the circulation of images within the culture of the US as a whole. In part, Warhol, Lichtenstein and others wanted to connect the traditional and supposed 'autonomous' fine-art traditions and interests with the popular culture of images burgeoning in the country through the saturation of television and film. From this perspective, the return to a concern with the medium of painting as a self-sufficient activity – containing its own justification – became impossible. By 1968 and the re-radicalization of artists over crises such as the Vietnam War, and with the rise of the Black Civil Rights movement and the 'New Left' (feminist, ecological and cultural political formations), an extremely critical and unambivalent coalition of artists' groups came into being concerned to analyse the nature and diversity of power in US society. Particular struggles developed around the visual forms and embodiments of power relations in the culture as a whole; examples here include the feminist examination of the pornographic representation of women, and of sexism generally, and the anti-imperialist critique of the dominant representations of the 'Third World'.[10]

For many artists working around 1968, the question of culture *and* democracy became pressing as a factor influencing the development and rationalization of artistic practice. Though a group or individual might have a particular interest in an issue to do with class, gender, race or anti-imperialism, a linking theme was the relationship between the 'democracy' of US society and the nature of the cultural forms within it. Fine or 'high' art practices and values, exemplified by Modernist notions of 'autonomy' and self-criticism, could not be mobilized within the re-politicized conjuncture of 1968. On the other hand, the electronic media (considered by Benjamin as a key to political revolution) were seen to be controlled by the forces of capitalism and the state and were therefore active in maintaining the system. The possibility, then, of a politically critical dialectic between the two facets of the culture, which might transform the understanding of both and their interrelationship, was a central issue that confronted the contemporary artists who saw themselves engaged *in* the culture – rather than placed, idealistically, outside it.

'High art' and 'mass culture', avant-garde and kitsch, Jackson Pollock and satellite television: these polarities may be seen as aspects of a single perspective, two sides of one judgement:

> The two faces of this 'Modernism' could literally not recognize each other, until a very late stage. On the one hand what was seen was the energetic minority art of a time of reduction and dislocation; on the other the routines of a technologized 'mass' culture. It was then believed that the technologized mass culture was the enemy of the minority art, when in fact each was the outcome of much deeper transforming forces, in the social order as a whole.
> (R. Williams, 'Culture and technology', p.143)

[10] In Chapter 2, F. Frascina considers in detail these oppositional forms and the circumstances in which they emerged; see also G. Pollock's 'Vision, voice and power', E. Said's *Orientalism*, N. Chomsky's 'Politics' and L. Lippard's 'Mapping'.

What emerged from this lack of recognition, according to Raymond Williams, was the 'unholy alliance' of a simple technological determinism (the belief that the advanced technologies of Western societies in the twentieth century necessarily led – and will continue to lead – to the extension of a massified 'kitsch' culture) and a 'cultural pessimism', common to large sections of the left- and right-wing intelligentsias. In this 'unholy alliance', the possibility (or the question of the possibility) of substantive democracy in political or cultural terms – and the very attempt to determine what a 'cultural democracy' might mean – is either shelved or disregarded altogether. It becomes, as with Greenberg, a 'repressed' context for critical evaluation, yet *simultaneously* an apparent irrelevance in the formulation of those critical judgements, which are held to be 'autonomous' or 'intuitive'.

For Michael Fried, a supporter of Greenberg writing in the 1960s, the ultimate determination of value becomes an unexplained intuition of 'rightness' or 'wrongness' based on the experience of the works themselves:

> … only one's actual experience of works of art ought to be regarded as bearing *directly* on the question of which conventions are still viable and which may be discarded as having outlived their capacity to make us accept them …
>
> (M. Fried, *Three American Painters*, p.44)

This begs the question: what kind of 'experience' is Fried talking about? Is it an experience that can somehow exclude all the knowledges, ideas and values that people carry around in their heads? Is he arguing that the proper kind of 'experience' in front of the work of art involves somehow first divesting oneself of such knowledges, ideas and values (and all other experiences for that matter) that might *interfere* with the operation of intuition? 'Experience', as an obviously central category, needs explanation.

The sites of values, experiences, intuitions and accounts, however, remain for Fried those of Art – painting, the artist and the canvas. This 'specialization' is in itself symptomatic of the basic judgement that needs questioning. Williams poses the issue bluntly:

> High technology can distribute low culture: no problem. But high culture can persist at a low level of technology: that is how most of it was produced. It is at plausible but hopeless conclusions of this kind that most current thinking about the relations between culture and technology arrives and stops.
>
> (Williams, 'Culture and technology', p.128)

On the one hand, we have 'high art': take Michelangelo's *Isaiah*, painted in the Sistine Chapel in 1508–12 (Plate 65). On the other, we have Norman Rockwell's *Saturday Evening Post* cover, *Rosie the Riveter*, of 1943 (Plate 54). Do these represent 'minority civilization' and 'mass culture', with both being components of a single (Western) human culture although separated by over four hundred years of continuous social transformation? In the mid-twentieth century, Pollock and Rothko were posed as elements of continuity within that 'minority civilization': they were represented as emblems of Art and Value, and seen as resistant to the technologies, the social relations, the 'ordinary culture' and life of actual contemporary Western societies.

In the late 1930s artists, critics and others in the USA argued for the creation of a permanent government Bureau of Fine Arts. They believed that capitalism, in its organization of production and social relations, was inherently incapable of providing, or engendering, the conditions for the development of a democratic culture. If the state could successfully reform the financial and industrial institutions of US society (which was, and is, a big 'if'), then why shouldn't cultural institutions and production also be democratized? Then, as now, one immediate retort was: what does it mean to talk about a 'democratic culture'? Even the coupling of the two words is condemned as anachronistic (or worse, as 'Fascist' or 'Stalinist'). One legacy of Stalinism and Fascism from the 1930s has been the belief, held by those on both the Left and the Right, that 'real', 'authentic'

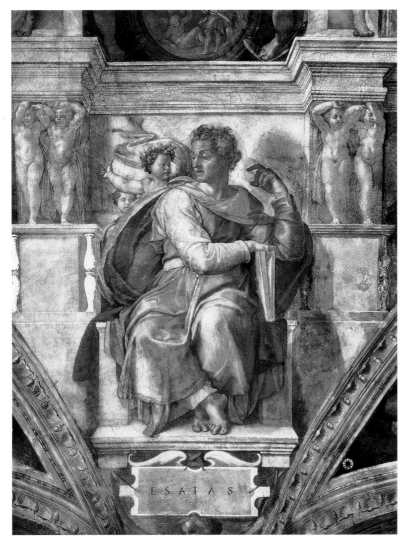

Plate 65 Michelangelo, *Isaiah* (detail from the ceiling of the Sistine Chapel), 1508–12, fresco. Sistine Chapel, Vatican. Photograph: Alinari.

culture (Art with a capital 'A') is an activity or object, a value, an ambition, a purity – threatened historically by the social relations of capitalist society (a society that is also called 'democratic') and certainly likely to be eradicated altogether by those who would wield power in the most commonly offered and assumed versions of future socialist or communist societies.

I do not mean to declare worthless or élitist the paintings of Pollock, Rothko or any of the other Abstract Expressionists. Nor have I called for a return to 'Realism', via Gustave Courbet or anyone else. Simply to choose either of these alternatives would be to ratify and privilege the practices and values defined and defended as Art and as the fulcrum of critical cultural activity in modern capitalist societies. Nor am I insisting on 'the end of art criticism' or art history. Rather, I suggest a return to an open dialogue about culture – the traditional and new technologies of visual representation – and its relations to a debate about the meanings of democracy in this society. This kind of debate would find echoes in the searching inquiry that 'Avant-garde and kitsch' represented in 1939.

If we take these questions seriously, we will be willing to consider the range of actual cultural forms prevalent and influential in contemporary Western societies. Rather than beginning with what is actually a conclusion – that, say, prints, film, television, video are irretrievably compromised forms of 'mass culture' (or simply not part of the history of

'Modern Art') – this seriousness will require us to make an investigation. We will need to examine particular materials, means of production, conventions and codes of communication – as well as particular audiences and publics, modes of reception, and the institutional arrangements that have controlled, do control and could control the values, meanings and contents of visual cultural technologies and forms. By the mid-1960s many artists and artists' groups, associated with Pop, Performance and other forms of 'inter-arts' activity, were investigating these technologies and the values associated with them.

At the same time, however, painting and sculpture should not be seen as simply irrelevant or outmoded in some technicist-ideological sense. In an adequate cultural history of visual representations in the twentieth century, there could be an active consideration of all forms of visual representation, and recognition of the inter-connectedness of these forms, as elements in a single culture or society. The question of values, and how values are formed within specific social and historical frameworks, could also be recognized as a necessarily political issue, as was clearly seen by artists and critics (and others) in the USA during the 1930s. Interest in and commitment to the principles of democracy and a democratic culture were central characteristics of debates and practices of artists and critics active in the period. Davis's concern about 'cultural monopoly' in the art world of New York in the 1930s could be extended to a contemporary concern over the cultural monopoly of newspaper and television ownership in the 1990s. The persistence of the issues around 'democracy' and 'culture', and the place of art in relation to both, requires that histories and theories of Modernist art and criticism should address these questions openly and as a recognized and central part of that inquiry.

References

BARR, A.H. jr, *The New American Painting*, exhibition catalogue, New York, Museum of Modern Art, 1959.

BENJAMIN, W., 'The work of art in the age of mechanical reproduction', 1936, translated by H. Zohn in H. Arendt (ed.), *Illuminations*, London, Cape, 1970 (an edited version is reprinted in Frascina and Harris, *Art in Modern Culture*, and in Harrison and Wood, *Art in Theory, 1900–1990*, section IV.d.6).

BERMAN, G., *The Lost Years: Mural Painting in New York under the Works Progress Administration Federal Art Project*, New York, Garland, 1978.

BERNSTEIN, B.J., 'The conservative achievements of liberal reform' in B.J. Bernstein (ed.), *Towards a New Past: Dissenting Essays in American History*, New York, Pantheon, 1968.

BOURDIEU, P., *Outline of a Theory of Practice*, Cambridge University Press, 1979.

BOURDIEU, P. and DARBEL, A., 'Signs of the times' and 'Conclusion' in *The Love of Art*, Cambridge, Polity Press, 1990 (an edited version is reprinted in Frascina and Harris, *Art in Modern Culture*).

CAHILL, H., *New Horizons in American Art*, exhibition catalogue, New York, Museum of Modern Art, 1936.

CHOMSKY, N., 'Politics' in *Language and Responsibility*, Brighton, Harvester Press, 1979 (an edited version is reprinted in Frascina and Harris, *Art in Modern Culture*).

CLARK, T.J., 'Clement Greenberg's theory of art', *Critical Inquiry*, vol.9, no.1, 1982.

COCKCROFT, E., 'Abstract Expressionism: weapon of the Cold War', *Artforum*, vol.XII, no.10, 1974 (an edited version is reprinted in Frascina and Harris, *Art in Modern Culture*).

CRAVEN, T., *Modern Art: The Men, The Movements, The Meaning*, New York, Simon and Schuster, 1934.

D'HARNONCOURT, R., 'Challenge and promise: modern art and modern society', *Magazine of Art*, 41, November, 1948.

DOSS, E., *Benton, Pollock and the Politics of Modernism: From Regionalism to Abstract Expressionism*, New Haven and London, Yale University Press, 1991.

FRASCINA, F. and HARRIS, J. (eds), *Art in Modern Culture: An Anthology of Critical Texts*, London, Phaidon, 1992.

FRIED, M., *Three American Painters: Kenneth Noland, Jules Olitski, Frank Stella*, Cambridge Massachusetts, Harvard University/Fogg Art Museum, 1965 (an edited version is reprinted in Harrison and Wood, *Art in Theory, 1900–1990*, section VI.b.8).

GIDDENS, A., 'Introduction' to *Modernity and Self-Identify: Self and Society in the Late Modern Age*, Cambridge, Polity Press, 1991 (an edited version is reprinted in Frascina and Harris, *Art in Modern Culture*).

GOODMAN, C., *Hans Hofmann*, New York, Abbeville Press, 1986.

GREENBERG, C., 'Avant-garde and kitsch', *Partisan Review*, vol.vi, no.5, 1939 (reprinted in Harrison and Wood, *Art in Theory, 1900–1990*, section IV.d.10).

GREENBERG, C., 'Towards a newer Laocoon', 1940, in F. Frascina (ed.), *Pollock and After: The Critical Debate*, London, Harper and Row, 1985 (an edited version is reprinted in Harrison and Wood, *Art in Theory, 1900–1990*, section V.a.1).

GREENBERG, C., 'Review of exhibitions of Hedda Sterne and Adolph Gottlieb' in J. O'Brian (ed.), *Clement Greenberg: The Collected Essays and Criticism*, 2 vols, University of Chicago Press, 1988.

GREENBERG, C., 'The present prospects of American painting and sculpture' in J. O'Brian (ed.), *Clement Greenberg: The Collected Essays and Criticism*, 2 vols, University of Chicago Press, 1988.

GREENBERG, C., 'Review of exhibitions of Jean Dubuffet and Jackson Pollock' in J. O'Brian (ed.), *Clement Greenberg: The Collected Essays and Criticism*, 2 vols, University of Chicago Press, 1988.

GREENBERG, C., 'The situation at the moment', *Partisan Review*, vol.15, no.1, 1948.

GREENBERG, C., 'The decline of Cubism', *Partisan Review*, vol.15, no.3, 1948 (an edited version is reprinted in Harrison and Wood, *Art in Theory, 1900–1990*, section V.a.9).

GREENBERG, C., 'The plight of culture: industrialism and class mobility' (Part 1), *Commentary*, vol.XV, June, 1953; and 'Work and leisure under industrialism' (Part 2), *Commentary*, vol.XV, August, 1953.

GREENBERG, C., 'Master Léger', *Partisan Review*, vol.XXI, January–February 1954 (a revised version is printed in C. Greenberg, *Art and Culture: Critical Essays*, Boston, Beacon Press, 1961).

GREENBERG, C., '"American-type" Painting', 1955, in F. Frascina and C. Harrison (eds), *Modern Art and Modernism: a critical anthology*, London, Harper and Row, 1982.

GREENBERG, C., 'Collage' (first published as 'The pasted-paper revolution', *Art News*, LVII, September, 1958).

GREENBERG, C., 'Modernist painting', 1961, in F. Frascina and C. Harrison (eds), *Modern Art and Modernism: a critical anthology*, London, Harper and Row, 1982 (reprinted in Frascina and Harris, *Art in Modern Culture*, and in Harrison and Wood, *Art in Theory, 1900–1990*, section VI.b.4).

GUILBAUT, S., 'The new adventures of the avant-garde in America', *October*, 15, winter, 1980 (an edited version is reprinted in Frascina and Harris, *Art in Modern Culture*).

GUILBAUT, S., *How New York Stole the Idea of Modern Art: Abstract Expressionism, Freedom and the Cold War*, University of Chicago Press, 1983.

HARRIS, J., 'State power and cultural discourse: Federal Art Project murals in New Deal USA', *Block*, 13, 1987–88.

HARRIS, J., 'Mark Rothko and the politics of American Modernism', *Oxford Art Journal*, vol.11, no.1, 1988.

HARRISON, C., and WOOD, P. (eds), *Art in Theory, 1900–1990*, Oxford, Blackwell, 1992.

HENRI, R., *The Art Spirit*, Philadelphia, Lippincott, 1923.

LIPPARD, L., 'Mapping' in *Mixed Blessings: New Art in a Multicultural America*, New York, Pantheon, 1990 (an edited version is reprinted in Frascina and Harris, *Art in Modern Culture*).

MARKOWITZ, G.E. and PARK, M., *New Deal for Art*, Hamilton, Gallery Association of New York, 1977.

Mark Rothko, 1903–1970, exhibition catalogue, London, Tate Gallery, 1987.

MARLING, K.A., *Wall-to-Wall America: A Cultural History of Post Office Murals in the Great Depression,* Minneapolis, University of Minnesota Press, 1982.

NEWMAN, B., 'The sublime is now', 1948, in Harrison and Wood (eds), *Art in Theory, 1900–1990,* (section V.a.10).

O' BRIAN, J. (ed.), *Clement Greenberg: The Collected Essays and Criticism,* 2 vols, University of Chicago Press, 1988.

O' CONNOR, F.V. (ed.), *Art for the Millions: Essays from the 1930s by Artists and Administrators of the Works Progress Administration Federal Art Project,* Greenwich, New York Graphic Society, 1973.

POLLOCK, G., 'Vision, voice and power: feminist art history and Marxism', *Block,* 6, 1982 (an edited version is reprinted in Frascina and Harris, *Art in Modern Culture*).

POUSETTE-DART, N., 'Freedom of expression', *Art and Artists of Today,* June–July, 1940.

RATHBONE, P.T., *Trends in American Painting Today,* St Louis, Missouri, City Art Museum, 1942.

REISE, B., 'Greenberg and the group: a retrospective view', *Studio International,* CLXXV, May–June, 1968 (an edited version is reprinted in Frascina and Harris, *Art in Modern Culture*).

ROSE, B. (ed.), *Readings in American Art since 1900,* London, Thames and Hudson, 1967.

ROSE, B., *American Painting: The Twentieth Century,* London, Macmillan, 1980 (first published 1969, revised 1977).

ROTHKO, M., 'The Romantics were prompted', *Possibilities,* 1, winter, 1947/8 (reprinted in Harrison and Wood, *Art in Theory, 1900–1990,* section V.a.4).

SAID, E., *Orientalism,* Harmondsworth, Penguin, 1977 (an edited version is reprinted in Frascina and Harris, *Art in Modern Culture*).

SANDLER, I., *The Triumph of American Painting,* New York, Praeger, 1970.

SANDLER, I., *The New York School,* New York, Harper and Row, 1978.

SMITH, D. and SIRACUSA, J., *The Testing of America,* St Louis, Forum, 1979.

TROTSKY, L., 'Towards a free revolutionary art', 1938, in P.N. Siegel (ed.), *Leon Trotsky on Literature and Art,* New York, Pathfinder, 1970 (reprinted in Harrison and Wood, *Art in Theory, 1900–1990,* section IV.d.9).

WALDMAN, D., *Arshile Gorky, 1904–48: A Retrospective,* exhibition catalogue, New York, Harry N. Abrams and Solomon R. Guggenheim Museum, 1981.

WILLIAMS, R., 'Culture and technology' in *Towards 2000,* London, Chatto and Windus, 1983.

WILLIAMS, R., *Culture,* Glasgow, Fontana, 1986 (an edited version of Chapter 5, 'Identifications', is reprinted in Frascina and Harris, *Art in Modern Culture*).

CHAPTER 2
THE POLITICS OF REPRESENTATION

by Francis Frascina

Politics and representation: an introduction

Institutions and the selective tradition

Let's start with what may seem a banal observation. In 1991 the Museum of Modern Art in New York reorganized the display in the final rooms of its permanent collection. This was a radical and symbolic act for an institution that in the words of Kirk Varnedoe, director of painting and sculpture, has 'often been referred to as the "Kremlin of Modernism"'.[1] A few years earlier, the Tate Gallery in London had caused a stir with a much more substantial reorganization of its cosmopolitan Modernist allegiances, with a rehang emphasizing British art and a notion of national identity. Such acts draw attention to what is often overlooked in the experience of visiting a museum or gallery: these institutions offer a *representation* of the past through the process of acquisition, selection and display of 'Art'. What, though, are the interests that underpin the selection, the history presented?

The display of MOMA's permanent collection has normally given an account of the past that privileges the formal development of abstraction in modern art. As Carol Duncan and Alan Wallach described it, this has been 'a history of progressive dematerialization and transcendence of lived, historical experience' in which Abstract Expressionism appears 'as the logical fulfilment of the original historical scheme, which in effect prophesied its coming' ('MOMA', p.53). This narrative display has long culminated in enormous canvases by Abstract Expressionists, such as Jackson Pollock's *One (Number 31, 1950)* and Barnett Newman's *Vir Heroicus Sublimis* (Plates 46 and 66). These are hung in rooms with plush carpet, which distinguishes them from works in the subsequent gallery space, housing the 'temporary displays' of art produced since the 1950s, where the floor is wooden. Varnedoe sees this change underfoot, from carpet to wood, as a big 'symbolic moment' – doubly so as the moment is also marked by a short intervening stretch of marble floor at the top of a staircase, a symbolic remnant of the original museum from 1939 when its dominating status was established under the directorship of Alfred H. Barr jr.[2]

After the 1991 rehang the final carpeted rooms of the permanent collection, representing the heroic point of 'the great modern tradition', *also* included works from the later 1950s and early 1960s by US male artists such as Johns, Stella, Lichtenstein, Rauschenberg, Judd, Ruscha and Warhol (see, for example, Plates 67–71). The Warhol Foundation is thanked for its financial support. Art and artists originally regarded as 'critical' of

[1] interview with the author, 12 December 1990. One instance of the phrase 'Kremlin of Modernism' can be found in M. Rosler, 'Lookers, buyers, dealers and makers', p.324.
[2] On changes at MOMA, see A. Wallach, 'The Museum of Modern Art'. Note that the museum building was greatly altered and expanded in 1984.

Plate 66 Barnett Newman, *Vir Heroicus Sublimis*, 1950–51, oil on canvas, 242 x 514 cm. Collection, Museum of Modern Art, New York; gift of Mr and Mrs Ben Heller. Reproduced courtesy of Annalee Newman in so far as her rights are concerned.

Abstract Expressionism and – in the case of Johns, Rauschenberg and Warhol – as somehow critical of the values of US society are decades later officially incorporated within *the* tradition; and they are assisted in this process by organizations that represent the financial success of an art world and larger society that easily absorb novelty and dissent.

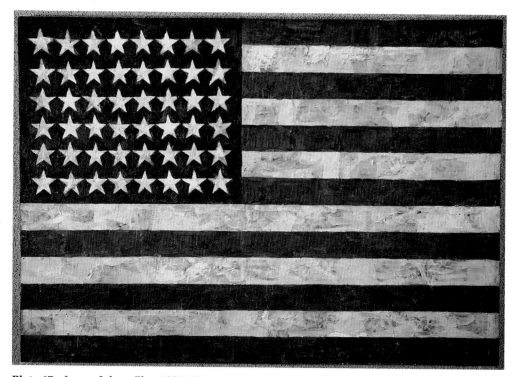

Plate 67 Jasper Johns, *Flag*, 1954–55, encaustic, oil and collage on fabric mounted on plywood, 107 x 154 cm. Collection, Museum of Modern Art, New York; gift of Philip Johnson in honour of Alfred H. Barr jr. © Jasper Johns, DACS, London and VAGA, New York, 1993.

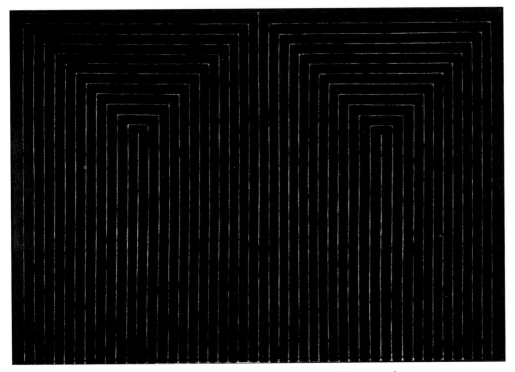

Plate 68 Frank Stella, *The Marriage of Reason and Squalor, II*, 1959, enamel on canvas, 231 x 337 cm. Collection, Museum of Modern Art, New York; Larry Aldrich Foundation Fund. © 1992 Frank Stella and ARS, New York.

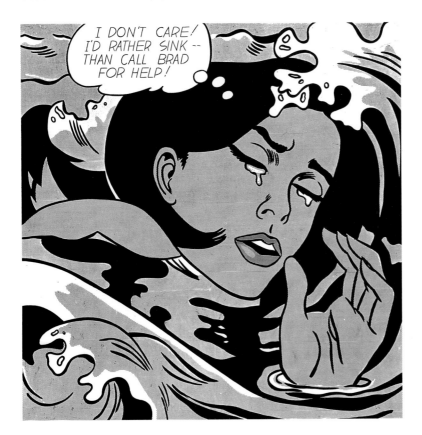

Plate 69 Roy Lichtenstein, *Drowning Girl*, 1963, oil and synthetic polymer paint on canvas, 172 x 170 cm. Collection, Museum of Modern Art, New York; Philip Johnson Fund and gift of Mr and Mrs Bagley Wright. © Roy Lichtenstein and DACS, 1993.

Plate 70 Andy Warhol, *Gold Marilyn Monroe*, 1962, synthetic polymer paint, silkscreen ink and oil on canvas, 211 x 145 cm. Collection, Museum of Modern Art, New York; gift of Philip Johnson. © 1992 Andy Warhol Foundation for the Visual Arts.

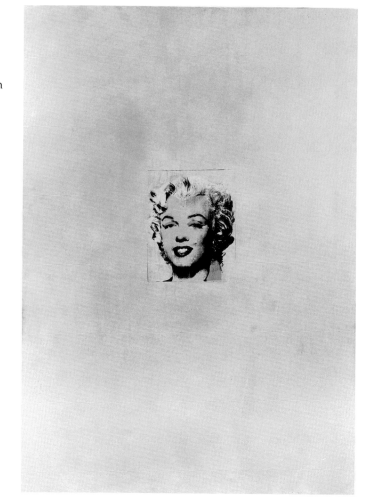

Abstract Expressionism was originally associated with the Left. But historians have argued that in the 1950s and 1960s, through a process of incorporation and canonization, its politics were transformed to be in tune with the anti-Communist rhetoric and reality of the Cold War. There was an emphasis on 'art for art's sake' and a radical formal account (stressing technique, surface, size, shape and flatness) epitomized by Clement Greenberg, Michael Fried and William Rubin (see Frascina, *Pollock and After*). This emphasis and account have been associated with MOMA in its displays, travelling exhibitions and publications. (For instance, Rubin became a curator at MOMA in 1967, and from 1973 to 1988 was director of painting and sculpture; his brother, Larry, was a dealer who bought the work of artists favoured by Greenberg.) But, it might be countered, surely this is the normal way of things? Isn't it the duty and function of museums to identify the greatness of great art that transcends initial philistine reaction and the pervasiveness of ordinary life? Museums are repositories for those precious objects picked out from the dross by experienced and specialized critics, historians and curators engaging in 'disinterested' aesthetic contemplation. Doesn't critical judgement demand ethical rigour to assess the highest standards manifest in those aesthetic products that express the human potential to transcend 'normalized' life (which is characterized by alienated labour and the kitsch of mass culture)?

An alternative account, put forward since at least the 1960s, suggests that museums and galleries are powerful institutions that, by their selection and curatorship, accord a

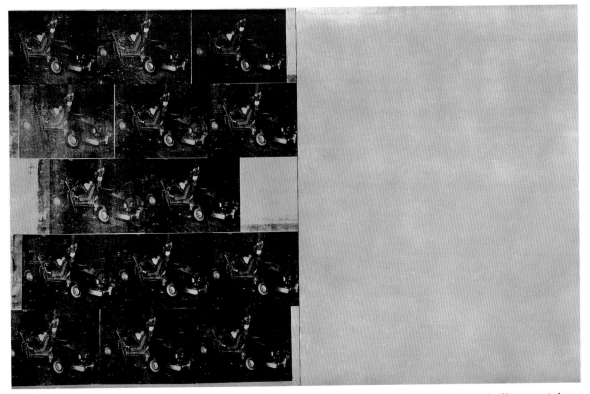

Plate 71 Andy Warhol, *Orange Car Crash Fourteen Times*, 1963, synthetic polymer paint and silkscreen ink on canvas, two panels, in total 269 x 417 cm. Collection, Museum of Modern Art, New York; gift of Philip Johnson. © 1992 Andy Warhol Foundation for the Visual Arts.

particular cultural and socio-economic value to the objects they conserve. It's not, so the argument goes, that they provide space into which great art can be brought for display; rather, that they confer 'greatness' on works by deciding to display them. Religious metaphors have also been coined – museums as temples, critics as clergy, aesthetic experience as mystical revelation, the 'art world' as a secular replacement for religion (see P. Bourdieu and A. Darbel, *The Love of Art*, and Bourdieu, *Distinction*). Museums have also been scrutinized as educational institutions, and many critics and historians have concluded that they are among the main agencies for transmitting an effective dominant culture. Along with other sites, such as the art magazine, the art school, publishing houses and media organizations, they are part of a process that Raymond Williams calls the 'selective tradition':

> … that which, within the terms of an effective dominant culture, is always passed off as '*the* tradition', '*the* significant past'. But always the selectivity is the point; the way in which from a whole possible area of past and present, certain meanings and practices are chosen for emphasis, certain other meanings and practices are neglected and excluded. Even more crucially, some of these meanings and practices are reinterpreted, diluted, or put into forms which support or at least do not contradict other elements within the effective dominant culture.
>
> (R. Williams, 'Base and superstructure in Marxist cultural theory', p.39)

MOMA is regarded as the paradigmatic Modernist museum in that it most spectacularly represents a particular 'selective tradition'. It had been subject to several earlier critiques, but it was in the late 1960s and 1970s that this representation and its politics began to be systematically questioned. As we shall see, the questions ranged from the possible links between the economic, political and cultural interests of the board of trustees (many of

whom were also on the boards of multinationals supporting the Vietnam War) to the reasons why the work of women, members of ethnic minorities and explicitly political artists was neglected or under-represented in the collection.

These questions were connected to broader ones about capitalist power relations in general and the relationship between art and politics in particular. One centre for this questioning was the women's movement and early feminist critiques, characterized by slogans such as 'the personal is political' and by collectives such as Women Artists and Revolution (WAR) from 1969, Ad Hoc Women Artists' Committee from 1970, and Heresies from 1975 (which had its own journal from 1977). 'The personal is political' was a rejection of what women saw as the marginalization and repression of the personal, which in patriarchal politics had been negatively associated with the 'feminine'. For many feminists the slogan also asserted that the aspect of women's oppression that was experienced privately by an individual within her own life, had in fact a political dimension. Such actions and arguments were part of an attempt to give value to women's traditional arts and experiences which feminism saw as erased by *the* tradition officially validated by a system represented by museums and galleries. Feminists regarded this tradition as selective, a representation that was essentially patriarchal, individualist and circumscribed by a particular gendered notion of 'public' importance.

Art institutions have biases, implicit and explicit, that affect the way in which they represent the past and the present. The same is true of art critics and art historians. Of course, no history or criticism can be produced without interests and biases, but how do we account for the dominance of particular interests and their politics in the period since 1945? What is the relationship between, on the one hand, the way in which institutions and texts represent art works and, on the other, the specific historical meanings of those art works that are themselves representations within *a* culture?

From the margins: representation and the critique of power

Such questions can be developed a little with another related observation. In 1990 MOMA acquired a recent work by Cindy Sherman (Plate 72), who follows the traditions of the feminist movement. Varnedoe stated in an interview with the author that the work was 'bought' by the museum, which now lists it as a 'gift of the Norton Family Foundation, 1990'. It should be noted that MOMA often 'buys' works by means of 'bequests', 'gifts' and bequested funds; all these works are assessed by a committee. In late 1991 *No.228* was displayed as one of the final examples of contemporary art in the 'temporary' exhibition space. Sherman's work is not a painting but a large chromogenic photograph. Her choice of medium inevitably suggests a connection with Walter Benjamin's discussion – in 'The work of art in the age of mechanical reproduction' of 1936 – of the potentially 'democratic' use of photography (where numerous prints can be made from the same negative) in contrast with the individual 'aura' normally accorded to paintings as unique objects. Sherman has talked about 'getting disgusted with the attitude of art being so religious or sacred', and of a wish to make something 'that anybody off the street could appreciate … I wanted to imitate something out of the culture, and also make fun of the culture as I was doing it' (quoted in Laura Mulvey, 'A phantasmagoria of the female body', p.137).

The high cultural status accorded to painting in 'the modern tradition' is monumentally inscribed in MOMA's display of Abstract Expressionism, and in texts such as Greenberg's 'Modernist painting' of 1961. Apart from the difference of medium, the subject-matter of Sherman's work is also rooted in alternative traditions and issues (which do not privilege autonomy and painterly abstraction). Many of these, including discourses from outside 'Art' as a hierarchical specialism, became important to the women's movement – masquerade and female identity, feminine stereotypes in visual representation, the gendered viewer, the female body and fetishism, 'his-tory' and 'her-story', etc.

Plate 72 Cindy Sherman, *No.228*, 1990, chromogenic colour print (ektacolour), 208 x 122 cm. Courtesy of Metro Pictures, New York.

Plate 73 Cindy Sherman, *No.6*, 1977, photograph, 102 x 76 cm. Courtesy of Metro Pictures, New York.

Only given a number as a title, evoking an ironic reference to, for instance, Pollock's numerical recording of his paintings, Sherman's work is from a series based on Old Master images and themes. Here, the reference is to Judith and Holofernes and – in psychoanalytic terms – is particularly important to feminists with its emphases on masquerade and the power of male desire. The event comes from the Old Testament story about an Assyrian siege of the Israelite city of Bethulia, which was near to capitulation. Judith, renowned for her wisdom, devised a plan to save the city. In preparation, 'she removed the sackcloth which she had been wearing, and took off her widow's garments', dressing up in fine clothes and ornaments, making herself very 'beautiful, to entice the eyes of all men who might see her' (Judith 10, The Bible). Because this dressing-up did not proceed from sensuality but from virtue, the Lord increased her beauty to all male beholders. Having reached the Assyrian lines with her maid, she convinced their commander, Holofernes, that she had a feasible plan to capture Bethulia without Assyrian loss. In celebration, he organized a banquet in Judith's honour while also secretly 'moved to possess her'. However, by the end of the feast when the two were left alone, Holofernes 'was overcome with wine'. Seizing her opportunity, Judith severed his head with two blows of his sword and gave it to her maid who placed it in a food bag. Both of them, with the maid carrying the head of Holofernes, made their way back to Bethulia before the deed was discovered. When the news broke, the Assyrians were thrown into disarray and fled.

In *No.228* the central figure of Judith is Sherman herself, dressed up, in 'masquerade', and in a theatrical setting that imitates the original Old Master theme. In the late seventies and early eighties, Sherman produced a series of photographs in which she assumed a wide range of stereotypical female characters, again through 'disguise' and 'masquerade', in imitations of typical shots from New Wave, Neo-Realist, Hitchcock or Hollywood B

Plate 74 Cindy Sherman, *No.13*, 1978, photograph, 25 x 19 cm. Courtesy of Metro Pictures, New York.

movies – referring to the fifties (Plates 73 and 74). In Plate 72 the verisimilitude of the 'film' series is replaced by a crucial balance between a seamlessly accurate tableau of a painting source and obvious signs of the constructed image – deliberate traces of make-up, of theatrical props (such as the 'head' of Holofernes), and so on. The viewer is thrown back onto references and processes both within and outside the discourses of 'Art'. Some of these references bypass the normal narrative history – and many of the critical assumptions – of post-war art. Compare, for instance, the terms and references of Modernist texts, such as Greenberg's and Fried's (for example, Greenberg's 'Modernist painting' and Fried's 'Art and objecthood'), with Mulvey's discussion of Sherman's work in terms of feminine masquerade referenced to Marilyn Monroe, Madonna and the Mexican artist Frida Kahlo (Plates 75 and 76):

> Frida depicted her face, in an infinite number of self-portraits, as a mask, and veiled her body in elaborate Tehuana dresses. Sometimes the veil falls, and her wounded body comes to the surface, condensing her real, physical wounds with both the imaginary wounds of castration and the literal interior space of the female body, the womb, bleeding, in her autobiographical painting, from miscarriage. Frida Kahlo's mask was always her own. Marilyn's was like a trademark. While Cindy Sherman and Madonna shift appearance into a fascinating debunking of stable identity, Marilyn's masquerade had to be always absolutely identical. Her features were able to accept cosmetic modelling into an instantly recognizable sign of 'Marilyn-ness'. But here, too, the mask is taut, threatened by the gap between public stardom and private pressures …
>
> (Mulvey, 'A phantasmagoria of the female body', p.149)

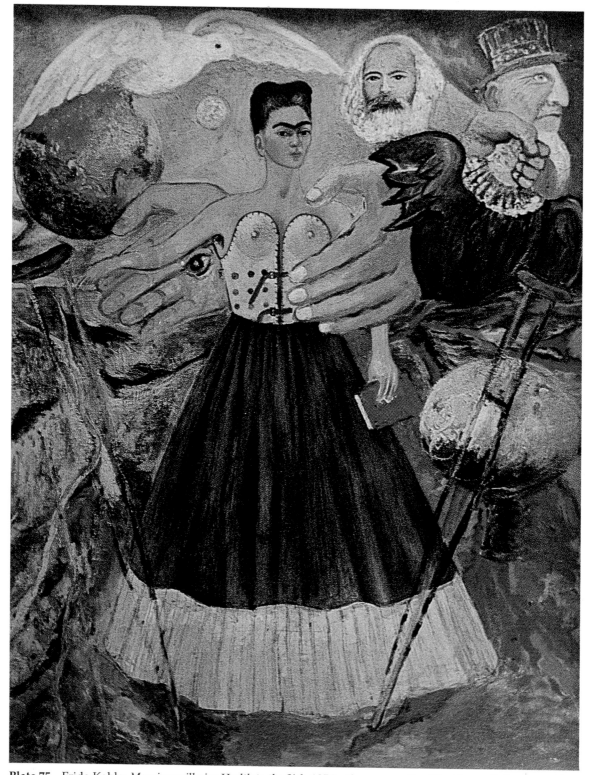

Plate 75 Frida Kahlo, *Marxism will give Health to the Sick*, 1954, oil on masonite, 75 x 60 cm. Collection of the Frida Kahlo Museum, Mexico City. Photograph: CENIDIAP/INBA, Mexico. Reproduction authorized by the Instituto Nacional de Bellas Artes y Literatura.

Plate 76 Frida Kahlo, *Fulang-Chang and Me*. Part 1 (left): 1937, oil on composition board, 40 x 28 cm; with painted mirror frame (added after 1939), 57 x 44 x 5 cm. Part 2 (right): after 1939, mirror with painted mirror frame, 64 x 49 x 4 cm including frame. Collection, Museum of Modern Art, New York; Mary Sklar Bequest.

Mulvey relates Sherman's work to the tensions that women have to negotiate between the representational demands of being a public icon (a 'star' and sex object) and the often undervalued or overlooked social and psychological demands and needs of *actual* feminine experience. In terms of painting she cites Kahlo, who during her lifetime was more publicly known for being married to Diego Rivera, renowned for his public murals in Mexico and the USA; both Kahlo and Rivera were Communists. MOMA has three works by Kahlo (including a two-part self-portrait, Plate 76), all of them 'gifts' or 'bequests'. Since at least the 1970s, Kahlo's work has been part of a feminist canon, where the artists and representations that are valued are not those that are central to the dominant US culture of the post-war years. Many feminists regarded this alternative selection as a political act; and 'political', for some of them, went beyond cultural or gender politics.

Among the possible reasons for MOMA's acquisition of the Sherman may be the museum's attempt to be 'up to date', to collect works that in Varnedoe's terms are not only 'linked to the modern tradition in one form or another' but also 'absolutely engaged with the issues of race, gender, social pathology and disease in our time' (interview with the author, 12 December 1990). MOMA had also just acquired a work by David Hammons, an African-American, and one by Kikki Smith evoking AIDS. Alternatively, it may be an instance of the paradoxical fate of works that are critical of conventions (for instance, feminist critiques of Modernist abstraction) to be assimilated by institutions that largely conserve those conventions. In Williams's terms, these works are placed so that they 'do not contradict other elements within the effective dominant culture'. Kahlo has also become a cult within the capitalist culture industry, her work and its meaning appropriated and absorbed for profit and spectacle.

Plate 77 Diego Rivera painting Frida Kahlo handing out Stockholm peace petitions, in his *The Nightmare of War and the Dream of Peace*, 1952. Photograph by courtesy of CENIDIAP/INBA, Mexico. Reproduction authorized by the Instituto Nacional de Bellas Artes y Literatura.

The features that lead feminists to connect and value Kahlo's paintings and Sherman's photographs are often marginalized in the selective tradition of the dominant culture.[3] Two images from the early fifties are instructive here. The first is a photograph of Rivera painting Kahlo who, from a wheelchair, is handing out Stockholm peace petitions to end the Korean War (Plate 77). His work *The Nightmare of War and the Dream of Peace*, a large movable mural, was commissioned by the Instituto Nacional de Bellas Artes y Literatura for an exhibition of Mexican art to tour Europe. However, it was not exhibited: the political content of Rivera's work was regarded as potentially hostile to the USA, which was actively anti-Communist in its involvement in Korea. The resulting furore saw Rivera returning his advance and the Instituto giving back the mural. The event became another controversy in Rivera's career, and the painting a Communist symbol. In a letter to the president of The American Federation of Art, Lloyd Goodrich (associate director of the Whitney Museum of American Art) wrote:

> I do not mean that I would be in favor of including in American exhibitions abroad any works which were clearly anti-democratic propaganda, whether pro-fascist or pro-communist, such as the recent painting by Diego Rivera ... A picture like this is a clear piece of political propaganda, and as such in my opinion has no place in a governmental exhibition sent abroad.
>
> (L. Goodrich, letter to Lawrence M.C. Smith, 3 April 1952)

[3] Specifically, see Mulvey and Wollen, *Frida Kahlo and Tina Modotti*; generally, see L. Lippard, *Mixed Blessings*.

As we will see, Picasso's *Massacre in Korea* (Plate 122) was similarly viewed, particularly in the USA.

Kahlo's *Marxism will give Health to the Sick* (Plate 75) is very different from Rivera's work in its scale and in the form of its political address. In contrast with Modernist emphases on the transcendental and the international avant-garde, many Mexican artists celebrated their indigenous popular and folk idioms, satisfying commitments to political radicalism and to the critique of academicism. Kahlo actually used the format of *retablos* and *ex-votos*, which were traditional images painted on tin sheets placed in churches as offerings of thanks following a miraculous recovery from disaster, accident or illness. Conventionally, at the top is the figure of the saint, saviour or the Virgin Mary whose miraculous intercession was prayed for. The disaster, accident or illness is graphically depicted in the centre of the image. In *Marxism will give Health to the Sick* Kahlo combined references to such traditional subject-matter and to interests that were both personal and political. As a child she contracted polio, which withered her right leg, and in an accident at eighteen she suffered multiple injuries requiring over thirty operations throughout the rest of her life. Not surprisingly, Kahlo often had to work from a wheelchair or her bed. This painting was produced several months after the amputation of her right leg because of gangrene. The year 1954 was also the height of the early Cold War and of McCarthyist anti-Communism in the USA – concerns, as we will see, of many artists such as André Fougeron in France (Plate 118).

As with the Sherman work, the imagery, references and format of Kahlo's painting produce readings that Modernism downgraded as 'iconographical', 'literary', 'political' and 'moralistic'. Hayden Herrera offered this non-Modernist reading of Plate 75:

> ... Frida, dressed in an orthopedic corset and clutching a red book that must be Marx's *Capital*, is the victim saved by the miracle-making saint, Karl Marx. Two enormous hands, one with an extra eye signifying wisdom, descend from the vicinity of Marx to support Frida so that she can cast aside her crutches. Another hand projects from Marx's head and strangles an American eagle, which is a caricature of Uncle Sam. Beneath the eagle, rivers run red and an atomic bomb explodes. The other side of Marx's head is touched by a peace dove that hovers protectively over both Frida and a globe dominated by the Soviet Union, where the rivers are blue ... Communism versus capitalism as day versus night, holy peace dove versus evil eagle.
> (H. Herrera, *Frida Kahlo*, pp.214–15)

Such a reading, as with Mulvey's, raises issues about the politics of representation – visual, verbal, institutional – in the period since 1945. How did the women's movement, and counter-cultural manifestations focused on civil rights and anti-Vietnam War groups of the 1960s, reveal the assumptions that invested power in a selective dominant culture? Was it inevitable that the capitalist Cold War would develop individualism and consumerism to enhance the success of its economic, cultural and political aims, and thereby impede the development of a collective, socialist political consciousness? Was critical Modernism a product of this process whereby its symbolic sites – museums and galleries, art journals and magazines, and the media in general – became upmarket versions of shopping malls, glossy monthly magazines and the entertainment industry? In other words, did Modernism become a *part* of the 'kitsch' of 'mass culture' so despised by Modernists?

Issues and debates: the late 1960s as a representative moment

Modernism as salvation

To explore such questions, I want to examine the late 1960s as a moment of transformation in practices and debates concerned with the politics of representation since 1945. One way to begin is to consider an issue of *Artforum*, which by 1970 was probably the leading art journal in the USA. In September of that year, *Artforum* opened with 'Caro's abstractness' by Fried, who had gained a substantial critical reputation with a series of articles and catalogues indebted to Modernist criticism and history in general, and to Greenberg's writings in particular. These articles and catalogues did much to establish the canonical status of abstract artists, such as Caro, in the Modernist tradition.

Fried writes as though the experience of every beholder of *Sun Feast*, for example, corresponds to his *own* intellectual and bodily response to 'the internal relations (or syntax) of the sculpture alone'. In so doing he generalizes the beholder as *male* and as coming from a white, Eurocentric tradition. For instance, he identifies 'three types of order' at work in *Sun Feast* (Plate 78):

> First, that of Caro's table sculptures [a series from the sixties] … The long horizontal plank that runs almost the full length of the sculpture serves as the 'table' on top of which various elements are placed and off which these and other elements depend or spring or otherwise make their way. Second, the play of elements along and against a dominant axis or track, also identified with the long horizontal plank … And third, a kind of sensuous, dishevelled, almost certainly feminine though not quite figural *sprawl*, as if the sculpture were displaying itself for its own delectation. The combination of intellectual rigor and intense sensuality again recalls Matisse.
>
> (M. Fried, 'Caro's abstractness', p.34)

Plate 78 Sir Anthony Caro, *Sun Feast*, 1969–70, painted steel, 181 x 417 x 218 cm. Private collection. Photograph by John Goldblatt, reproduced by permission of the artist.

The gendered metaphors and polarities of this Modernist assessment are complemented by a general oppositional distinction in the article: Fried claims that one important aspect of Caro's sculptures has been 'their anti-literal, anti-situational character; and *that* has been an index at once of their radical abstractness and of their deep antagonism to the theatrical in all its current forms and manifestations' (p.33).

To understand the terminology of this distinction between 'abstractness' and 'theatrical', it's necessary to refer to an earlier essay by Fried, 'Art and objecthood', published in *Artforum* in June 1967. There he opposed Modernist painting and sculpture on the one hand, and Minimal Art (or 'Literalist Art') and Pop Art on the other. For example, the Modernists Caro, Olitski, David Smith and Noland (Plates 78, 142, 146 and 163) were set against Minimalists such as Judd and Morris (Plates 82 and 162) and Pop Artists such as Rauschenberg (Plates 79 and 80). Because Minimalism and Pop Art entailed the beholder in a 'duration of experience' (including outside associations that threatened the established boundaries of a self-referential 'art'), they were in Fried's terms 'largely ideological', 'theatrical', 'literary', 'historically specific' and the 'negation of art'. Modernist paintings and sculptures, by contrast, served to 'defeat theatre' because they were 'more explicitly concerned with the conventions that constitute their respective essences' (p.21); these are experienced as a kind of 'presentness' or 'instantaneousness'.

Fried argues for a self-referential moral rigour in the production of abstract art and in writing about it, a specialized aesthetic experience serving as a corrective to what characterizes the rest of 'our lives'. In Max Weber's words, 'art becomes a cosmos of more and

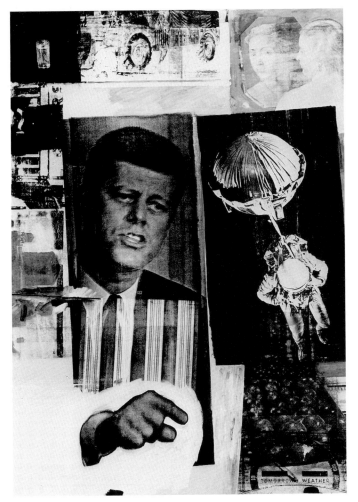

Plate 79 Robert Rauschenberg, *Retroactive, II*, 1964, oil and silkscreen ink on canvas, 213 x 152 cm. Stefan T. Edlis Collection. Photography by courtesy of the Castelli Gallery. © Robert Rauschenberg, DACS, London and VAGA, New York, 1993.

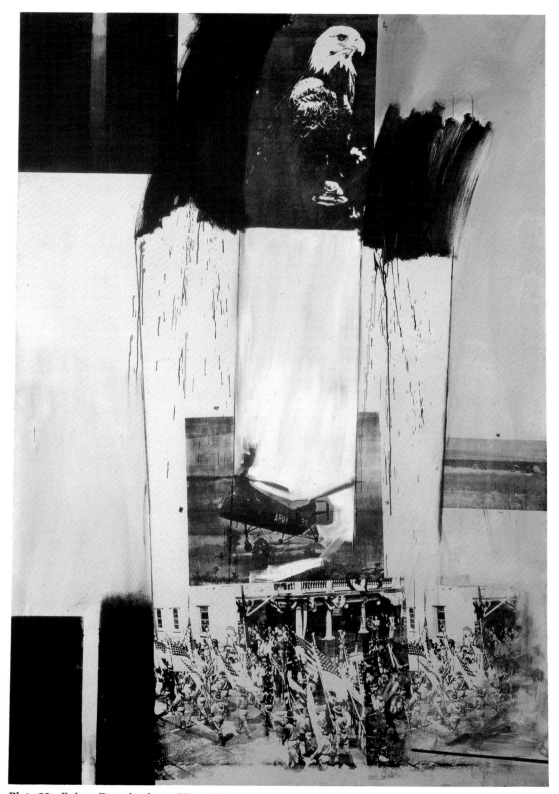

Plate 80 Robert Rauschenberg, *Kite*, 1963, oil and silkscreen on canvas, 213 x 152 cm. Collection of Mr and Mrs Michael Sonnabend, New York. © Robert Rauschenberg, DACS, London and VAGA, New York, 1993.

more consciously grasped independent values which exist in their own right. Art ... provides a *salvation* from the routines of everyday life...' ('Religious rejections of the world and their directions', p.343). Courting such religious parallels, at the end of 'Art and objecthood', Fried declares:

> ... I have wanted to call attention to the utter pervasiveness – the virtual universality – of the sensibility or mode of being which I have characterized as corrupted or perverted by theatre. We are all literalists most of our lives. Presentness is grace.
>
> (Fried, 'Art and objecthood', p.23)

The artist and politics

In the September issue of *Artforum* in 1970, directly after 'Caro's abstractness' by Fried, came 'The artist and politics: a symposium'. This consisted of artists' replies to the following question:

> A growing number of artists have begun to feel the need to respond to the deepening political crisis in America. Among these artists, however, there are serious differences concerning their relations to direct political actions. Many feel that the political implications of their work constitute the most profound political action they can take. Others, not denying this, continue to feel the need for an immediate, direct political commitment. Still others feel that their work is devoid of political meaning and that their political lives are unrelated to their art. What is your position regarding the kinds of political action that should be taken by artists?
>
> (*Artforum*, vol.IX, no.1, 1970, 'The artist and politics: a symposium', p.35)

Much of the 'political crisis' centred on the New Left's response to militarism and racism in the late sixties. This is powerfully symbolized by the 90,000-strong siege of the Pentagon on Saturday 21 October 1967, in the USA's seventh national protest against the Vietnam War. Perched above the crowd at the Lincoln Memorial, an African-American protester held aloft a placard saying 'No Vietnamese ever called me a Nigger'. Hence the solidarity of the colonially oppressed – internally the African-Americans, externally the Vietnamese.

By the end of 1968, 30,500 Americans had died in the Vietnam War. A mark of the escalation from initial involvement in 1962 is that almost half of this number had died in the previous twelve months. The government was spending 30 billion dollars per year on the war with a troop commitment of 550,000 – many of them African-Americans who had been living in poverty. At the same time, one in seven US citizens officially existed below the poverty line. In 1968 both Robert Kennedy, the hope of the liberal Democratic left, and Martin Luther King jr, non-violent campaigner for African-American civil rights, were assassinated. In the previous year eighty people had died in riots in more than 100 cities, and after King's death there was further widespread rioting. Eugene McCarthy, champion of the anti-war faction, was defeated by Hubert Humphrey at the Democratic National Convention at Chicago in August 1968. Violent disorder in the streets of Chicago from anti-war protesters, as well as from opposition to party positions, dominated the event. Subsequently, Humphrey was defeated by Richard Nixon in the presidential election of November 1968. This blow to the Left's democratic aspirations was compounded by Nixon's right-wing reputation established when he supported Senator Joe McCarthy in 1950–54, and as Eisenhower's vice-president between the elections of 1952 and 1960.

The following gives an idea of the New Left's increasing support: by the beginning of 1969 Students for a Democratic Society (SDS) numbered 60–100,000, arranged in local groups; three years earlier there were only 8,000 members. Following the student rebellion at Columbia University in April 1968, almost every campus in the USA had members of SDS ready to make effective protests. In May 1969 the Permanent Subcommittee on Investigations reported 471 disturbances at 211 colleges during the previous two years – including 25 bombings, 46 cases of arson, 598 injuries, 6,158 arrests and 207 buildings occupied.

The Left, however, was not unified. One of several splits within the SDS happened at its convention in Chicago on 18 June 1969: the so called 'Weatherman Manifesto' called for increased direct action and the creation of a revolutionary organization under a single general staff. Direct action was precipitated by a coalition between two SDS factions (the Revolutionary Youth Movement and the Weathermen) and the Black Panthers, a group that did not exclude violent action in the struggle for civil rights and African-American power. As David Caute summarizes:

> Between August 1969 and March 1970 seven major companies were bombed in New York. 'Revolutionary Force 9' claimed credit for the simultaneous explosions at GE, Mobil and IBM on 12 March. At one point 30,000 people were evacuated from buildings in Central Manhattan, with threats coming in at the rate of one every six minutes. All Washington schools were evacuated after explosions in the capital and Pittsburgh. ROTC [Reserve Officers' Training Corps] buildings from Oregon to Texas were attacked. On 6 March a Weatherman group blew itself up while manufacturing bombs in a town house on 11th Street, New York. Two women escaped naked, were given clothes by unsuspecting neighbours, and vanished. Three others, one a woman, died in the explosion. From January 1969 to April 1970, bomb blasts caused forty-three deaths (mainly novice saboteurs) and caused $21.8 million of damage.

> Ten years had passed since the day in February 1960 when four Negro students entered the F.W. Woolworth store in Greenboro, North Carolina, sat down at the whites-only lunch counter, and made their famous request to be served coffee. The New Left had come – and gone – a long way.
> (D. Caute, *Sixty-Eight*, pp.389–90)

At about this time there was the trial of the 'Chicago Eight' (to become the 'Chicago Seven'), which began on 24 September 1969 and lasted four months. They were charged with conspiring to cross state lines and with intent to riot at the Democratic National Convention of 1968. Massive publicity fed further divisions in public opinion both during the trial and, at the end, when five – including Jerry Rubin and Abbie Hoffman, two members of the Youth International Party ('Yippies') – were found guilty. Prison sentences and appeals followed. The Yippies had formed after the Pentagon demonstration of October 1967. Utopian, and hostile to US bureaucracy and hypocritical social inequalities, they advocated 'happenings, community, youth power, dignity, underground media, music, legends, marijuana, action, myth, excitement, a new style' (quoted in Caute, p.268). This drew criticism from the orthodox New Left, and surveillance from state agencies.

Foreign policy events, following the accession of Richard Nixon as president and Spiro T. Agnew as vice-president, heralded a further increase in the activities of the anti-war movement, with violent responses from the state. On Saturday 16 November 1969 around half a million attended the New Mobilization demonstration at the Washington Monument. However, this received no live television coverage because of Agnew's attack on the networks, the press, SDS, Weathermen and Yippies. Ronald Reagan, then governor of California, claimed that the demonstrations were Communist conspiracies and had been planned in East Berlin! John Mitchell, attorney-general and later to be implicated in the Watergate scandal, ordered 9,000 troops into federal buildings. In this tense atmosphere, the following spring erupted into violence, particularly after Nixon's announcement on 30 April 1970 that he had ordered military intervention into Cambodia. The student response was widespread throughout the USA's universities and colleges, the state's response bloody. At Kent State University on 4 May, the Ohio National Guard opened fire on student demonstrators, killing four and wounding nine. At Jackson State College, an African-American campus in Mississippi, two students were killed and nine wounded by police gunfire. Some 350 colleges saw their students strike, at thirty campuses ROTC buildings were burned, and the National Guard was called out in sixteen states.

The manifestations of rock culture also symbolized contradictory forces. In August 1969 the Woodstock Music and Art Fair (at Bethel, New York) represented the Utopian vision of hippie 'flower power'. Four months later on 6 December at Altamont, California, a crowd of roughly one-third of a million turned up for a free concert starring the Rolling Stones. Seven hundred people were treated for bad acid trips; and in savage violence, much of it racial, four people died and hundreds were injured in attacks begun by Hell's Angels who had been hired as 'stewards': 'They seemed on the verge of going out of control … the violence culminated in the Angels' stabbing a black man named Meredith Hunter to death, right in front of a stunned Mick Jagger' (Edward P. Morgan, *The 60s Experience*, p.196). For many of those involved in the political, social and cultural protests of previous years, the *Berkeley Tribe*, the most widely read underground paper in the San Francisco Bay Area, summed up their mood: 'Stones Concert Ends it – America Now Up for Grabs.' This judgement was confirmed for many by the publication of the definitive account of the My Lai massacre by Seymour Hersh (*Harper's Magazine*, May 1970). Five hundred and eighty-three women, children, babies and elderly Vietnamese had been massacred by US infantrymen on 16 March 1968. When the event had first been made public, the full details had been suppressed. Nevertheless, the news led to the big Moratorium march on Washington on 15 October 1969.

The politics of 'autonomous art'

Even these brief details give a vivid impression of what *Artforum* meant by the 'deepening political crisis in America'. Responses to the *Artforum* symposium question were, not surprisingly, mixed. One was that of the critic and painter Walter Darby Bannard (Plate 81), a friend and in the fifties and early sixties a fellow student of Michael Fried and the

Plate 81 Walter Darby Bannard, *Mandragora no.3*, 1969, alkyd resin on canvas, 168 x 252 cm. Collection, Museum of Modern Art, New York; given anonymously.

artist Frank Stella at Princeton University. (Bannard had introduced Stella to Greenberg in 1958 and was part of what Barbara Reise calls 'Greenberg and the group', a powerful social formation in the New York art world.) Bannard replied:

> You have asked what kind of political action should be taken by artists, and I can answer only that any particular artist should take whatever political action he wants to. Political things should not affect the *making* of art because political activity and art-making have never mixed to art's advantage, and my guess is that most artists are better off out of politics. But it is an individual's choice. As a subject it really does not merit the attention you are giving it.
>
> (W.D. Bannard, *Artforum*, 'The artist and politics: a symposium', p.36)

This is consistent with the Modernist view exemplified by Fried that the 'tendency of ambitious art [has been] to become more and more concerned with problems and issues intrinsic to itself'; and with his claim that the 'formal critic of modernist painting, then, is also a moral critic: not because all art is at bottom a criticism of life, but because modernist painting is at least a criticism of itself' (*Three American Painters*, pp.7 and 10). There are two important points to note about this position.

First, it implies for Fried a 'new *modus vivendi* between the arts and bourgeois society gradually arrived at during the first decades of the present century' and extended in the USA since the Second World War. He claims that although the 'radical change [in] the relation of art – as well as of the church and state – to society' cannot be 'understood apart from a consideration of economic and other non-artistic factors, by far the most important single characteristic' of the change in question has been the rigorous pursuit of artistic autonomy (*Three American Painters*, pp.4–10 and especially p.7).

The second point about Fried's position is that, as Theodor Adorno argued in 1962, the emphasis on 'art for art's sake' or on 'autonomous' works is itself 'sociopolitical in nature'. It presupposes a particular notion of the value and critical complexity of high culture, a moral integrity in the preservation of *Art* – insulated from kitsch on the one hand, and from political commitment or tendency on the other. Adorno put it thus in 1962: 'This is not a time for political art, but politics has migrated into autonomous art, and nowhere more so than where it seems to be politically dead' ('Commitment', p.318). But what is this the politics of?

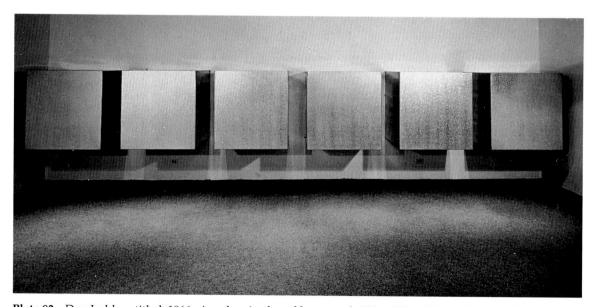

Plate 82 Don Judd, untitled, 1966, six galvanized steel boxes each 102 x 102 x 102 cm, for a total length of 8.63 m, exhibited at Dwan Gallery, New York, 1967. Reproduced by courtesy of the artist.

A second response to the *Artforum* question came from the Minimalist sculptor Don Judd (Plate 82):

> I've always thought that my work had political implications, had attitudes that would permit, limit or prohibit some kinds of political behaviour and some institutions. Also, I've thought that the situation was pretty bad and that my work was all I could do. My attitude of opposition and isolation, which has slowly changed in regard to isolation in the last five years or so, was in reaction to the events of the fifties: the continued state of war, the destruction of the UN by the Americans and Russians, the rigid useless political parties, the general exploitation and both the Army and McCarthy.
>
> Part of the reason for my isolation was the incapacity to deal with it all, in any way, and also work. Part was that recent art had occurred outside of most of the society. Unlike now, very few people were opposed to anything, none my age that I knew ... So my work didn't have anything to do with the society, the institutions and grand theories. It was one person's work and interests; its main political conclusion, negative but basic, was that it, myself, anyone shouldn't serve any of these things, that they should be considered very sceptically and practically ...
>
> My interest in actually doing something grew partly because my work became easier, clearer, more interesting, so that I didn't feel I would be swamped by other interests; partly by the example of the civil rights movement, that things could change a little; by the Vietnam War, which presented a situation of either/or: I marched in the first Fifth Avenue parade and I hate group activities (Ad Reinhardt was the only artist I recognized); by the realization that politics, the organization of society, was something itself, that it has its own nature and could only be changed in its own way. Art may change things a little, but not much; I suspect one reason for the popularity of American art is that museums and collectors didn't understand it enough to realize that it was against much in the society.
>
> (D. Judd, *Artforum*, 'The artist and politics: a symposium', pp.36–7)

There's a contradictory tension in Judd's response which is largely absent from that of Bannard. He claims that the pursuit of his own interests and work which 'didn't have anything to do with the society' resulted in a 'political conclusion, negative but basic'; however, this stance led to both social isolation and a specialized popularity among museums and collectors unaware, or unable to understand, that they owned objects produced, in part, to resist the political attitudes and values they represented.

Judd's opening comments suggest a comparison with Adorno's position of 1962. Both men had a pessimistic view of the public politics of the Cold War, which in Adorno's terms 'oblige the mind to go where it need not degrade itself'. For Adorno, works such as Kafka's novels, Beckett's plays and Schönberg's music are exemplary in that their uncompromising rejection of 'empirical reality' arouses a 'fear', a 'shudder', an 'indignation' in the audience for 'avant-garde' culture. Their austerity, internal complexity and intellectual difficulty are, it is claimed, a lingering moral counterweight to the quick fix of popularization, such as best-selling novels, Hollywood movies, jazz and pop music, on which the market thrives. Adorno distrusted the manipulative effect on people's minds of cultural forms that give a message, since he feared propaganda (as in Fascist Germany, Stalinist Russia, capitalist USA). He also distrusted work that provided what he regarded as instant gratification, such as the 'kitsch' products of the mass media. The effect could lead, he argued, to a technologically dependent, uncritical populace susceptible to any totalitarian ideology. This view has been criticized for applying these terms to *all* art that had a political message or engaged with 'mass culture'. On the other hand, Adorno also warned of a danger in the politics of autonomous art:

> [art that] concludes that it can be a law unto itself, and exist only for itself, degenerates into ideology no less. Art which even in its opposition to society remains a part of it, must close its eyes and ears against it; it cannot escape the shadow of irrationality.
>
> (Adorno, 'Commitment', p.317)

By the time Adorno had written this, Abstract Expressionism had become enmeshed in Modernist criticism, which celebrated its painterly autonomy. It had also been used, by institutional agencies such as the USIA (United States Information Agency) and MOMA, as a Cold War symbol of the so-called Free West, in contrast to Socialist Realism characterized as a symbol of Soviet totalitarianism (see the texts in Part II of Frascina, *Pollock and After*).

In his work of the 1960s, Judd's notion of the legacy of Abstract Expressionism was different from the one that informed the large Modernist paintings or sculptures of Louis, Noland, Stella, Olitski and Caro, though for all of them 'autonomy' was central. Judd's sculptures seem to be explorations of the possibility of making three-dimensional versions of Newman's paintings rather than developments out of Pollock's drip-paintings. His works also show no interest in Pop Art's more literal use of the imagery and stereo-types of modern consumer society (Plates 69–70 and 79–80). Pop Art was one critical reaction to Abstract Expressionism, making the world of everyday life an explicit resource rather than implicitly rejecting it. Alternatively, a work by Judd from 1966, for example, consists of six galvanized steel boxes hung on a wall, having a total length of 8.63 metres (Plate 82). From one perspective, works such as this demanded new notions of artistic enterprise, of historical precedents and of private and institutional display. However, to some, Judd's sculptures are linked, metaphorically at least, to aspects of modern US experience such as blandness, meaningless repetition, industrial geometry and the rhetoric of male power (see A. Chave, 'Minimalism and the rhetoric of power').

In his *Artforum* response, Judd suggests that he was aware of the precarious political and social importance of his works. He sees few uncompromised possibilities for a current productive relationship between art practice and politics, given that politics has its 'own nature and could only be changed in its own way'. Artists should politicize themselves as citizens, demonstrating and protesting when necessary, but art should be free of political responsibility and only used 'when the purpose is extremely important and when nothing else can be done' (p.37). However, the dilemma for politically-conscious citizens making art that 'didn't have anything to do with the society' was that their work could be read, in the words of Carl Andre (another respondent to the *Artforum* symposium question), as 'Silence is assent' (p.35).

In an interview published a month later, Andre vividly expresses the dilemma. He saw himself as an 'artworker', an 'artisan', with the freedom to employ 'himself essentially as his own tool to produce goods that he exchanges for other people's goods'. The members of his artistic community share social and political concerns that are in contrast with those of people who have 'the kind of social pretensions of the good solid bourgeoisie or who lead neat Cadillac-driven lives' – even though these are likely to be the

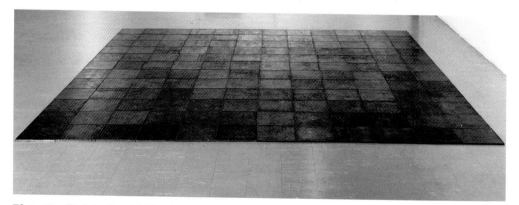

Plate 83 Carl Andre, *144 Lead Square* [*sic*], 1969, 144 lead plates each approximately 1 x 31 x 31 cm; overall, 1 x 368 x 369 cm. Collection, Museum of Modern Art, New York; Advisory Committee Fund. © Carl Andre, DACS, London and VAGA, New York, 1993.

people who buy and collect his work. For Andre, the meaning of his work may be different from that ascribed to it by critics, collectors and curators – all of whom, he says, are interested 'not in quality but commodity'. Yet, the fact that his own work can easily be treated as a commodity, by being purchased by institutions such as MOMA (Plate 83), may be related to his insistence that artists should politicize themselves rather than their work. In the 1930s Benjamin had argued that a necessary aspect of political art was its ability to subvert the normal system of reception, appropriation and commodification. In resisting the politicization of his art, Andre is caught in a dilemma that centres on his notion of a 'crisis of freedom':

> ... it is the pretence of the museum that they are an apolitical organization. And yet ... the board of trustees are exactly the same people who devised the American foreign policy over the last twenty-five years ... [they] favour the war, they devised the war in the first place and wish to see the war continued, indefinitely. The war in Vietnam is not a war for resources, it is a demonstration to the people of the world that they had better not wish to change things radically because if they do the United States will send an occupying, punishing force. It is a war of punitive oppression. And they wish to run these quiet apolitical institutions like museums and universities suppressing politics among artists, among students, among professors ... we are killing people ostensibly to maintain the rationale of artistic freedom.
>
> (Andre, in Siegel, 'Carl Andre', pp.176–7)

Both Judd and Andre are uncomfortably aware of the way in which institutionalized power uses the symbols of 'artistic freedom'. No matter how politically conscious the producers of 'autonomous art' might be, a risk is run. Judd's cold-rolled steel pieces (for example, Plate 82) – which have a geometric uniformity and pristine surface, and have often been constructed by commercial methods – can be viewed as radical sculptural acts, as 'oppositional' within a particular artistic frame of reference. They certainly bothered Modernists such as Fried. On the other hand, their popularity with prosperous collectors, institutions and the agencies of corporate capital has led others to regard them as *continuous* with many of the ideals and values of a modern capitalist society dominated by technology. And although Judd's sculptures keep steel fabricators in work, they are alien to those fabricators' notions of culture or politics.

Another response to the *Artforum* question came from Robert Smithson, best known at the time for the large earthwork, *Spiral Jetty* (Plate 84):

> The artist does not have to *will* a response to the 'deepening political crisis in America'. Sooner or later the artist is implicated or devoured by politics without even trying. My 'position' is one of *sinking* into an awareness of global squalor and futility. The rat of politics always gnaws at the cheese of art. The trap is set. If there's an original curse, then politics has something to do with it. Direct political action becomes a matter of trying to pick poison out of boiling stew ... Conscience-stricken, the artist wants to stop the massive hurricane of carnage, to separate the liberating revolution from the repressive war machine. Of course, he sides with the revolution, then he discovers that real revolution means violence too ... The political system that now controls the world on every level should be denied by art. Yet, why are so many artists now attracted to the dangerous world of politics? Perhaps, at the bottom, artists like anybody else yearn for that unbearable situation that politics leads to: the threat of pain, the horror of annihilation, that would end in calm and peace ... the clean world of capitalism begins to stink, 'the sexual channels are also the body's sewers' (Georges Bataille), nausea and repugnance bring one to the brink of violence. Only the fires of hell can burn away the slimy, maggot-ridden decomposition that exists in life; hence *Revolution for the Hell of It* [Abbie Hoffman] ... When politics is controlled by the military, with its billions of dollars, the result is a debased demonology, a social aberration that operates with the help of Beelzebub (the pig-devil) between the regions of Mammon and Moloch.
>
> (R. Smithson, *Artforum*, 'The artist and politics: a symposium', p.39)

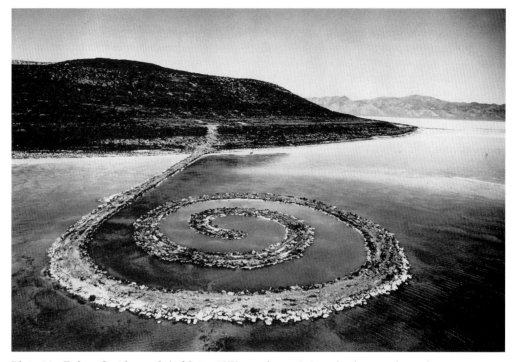

Plate 84 Robert Smithson, *Spiral Jetty*, 1970, mud, precipitated salt crystals, rocks, water; length of coil 457 m; 10-acre site at Rozel Point, Great Salt Lake, Utah. Photograph: estate of Robert Smithson by courtesy of the John Weber Gallery, New York.

As well as giving the quotation from the Surrealist writer Georges Bataille, Smithson draws a metaphorical link, elsewhere in his response, between contemporary society and William Golding's *Lord of the Flies* – a novel whose overall mood Smithson describes as 'one of original disgust'. And Bataille's emphasis on the bestial side of human nature, its profound historical links to sacrifice and mythical cults/rituals, is echoed by Smithson's claim:

> Student and police riots on a deeper level are ceremonial sacrifices based on a primal contingency – not a rite but an accident. Nevertheless, because of media co-option, the riots are being structured into rites. The students are a 'life force' as opposed to the police 'death force'.
>
> (Smithson, p.39)

Bataille's work examined the connections between our social behaviour and the suppressed images of the subconscious. One major area of this subconscious was the powerful and largely forbidden area of sexuality and fantasy. Again, Smithson echoes Bataille while also evoking *Lord of the Flies*:

> As the Earth thickens with blood and waste, as the population increases, one stress factor could bring 'the system' to total frenzy. Imagine a future where eroticism and love are under so much pressure and savagery that they veer towards cannibalism.
>
> (Smithson, p.39)

In Smithson's writing we encounter an anti-rationalist preoccupation with concepts of nature, human experience, geological time, prehistoric monuments and landscapes. These preoccupations informed his attempt to engage with non-conventional art sites, materials and objects. An example is his series of 'Nonsites'. In one, *The Palisades, Edgewater, New Jersey* (Plate 85), a signed statement and map form part of a work that also includes a

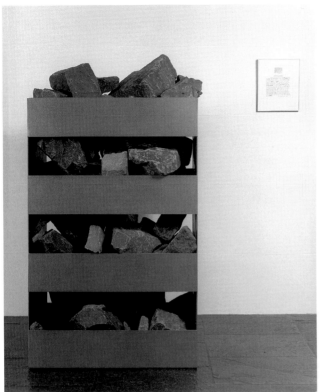

Plate 85 Robert Smithson,
Nonsite (The Palisades, Edgewater,
New Jersey), 1968; painted aluminium, enamel
and stone, 142 x 66 x 91 cm; typed description
(signed), and map, 25 x 19 cm.
Detail (below): statement and map. Collection,
Whitney Museum of American Art, New York;
purchase, with funds from the Howard and
Jean Lipman Foundation, Inc. 69.6a–b.

A NONSITE (THE PALISADES)

The above map shows the site where **trap** rocks (from
the Swedish word **trapp** meaning "stairs") for the **Nonsite** were
collected. The map is $1\frac{7}{16}$" X 2". The dimensions of the map
are 18 times (approx.) smaller than the width 26" and length
36" of the **Nonsite**. The **Nonsite** is 56" high with 2 closed
sides 26" X 56" and two slatted sides 36" X 56" -- there are
eight 8" slats and eight 8" openings. Site-selection was
based on Christopher J. Schuberth's The Geology of New York
City and Environs -- See Trip C, Page 232, "The Ridges". On
the site are the traces of an old trolly system that connected
Palisades Amusement Park with the Edgewater-125th St. Ferry.
The trolly was abolished on August 5, 1938. What was once a
straight track has become a path of rocky crags -- the site
has lost its system. The cliffs on the map are clear cut
contour lines that tell us nothing about the dirt between the
rocks. The amusement park rests on a rock strata known as
"the chilled-zone". Instead of putting a work of art on some
land, some land is put into the work of art. Between the site
and the **Nonsite** one may lapse into places of little organization
and no direction.

Robert Smithson 68

painted aluminium box containing rocks collected from an actual site. Echoing Bataille (and perhaps Marcel Duchamp), Smithson ends the statement: 'Between the site and the *Nonsite* [in the gallery] one may lapse into places of little organization and no direction.' Smithson articulates a sceptical and pessimistic politics that links to a particular notion of 'public art'; for example, earthworks such as *Spiral Jetty* are not only sites of 'art' but also sites independent of the gallery space, though not of the dealer system. However, there's a contradiction here. Arguably, people can only understand the work and its criticism of the dealer system if they visit the site, yet the site is so inaccessible that for most people this isn't feasible. They end up going to a gallery to look at a photograph of it, a photograph that is necessarily a gallery commodity. As far as contemporary politics is concerned, Smithson is a sceptical sightseer – distrusting organization, and more concerned with the place of an oppositional 'art' in a decaying modern culture.

A burgeoning feminism?

Two of the twelve published respondents to the *Artforum* question were women – Jo Baer and Rosemarie Castoro. Neither of them had as much public status as the artists already mentioned. However, Lucy Lippard, in a review from 1972, remarked that Baer had one of the most impressive 'underground' reputations in New York (*From The Center*, p.172). Baer's response opened:

> I think the time for political action by artists is now, and I believe action should be taken in the art world and in the world at large … all art is eventually political. As the carrier of esthetic experience, art is a powerful effector of choice and action.
>
> (Baer, *Artforum*, 'The artist and politics: a symposium', p.35)

Baer's work was abstract (Plate 86). For her, imitative art had a 'conservative heart' that longed for 'authorities' and 'rules': 'There is no doubt why Nixon removed all abstract art from the White House when he moved in. Abstract art seldom provokes a clear affection

Plate 86 Jo Baer, *Double-Bar Grey (Green Line)*, 1968, oil on canvas, 92 x 99 cm. Collection, Museum of Modern Art, New York; Ruth Vollmer Bequest.

for the past' (p.35). Since 1947 Nixon had had a reputation as an anti-Communist; and he was therefore associated with claims made in the 1940s and 1950s by Congressman George A. Dondero, and by others even higher in the administration, that 'modern art' was 'communist'. However, Baer distances herself from current versions such as 'that pair of sexual solipsisms currently known as Concept Art and Color Painting' (p.35). Here we meet again the argument that there could be some abstract art as a critical resource for an ideal public. On the other hand, as Smithson argued in an essay from 1968 where he takes Fried to task, abstract painting can also be subject to critical whims depending on the context in which it is discussed. Perhaps, too, it depends on the use to which it is put, as with the *use* of Abstract Expressionism during the fifties and sixties for anti-Communist ideological purposes. Baer argues that the mainspring of much contemporary work

> is the status quo. It is unidealized, displaying both the good and bad aspects of the now ... It is interesting to observe how intimately these art movements are joined to modern media, with their heavy reliance on promotion for distribution of products (and it is no accident to find their best customers in the bourgeoisie), for entertainment commodities. They posit no radical changes and deal with conundrums, not problems. Their net political effect is a tacit support of the present system.
> (Baer, p.35)

Baer's critical awareness is followed by an unresolved discussion of 'new ways' and 'issues' for 'radical artists' (pp.35–6), particularly for women: an opposition to works of art 'presented as a precious class of objects'; a focus on forms and work-processes generated 'internally' (related to 'the personal is political') rather than imposed by the external dominance of 'the art object itself' (with a 'special class of subjects'); 'new ways' that 'have political implications that bear on the sovereignty of the subject and the nature of self'.

In her response to the *Artforum* symposium question, Castoro had some of the same concerns as Baer:

> I think of myself as a container, and what I do as an eruption of what I am. Where do you get nourished? That's where you have something to do. The body of the octopus is full. Its tentacles need only be directed to the caverns of waiting mouths.
> (Castoro, *Artforum*, 'The artist and politics: a symposium', p.36)

The analogies of 'container', 'nourishment', 'full body' and feeding 'waiting mouths' became part of debates and practices informed by feminism during the seventies. In 1970 Castoro wrote of paintings as 'the manifestations of sexuality' (quoted in Lippard, *From the Center*, p.255), and she focused on issues of 'the self' – both as 'body' and, in Lippard's words, as 'an independent and ambitious woman in the art world'. These elements were part of the raw beginning of 1970s feminist debates such as those about essentialism (women's 'difference' as biologically determined) and social construction ('difference' as socio-cultural).

Baer's and Castoro's responses are examples of the burgeoning critiques that the women's movement was making – against what it saw as the rhetoric of power in existing art discourses connected by way of a market system to a white, male power élite. To a Modernist, these responses seem to be untheorized examples of special pleading. To someone within the women's movement, they demonstrate a new-found emancipation to express the 'personal as political'. The 'new ways' and the need for 'nourishment' are metaphors for representing the unrepresented; they could give an impetus to projects for establishing a productive feminist community, and for creating a revised pedagogy whereby such concepts as 'pleasure', 'desire', 'sexuality' and 'gender' were scrutinized. A major dilemma for many feminists was whether to focus critically on Modernist gendered abstraction – a signifying system in which they had become locked – or to establish an alternative signifying system that gave voice to their actual experience. Choosing the latter meant confronting the crushing power of the selective tradition and its institutions.

Making fantasies? Isn't that what artists do?

In order to expand this discussion, I want to look briefly at the third article in that issue of *Artforum*. It was by the editor of the journal, Philip Leider, and entitled 'How I spent my summer vacation or, Art and Politics in Nevada, Berkeley, San Francisco and Utah'. Unlike Fried's piece of professional criticism or the symposium responses, it reads more like a diary of an intellectual's contemporary concerns. Leider starts by charting his drive from Berkeley, California, to Nevada, together with Richard Serra (a sculptor) and Joan Jonas (a body artist) to see Michael Heizer's huge earthwork, *Double Negative* (Plate 87). Fairly quickly, there's talk of art, revolution and Abbie Hoffman. Leider recalls that 'revolution' was one of the words he came across most frequently during that summer of 1970. Significantly, though, the word was not used to mean the transfer of political power from one class to another, but had a more humanitarian meaning.

Leider's and Serra's discussion of 'what was the most revolutionary thing to do?' with respect to art had a similar edge. While Serra wondered whether contemporary events were forcing the emergence of a completely new set of ideas about what an artist was and what an artist did, Leider

> argued for Michael Fried's idea that the conventional nature of art was its very essence, that the great danger was the delusion that one was making art when in fact you were doing something else, something of certain value but not the value of art.
>
> (Leider, 'How I spent my summer vacation...', pp.40–41)

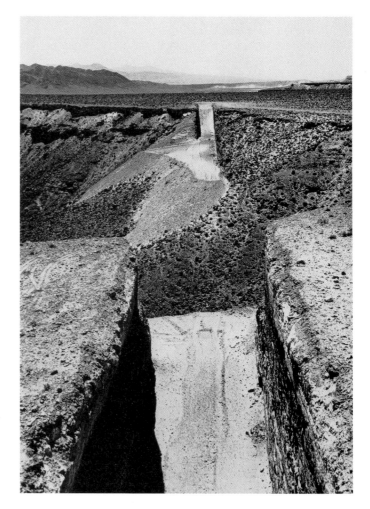

Plate 87 Michael Heizer, *Double Negative*, 1969–70, view looking from east to west, 9 x 458 x 15 m, with a displacement of 240,000 tons, Virgin River Mesa, Nevada. Reproduced by courtesy of Virginia Dwan.

He echoed this after they had all been greatly impressed by Heizer's *Double Negative* which 'shook hands' with the work of Barnett Newman (Plate 66), a leading Abstract Expressionist who died that summer. Leider recalled Newman's claim that his paintings, if understood, would mean the end of state capitalism: 'Maybe they did. Not many artists who dug Newman and [Clyfford] Still found those claims outlandish. About the people who traded in them, well that was another thing' (p.43). He and Serra were gloomy about the fact that 'everything is purchasable', and even if Heizer's piece had moved art a little more out of the system by resisting commodification, it was still backed by the galleries, by dealers and by art-world money.

This was also the case with the work central to the last event chronicled by Leider. He and the writer John Coplans (his deputy at *Artforum*) met Robert and Nancy Smithson in Salt Lake to see *Spiral Jetty* (Plate 84). Leider does not provide details of the work, but they are instructive. To make *Spiral Jetty*, 6,650 tons of material were moved, involving 292 truck-hours and 625 hours' work in total. Approximately $9,000 (not including the many administrative expenses) was spent on constructing the earthwork alone, by Virginia Dwan of Dwan Gallery, New York; and another $9,000 was provided by Douglas Christmas of Ace Gallery, Vancouver, and Venice, California, for a film of the work. Later Smithson traded a number of early works to these two dealers in return for the sole ownership of the *Jetty* and the film. Smithson was killed in an air crash in 1973. His widow maintains yearly payments of $160 on the twenty-year renewable lease that Smithson negotiated with the Utah Land Board for the ten-acre site. Since 1972 *Spiral Jetty* has been under water, as the level of the lake has risen. Smithson sold signed photographs of the *Jetty* to collectors (see R. Hobbs, *Robert Smithson*, pp.191–7). Leider recounts that the 'failure' of ecological groups came up in their discussion:

> The handwriting was on the wall for ecology, Smithson felt. 'All those sins. And here's 2000 coming so near. Sin everywhere. The dead river with its black oil slime. The crucified river instead of the crucified man. When do you think they'll start burning polluters at the stake?' … Smithson had been making fun of something I'd written about the 'ever deepening' political crisis. He thought there was a phoney moral urgency to the use of terms like that. 'Yeah,' he said balefully, 'the ever-deepening spiral of politics.'
>
> (Leider, 'How I spent my summer vacation…', pp.48–9)

Irony and detachment, the pursuit of individual work, and a pessimistic attitude to the status and function of art in contemporary culture and society: are these what are left to the 'ethical' artist who has to make deals with art-world money? Leider comments:

> Art is nature, rearranged. Like everyone else, Smithson learned it in High School. In a free society, artists get to rearrange nature just like everyone else, lumber kings, mining tsars, oil barons; nature, a kind of huge, placid Schmoo, just lays there, aching with pleasure. Smithson, reaching for his artistic birthright, kept turning up another kind of nature: 'The non-sites let you know about the entropy of the urban' … Art is also art rearranged, and *Spiral Jetty* does what it can … The piece was a fantasy. In the middle of Utah. Well, isn't that what artists do? Make fantasies?
>
> (Leider, pp.48–9)

Leider finishes with a list of events, including the fact that

> the Bay Area was leading the nation in draft resistance – 34 per cent someone said. But the issue kept coming up like a toothache … The ever-deepening spiral of politics. Just before I left, Smithson had given me a xerox of his lease on Rozel Point, for a souvenir.
>
> (Leider, p.49)

In the same year newspapers showed photographs of the US Forces' rearrangement of 'nature' in Vietnam with defoliants. One such 'earthwork' was an emblem, *a mile and a half long*, of the First Infantry Division (a pentagon with a '1' in the centre) bulldozed in the jungle, north-west of Saigon.

Political engagement

What about artists who advocated *active* political engagement? Consider the 'movement sisters' who picketed an exhibition of prints by Paul Wunderlich at the Phoenix Gallery in Berkeley, California. The gallery supported the anti-war movement, and at this time was also showing children's drawings, many by Vietnamese to whom all proceeds were donated; every half-hour there was a slide-and-tape presentation about the war, and movement literature was always available at the gallery. However, the 'movement sisters' saw the Wunderlich show (Plate 88) as morally indefensible:

> THEY SAY THEY'RE SELLING PICTURES TO SEND MONEY TO VIETNAM, BUT ALL THESE ARE, ARE PICTURES DRAWN OF A WOMAN BY A MAN. WE'RE TIRED OF BEING BODIES AND WE'RE TIRED OF BEING SOLD. WE'RE TIRED OF BEING LABELLED IN A NUDIE CUTIE ROLE. SO FOR ALL THESE MALE PRIG ARTISTS LET THIS NOW BE KNOWN: WE'RE GOING TO WIN THIS TIME. WE'LL MAKE THIS WORLD OUR OWN. FOR OUR SISTERS THAT WE'RE PAINTING, FOR THE WOMEN THAT THEY DRAW, WE'RE LETTING IT BE KNOWN WE WON'T BE SOLD ANYMORE. SOUTH-EAST ASIAN SISTERS DIE FROM BULLETS FROM THE GUN: MALE ARTISTS IN AMERICA DRAW WOMEN JUST FOR FUN. WE'LL WIN TOGETHER NOW, ALL WOMEN NOW ARE ONE.
>
> (quoted in Leider, 'How I spent my summer vacation...', p.42)

Perhaps better known than the protest of the 'movement sisters' was a poster by the Poster Committee of the Art Workers' Coalition (AWC). Published anonymously (though produced by Fraser Dougherty, Jon Hendricks and Irving Petlin), it used Ronald Haeberle's colour photograph from the My Lai massacre, which had been published in *Life* magazine. Overprinted were the words 'Q: And Babies? A: And Babies' (Plate 89), which were taken

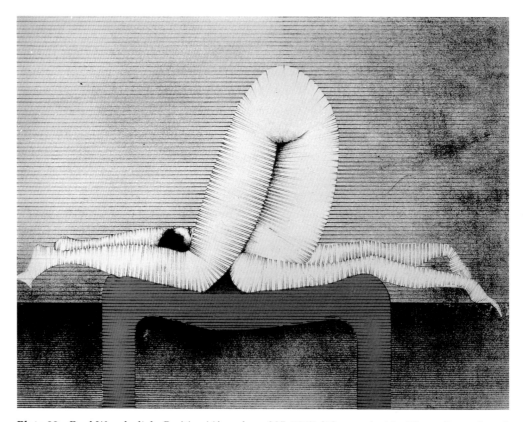

Plate 88 Paul Wunderlich, *Position 'A' work, no.305*, 1967, lithograph, 46 x 70 cm. Reproduced by courtesy of Edition Volker Huber, Offenbach am Main.

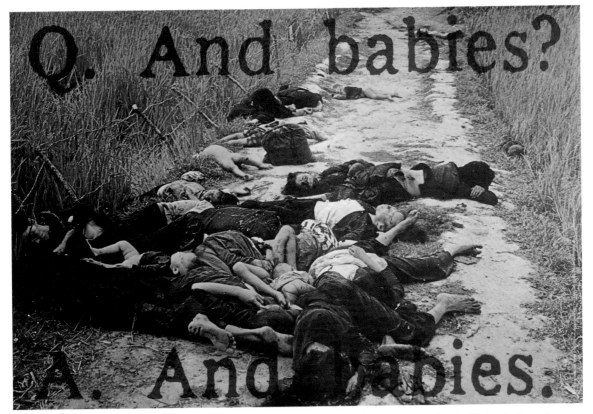

Plate 89 Ronald Haeberle (photographer) and Peter Brandt (supplier of paper), *Q: And Babies? A: And Babies*, 1970, offset lithograph printed in colour, 64 x 97 cm. Collection, Museum of Modern Art, New York; gift of the Benefit for the Attica Defense Fund.

from an interview by Mike Wallace with My Lai participant Paul Meadlo. Offset lithography was chosen to make the poster appear similar to high-quality mass-produced images. And the use of colour was striking in that war photography was conventionally printed in black and white. For the AWC the Haeberle photograph was both a vivid image of US violence and technically innovative. The poster was to have been distributed under the auspices of the Museum of Modern Art, New York, but the staff decision was over-ruled by William Paley, president of the board of trustees. On 8 January 1970 MOMA issued a statement, 'The Museum and the poster', in which arguments against MOMA's participation were stated:

> The Museum's Board and Staff are comprised of individuals with diverse points of view who have come together because of their interest in art, and if they are to continue to function effectively in this role they must confine themselves to questions related to their immediate subject.
>
> (MOMA, 'The Museum and the poster', p.3)

In response to this act of censorship, 50,000 copies of the poster were printed by the lithographers' union and distributed world-wide by informal art community networks. The AWC also staged two demonstrations in MOMA (Plate 90), with copies of the poster in front of Pablo Picasso's *Guernica*. Painted in 1937, *Guernica* was a pro-Republican commemoration of the bombing of the undefended Basque town by German aircraft in the Spanish Civil War. It was only on loan to MOMA until Spain returned to Republican democracy.

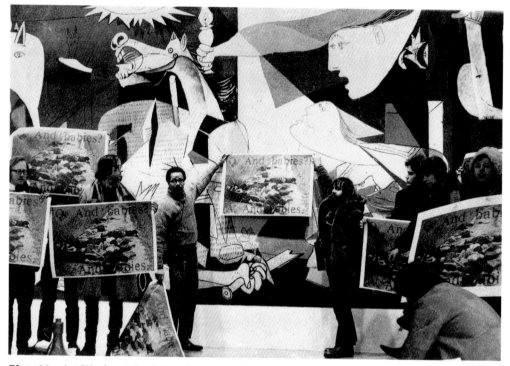

Plate 90 Art Workers' Coalition demonstration, 1970, in front of Pablo Picasso's *Guernica* at the Museum of Modern Art, New York. Photograph: Jan van Raay.

Plate 91 Rudolf Baranik, *Angry Arts*, 1967, offset lithograph, 54 x 44 cm. Courtesy of Rudolf Baranik.

Plate 92 Installation of *The Collage of Indignation*, 1967, 3 x 37 m, Loeb Students' Centre, New York University. Photograph: E. Tulchin.

A significant precursor to such action and production was Angry Arts Week (29 January–5 February 1967) organized in New York by Artists and Writers Protest. In his poster advertising the week (Plate 91), Rudolph Baranik used a 'quote' from *Guernica*. Some 600 artists took part in a series of dance, music, film, poetry and photography events which contributed to the growth of artists' anti-war movements. One of the largest components of the week was *The Collage of Indignation*, organized by critics (such as Ashton and Kozloff) and artists (Golub, Jack Sonenberg, Petlin, Dougherty, Spero, Baranik, Stevens and Phoebe Hellman Sonenberg) at the Loeb Students' Centre, New York University. Militantly against the war in Vietnam, it attracted hordes of visitors. Enormous, at 3 x 37 metres, *Collage* was a collaborative production by around 150 artists over five days (see Plates 92–94). Among them were the above and Frasconi, Matta, Petlin,

Plate 93 *The Collage of Indignation*, detail: panel by Roberto Matta and Irving Petlin. Photograph by courtesy of Angry Arts, New York.

Plate 94 *The Collage of Indignation*, detail: panel and platinum barbed wire by James Rosenquist. Photograph by courtesy of Angry Arts, New York. © James Rosenquist, DACS, London and VAGA, New York, 1993.

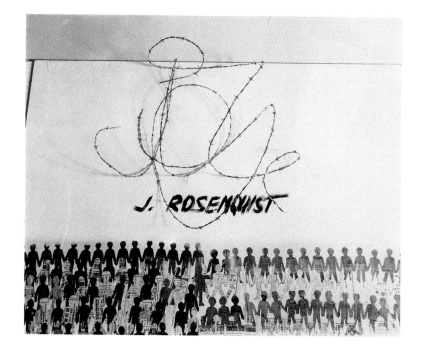

Graves, Rosenquist, Serra, Lichtenstein and di Suvero. The position, technique and effect of *Collage* are touched on in Leon Golub's contemporary commentary:

> Today art is largely autonomous and concerned with perfectibility. Anger cannot easily burst through such channels. Disaffection explodes as caricature, ugliness, or insult and defamation – the strong disavowal of intellectuals and artists (comparable to French protests about Indo-china and Algeria) … essentially the work is angry – against the war, against the bombing, against President Johnson, etc. The Collage is gross, vulgar, clumsy, ugly!
>
> (Golub, 'The artist as an angry artist', p.48)

The point is that in an art world that could produce Fried's 'Art and objecthood' and the works of Noland, Olitski and Caro – where problems of 'shape', 'form' and 'colour' dominate those of contemporary history – the collectivism of *Collage* and the terms 'gross, vulgar, clumsy, ugly' become strategies.

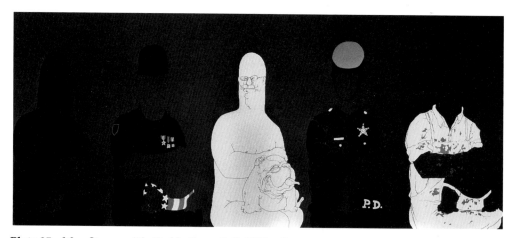

Plate 95 May Stevens, *Big Daddy Paper Doll*, 1968, oil on canvas, 198 x 426 cm. Collection of the artist. Reproduced by permission of the artist.

Plate 96 Nancy Spero, *Helicopters and Victims*, from *War Series*, 1967, ink and gouache on paper, 91 x 61 cm. Photograph by David Reynolds, reproduced by permission of the artist.

In his 1967 article 'A collage of indignation', p.249, Kozloff described the collage as 'this aesthetic wailing wall'. Several of the artists involved in it were, in their own work at this time, making explicit references to the Vietnam War with its atrocities and the use of napalm – Stevens, Spero, Baranik and Golub, for example (Plates 95 and 96). For others such as Serra, whose work was closer to Smithson's, participation in the collage was more a mark of solidarity against the war than a support for such 'realist' artistic themes.

A similar mix of artists had participated in the Los Angeles *Peace Tower*, organized by the Artists' Protest Committee in 1966; it was eighteen metres high and included 400 small panels of uniform size sent by artists from all over the world (Plates 97 and 98). Initiated by Irving Petlin and designed by sculptor Mark di Suvero, it was supposed to stand until the end of the war in Vietnam. Because of hostility from pro-war factions, the tower had to be guarded day and night; and it came down when the landlord of the rented site submitted to pressure and pulled out of the rental agreement. Participating artists included: Evergood, and Moses and Raphael Soyer, active social realists since the thirties; Reinhardt and Motherwell, both associated with Abstract Expressionism; Judd; and Nevelson, Hesse and Chicago, who became important in the women's movement.

What do these events tell us about artists' engagement with contemporary issues? For some artists there were dilemmas: consider, for example, Petlin's response to the *Artforum* symposium question. As we've seen, Petlin was a central participant in the *Peace Tower*, *The Collage of Indignation* and the AWC's My Lai poster (Plate 89). Committed politically, he said: 'It is the last sentence of the question [What is your position regarding the kinds of

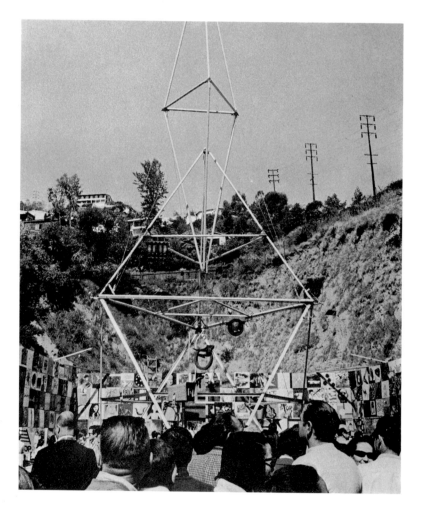

Plate 97 Los Angeles *Peace Tower* in construction, 1966. Photograph by courtesy of Mark di Suvero/Spacetime, and the Oil and Steel Gallery, Long Island City.

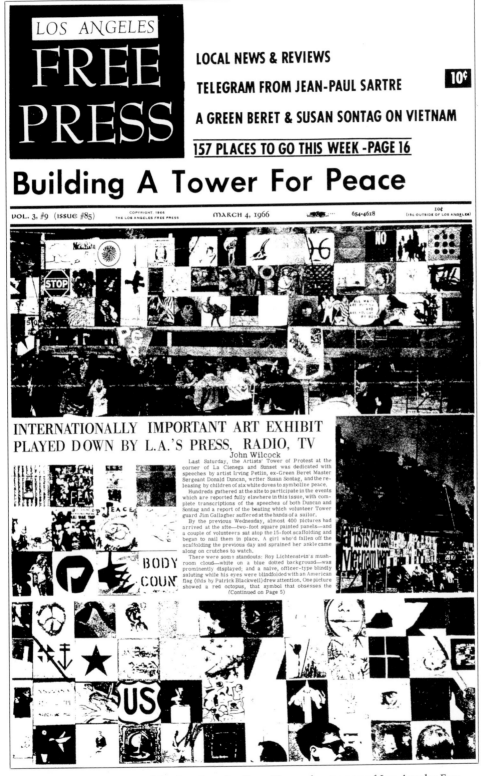

Plate 98 Press coverage of the Los Angeles *Peace Tower*: front page of *Los Angeles Free Press*, 4 March 1966. Photograph by courtesy of Mark di Suvero/Spacetime, and the Oil and Steel Gallery, Long Island City.

political action that should be taken by artists?] that seems unanswerable to me' (p.38). Why? One reason may be that most of Petlin's art work was less about overt political themes, more 'about the human condition in one form or another' (Petlin, quoted in Lippard, *A Different War*, p.34). Another is that while strongly advocating that artists and other workers should be active in political protests and consciousness-raising (which Petlin was, to great effect), he sees a difference between the making of art and its reception. In the latter, artists can act politically:

> There are no distinct boundaries between governmental cultural 'boosterism' and individual patronage. But where they are recognizable, artists should choose to withhold their work, deny its use to a government anxious to signal to the world that it represents a civilized, culturally centred society while melting babies in Vietnam and gunning down kids all over the States.
>
> (Petlin, *Artforum*, 'The artist and politics: a symposium', p.38)

Installations: oppositional art?

Installations that were perceived as anti-war and as 'political' range from James Rosenquist's *F-111* to Edward Keinholz's *The Eleventh Hour Final* and *The Portable War Memorial*. The Rosenquist was made up of 51 panels to be assembled along the wall(s) of an interior, in total measuring 3 x 26 metres (later reproduced as a 91 x 760 cm print) (Plates 99 and 100). In scale it evokes public murals, especially those on social and political themes produced during the WPA Federal Art Project of the 1930s (see Chapter 1) and by Mexicans in the USA (Plates 25, 26 and 129). Its imagery, too, provides a sixties version of many examples of thirties 'realist' paintings and murals on themes of US life. Here, the image of a new US Air Force supersonic, missile-carrying fighter-bomber runs the length of the work. But the image is fragmented both literally (into panels) and, from left to right, by images of: a hurdle; a huge Firestone tyre above a cut cake with flags identifying the nutritional ingredients ('food energy', 'protein', 'riboflavin', 'iron', etc.); three large light bulbs with the central yellow one looking like a cracked egg; a girl under a hairdryer in front of a

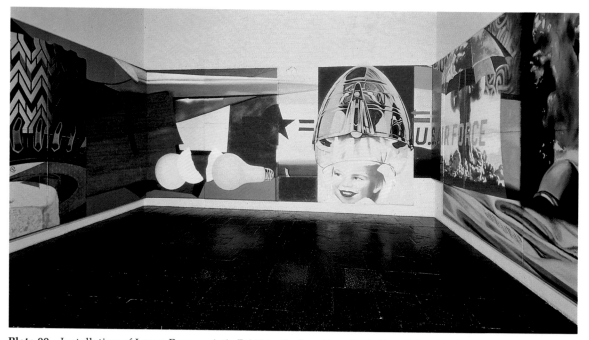

Plate 99 Installation of James Rosenquist's *F-111* in the Leo Castelli Gallery, New York, 1965. Photograph by courtesy of Leo Castelli Archives. © James Rosenquist, DACS, London and VAGA, New York, 1993.

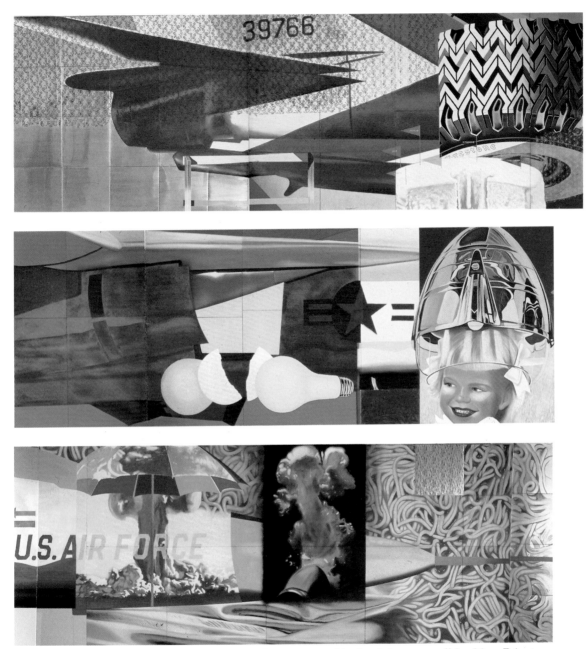

Plate 100 James Rosenquist, *F-111*, 1964–65, oil on canvas with aluminium, overall 3 x 26 m. Private collection. Photograph courtesy of Jeffrey Deitch. © James Rosenquist, DACS, London and VAGA, New York, 1993.

lawn painted in day-glo green; a beach umbrella left out in the winter with frost or snow on top in front of the mushroom cloud of an atomic explosion; an underwater swimmer wearing a helmet with an exhaust air bubble above; and canned spaghetti, which also appear behind the umbrella.

In an interview, Rosenquist claimed a link between Mexican muralists and the 'anti-style' (non-individualist) of US billboard painting traditionally associated with mass culture – everyday messages, icons, commercial style. In working with the signifiers of

these two systems of representation, *F-111* also had contemporary Cold War significance:

> When I was working in Times Square and painting signboards, the workmen joked around and said the super centre of the atomic target was around Canal Street and Broadway [part of downtown Manhattan's artistic community]. That's where the rockets were aimed from Russia ... The Beat people, like Kerouac and Robert Frank, Dick Bellamy, Ginsberg and Corso [protest poets and writers from the fifties], their first sensibility was of it [atomic war] being used immediately and they were hit by the idea of it, they were shocked and sort of threatened. Now the younger people are blasé and don't think it can happen. So this is a restatement of that Beat idea, but in full color.
>
> (Rosenquist, in G. Swenson, 'The F-111', p.599)

The notions of ideological forgetting and of modern consumerist alienation are central to Rosenquist's use of the F-111:

> It is the newest, latest fighter-bomber, at this time, 1965. This first of its type cost many million dollars. People are planning their lives through work on this bomber, in Texas or Long Island. A man has a contract from the company making the bomber, and he plans his third automobile and his fifth child because he is a technician and has work for the next couple of years. Then the original idea is expanded, another thing is invented; and the plane already seems obsolete. The prime force of this thing has been to keep people working, an economic tool; but behind it, this is a war machine.
>
> (Rosenquist, in Swenson, pp.589–90)

The man who makes the actual plane is, according to Rosenquist, 'just misguided ... snagged into a life', dominated by the conveyor belt of technology promising domestic economic prosperity and guaranteeing state power, both ideologically and as an actual imperialist war machine. The little girl, a daughter, 'is like someone having her hair dried out on the lawn, in Texas or Long Island'. The birthday cake (hers?) has flags which also 'mean flaming candles' and 'flags being planted out and staking out areas in life, like food, being eaten for energy'. At the heart of this angel food cake is a big hole, which Rosenquist says is 'from the core or mould used to bake those cakes. I always remember it as some kind of abyss.'

The possible powerful metaphors range from an automated capitalist technocracy, a normalized and eminently policeable 'free' life, to the Stars and Stripes being planted out in Vietnam with all its boost to arms manufacturers, to employment (in war industries and in the military) and to the rhetoric of anti-Communism. The USA's ideology of freedom is linked to a mechanism of oppression, at home and abroad. Rosenquist observes that 'the plane itself could be a giant birthday cake lying on a truck for a parade or something – it has even been used like that – but it was developed as a horrible killer' (the 'abyss' at the heart of modern commodities?). And, as with the atomic explosions at Hiroshima and Nagasaki and the bombing of Vietnam, the 'horrible killer' acts far away – far enough for someone with a Long Island beach umbrella to be so immune from the realities of a bright red and yellow atomic bomb blast that they see it as 'something like a cherry blossom, a beautiful view of an atomic blast'. This confusion of the natural and the 'man-made' is echoed by the underwater swimmer:

> His 'gulp!' of breath is like the 'gulp!' of the explosion. It's an unnatural force, man-made.
>
> I heard a story that when a huge number of bombers hit in Vietnam, and burned up many square miles of forest, then the exhaust of the heat and the air pressure of the fire created an artificial storm and it started raining and helped put the fire out. The natives [*sic*] thought that something must be on their side; they thought it was a natural rain that put the fire out but it was actually a man-made change in the atmosphere.
>
> (Rosenquist, in Swenson, p.599)

First displayed in April 1965, *F-111* filled the entire Castelli Gallery when installed as a four-walled room. Is it subversive to have such a work in the heart of one of the most

powerful US dealers, or is this another instance of a work caught in the system it seeks to criticize? In his attempt to address this paradox, Rosenquist originally intended to make the painting out of 51 panels to be sold individually. Each purchaser of each incomplete 'fragment' of *F-111*

> has already bought these airplanes by paying income taxes or being part of the community and the economy. The present men participate in the world whether it's good or not, and they may physically have bought parts of what this image represents many times … that's the joke – he would think he is buying art and, after all, he would just be buying a thing that paralleled part of the life he lives. Even though this picture was sold in one chunk [to Pop Art collector Robert Scull, for a reported $60,000], I think the original intention is still clear. The picture is in parts.
>
> (Rosenquist, in Swenson, p.597)

Rosenquist's statement indicates what he thought was possible in the existing dealer system without biting the hand that fed him. Certainly the 'joke' he talks of is compounded. Becoming operational in 1964–65, the F-111 had been produced after enormous military controversy and a Congressional investigation. Although a potentially alarming weapon and symbol of modern US technology, it had crashed and also cracked several times. Thus in 1965 the plane had a peculiarly hollow public image, a bit like the cake. Only later on in Vietnam and the Middle East (Arab–Israeli wars) was its portentous destructive power confirmed. The status and meaning of Rosenquist's *F-111* were hotly debated in artistic circles in New York in 1965. Eliciting bitter public controversy thereafter, the mural became a focal point once again when shown at the Metropolitan Museum in 1968. Some objected that it was not of the same calibre as the works by Titian and Velázquez in the museum; others tried to trivialize its politics. On the other hand, for Kozloff in *The Nation*, April 1968, the picture 'consciously or not replies to … [Picasso's] *Guernica* across the years' and 'maximizes the political implications of Pop art' ('Art', p.579); and for Dore Ashton in *Art in America* (January–February 1969), it was 'clearly a commentary on war and an assault on the art-for-art's-sake philosophy' ('Response to crisis in American art', p.345).

Lippard recalls that the Vietnam reference was taken for granted but was hardly mentioned in reviews. This may be a symptom of many responses to the Vietnam War. Even though historians agree that media coverage, especially on TV, was a major contribution to protests that eventually led to the ending of the war, there are inevitably powerful symbolic forces at play in 'images' of such conflicts. Even in 1992 a British survey by David Morrison, *Television and the Gulf War*, showed that many viewers wanted information on the Gulf War's progress, not its horrors; they preferred 'victory' to the truth. For many Americans the same was the case, as it had been with the Vietnam war.

Keinholz took this up in an installation from 1968, *The Eleventh Hour Final* (Plate 101). In a replica of a typical US living room, complete with furniture and *TV Guide*, is a television that has been set into a tombstone. On the screen we read:

<div align="center">

THIS WEEK'S TOLL

AMERICAN DEAD	217
AMERICAN WOUNDED	563
ENEMY DEAD	435
ENEMY WOUNDED	1291

</div>

These statistics are in front of the modelled horizontal head of a Vietnamese child, in the tube, staring out at the viewer. A cable from the TV to the remote control on the coffee table is an ambiguous umbilical cord: the envisaged person/viewer seated on the couch can see it either as a way of switching off the information (having had enough of the war's 'progress' or of its unpalatable human cost), or as a metaphor that demonstrates their responsibility as a citizen, going some way to revealing the horror in which they are

Plate 101 Edward Keinholz, *The Eleventh Hour Final*, 1968, mixed-media installation, 366 x 327 cm. Private collection, Cologne. Reproduced by courtesy of the artist.

implicated. The work is also a mark of Keinholz's own transformation. When in Los Angeles, he refused to join the production of the Los Angeles *Peace Tower* – identifying, as many did, with the working-class macho GI. By 1968 he, again like many others, had realized how much of an ideological fiction this identification was.

Keinholz's *The Portable War Memorial* from 1968 (Plate 102) is also an installation with, as in *F-111*, a prominently placed umbrella (this time an actual one). At the centre of the mixed-media work is a large blackboard in the shape of a giant tombstone, with the US eagle and the words 'A PORTABLE WAR MEMORIAL COMMEMORATING V__ DAY 19__'. The viewer fills in the gaps appropriate to whichever war is being considered. On the blackboard are the names of some 475 formerly independent countries. To the left is the Uncle Sam 'I Want You' recruiting poster illuminated by two lamps. In front, five soldiers raise

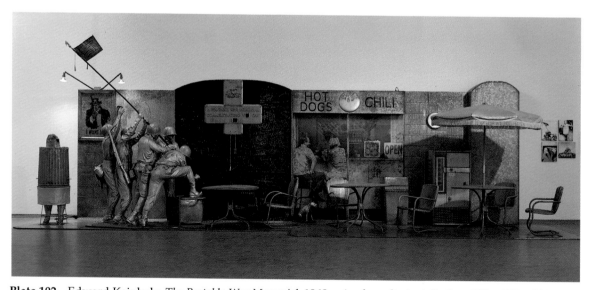

Plate 102 Edward Keinholz, *The Portable War Memorial*, 1968, mixed-media installation, 290 x 975 x 244 cm. Collection of the Museum Ludwig, Cologne. Photograph: Rheinisches Bildarchiv.

the US flag (actually a reproduction of it on a piece of cloth); they are about to place the pole in the central hole, designed for an umbrella, of one of the tables from this all-American diner.

The group of soldiers imitates a famous national image – the Iwo Jima photograph. In 1945 the Japanese and Americans fought a bloody battle for the island of Iwo Jima, eight square miles in the Volcano Islands in the Western Pacific. Of about 22,000 Japanese, 1083 survived; US casualties numbered 5931 dead and 17,272 wounded. Two of the fiercest battles were for Meatgrinder Hill in the north and the extinct volcano of Mount Suribachi in the south. A celebrated photograph of five marines raising the flag at the top of the latter became the basis for paintings, statues, millions of posters and a three-cent US postage stamp. Keinholz evokes the patriotic and propaganda significance of the Iwo Jima statue (in Arlington National Cemetery), which is 9.8 metres high with a bronze flagpole of 18.3 metres from which an actual flag permanently flies. The statue is inscribed 'In honor and memory of the men of the United States Marine Corps who have given their lives to their country since November 10, 1775'. In the Arlington grounds, military concerts and parades take place and many visitors picnic on the grass. In *The Portable War Memorial*, too, a couple, with their dog, eat while the flag is raised in their diner. They tuck into food produced from a 'meatgrinder' (hot dogs and chili) next to the names of the 'extinct' countries, while the Iwo Jima heroes raise a flag in a banal metaphor for the capture of the extinct Suribachi volcano. The several tragic ironies are added to by the significance of the year in which Keinholz made the work: in 1968 the Volcano Islands, where so many died in battle, were returned to Japan by the government of the USA.

Protest art and systems of power

One problem that art works encounter – whether they are installations, or 'protest' paintings such as Golub's (Plate 103) – is their relationship to the 'system'. Who are these works for, and how are they received? The problem is vividly put by Hans Haacke, who since the 1970s has established a reputation as a 'political artist' within the 'high art' system. In an interview in 1975, Mary Gordon asked him about 'artists whose paintings were very directly political statements in a poster-like fashion'. This was his reply:

> I sympathize with their feelings, but I'm not sure that the way some of them go about it in a rhetorical way is at the level at which their targets are operating.
>
> If you make protest paintings you are likely to stay below the sophistication of the apparatus you are attacking. It is emotionally gratifying to point the finger at some atrocity and say this here is the bastard responsible for it. But, in effect, once the work arrives in a public place, it only addresses itself to people who share these feelings and are already convinced. Appeals and condemnations don't make you think.
>
> (H. Haacke, in M. Gordon, 'Art and politics', p.8)

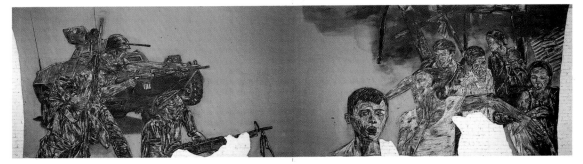

Plate 103 Leon Golub, *Vietnam, II*, 1973, acrylic on linen, 305 x 1219 cm. Photograph: David Reynolds. Courtesy of the Josh Baer Gallery, New York and the artist.

Lippard states that in the late sixties the bulk of US critics and artists were either politically naïve or, as with many of the Greenbergians, 'conservative' and 'pro-war'. On the other hand, several of those artists who made connections with the 'real world' were 'non US citizens ... or immigrants ... Takis who was Greek via Paris and Hans Haacke who was German ... [they] tended to be the most militant and the best educated politically although we came along fairly fast' (Lippard, in an interview with the author, 15 December 1990). Europe had a longer and deeper tradition of leftist activities and debates. Haacke's statement from 1975 echoes what Benjamin wrote in 'The author as producer' in 1934:

> Before I ask 'what is a work's position *vis-à-vis* the production relations of its time?', I should like to ask 'what is its position *within* them?'
>
> (Benjamin, 'The author as producer', p.87)

Benjamin cites the photomontages of John Heartfield, whose covers for the Marxist journal *AIZ* 'made the bookjacket into a political instrument' (p.94) because – as mass-produced images – they could not be commodified easily as 'works of art' with the 'aura' of creative individualism so prized by consumers of 'high art'. But even a Grosz painting that exposed hypocritical and corrupt bourgeois values of Weimar Germany was neatly framed and collected by the bourgeoisie themselves. To avoid such appropriation, Benjamin argued, 'authors' as 'producers' needed to combine three elements. The first was progressive 'technique': the dialectical relationship between 'form' and 'content' had to be at least on a par with the avant-garde in bourgeois culture. Second was 'politically correct tendency', in pursuit of a non-doctrinaire (i.e. non-Stalinist) socialism. And third was a subversive 'position' within the relations of production and, importantly, consumption (dealers, the market, museums, the careerism of critics, etc.). For Haacke, many 'protest paintings' failed to address the third requirement.

How did Haacke respond? In the sixties, his works (such as an incessant flow of news from a telex machine) had been concerned with technological, biological and social systems. In 1970 he was invited to participate in an international group exhibition at MOMA entitled Information (held June–September), 'curated by Kynaston McShine who was a young, incidentally black curator, which really was the most political show that the Museum of Modern Art ever had and probably ever will have' (Lippard, interview with the author, 15 December 1990). It wasn't intended to be 'political', but several participating artists started changing their pieces, with McShine's support, in response to contemporary events. Lippard recalls 'all hell was breaking loose': two months before the opening of the exhibition, US military forces bombed and invaded Cambodia – a country that had declared itself neutral in the Indo-China conflict. As we have seen, the wave of protest led to bloody state repression – at Kent State University, for example, and Jackson State College. Under the banner of the Art Strike, artists called for the temporary closure of museums as a gesture of protest. And on 'May 22nd, an outrage of 500 painters, sculptors and various kinds of art workers and others involved in New York's fragmented and often cloistered art world effectively shut down the Metropolitan Museum of Art' (T. Schwartz and B. Amidon, 'On the steps of the Met').

Haacke's 'installation for audience participation' (Plate 104) explicitly politicized his previous information/systems work. Visitors to the exhibition were given a ballot paper, at the entrance, colour-coded to indicate whether they were a full-paying visitor, museum member, holder of a courtesy pass, or visitor on Monday when admission was free (a concession to the AWC's demand for free admission). They then cast their paper into one of two transparent acrylic boxes, equipped with a photoelectric counting device, in response to the following printed on the wall:

> Question:
> Would the fact that Governor Rockefeller
> has not denounced President Nixon's
> Indochina policy be a reason for you not
> to vote for him in November?

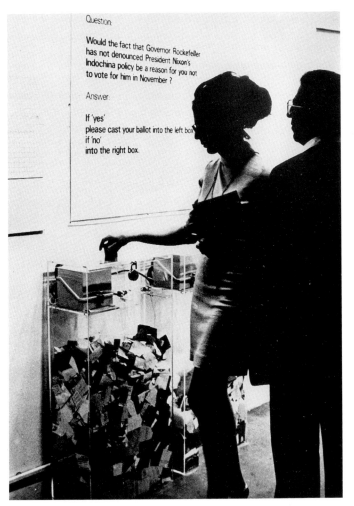

Question:

Would the fact that Governor Rockefeller
has not denounced President Nixon's
Indochina policy be a reason for you not
to vote for him in November?

Answer:

If 'yes'
please cast your ballot into the left box
if 'no'
into the right box.

Plate 104 Hans Haacke, *MOMA-Poll*, 1970, photograph from the exhibition Information, at the Museum of Modern Art, New York. Reproduced by courtesy of Hans Haacke and John Weber Gallery.

The question refers to Nelson Rockefeller, Republican governor of the state of New York, who was running for re-election in 1970. The Rockefeller family helped found and support MOMA, with Nelson a member of the board of trustees since 1932 (president, 1939–41; chair, 1957–58). In 1969 the Guerrilla Art Action Group had called for the resignation of the Rockefellers from the board because of their financial interests in companies such as Standard Oil and Chase Manhattan Bank. These and other Rockefeller companies were allegedly connected to the production of napalm, to chemical and biological weapons research, and to armaments, some of which were linked to the Pentagon. Among the 'information' resulting from Haacke's *MOMA-Poll* was:

Yes: 25,566 (68.7%)
No: 11,563 (31.3%)

Total participation in the work was 37,129, or 12.4% of the 299,057 visitors to
the museum during the exhibition.
(Haacke, 'Catalogue of works', p.86)

This work was to have been followed by an exhibition, Hans Haacke: Systems, at the Guggenheim Museum, New York in April 1971. Six weeks before its planned opening Thomas Messer, the director, cancelled the exhibition because Haacke refused to remove three works including the 'real estate' surveys that dealt with malpractice (Plates 105–107).

These consisted of maps of Manhattan marking the locations of properties owned by real estate partnerships and families, plus photographs of façades of these properties with documentation including financial and ownership details. The Shapolsky piece, for instance, details properties in the Lower East Side and Harlem rented out to two of the poorest communities in Manhattan – Puerto Ricans and African-Americans, respectively. Technically these were owned by seventy corporations that frequently sold and mortgaged the properties among themselves, to increase profits and avoid taxes; but the Shapolsky family had the largest holding. Harry Shapolsky appeared to be the key figure of the group, and he was described by the New York District Attorney's Office as 'notorious', as a 'front for high officials of the Department of Buildings' and of having 'ruthlessly exploited the shortage of housing space'. He had 'been indicted for bribing building inspectors [and convicted of taking] under-the-table payments from Puerto Rican tenants' in exchange for allowing them to rent property (Haacke, 'Catalogue of works', pp.92–97). These 'social systems' pieces – which specifically linked the workings of corporate capital, élite family interests and malpractice with the slum reality of deprived ethnic groups – were too much for the Guggenheim. Not only were these pieces political but, worse, they might be said to threaten the source of the Guggenheim's financial sponsorship. Messer wrote to Haacke on 19 March:

> … the trustees [of the Guggenheim] have established policies that exclude active engagement toward social and political ends. It is well understood, in this connection, that art may have social and political *consequences* but these, we believe, are furthered by indirection and by the generalized, exemplary force that works of art may exert upon the environment, not, as you propose, by using political means to achieve political ends, no matter how desirable these may appear to be in themselves.
>
> (Messer, quoted in 'Gurgles around the Guggenheim', p.249)

Plate 105 Hans Haacke, *Shapolsky et al. Manhattan Real Estate Holdings, a Real-Time Social System, as of May 1, 1971*, 1971, photograph of the installation. Two maps (photo-enlargements), one of the Lower East Side and one of Harlem, each 61 x 51 cm; 142 photographs of building façades and empty lots, each 25 x 20 cm; 142 typewritten data sheets, attached to the photographs and giving the property's address, block and lot number, lot size, building code, the corporation or individual holding title, the corporation's address and its officers, the date of acquisition, prior owner, mortgage, and assessed tax value, each 25 x 20 cm; six charts on business transactions (sales, mortgages, etc.) of the real estate group, each 61 x 51 cm; one explanatory panel, 61 x 51 cm. Reproduced by courtesy of Hans Haacke and the John Weber Gallery.

212 E 3 St.
Block 385 Lot 11
5 story walk-up old law tenement

Owned by Harpmel Realty Inc., 608 E 11 St., NYC
Contracts signed by Harry J. Shapolsky, President('63)
 Martin Shapolsky, President('64)
Principal Harry J. Shapolsky(according to Real Estate
Directory of Manhattan)

Acquired 8-21-1963 from John the Baptist Foundation,
c/o The Bank of New York, 48 Wall St., NYC,
for $237 600.- (also 7 other bldgs.)

$150 000.- mortgage at 6% interest, 8-19-1963, due
8-19-1968, held by The Ministers and Missionaries
Benefit Board of the American Baptist Convention,
475 Riverside Drive, NYC(also on 7 other bldgs.)

Assessed land value $25 000.- , total $75 000.- (includ-
ing 214-16 E 3 St.)(1971)

Plate 106 Hans Haacke, *Shapolsky et al.
Manhattan Real Estate Holdings, a Real-Time
Social System, as of May 1, 1971*; detail: one
photograph and a typewritten sheet.
Reproduced by courtesy of Hans Haacke and
the John Weber Gallery.

Plate 107 Hans Haacke, *Shapolsky et al. Manhattan Real
Estate Holdings, a Real-Time Social System, as of May 1, 1971*;
detail: map of the Lower East Side showing Shapolsky
properties. Reproduced by courtesy of Hans Haacke and
the John Weber Gallery.

Following the cancellation of the exhibition – and the firing of its curator, Edward Fry,
when he tried to defend the works – there was a large protest at the Guggenheim, and
over one hundred artists pledged not to exhibit at the museum 'until the policy of art
censorship and its advocates are changed'. Kozloff recalls that Messer

> had no objection whatsoever to showing abstract art. That would have been very typical
> … of a programme considered acceptable by art museums. This was violently contested
> by Donald Judd … who considered that for his work to be considered inoffensive was a
> great insult and his abstraction was certainly capable of political intonations.
> (Kozloff, in an interview with the author, 26 November 1991)

Attitudes: origins and cultural difference

We've been considering works from the late 1960s and early 1970s, examining the extent to which they were critical of the political system. To pursue this we need to place the issues in the broader post-war context. For many artists, questions raised by the civil rights movement and the Vietnam War (or, in Europe, by '1968' with its abortive 'revolutions') could be connected to more general critiques of power – state, institutional and patriarchal. Such questions could be traced back to the political settlement made after the Second World War. Looking back, commentators such as Frederic Jameson see the post-war period as characterized by an emergent social order of late capitalism, with new formal features in culture. He writes of

> what is often euphemistically called modernization, post-industrial or consumer society, the society of the media or the spectacle, or multinational capitalism. This new moment of capitalism can be dated from the post-war boom in the United States in the late 1940s and early '50s or, in France, from the establishment of the Fifth Republic in 1958. The 1960s are in many ways the key transitional period, a period in which the new international order (neocolonialism, the Green Revolution, computerization and electronic information) is at one and the same time set in place and is swept and shaken by its own internal contradictions and by external resistance.
> (F. Jameson, 'Postmodernism and consumer society', p.113)

It is generally agreed that the heritage of the pre-war Left, with various commitments to 'aesthetics and politics', was transformed by the early effects of Cold War policies and propaganda (from the late 1940s onwards) which isolated and contained reform movements. While one effect of the Second World War was to redraw maps both geographically and intellectually, another was to alter the grounds of choice, politically and aesthetically, in *different* ways in Europe and the USA respectively. A major aim of this section will be to consider these differences.

Cultural difference and the 'American experience'

Some of these differences were clear, others muddy and contradictory. We can begin, though, with the following distinction. Europe, ravaged by the war, rebuilt its social, economic and cultural infrastructure while still engaged in political debates and struggles informed by the Left in general and Communism in particular. The strength and importance of the Communist parties (PCF in France, PCI in Italy), at least until 1954, attest to the latter. In the USA, on the other hand, such political options were circumscribed by a combination of neo-conservatism (policed, for instance, by the Committee on Un-American Activities, which was anti-Communist) and the economic and ideological interests of a country whose industrial base was able to move from a war footing to a promise of almost endless consumerism. 'Americanization' became a buzz word: for its supporters, it legitimated 'free-market' forces; for its critics, it identified the US imperialist economic and ideological colonization of Western Europe and 'Third World' countries. But this was not just a simple 'either/or': there was strong ambivalence about America and the 'American experience'. For instance, Adorno – who together with many of his Frankfurt School colleagues lived in the USA from the late thirties until the early fifties as an exile from Nazism – claimed 'that any contemporary consciousness that has not appropriated the American experience, even if in opposition, has something reactionary about it' ('Scientific experiences of a European scholar in America', pp.369–70).

One aspect of the American experience was the production of consumerist and imperialist ideologies feeding on a newly found economic and cultural power. In 1948 Greenberg claimed, as we saw in Chapter 1, that European artists had 'declined so grievously' because 'the general social premises that used to guarantee their functioning

have disappeared'. On the other hand, the 'level of American art has risen in the last five years' so much that 'the conclusion forces itself … that the main premises of Western art have at last migrated to the United States, along with the center of gravity of industrial production and political power' ('The decline of Cubism', p.369). Greenberg makes an explicit correlation between artistic issues and political conditions. For him the supremacy of European art, as the highest form of culture, has been replaced by the works of Americans, later to be labelled Abstract Expressionists, who have assumed the mantle of Western civilization.

The 'five years' up to 1948 were a period of war-induced rhetoric and prosperity. US cultural aspirations were expressed in, for example, reviews of Pollock's first one-person show, which was held at Peggy Guggenheim's Art of This Century Gallery in 1943. In *Art News* we read, '[Jackson's] abstractions are free of Paris [and] contain a disciplined American fury' (quoted in S. Naifeh and G. White Smith, *Jackson Pollock*, p.466). Greenberg attributed national characteristics to Chagall ('French'), Feininger ('German') and Pollock ('American') (*The Nation*, 27 November, p.621) in order to identify a distinct and novel American style. Between 1942 and 1946 the GNP of the US rose 66 per cent, share prices by 80 per cent and much of the population saw its income rise markedly. The demand for consumer durables and luxury goods increased dramatically in the mid-forties with a boom for commercial galleries. (For some galleries there was a 300 per cent rise in sales between 1940 and 1946: see D. Robson, 'The market for Abstract Expressionism'.) The export value, alone, of French art to the US rose from 317,600 new francs in 1938 (a third of the French export market share) to nearly 6 million in 1953 (just over half), and to over 59 million in 1963 (about 40 per cent). (See R. Moulin, *Le Marché de la peinture en France*, p.372.) For many French critics at the time, this wasn't an importation of French values into the USA but evidence of US imperialist appropriation in a Cold War process that provided the title for a major book by Serge Guilbaut – *How New York Stole the Idea of Modern Art: Abstract Expressionism, Freedom and the Cold War*.

Greenberg's juxtaposition of optimism about American Art and its 'industrial production and political power' is paralleled in *Life* magazine of 8 August 1949. This issue contains a double-page colour spread in which three of Pollock's works are reproduced, plus a full-length photograph of the artist (see Plate 108). And in the title of the spread, 'United States' could be taken to mean 'Western World', given Greenberg's claim of the previous year. A double-page spread in the same issue, with a layout very similar to that of the Pollock spread, presents the other half in Greenberg's correlation: 'Arms for Europe: The top brass of the US comes up with a program to defend Europe with revitalized European armies' (Plate 109). This spread is in black and white, which is conventional for military photography. The text discusses 'a new concept in US military thinking' by the chiefs of staff of the US Army, Navy and Air Force:

> Joining with Secretary of State Dean Acheson in the opening debate on President Truman's $1.4 billion program for military aid to back up the Atlantic Pact, they told the US that there was an immediate way – militarily – to contain Communism. They added that time was wasting. Said Acheson, 'When political aggression fails, totalitarian regimes often are tempted to gain their objectives by military means…'

> Behind the thinking of the military was the contention that … To force a quick crossing [of the Rhine], Russia would have to concentrate her armies so that her 1,000-mile supply lines would be vulnerable to tactical air attack and her Rhineside concentrations of men and material to destruction by US atomic bombs [the map shows three atomic bombs exploding over 'enemy concentrations' on the Rhine].
> (*Life*, 8 August 1949, p.26)

The dropping of atomic bombs on Hiroshima and Nagasaki ensured that the USA had a military and psychological superiority immediately after the war. This superiority was reinforced by the USA's role in the armistice negotiations with Germany and Japan, and in

Plate 108a Layout of *Life* magazine, 8 August 1949, pp.42–3, 'Jackson Pollock: Is he the greatest living painter in the United States?'; (a) *Summertime Number 9A (1948)*, (b) *Number 12 (1948)*, (c) *Number 17 (1948)*.

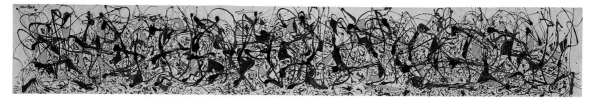

Plate 108b Jackson Pollock, *Summertime Number 9A (1948)*, 1948, oil, enamel and house-paint on canvas, 85 x 550 cm. Tate Gallery, London. © 1992 Pollock-Krasner Foundation, ARS, New York.

the Western Allies' conferences. The US dominated the way in which the Allies perceived the intentions of the USSR, thus establishing an era of imperialism in the early Cold War years. Many writers and politicians in the USA saw their country as the political and cultural centre of Western 'democratic' power, the heart of industrial production and the guardian of those cultural values enshrined in European civilization until the rise of Fascism. This cultural perception had an economic basis too. The Marshall Plan, announced in 1947, was the popular name for the US-sponsored European Recovery Program designed to rehabilitate the economies of European nations. The USA feared that the popularity of left-wing or communist parties (for example, the Labour Party in Britain, the PCF in France and PCI in Italy), coupled with the material and ideological reconstruction of European countries, would lead to the proliferation of Communist-dominated or Communist-friendly governments in Western Europe. In the four years from 1948, the Economic Cooperation Administration (ECA) distributed some $12 billion of economic aid. This was used for industrial and agricultural production, the expansion of trade and 'financial stability'. Arguably, the existence of this aid led to fatal compromises

Plate 109 *Life* magazine, 8 August 1949, pp.26–7, 'Arms for Europe: The top brass of the US comes up with a program to defend Europe with revitalized European armies'. Courtesy of *Life* magazine © Time Inc./Katz.

by the post-war Left, which acquiesced in a revitalization of the capitalist system in post-war Europe. Working together under the Organization for European Economic Cooperation, the sixteen nations (plus West Germany) that were receiving ECA funds saw a rise in their gross national products of 15 to 25 per cent during the period. President Truman extended economic intervention to developing countries throughout the world under the Point Four Programme, begun in 1949. This has been much criticized for renewing the capitalist exploitation of 'Third World' countries during this period.

While aid was being distributed abroad, in the USA there was considerable domestic speculation and investment in the cultural symbols of power and prosperity. In the period after 1950, we see both the consolidation of the USA as a new type of state power, and a boom in culture ranging from the expansion of 'high art' to the influence of Hollywood movies. There was also a refinement of a self-managing artistic discourse characterized by claims for aesthetic value, autonomy and self-purifying criticism, epitomized by Greenberg's 'Modernist painting', first broadcast world-wide in 1961 as a radio programme for the USIA's Voice of America. 'Political art' of the thirties and forties was out, abstraction and a US canon (as distinct from the supposedly declining European art) was in. This was riding on the back of 'boosterism'. Between 1950 and 1977

> a minimum grand total of $561,700,000 has been committed to the construction of at least 10.2 million square feet of total space at 123 American art museums and visual arts centers; more than a third of that (3.5 million square feet) comprises gallery space. Taking the figure of 750,000 square feet for the total size of the Louvre, one can calculate that the total square footage is the equivalent of 13.6 Louvres or, to make a more parochial comparison, the equivalent of 1,643.7 football fields.
>
> (K.E. Meyer, *The Art Museum*, p.271)

Even by 1955,

> the art world was being rocked by cataclysmic change. Record prices, proliferating
> galleries, media coverage, and postwar prosperity were producing a new generation of
> young collectors and reshaping the art market into something rich and strange and unrec-
> ognizable. In December 1955, *Fortune* magazine announced that art works had become
> much more than mere status symbols; these were now first-rate investments ... the works
> of living artists were by far the best buy – 'investments for the future', *Fortune* called them.
> For a mere $500 to $3,500, a 'tyro collector' could buy the paintings of artists like de
> Kooning, Rothko and Pollock, and get in on the ground floor of the international boom.
> (Naifeh and White Smith, *Jackson Pollock*, p.763)

As a result of this boom, many art museums and corporate collections were founded
between 1940 and 1980. Of the 198 art museums in existence in 1980, 67 per cent had been
founded in that forty-year period. Of the 99 corporate collections in existence in 1980, 93
per cent had been founded in those forty years; 76 collections were founded in the 1960s
alone (see D. Crane, *The Transformation of the Avant-Garde*, p.6). Naifeh estimates that there
were 73 serious galleries in New York in 1945; 123 in 1955; 246 in 1965; and 287 in 1970.
And 'Across the nation, the number of galleries had risen at least five-fold since the end of
World War II' (*Culture Making*, pp.81–2). This was matched by the increase in prices paid
for paintings, though those for Abstract Expressionist paintings only took off in the fifties.
For instance, in 1950 Pollock's *Number 1 (1948)* (Plate 3) was sold by the Betty Parsons
Gallery to MOMA for $2,350; in 1957 the Metropolitan bought *Autumn Rhythm* (Plate 58) for
$30,000, and in 1961 Greenberg wrote of a Pollock having recently been sold for $100,000
in New York (by 1955 a Matisse could fetch $75,000; works by Kandinsky, Klee and Léger
$8,000–10,000). By 1961, this market success was accompanied by an *American* reputation:
Pollock was 'not only an original artist, but a culture hero – in European eyes the first and
only genuine American culture hero since Walt Whitman' (Greenberg, 'The Jackson Pol-
lock market soars', p.42). As with the previous 'boom', this one was primed by war – in
this case the Korean War (1951–53), with its economic as well as ideological payoff.

What were the relationships between such developments in the discourses and insti-
tutions of art and those of the Cold War? If we take Paris and New York as case studies,
how did this period of 'reconstruction' and 'reformism' affect possibilities for a 'political'
art? The dilemma for many artists and intellectuals on the Left in the USA was vividly put
in 1947 by Dwight MacDonald in 'Truman's doctrine: abroad and at home':

> In terms of 'practical' political politics we are living in an age which consistently presents
> us with impossible alternatives [i.e. between Stalinism and Truman's liberal-democratic
> conservatism] ... It is no longer possible for the individual to relate himself to world poli-
> tics ... Now the clearer one's insight, the more numbed one becomes.
> (D. MacDonald, quoted in Guilbaut 'The new adventures of the avant-garde in America', p.70)

In Europe the alternatives were differently perceived.

Paris, 1947–54

After the war, there was a discourse on *l'homme* in many parts of the ideological spectrum
in France (women were subsumed under the term 'man', without recognition of any dif-
ferences). The participants ranged from the conservative apologists for national culture (a
legacy of the anti-modernist and xenophobic Vichy government) to the defenders of a
reconstruction of culture and society under the principles of the French Communist Party,
the PCF. The positions included philosophical texts on existentialism, one version of which
was propounded by Jean-Paul Sartre who was still indebted to the Marxist tradition.
Another version was Camus's more conservative humanism; and this was attractive to
liberal intellectuals, who defended *one* aspect of inter-war modernism – the emphasis on
the autonomy of individual practice as the authentic expression of modern experience

(often thought of as quintessentially French). One reason for the dominance of this discourse was that, as in the years immediately after the First World War, there was an urgent debate about how society could be reconstructed so that the 'mistakes' of the pre-war period would not be repeated.

Often, though not invariably, artists adopted practice according to their position on the ideological or political spectrum. However, artists in the PCF, and those such as the Surrealists who were explicitly critical of the Communist Party, attracted the most public attention. One influential public figure was Fernand Léger, who had spent time in New York during the war. On his return to France he joined the PCF, in 1945, and set up his own teaching school. Another influential figure was Picasso, who had remained in Paris during the Occupation and who joined the PCF in October 1944. However, the leading figures celebrated in the party were Boris Taslitzky and André Fougeron.

Realism and the PCF

In 1946 Taslitzky, who had been interned as a Communist Jew during the war, exhibited *The Little Camp at Buchenwald* (Plate 110) in the Art et Résistance exhibition in Paris. This was organized by cultural leaders of the Resistance to celebrate artistic opposition to the German Occupation and to the collaborationist Vichy government. Many artists contributed, including Picasso who showed his monochrome of a charnel house – the house or vault in which dead bodies or bones are piled (Plate 111). Taslitzky's charnel house is specific to Buchenwald, Picasso's a more anonymous place, though both coincide with the contemporary horror as news of the camps became known and as survivors arrived by train in Paris. The two paintings illustrate how artists might use different traditions to deal with the same contemporary subjects and themes. For Taslitzky, echoing a vividly coloured nightmarish combination of El Greco, Goya, Grosz and Dix, the tradition of Realism from the nineteenth century to Weimar Germany is central. Picasso, on the other hand, draws upon the legacies of Cubism and Surrealism, as represented by his own *Guernica* of 1937 (Plate 13).

By 1947 Taslitzky's practice, exemplified by *The Delegates* (Plate 112), had become consistent with the ideas and pictorial means advocated by the Soviet Union. In 1934 in Moscow, Stalin's cultural theorist Andrei Zhdanov had announced the Stalinist (as distinct from Marxist) doctrine of Socialist Realism. This remained official Communist Party policy until the dissolution in 1956 of the Cominform (Communist Information Bureau) which was set up in September 1947 in response to the launching of the Marshall Plan in the previous June. The doctrine of Socialist Realism vulgarized the theories of Marx and Engels and was opposed to all forms of modernism (including those informed by Marxism) such as Surrealism, the avant-garde in post-Revolutionary Russia, and practices indebted to the writings of Bertolt Brecht, Walter Benjamin, etc., such as Heartfield's political photomontages.

For Socialist Realists, claims for 'art for art's sake' or 'autonomy' were the decadent preoccupations of bourgeois aesthetes who had sold out to capitalist culture (then perceived as centred in the USA). Hence, for the PCF, engaged art was art that equated 'realism' with exposing both the evils of the capitalist system and the interests of imperialism and war. There were substantial critiques of this doctrine from *within* the Marxist tradition – from the Frankfurt School and from the exiled Bolshevik Leon Trotsky. Trotsky, like Brecht and Benjamin, saw that Stalinism and the doctrine of Socialist Realism had made a caricature of the Marxist 'base and superstructure' model. Marx and Engels had argued that there was an inevitable relationship between the economic base of a society and the superstructure (for example, art, literature, religious beliefs, the legal system). They did not argue, however, that there was an automatic cause and effect between changes in the economic base and manifestations in the superstructure. They insisted that there was

Plate 110 Boris Taslitzky, *Le Petit Camp à Buchenwald* (*The Little Camp at Buchenwald*), 1945, oil on canvas, 300 x 500 cm. Musée National d'Art Moderne, Centre Georges Pompidou, Paris. © ADAGP, Paris and DACS, London, 1993.

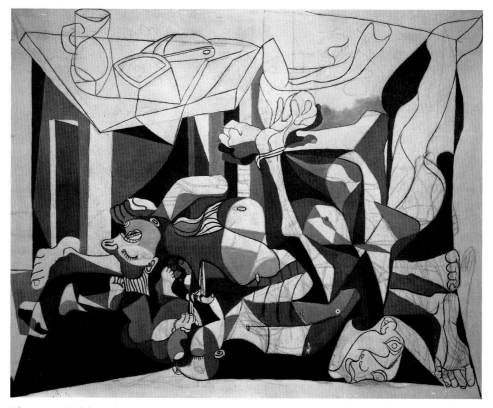

Plate 111 Pablo Picasso, *Le Charnier* (*The Charnel House*), 1944–45 (dated 1945), oil and charcoal on canvas, 200 x 250 cm. Collection, Museum of Modern Art, New York; Mrs Sam A. Lewisohn Bequest (by exchange) and Mrs Marya Bernard Fund in memory of her husband Dr Bernard Bernard and anonymous funds. © DACS, 1993.

mediation and contradictory interaction. Stalinism, on the other hand, transformed Marxist ideas into a perverted doctrine. Here the 'base and superstructure' model was reduced to a crude reflectionist process. By arguing that the capitalist economic base inevitably produced decadent art and literature, an unequal system of justice and so on, Stalinists could claim that a Soviet art and literature that heroized workers, and glorified collective farms (Plate 10) inevitably confirmed the existence of a truly socialist economic system. This was of course false, and the product of totalitarian ideology backed up by secret police and gulags. Many artists and intellectuals on the Left in Europe and the USA looked to theorists and commentators who could see through the Stalinist haze, back to the writings of Marx. The Surrealists in France and those in the USA, for whom *Partisan Review* after December 1937 (post-Popular Front) was a focus of Marxist culture of sorts, turned to the writings of Trotsky.

Trotsky argued for the relative autonomy of art. However, this did not mean that he advocated 'art for art's sake', which in his view would lead to artists' producing idealized commodities. For him progressive art had *ultimately* to be rooted in 'real life'; this was in contrast to the state's or ruling-class's way of determining people's lives and beliefs, through a variety of means in totalitarian or capitalist societies. Many artists in the PCF such as André Fougeron, and intellectuals such as Louis Aragon, would not have disagreed with Trotsky's views in principle, though politically they would not have allied themselves with his name. Those artists in France who regarded Realism as a strategy in the service of the working class did not claim that their art could be judged apart from the 'laws of art'; for them the issue was how 'art' was defined as historically specific rather than as an absolute that transcended historical circumstances. They certainly regarded abstraction as compatible with lies, hypocrisy and the spirit of conformity, as Brecht had in the thirties in 'On non-objective painting'. Claims for artistic autonomy and the disinterested nature of aesthetic experience did not seem appropriate to their new post-war situation; social realism did. So, too, did an attitude of direct intervention.

Plate 112 Boris Taslitzky, *Les Délégués* (*The Delegates*), 1947, oil on canvas, 114 x 197 cm. Collection of the artist, Paris. © ADAGP, Paris and DACS, London, 1993.

Fougeron started a controversy at the Salon d'Automne of 1948 with his *Parisian Women at the Market* (Plate 113). His strategic intervention began *La Bataille Réalisme– Abstraction* ('The Battle between Realism and Abstraction'), which was to dominate the discourse on art and politics until 1953, fuelled by the powerful Communist press. Fougeron's painting evokes the Renaissance tradition, but instead of the celestial light of religious figures, the dark shadows on the faces of working-class women in a poorly stocked market convey the experience of wartime shortages continuing in peacetime. In responding to the painting, the bourgeois press attacked what they regarded as the con- servative and unsophisticated technique and the social depiction of food shortages for ordinary people. For the party, as represented by Aragon, Fougeron's work was the reproduction of real life and a critique of the corrupting 'silence' and 'cancer' of modern abstract art (see the preface to *Dessins de Fougeron*, 1947, in Aragon's *Écrits sur l'art moderne*, pp.70–71).

In the same year that Fougeron's painting inaugurated 'The Battle between Realism and Abstraction', other artists such as Léger were working on themes with contemporary messages – for example, *Leisure Activities: Homage to Louis David* (Plate 114). This painting raised issues of tradition, nationalism and the legacy of the Popular Front's pre-war leisure programmes for workers. Here they are referenced to Jacques-Louis David (1748– 1825), whose paintings were symbolic of revolutionary Republicanism and of the 'classic' as public art. The 1948 exhibition of David's work, celebrating his bicentenary, contributed to revisions and reviews of the 'classic' and 'nationalism' under Vichy. The early 1940s under the occupation were characterized by, among other things, a discourse against modernity, where xenophobia, anti-Semitism and anti-Communism were combined. A self-conscious 'cleansing' after Vichy, by means of references to David, partly explains why Léger's *Homage* was shown in his own retrospective in 1949.

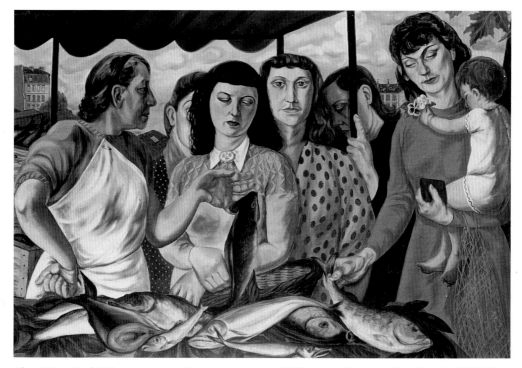

Plate 113 André Fougeron, *Les Parisiennes au marché* (*Parisian Women at the Market*), 1947–48, oil on canvas, 130 x 195 cm. Collection of the artist. Photograph by courtesy of Galerie Jean-Jacques Dutko. © DACS, 1993.

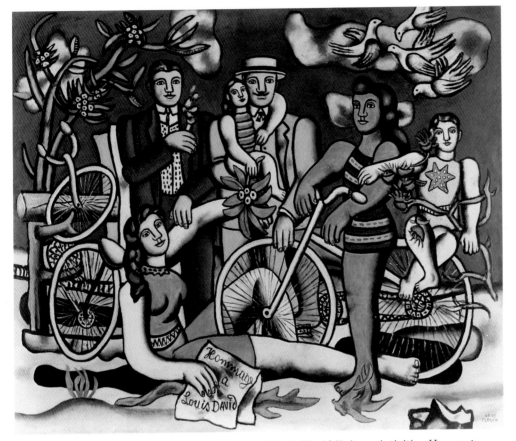

Plate 114 Fernand Léger, *Les Loisirs: Hommage à Louis David* (*Leisure Activities: Homage to Louis David*), 1948–49, oil on canvas, 154 x 185 cm. Musée National d'Art Moderne, Centre Georges Pompidou, Paris. © DACS, 1993.

By the time that the Cominform was set up in September 1947, it was clear that in France the PCF had fully embraced Socialist Realism, with theoretical support from the translation of Zhdanov's writings into French. This led to the prominence of social themes in cultural output: workers' strikes, including the confrontation between the miners and the government in 1947 and 1948; and protests against French colonial and imperialist interests in Indo-China and the subsequent war that ended in 1954. Importantly, it was not only the PCF who were engaged with the latter protests. In 1947 the Revolutionary Surrealists published *Liberté est un mot Vietnamien* ('Freedom is a Vietnamese word'), critical of French imperialism, and *Rupture inaugurale* ('Inaugural rupture'), reasserting their Trotskyism in the face of the PCF's adherence to Zhdanovism and Moscow. This obviously led to difficult decisions for artists in the PCF.

La Bataille Réalisme–Abstraction

It is hard to recapture the passion and commitment that artists felt when having to make choices in those years of intense political, social and cultural struggle. Taslitzky, for instance, recalled that the battle between Realism and Abstraction was so violent that artists from each faction had to avoid each other by crossing the street. For many, the PCF represented the only collective hope for establishing socialism and a genuinely egalitarian reconstruction. Artists such as Jean Dewasne, close to the PCF, saw their abstractions as

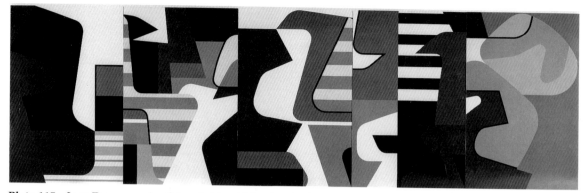

Plate 115 Jean Dewasne, *Apothéose de Marat* (*Apotheosis of Marat*), 1951, 'glycerophtalique' painting, five panels, each 250 x 167 cm. Musée National d'Art Moderne, Centre Georges Pompidou, Paris. © DACS, 1993.

furthering the cause of the working class (see Plate 115, a homage to a famous painting by David from the French Revolution). Others, such as Pierre Soulages (Plate 116), were associated with a more generalized modernist progressiveness.

Aragon, the main advocate of 'realism', attacked those on the Left who expressed humanitarian sentiments but would not commit themselves to the party. In the first editorial for *La Nouvelle Critique*, December 1948, he called Sartre, Mauriac, Blum and Malraux 'rummagers in dustbins'. And, according to Françoise Gilot, when André Breton returned from exile where he had been broadcasting for the Voice of America, he refused to shake Picasso's hand when meeting for the first time after the war. For Breton, Picasso's joining the PCF in 1944 was a betrayal of the Surrealist pro-Trotskyist critique of the PCF in the 1930s. Picasso's reply was that remaining in France during the Occupation had changed the nature of political choice for him, as it had for Paul Éluard (F. Gilot and

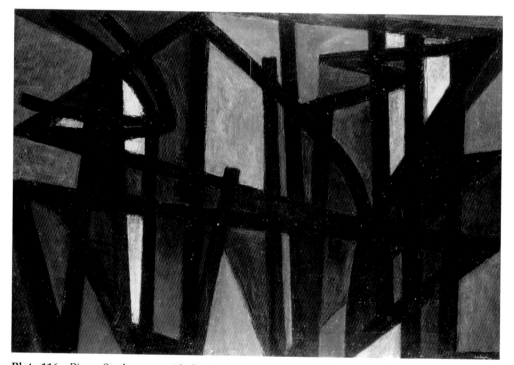

Plate 116 Pierre Soulages, untitled, 1949, oil on canvas, 130 x 198 cm. Private collection. Photograph by courtesy of Christie's.

C. Lake, *Life with Picasso*, pp.132–3). The need for *collective* action had become urgent, and the PCF had the best credentials among those who had actively fought in the Resistance.

What do we learn about the relationship between art and politics produced within the specific conditions and relations of post-war France? Let's look at 1951, when the effectiveness of the PCF was most pronounced. In the previous year Fougeron had produced some forty paintings, drawings and related studies engaged with the miners' struggles with the government. He exhibited them in 1951 in Bernheim-Jeune, a historically prestigious Parisian gallery with whom he had a contract. Such was the support for the miners' cause (the situation was similar to that of the Coal Strike in the UK in 1984–85) that some 50,000 people visited the exhibition when it was in Paris, and a higher number when it was taken around France. The main theme of these paintings was the post-war conditions of miners and the violent suppression of their protests by government agencies. While coal production was doubling, there was a grave deterioration in working conditions and a reduction in miners' purchasing power. With severe economic instability in 1947, thousands of miners went on strike; in the following year, in October, there was an eight-week strike. The government's response was to call for economic 'realism', for *Charbon à bas prix* ('low-priced coal'), while not acknowledging the dangerous working conditions (in 1948, 348 miners were killed and thousands injured). Fougeron's *National Defence* (Plate 117) depicts the result of action taken by Jules Moch, Home Minister of the

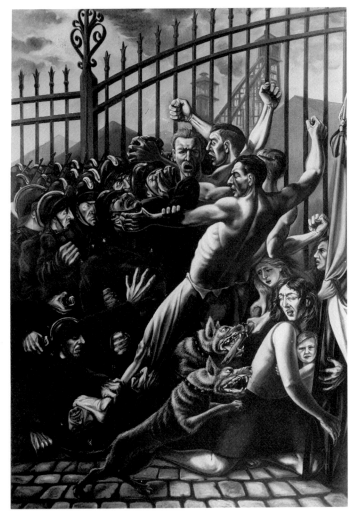

Plate 117 André Fougeron,
La Défense Nationale (*National Defence*),
1950, oil on canvas, 325 x 225 cm.
Museum of Fine Arts, Bucharest.
Photograph by courtesy of the Galerie
Jean-Jacques Dutko. © DACS, 1993.

French Socialist Party, to break the strike of 1948. In 1947 he had sent in troops and police; now he issued them with tanks, gas and machine-guns. In the ensuing violence four miners were killed and hundreds wounded; almost half the miners' delegates were arrested and imprisoned, and in some areas miners were forced to go down the pits at machine-gun point.

Later in 1951, there was political conflict at the Salon d'Automne. On 6 November, just before a presidential visit to the Salon, the police were ordered by the government to remove seven paintings, all of which had PCF associations. These paintings included: a depiction by Georges Bauquier (who taught in Léger's school) of dockers striking in protest against ships being loaded for the war in Indo-China; Taslitzky's *The Strike at the Port de Bouc* depicting the paramilitary CRS and their dogs attacking dockers striking for the same anti-war reason; and Gérard Singer's *10th February at Nice* when, according to Aragon, 'the population of the city threw a launching ramp for a V2 rocket into the sea' (*Écrits sur l'art moderne*, p.80). Protests against this act of government censorship appeared in the leftist press and were made by artists such as Matisse and Picasso. Under criticism concerning the 'dirty war' in Indo-China, the official defence was a claim to have acted in the interests of *le sentiment national* ('national feeling'). Aragon responded to this claim in his review of the exhibition in *Les Lettres françaises*, 15 November 1951, entitled 'L'Art et le sentiment national'. Asserting that 'Here is an instance where to paint ceases to be a game', he attacked the intervention of government agencies, and distinguished between the 'national sentiment' imposed by the state and the 'national sentiment' that united the Resistance movement during the time of Vichy (*Écrits sur l'art moderne*, pp.78–86).

Social realism: strategy and difference

By 1953 the unity of purpose that had collectivized many artists under the PCF began to crack, partly because of the party's failure to turn support and commitment into actual power. The economic and cultural influence of the Marshall Plan had begun to bite, and the Left had become compromised by not successfully confronting government agencies seeking out capitalist options. There had never been a stylistic consensus among artists in the party but, for Aragon, Fougeron was the paradigmatic social realist. In 1953, however, contradictions became too difficult to manage. In the Salon d'Automne of that year Fougeron exhibited *Atlantic Civilization* (Plate 118), which he saw as a 'manifesto picture' to be read 'plastically' (interview with the author, in *Art and Political Engagement 1947–53*).

At the top left is depicted the Melun gaol in which Henri Martin was confined. A young sailor who had been to Indo-China, Martin was sentenced to five years' solitary confinement for distributing anti-war leaflets among his fellow sailors; a popular slogan from one of his leaflets was, 'It's for your millions that you sacrifice the twenty-year-olds'. He was released in 1953 after PCF campaigns. Also depicted are the factories and the children of Aubervilliers; Aubervilliers was an industrial suburb notorious for its appalling living conditions, ironically represented by a contemporary popular song by Jacques Prévert and Josef Kosma. On the left Fougeron depicts homelessness in post-war Paris, where people were still living in tents and old German bomb-proof vaults; these shelters contrast with the brand new housing for US NATO officers, on the right. 'Americanization' and the US 'occupation' are represented by other elements: the immigrant shoe-black polishes the boot of a GI who reads a pornographic magazine published in Paris for US troops; a fat capitalist, out of a George Grosz image, takes his hat off to a symbol of US culture, the gleaming blue Buick. The latter carries a German sniper representing the US support for German rearmament in 1953. This was regarded by many in France as an anti-Communist expedient and a deep insult to France. In the middle is an electric chair symbolizing the hated death penalty, and referring specifically to the death of the US Communists Julius and Ethel Rosenberg who were executed, despite international protests, on 19 June 1953, for passing atomic secrets to the Soviet Union. The French colonial

Plate 118 André Fougeron, *Civilisation atlantique* (*Atlantic Civilization*), 1953, oil on canvas, 380 x 560 cm. Collection of the artist, Paris. Photograph by courtesy of the Galerie Jean-Jacques Dutko. © DACS, 1993.

war in Indo-China is indicated by the government propaganda posters on the NATO building, encouraging French youth to glory in the 'free fight' of the colonial parachutists; in contrast, a French widow mourns over a coffin in which a dead parachutist returns. More coffins are unloaded from a ship painted white, the Vietnamese symbol of death; and below, a Vietnamese mother carries a dead child.

Aragon attacked this painting in his review of the Salon for *Les Lettres françaises*. While he did not quarrel with the ideas evoked by the painting – 'the American occupation of our country', 'the political brutality of the Yankees', 'the honour of France' – he objected to its 'lack of verisimilitude', its 'anti-realist' composition and perspective, 'its countless number of symbols'. He claimed that if this was painted for those who knew and resented the fact that France was occupied, a 'simple *Go Home* on the walls [would be] more significant than this caricature'. To him it was a caricature because it combined several 'methods', including the juxtaposition found in Surrealist painting and in photomontage. For Aragon, who broke with the Surrealists in the early 1930s to support the PCF, Surrealism and photomontage connoted Trotskyism. As this was ideologically unacceptable to a member of the PCF which was pro-Stalinist, *Atlantic Civilization* was a gross error of competence by Fougeron who was essentially the party's official artist.

Singer's *The Outskirts of Laon in 1953* (Plate 119), on the other hand, had for Aragon all the characteristics 'absent' from the Fougeron. He wrote of its 'French grandeur', its 'reality' and 'national conscience'; for him it represented a politically reinvested landscape genre. The identification of the specific location depicted was crucial: the plain of Laon towards Vervins is a historic national site of French resistance to invasion and occupation from the time of Caesar to the battles with German troops in the First World War. Aragon wrote of *la patrie* ('homeland') before discussing Singer's depiction of a new 'foreign

Plate 119 Gérard Singer, *Les Environs de Laon en 1953* (*The Outskirts of Laon in 1953*), 1953, oil on canvas, 196 x 256 cm. Collection of the artist. Photograph: Dumage/Studio Littré. © ADAGP, Paris and DACS, London, 1993.

occupation' and the transformation of the landscape into an immense building site for the construction of an *American* aerodrome: for an 'insane strategy, for a hypothetical war … our earth is excavated and in the end it is not even our own'. Aragon's nationalist eulogy of the depicted landscape (containing 'in its calm, its reality, a national conscience') ends by claiming that at night the words 'Go Home' are written in the sky above Laon (*Écrits sur l'art moderne*, pp.125–7 and 131–4).

Aragon's distinctions between the Fougeron and Singer paintings reveal some of the controversies in the PCF about art and politics. The responses of all three men indicate a sensitivity and resistance to claims that they were Vulgar Marxists. This sensitivity coincides with a concern for notions of a *national* culture and tradition. By 1953, too, these notions were firmly linked to an antipathy to abstraction, which was seen as fundamentally American both by critics in the PCF and those on the right such as Jean Cocteau. One reason for this was the exhibition of many US abstract artists in the Salon des Réalités Nouvelles in 1948 and 1949. With hostility to the US attempt to be 'big brother' through the Marshall Plan, it's not surprising, as Guilbaut points out, that the hand of the CIA was

> seen inside the hollowness of abstraction, manipulating French creativity, draining it of any thought and power … it was easy for the Communist Party to equate abstract art with American decadence and reaction.
>
> (Guilbaut, 'Postwar painting games', pp.45–6)

Plate 120 Fernand Léger, *Stalingrad*, 1955, charcoal on canvas, 128 x 161 cm. Musée National Fernand Léger, Biot. Photograph: Jacques Mer. © DACS, 1993.

And what of artists such as Picasso and Léger? Léger continued to paint themes with a social dimension, such as his unfinished *Stalingrad* (Plate 120), but he was increasingly disillusioned with the influence of the PCF on cultural forms. He wrote in 1950:

> At the present time, because of the desire to come closer to the workers, some painters, even in my school, have turned to pictures with a subject ... Certain mediocre painters quickly slap some large works together and *confuse everything* ... Unhappily, one thing is certain: in the evolution of a work of art, quality is secondary for those who direct the only interesting social movement of our time ... In Russia, efficiency is sought rather than quality. Perhaps it is necessary. I do not know about this. *But for us it is tragic.*
> (Léger, 'Mural painting and easel painting', p.163)

Paintings such as *The Country Picnic* (Plate 121) exemplify Léger's attempt to preserve and extend a dialectical relationship between a social imagery and a self-consciously modern technique. As an idyllic distraction from the realities of French labour, it is markedly different from Fougeron's manifesto on the pervasiveness of an Atlantic and essentially US civilization. Picasso, on the other hand, had a more complex relationship with the PCF. Like his close friend the poet Éluard, Picasso regularly supported the PCF at public functions. However, he was often attacked by some party members as 'decadent' because of his use of techniques, modes of representation and themes considered incompatible with official aims and objectives. I shall now explore some of these issues.

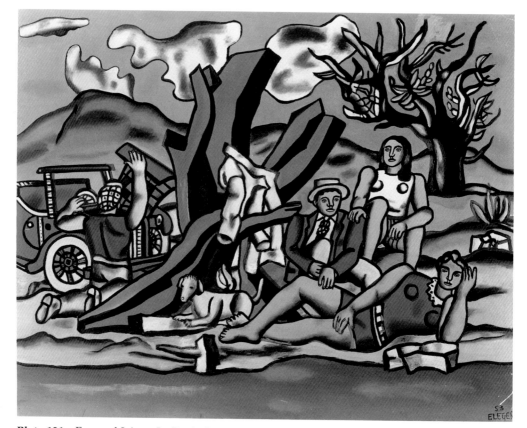

Plate 121 Fernand Léger, *La Partie de campagne* (*The Country Picnic*), 1953, oil on canvas, 130 x 160 cm. Musée d'Art Moderne de Saint Etienne. © DACS, 1993.

Massacre in Korea: the politics of reception

We know something of Picasso's public statements on art and politics from Jerome Seckler's interviews with him in November 1944 and January 1945. These were published in *New Masses*, a US journal with a strong Communist lineage. Picasso makes clear that – in terms of his immediate community (including Aragon, Éluard, Cassou and Fougeron), and the political implications of the liberation of Paris in August 1944 – membership of the PCF was a vital demonstration of solidarity. He does not regard art as the pursuit of arbitrary, disinterested or autonomous concerns; nor does he see an automatic or transparent relationship between art and politics, between artistic characteristics and political commitments:

> I am a Communist and my painting is Communist painting ... But if I were a shoemaker, Royalist or Communist or anything else, I would not necessarily hammer my shoes in a special way to show my politics.
>
> (Picasso, reprinted in D. Ashton, *Picasso on Art*, p.140)

When Picasso joined the PCF in 1944, he made a statement in *L'Humanité* (29–30 October) in which he talked of 'drawing' and 'colour' as 'weapons' in the fight to bring an 'increase in liberation': 'I am aware of having always struggled by means of my painting, like a genuine revolutionary' (quoted in A.H. Barr jr, *Picasso*, pp.267–8). This statement echoes the influence of the Surrealist artistic and intellectual community of which Picasso was a part in the thirties – largely Trotskyist and anti-Stalinist. For Picasso the practice of art involved some statement of a struggle for freedom – though, as he told Seckler, none of his

works displayed a deliberate sense of propaganda, 'except in the *Guernica*. In that [work] there is a deliberate appeal to people, a deliberate sense of propaganda' (reprinted in Ashton, p.140).

The same can be said of his *Massacre in Korea*, dated 18 January 1951, which was perceived in France and the USA as a subversive painting (Plate 122). In 1950 President Truman sent US troops (under the banner of the UN) to Korea to support anti-Communists in the war with the North. The PCF attacked US aggression as it had the French colonial war in Indo-China. Like Fougeron's *Atlantic Civilization*, Picasso's painting shows all the signs of rapid production as though in haste to record a particular moment or event; it was a modern history painting on the traditional theme of the Slaughter of the Innocents by military invaders. The terror and resignation of the children, young girls, mothers and pregnant women contrast with the unquestioning mechanical violence of the robotic executioners. The latter symbolize the depersonalized agents of war and imperialism rather than being recognizable depictions of particular soldiers. It's the title that connects this image to violence in Korea, and to US participation. When *Massacre in Korea* was exhibited in the May Salon of 1951 and reproduced across the front page of *Les Lettres françaises*, the issues of political engagement, social realism and comprehensibility were controversially raised again in the leftist press. Modernists, then and since, attacked the painting as an 'aesthetic failure'.

The New York art community was taken aback by Picasso's 'new *Guernica*' in which the aggressor against defenceless women and children was the *American*, rather than the German, war machine. In the context of early McCarthyite fears, the stereotypical view of Picasso took a battering: he had been characterized as a depoliticized, unworldly genius whose understandable concern for peace (Peace Offensive campaign, peace dove, etc.) had been exploited by the amoral and doctrinaire Communists. Since Congressman Dondero from Michigan had given his speech, 'Modern art shackled to Communism', in the US House of Representatives on 16 August 1949, there had been strenuous efforts by the institutional agencies of the art world to convince Americans that (despite what Dondero and his associates said) modern art was *not* a Communist plot to undermine Western values and democracy. Alfred H. Barr jr, Nelson Rockefeller and Thomas Hess (director of

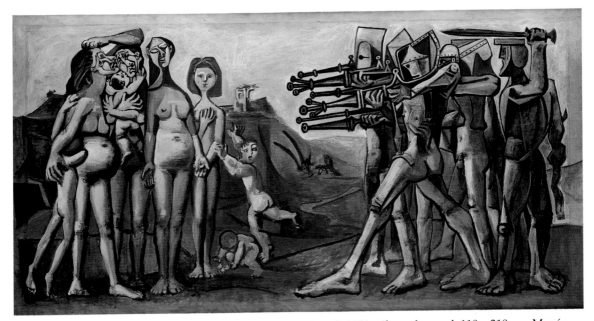

Plate 122 Pablo Picasso, *Massacre en Corée* (*Massacre in Korea*), 1951, oil on plywood, 110 x 210 cm. Musée Picasso, Paris. Photograph: Réunion des Musées Nationaux Documentation Photographique. © DACS, 1993.

Art News) had all been working hard to equate modern art with freedom. Now, here was Picasso, with numerous works in MOMA, muddying their case. In a letter to Barr dated 31 August 1951, Hess wrote:

> *Art News* has been offered a picture story on some recent Picasso paintings, including one of some soldiers shooting some naked women and children.
>
> I have heard that this picture represents American soldiers committing an atrocity on North Korean civilians. Do you know if this is true? Or is it simply an atrocity-of-war picture – reminiscent of Goya's *3 May*? Alfred Frankfurter heard somewhere that it was painted specifically as a piece of communist propaganda, a rumor that had passed me by.
>
> We feel rather honor-bound to publish it as a story, but are quite reluctant to get into the various political problems unless we know exactly what they are; i.e. is the artist actually taking on an active political role, or simply commenting as an artist on a world situation?
>
> (T. Hess, quoted in Guilbaut, 'Postwar painting games', pp.67–9, as corrected by F. Frascina from the original letter)

Barr's brief reply, handwritten on the letter, was: 'This big picture was shown publicly this spring ... and was generally considered as an anti-American propaganda pic [*sic*] though Picasso might deny this as he denied that the *Guernica* was political'. (In fact, Picasso did not deny that *Guernica* was political; see his interview with Seckler, pp.140–41 above.)

Here was a dilemma. American Cold War rhetoric claimed that aesthetic value and politics were separate. Yet Picasso, central to Barr's influential formal narrative in his pioneering Cubism and Abstract Art exhibition of 1936, was being 'political'. But surely, the liberal aesthete could counter, whatever moral and political impact the 'content' might have, *Massacre in Korea* is an 'unhappy picture': could anyone with any 'critical integrity' fail to admit that it is 'inferior' to Picasso's earlier *The Charnel House* (Plate 111)? If only it were a 'better picture', its rhetoric of anti-US imperialism wouldn't sound so hollow. Such a position (art as art; politics as politics) underpins a particular distinction that we find in the title of a contemporary article – 'The two Picassos: politician and painter' – by Joseph Barry in *The New York Times Magazine* of 6 May 1951. The subheading is 'His position as an artist stands unchallenged, but his political beliefs present a puzzle'.

Many wished – and still wish – to retain 'Picasso the painter'. A letter was drafted to Picasso and Léger in December 1952 by the recently founded American Committee for Cultural Freedom, affiliated to the Congress for Cultural Freedom (in the late sixties, these anti-Communist organizations were revealed as CIA-funded as part of Cold War attrition). The letter condemned both artists for supporting regimes that would suppress their art and persecute them as individuals. The letter was never sent, but Irving Kristol (executive director of the American Committee for Cultural Freedom) was confident of support for it. In a letter to Alfred Barr dated 2 December 1952, he stated that he could count on Greenberg's signature, and probably the signatures of Sweeney, Alexander Calder, Motherwell, Pollock, and Baziotes, who 'are all members of our Committee' (Guilbaut, 'Postwar painting games', p.73).

New York: political and cultural options

It is clear that the conditions for production in France and in the USA were markedly *different*. While in the former the PCF was regarded as the major collective agent for socialist change (as was the PCI in Italy, and the Labour Party in Britain), in the USA there was not only disillusionment with the leftist politics of thirties America, but also an active campaign – inside and outside the country, through the CIA as well as the economic Marshall Plan – to eradicate Communism and its sympathizers.

Many of the issues about Marxism, Communism and revolutionary action that characterized the debates among artists and intellectuals in the late thirties had been radically transformed by the late fifties. By that time we can identify two major strands in the USA.

On the one hand, there were those with pre-war Marxist roots who could opt neither for an association with the rhetoric of Zhdanovism (read 'Stalinist totalitarianism') nor for Truman's 'liberal democracy', which meant a rapid deployment of conventional capitalist priorities (read Marshall Plan). Taking a lead from European writers, they represented their alienation in terms of a hybrid of Sartrean existentialism and psychoanalytic concerns with the unconscious (via Surrealism): what united this group of US critics and artists was an emphasis on the 'self' as a 'body' and as an ideological 'being' trying to avoid the 'political trap' of commitment to any political grouping (see the editorial statement by Robert Motherwell and Harold Rosenberg, *Possibilities*, 1, winter 1947/8: p.157 below). Their risk was to be condemned as Bohemian romantics, or as irrelevant, disaffected 'radicals', or as involved in a politics which Greenberg condemned in 1956 as a 'theatre for moral attitudinizing' ('American stereotypes', p.381).

On the other hand, there were those such as Greenberg who saw no alternative but to be 'realistic' and opt for an industrialized, 'free' USA. What Gramsci called the 'American phenomenon' ('Americanism and Fordism') had created a new type of alienated, efficient worker epitomized by the Ford factory, a high level of consumerist 'satisfaction' and a new type of 'liberalized' citizen, predominantly 'middle-class'. Greenberg saw this process more positively. Writing in 1956 he placed trust in 'our politics'. He thought that these

> stand least in need of the attention of our specifically American tradition of self-criticism. It has worked – for whatever extra-political reasons – better than the politics of most other countries, and cannot be complained about in terms like those in which we complain about the American personality or the quality of our life.
>
> (Greenberg, 'American stereotypes', p.380)

For those who did take the 'realistic' approach, there were at least two risks. The first was to submit to a liberal 'conformism', publicly and privately. Submitting publicly meant colluding with McCarthyism and 'anti-Communist "conformism" [which] weighs mostly on people actually drawn to Communist politics'. Submitting privately meant 'an inner, voluntary conformism, from which American liberals suffer' (Greenberg, 'American stereotypes', pp.380–81). The second risk was to be ensnared – in attacking both the Continental Left and Americans such as Harold Rosenberg – by the ideological and economic priorities of a revamped capitalism.

By 1961 Abstract Expressionism was an economic, institutional and critical success. In the late fifties MOMA, under its international programme, had transported exhibitions of post-war US modernism all over the world. Characterized in formalist terms (stressing technical and abstract qualities) and as the 'free' expression of unfettered Americans, Abstract Expressionism was returned to New York as a triumphal avant-garde. At the same time, Greenberg's writings had a profound influence both on the art market and on criticism. By 1961 he was writing, 'some day it will have to be told how "anti-Stalinism", which started out more or less as "Trotskyism" [in the late thirties], turned into art-for-art's-sake, and thereby cleared the way, heroically, for what was to come' (*Art and Culture*, p.230). In the same year for Voice of America he broadcast 'Modernist painting' in which the 'American tradition of self-criticism' was ineluctably applied to account for the development of painting since Manet. Harvard graduate students Fried and Krauss took on Greenberg's methodology and entered his social world when beginning to write about art in the early 1960s. Krauss recalls adopting 'that curiously dissociated [Modernist] tone':

> For I was being carried by an idea of historical logic, buoyed like the others by the possibility of clarity.
>
> In the '50s we had been alternately tyrannized and depressed by the psychologizing whine of 'Existentialist' criticism. It had seemed evasive to us – the impenetrable hedge of subjectivity whose prerogatives we could not assent to. The remedy had to have, for us, the clear provability of an 'if x then y'.
>
> (Krauss, 'A view of Modernism', p.49)

The terms of Krauss's recollection are politically loaded and indicate her choice of a view of art, culture and American values as represented by Greenberg's writings.

Let's explore these alternatives. In 1957, Meyer Schapiro argued that recent abstract painting, such as that by the Abstract Expressionists, was a refusal to celebrate many current values and was at odds with the capitalist mode of production epitomized by US technocracy:

> This art is deeply rooted, I believe, in the self and its relation to the surrounding world. And the pathos of the reduction or fragility of the self within a culture that becomes increasingly organized through industry, economy and the state intensifies the desire of the artist to create forms that will manifest his liberty in this striking way ...
>
> (M. Schapiro, 'The liberating quality of avant-garde art', p.40)

Schapiro's view has much in common with Harold Rosenberg's. In 'The American action painters' of 1952, Rosenberg argues that these artists were concerned with 'a gesture of liberation, from Value – political, aesthetic, moral' (p.23). Their 'refusal of values', however, did not take the form of 'condemnation or defiance of society, as it did after World War I' (p.48). While Rosenberg saw these practitioners as refusing contemporary 'Value', he asserted that: 'If the picture is an act, it cannot be justified *as an act of genius* in a field whose whole measuring apparatus has been sent to the devil. Its value must be found apart from art' (p.23). This 'value', however, depends upon the formation of 'a genuine audience', opposed to the 'taste bureaucracies of Modern Art' which are 'limited to the aesthetics'. In these, 'One work is equivalent to another on the basis of resemblances of surfaces, and the movement as a whole a modish addition to twentieth-century picture-making' (p.50).

There are two aspects of Rosenberg's text that I want to highlight. The first is his Sartrean existentialist view of the limits of 'action', both political and 'artistic'. Alienated from the official ideologies of both the Left and the Right, Marxist radicals could fall into quietism. However, by stressing the integrity of a self-conscious 'refusal of values', Rosenberg was arguing that Abstract Expressionist works were 'acts' of subjective states in a world seeking the certainties of an industrialized liberal-conservativism or of a doctrinaire totalitarianism. For him, therefore, these artists were working with negative resources, revealing the limits of contemporary modernism and the impossibility of a collective 'social realism'. The second aspect is his stress on the absence of 'a genuine audience'. For many Americans, the early Cold War saw the formation of a public sphere where the Utopian Marxist visions of the thirties were replaced by one managed and manipulated by consumerism where the USA was to 'an appreciable degree along the road to a relatively polite and civilized form of totalitarianism'. That statement by Graeme C. Moodie, a British political scientist writing in 1950, was quoted and *criticized* by Greenberg in 1956 (in 'American stereotypes', p.381). The point is that one Marxist option, represented by Rosenberg, was to argue for a counter-public sphere; another, represented by Greenberg, was to argue for making the best of the existing public for 'high culture' – and in so doing to collude, consciously and/or unconsciously, with the anti-Communist imperialism of the USA.

Greenberg and Rosenberg argued violently about these issues, often publicly in print. But this shouldn't be reduced to a personality clash. They represented conflicting leftist positions, each with particular constituencies. For Greenberg, writing in 1953, in a modern industrialized society epitomized by the USA (where efficiency was 'essential'), it seemed improbable that 'work' could be integrated with culture '*without* sacrifice of its efficiency' ('The plight of our culture', Part II, p.60). While looking forward in theory to a Marxist Utopia where this integration might occur, he argued that the best hope was the continued tradition of a genuine 'highbrow' culture where, to avoid the 'vulgar', the 'highbrow has, as it were, to price his product out of the market in order to protect it from the market's demands' (p.54). Autonomy and the 'American' tradition of self-criticism were stressed in his critical celebration of art's separateness, which read to many like a sort of absolutist

'quality control', which was beyond criticism and which aimed to resist both the existentialist Left and the 'vulgar' culture of the industrialized 'masses'. There were other costs in Greenberg's compromise, as Annette Cox argued:

> As an editor of *Commentary* from 1945 to 1957, he [Greenberg] helped shape the anti-Soviet attitudes of his fellow conservative intellectuals.
>
> In one of the more bizarre convergences in American history, Dondero, the man who found a Communist conspiracy behind modernist painting, endorsed Greenberg's campaign against liberals with alleged pro-Soviet sympathies. This strange alliance took place in 1951 during a controversy over Communist infiltration of political news magazines. An anti-Communist group, the American Committee for Cultural Freedom, led this effort to expose Soviet sympathizers on the staff of *The Nation*. Once a contributor to this journal, Greenberg made the first public charges against his former editors. Delighted with Greenberg's accusations, Dondero immediately published them in the *Congressional Record*.
>
> (A. Cox, *Art-as-Politics*, p.142)

In his writings for magazines such as *Commentary*, and his membership of groups such as the American Committee for Cultural Freedom, Greenberg was part of the intelligentsia who, in Chomsky's terms, acted as 'cultural commissars' (N. Chomsky, *Language and Responsibility*).

Abstraction, realism, social content

Let's explore this context in a little detail. In 1947 (though some think it was earlier) Pollock produced a drawing which he titled *War* (Plate 123). According to Lee Krasner, this was the only drawing he titled. It contrasts vividly with a contemporary work on a similar theme by Philip Evergood (Plate 125), who maintained a commitment to social realism from the thirties. These two works signify one of the major dilemmas for leftist artists in the immediate post-war years – the problem of how, in the light of the ideological transformations wrought since 1939, to engage with contemporary life in their representations.

The era after the first use of the atomic bomb was described at the time as the 'age of anxiety', a seedbed for McCarthyite paranoia as represented by George Tooker's *The Subway* (Plate 124). In 1946 Dwight MacDonald described the problem like this: 'naturalism is no longer adequate, either esthetically or morally, to cope with the modern horrors' (quoted in Guilbaut, *How New York Stole the Idea of Modern Art*, p.108). These horrors may have had a particular resonance for artists and critics who were Jewish (Greenberg, Rosenberg, Schapiro, Rothko, Newman, Krasner, etc.). In 1962 Adorno, a German Jew, vividly and pessimistically stated what he saw as the problem for literature, which is equally applicable to post-war visual representation in general:

> I have no wish to soften the saying that to write lyric poetry after Auschwitz is barbaric; it expresses in negative form the impulse which inspires committed literature. The question asked by a character in Sartre's play *Morts sans sépulture*, 'Is there any meaning in life when men exist who beat people until the bones break in their bodies?', is also the question whether any art now has a right to exist; whether intellectual regression is not inherent in the concept of committed literature because of the regression of society.
>
> (Adorno, 'Commitment', p.312)

Earlier, in *Politics* in September 1945, MacDonald attacked contemporary attempts to incorporate, or 'naturalize', the 'Bomb' by those who claimed it was created

> not by the devilish inspiration of some warped genius but by the arduous labor of thousands of normal men and women working for the safety of their country ... Again, the effort to 'humanize' the Bomb by showing how it fits into our normal, everyday life also cuts the other way; it reveals how inhuman our normal life has become.
>
> (MacDonald, quoted in Guilbaut, *How New York Stole the Idea of Modern Art*, p.107)

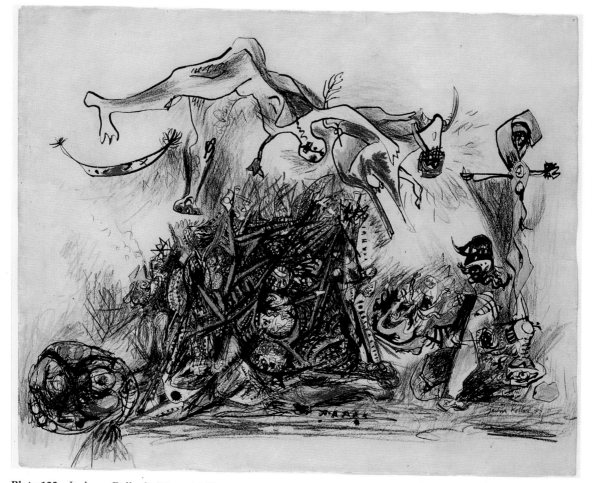

Plate 123 Jackson Pollock, *War*, *c.*1947, pen and ink, coloured pencils on paper, 52 x 66 cm. Metropolitan Museum of Art, New York; gift of Lee Krasner-Pollock in memory of Jackson Pollock 1982. © The Pollock-Krasner Foundation/ARS, New York.

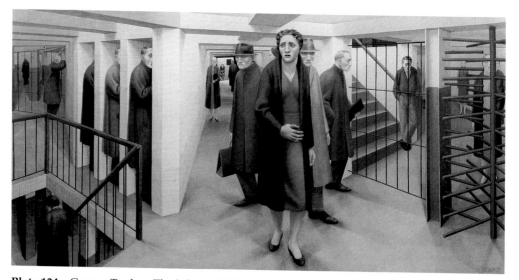

Plate 124 George Tooker, *The Subway*, 1950, egg tempera on composition panel, 46 x 92 cm. Collection, Whitney Museum of American Art, New York; purchase, with funds from the Julian Force Purchase Award 50.23.

Plate 125 Philip Evergood, *Renunciation*, 1946, oil on canvas, 125 x 90 cm. Private collection.

The 'American phenomenon' (here, the 'naturalization' of the Bomb) saw 125,000 workers participating in a project without knowing its purpose. MacDonald claimed that under such conditions 'democracy', 'freedom', 'progress' and 'science' no longer meant anything:

> The bomb is the natural product of the kind of society we have created. It is as easy, normal and unforced an expression of the American Way of Life as electric iceboxes, banana splits, and hydromatic-drive automobiles.
>
> (quoted in Guilbaut, p.108)

In the same year (1945) Pollock and Lee Krasner left New York, the focus of this 'Way of Life', to settle in the country at The Springs, East Hampton.

Neither Krasner nor Pollock experienced the Second World War directly, Pollock being classified 4-F for psychological reasons in April 1942. Nor did they produce war documentation or propaganda. Because of its title, at least, Pollock's *War* (Plate 123) may be connected to the atomic bombings of Hiroshima and Nagasaki or to the detailed disclosures of Nazi death camps. The image represents a pile of human and animal bodies (one of each hovers above the pyre) with a 'crucifixion' to the right. This could echo the imagery in Picasso's *The Dream and Lie of General Franco, II* (Plate 126) and his *Guernica* (Plate 13), which were critical reactions to the Spanish Civil War. Equally plausibly, the imagery of *War* can be connected to Pollock's early childhood traumas and his 'psycho-analytic' drawings – evoking Picasso's studies for *Guernica*, which obsessed him – produced while he was undergoing Jungian therapy in 1939 (see Plates 127 and 128).

It is clear that Pollock had forsaken commitments to 'regionalism' and the explicit social themes that characterized his work during the thirties (Plate 6), when his allegiances were, on the one hand, to Thomas Hart Benton (Plate 23) and, on the other, to the Mexican

Plate 126 Pablo Picasso, *Sueño y mentira de Franco, II* (*The Dream and Lie of General Franco, II*), 1937, etching and acquatint, printed in black, plate 32 x 42 cm. Collection, Museum of Modern Art, New York; the Louis E. Stern Collection. © DACS, 1993.

Plate 127 Pablo Picasso, study no.32, *Head of Weeping Woman*, for *Guernica*, 24 May 1937, pencil and grey gouache on canvas paper, 29 x 24 cm. Prado, Madrid; No. Reg. M. PRADO (Casón): 139. © DACS, 1993.

muralists. He worked in Siqueiros's workshop in the mid-thirties when he helped in the production of May Day floats (Plate 11), and he was a conspicuous supporter of the murals of Diego Rivera and José Orozco. Several times in that period he said that the latter's *Prometheus* (Plate 129) was 'the greatest painting of modern times' (quoted in Naifeh and White Smith, *Jackson Pollock*, p.298).

Evergood's *Renunciation* has more in common with the social realist depictions of the war than with the Surrealist and Mexican muralist traditions of Pollock's *War*. It depicts an atomic explosion tossing battleships and an aircraft-carrier in the air. At the bottom are monkeys (or mutants?), some reading books and perched around a crumbling brick kiln, which may signify the ovens of concentration camps. Why didn't Pollock follow the Evergood method of representation in his paintings?

There are different ways of answering this question. One is to adopt the autonomy thesis, which claims that modern art is a logical progression towards abstract painting and that Pollock was contributing to this progression. Another is to locate his work within the dilemmas of making art in this period. Those dilemmas led Greenberg, *at the time*, to use existentialist terms in characterizing Pollock's work and personality in the forties – 'morbid', 'paranoia', 'resentment', 'alienation' and 'states of mind'. During these years such terms were part of the discourse of the Left, part of the 'metaphysics of despair'. Tooker's Kafkaesque representations (Plate 124) of such states in terms of social realist depictions of particular alienating sites offer a counterpart to those of Pollock's 'negations'.

During the thirties Pollock was on the fringes of organized groups, and he never lost his leftist affiliations. As Motherwell recalled in 1967, 'one of the first things that

Plate 128 Jackson Pollock, *Drawings Presented for Psychoanalysis*, *c.*1939–40. A: dark brown, green and blue pencil on paper, 26 x 21 cm; B: pencil and coloured pencil on paper, 33 x 25 cm; C: coloured pencil, crayon, pen and ink, and ink wash on paper, 36 x 28 cm; D: pencil on paper, 38 x 28 cm. Private collection.
© 1992 The Pollock-Krasner Foundation/ARS, New York.

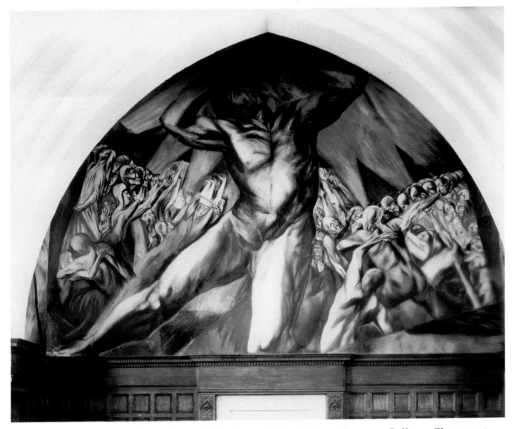

Plate 129 José Orozco, *Prometheus*, 1930, fresco, 600 x 869 cm. Pomona College, Claremont, California.

impressed me about Pollock was his lack of chauvinism ... Pollock in fact had very leftist views that seemingly had little to do with his art' ('Jackson Pollock', p.65). A lot hangs on 'seemingly'. There is also evidence of similar political views in the statements of other Abstract Expressionists. A major dilemma was how to produce radical art, now that social realism was associated with the failure of the Left to withstand the Fascist onslaught of the thirties. Events from the Popular Front, from 1935 onwards (the Moscow show trials, the Nazi–Soviet Non-Aggression Pact, the Soviet invasion of Finland), had compromised earlier affiliations.

Pollock's early commitment to the aims of the Mexican muralists remained throughout both his and the Left's various transformations during the late thirties and the forties. Two of those interrelated aims were to produce murals in a modern tradition, and to make them available to the public. This is, perhaps, best expressed by Orozco in his 'New world, new races and new art', published in the New York magazine *Creative Art* in 1929:

> The Art of the New World cannot take root in the old traditions of the Old World nor in the aboriginal traditions represented by the remains of our ancient indian peoples. Although the art of all races and of all times has a common value – human, universal – each new cycle must work for itself, must create, must yield its own production, its individual share to the common good ... Already, the architecture of Manhattan is a new value ... [it] is the first step. Painting and sculpture must certainly follow as inevitable second steps.

> The highest, the most logical, the purest and strongest form of painting is the mural. In this form alone, it is one with the other arts – with all the others.

It is, too, the most disinterested form, for it cannot be made the matter of private gain; it cannot be hidden away for the benefit of a certain privileged few.

It is for the people. It is for ALL.
(quoted in *Orozco: 1883–1949*, p.46)

The works by Pollock and other Abstract Expressionists, especially from 1947, were comparable in scale with both frescos and the 'portable mural'. Pollock's canvases were also often exhibited unstretched and without a frame, as though they were 'walls' or 'ceilings' (Plate 130). The similarity between Pollock's ambition and Orozco's can be gauged from two of Pollock's statements. The first is his application for a Guggenheim fellowship in 1947:

I intend to paint large movable pictures which will function between the easel and the mural. I have set a precedent in this genre in a large painting for Miss Peggy Guggenheim which was installed in her house [*Mural*, 1943, Plate 52] …

I believe the easel picture to be a dying form, and the tendency of modern feeling is towards the wall picture or mural. I believe the time is not yet ripe for a *full* transition from easel to mural. The pictures I contemplate painting would constitute a half-way state, and an attempt to point out the direction to the future, without arriving there completely.
(Pollock, quoted in O'Connor and Thaw, *Jackson Pollock*, vol.4, p.238)

And, in a 1950 interview with William Wright, broadcast on radio in 1951, Pollock states:

Modern art to me is nothing more than the expression of contemporary aims of the age we're living in … All cultures have had means and techniques of expressing their immediate aims – the Chinese, the Renaissance, all cultures. The thing that interests me is that today painters do not have to go to a subject-matter outside of themselves. Most modern painters work from a different source. They work from within … My opinion is that new needs need new techniques. And the modern artists have found new ways and new means of making their statements. It seems to me that the modern painter cannot express this age, the airplane, the atom bomb, the radio, in the old forms of the Renaissance or of any other past culture. Each age finds its own technique.
(quoted in O'Connor and Thaw, vol.4, pp.248–9)

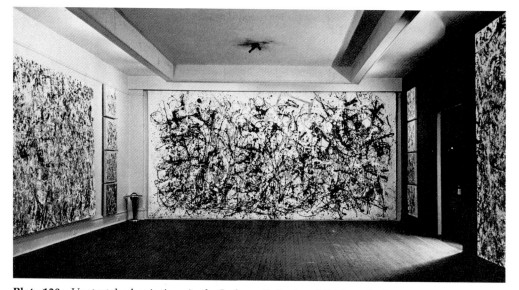

Plate 130 Unstretched paintings in the Jackson Pollock exhibition, the Betty Parsons Gallery, 1950 (*Autumn Rhythm*, Plate 58, is on the far wall). Photograph: Hans Namuth.

Judging by their statements during the period, artists were deeply concerned with 'identity', the 'self' and the 'social', particularly in the alienating context of modern urban experience. In the late forties, too, these issues were focal points in Greenberg's criticism. In 1947 he wrote:

> For all its Gothic quality, Pollock's art is still an attempt to cope with urban life; it dwells entirely in the lonely jungle of immediate sensations, impulses and notions …
> (Greenberg, 'The present prospects of American painting and sculpture', p.26)

And in 1948:

> Isolation, or rather the alienation that is its cause, is the truth – isolation, alienation, naked and revealed unto itself, is the condition under which the true reality of our age is experienced. And the experience of this true reality is indispensable to any ambitious art.
> (Greenberg, 'The situation at the moment', p.82)

In this connection, it is important to consider Pollock's relationship with Krasner, who was older and, when they began their relationship in 1941, more politically and artistically mature. De Lazlo, one of Pollock's early Jungian analysts (Pollock suffered from repeated bouts of depression, withdrawal and alcoholism), feared that he could become *too* dependent on Krasner's strong will and goal-oriented personality, a situation that could lead to resentment. (De Lazlo's fear proved well founded in the fifties.) From early on in her career Krasner signalled her modern psychological concerns – gendered identity, physical presence and resources as a painter. Perhaps the strongest symbol of these was an extract from Arthur Rimbaud's *A Season in Hell*, which Krasner wrote on her studio wall soon after it was translated by Delmore Schwarz in 1939:

> To whom shall I hire myself out?
> What beast must I adore?
> What holy image is attacked? What hearts shall I break?
> What lies shall I maintain? In whose blood tread?

Anne Wagner argues that these are the 'fruits and heritage of Rimbaud's alienation … They are also the questions that modernism, at its best, has repeatedly asked – and then all too often lost sight of…' The fact that Krasner faced these lines each day was a measure of her identification with Rimbaud's 'dismissal of mere Beauty', and with his 'belief in the absolutely modern, and with his claim that a voyage into the depths can lead to truth' (A. Wagner, 'Lee Krasner as LK', p.42).

'A voyage into the depths' of the unconscious as a route towards 'truth', with all its Surrealist associations, was a common aspiration among artists later labelled 'Abstract Expressionists'. Part of achieving this, for Pollock and Krasner, was the assimilation of Picasso's 'Surrealist' work, from the twenties and thirties, which was regarded as something to emulate and then to go beyond. The ambition was also wrapped up with Jungian notions of the unconscious as an authentic source of *contemporary* representation. In the early forties their paintings were characterized by an imagery and a process that accorded with the Surrealist emphases on automatism and the liberation of the unconscious (Plates 37 and 131). The 1938 manifesto by Breton and Rivera (later revealed to be by Trotsky and Breton) characterized one version of the task of a leftist art practice:

> … in the preparation of the revolution … the artist cannot serve the struggle for freedom unless he [*sic*] subjectively assimilates its social content, unless he feels in his very nerves its meaning and drama and freely seeks to give his own inner world incarnation in his art.
> ('Manifesto: Towards a free revolutionary art', p.52)

Pollock's 'incarnation' of his 'own inner world' was encouraged by the Surrealist emphasis on both Marx *and* Freud and by his dependency on Jungian and other therapy. Significantly, though, in the period between 1947 and 1950, Pollock went through a period of

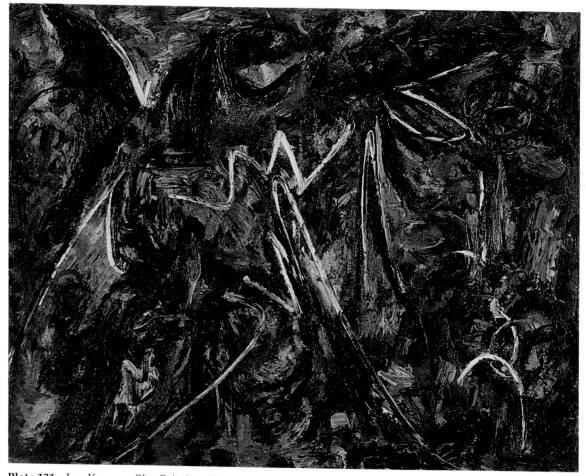

Plate 131 Lee Krasner, *Blue Painting*, 1946, oil on canvas, 66 x 71 cm. Private collection. Courtesy of the Robert Miller Gallery, New York. © 1992 The Pollock-Krasner Foundation/ARS, New York.

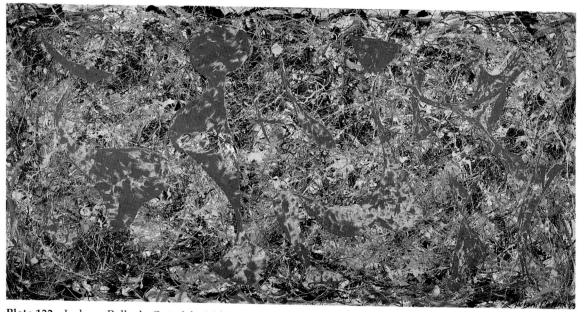

Plate 132 Jackson Pollock, *Out of the Web (Number 7, 1949)*, 1949, oil and enamel paint on masonite, cut out, 122 x 244 cm. Staatsgalerie, Stuttgart, Germany. © 1992 The Pollock-Krasner Foundation/ARS, New York.

controlling and *mastering* such imagery, veiling many of the figures and forms of his earlier work by means of a highly controlled drip process (Plates 3, 58 and 132). References to his 'inner world', to images and figures from the unconscious, became dispersed or denied a space in these more abstract paintings. By the early fifties, however, images and figures were explicitly restored. This restoration of imagery can be explained by reference to what the psychoanalyst Melanie Klein ('Mourning and its relation to manic depressive states') called 'reparation'. By this she basically meant the reparation of the internal world – fantasies, fears, desires, depressive anxieties and guilt – by repairing the external world often symbolized by an object such as a painting (Plate 133). One creative aspect of reparation is to externalize ambivalent feelings:

> I don't care for 'abstract expressionism' ... and it's certainly not 'non-objective', and not 'nonrepresentational' either. I'm very representational some of the time, and a little all of the time. But when you're painting out of your unconscious, figures are bound to emerge. We're all of us influenced by Freud, I guess. I've been a Jungian for a long time ... painting is a state of being ... Painting is self-discovery. Every good artist paints what he is.
>
> (Pollock, quoted in O'Connor and Thaw, *Jackson Pollock*, vol.4, p.275)

Pollock's practice demonstrates that to externalize ambivalent feelings is a risky business, psychologically and socially. This was particularly true in a era in which there were fragile illusions of artistic status in an art world subjected to the interests that also guaranteed the effectiveness of the Marshall Plan. By 1955 the art world had undergone cataclysmic changes – record prices, proliferating galleries, media coverage (Plate 134). And as a result of post-war, consumerist-induced prosperity, the art market had been transformed into 'something rich and strange and unrecognizable'. Such interests often manifested powerful tensions in practice, particularly for those artists rooted in pre-war leftism. For Barnett Newman, strongly anchored in the politics of his practice, his paintings *undoubtedly* opposed contemporary capitalism and offered a 'Utopian vision' (Plate 66). In an interview in 1962 he recalled an earlier statement:

> Almost fifteen years ago Harold Rosenberg challenged me to explain what one of my paintings could possibly mean to the world. My answer was that if he and others could read it properly, it would mean the end of all state capitalism and totalitarianism. That answer still goes.
>
> (Newman, in an interview with D. Seckler, 'Frontiers of space', p.87)

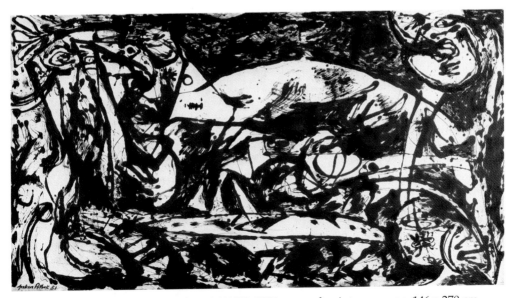

Plate 133 Jackson Pollock, *Number 14 (1951)*, 1951, enamel paint on canvas, 146 x 270 cm. Tate Gallery, London. © 1992 The Pollock-Krasner Foundation/ARS, New York.

Plate 134 'Spring ballgowns',
Vogue, 1 March 1951,
photograph by Cecil Beaton
of a model in front of Jackson
Pollock's *Autumn Rhythm*
(Plates 58 and 130). Copyright
Cecil Beaton, photograph by
courtesy of Sotheby's, London.

The 'self' and the 'social': traps and contradictions

For Pollock, the situation was psychologically more problematic; he always wrestled with the contest between identity and ambition, representation and meaning. This can be symbolized by one instance of the new 'media' coverage of artists whereby, in the developing processes of the American phenomenon, novelty and dissent are recorded, turned into an image and sold. Pollock was filmed at work by Hans Namuth in the autumn of 1950, which led to a powerful transformation: the *experience* of being filmed in the act of painting exposed conflicting and unresolvable tensions. It was as though he became trapped in his own growing celebrity, such as the *Life* double-page spread (Plate 108), playing a role, feeling more like the fraud and phoney that his brothers had always accused him of being and that the art world was seeming to confirm (accusations that not only was he a 'freak' painter, but also that the 'real artist' was de Kooning: Plate 42).

Greenberg, embarrassed by both the Surrealist emphases on sexual imagery and the ideological legacy of the Mexican muralists, had urged Pollock to get rid of the iconography, to let the *medium* act as the expressive force. In front of Namuth's camera, Pollock was publicly demonstrating a method even though he was unsure of its integrity (Krasner herself was rarely allowed to witness it). Clinging to the media *image* of the great, progressive, rebellious artist as spontaneous, impulsive, in contact with his unconscious, he was having to submit to Namuth's *directed* retakes of the 'artist in action'. Could he be sure that this media coverage wouldn't immortalize him on celluloid as *'fraud'*? And if he wasn't a fraud, if his work represented a genuine and complex identity expressing 'this

age, the airplane, the atom bomb, the radio', he still worried that 'Maybe those natives [*sic*] who figure they're being robbed of their souls by having their images taken have something' (quoted in Naifeh and White Smith, *Jackson Pollock*, p.652).

Directly after Namuth had finished filming on 25 November 1950, Pollock went on his first drunken binge since late 1948. This ended one of his most prolific periods of work, which had been marked by a return to the country (the 'West' and the 'farm' of his childhood), an absence of alcohol dependency, and the stabilizing presence of a powerful psychoanalytic 'couple' (Krasner and Greenberg). The ending of this 'stable' period saw the removal of his pictorial 'veiling', the surfacing of haunting imagery in his 'black paintings' (for example, Plate 133), and identity crises. The crises – manifested by highly volatile social behaviour – threatened his relationships with both members of this powerful 'couple', as well as other aspects of his inner stability. This raises important questions: what was the relationship between Pollock's inner psychological world and his external social world, and how far did one determine the other? Psychoanalytically, the relationship between the two is crucial in understanding Pollock's position within specific conditions of production.

There are contradictions within Pollock's practice that can, and did, lead to serious differences in accounts of his work. On the one hand, Pollock's work is represented as an affirmation of human potential in dire times, to be celebrated within what Krauss describes as the Modernist 'idea of historical logic, buoyed ... by the possibility of clarity'. It's a beacon, a touchstone of authentic and complex 'high art' in a society characterized by the 'kitsch' of mass culture and the remnants of those 'wishful thinking' leftists exemplified by Rosenberg and his Sartrean existentialism, whose ideas could not be assented to. Paradoxically, Pollock's work becomes a 'triumph' both for the institutional establishment and for that faction of the radical intelligentsia for whom politics in Adorno's words 'has migrated into autonomous art, and nowhere more so than where it seems to be politically dead'.

On the other hand, Pollock's work can be seen as a problematic negation – of existing values, of an official public and of 'Art' itself. His paintings are less something to be formally celebrated, and more a sign of the tensions and contradictions inherent in producing a 'political' art in a new phase of capitalist industrialism and reaction. Rosenberg's and Motherwell's editorial to *Possibilities*, 1947–48, put it thus:

> The temptation is to conclude that organized social thinking is 'more serious' than the act that sets free, in contemporary experience, forms which that experience has made possible. One who yields to this temptation makes a choice among various theories of manipulating the known elements of the so-called objective state of affairs. Once the political choice has been made, art and literature ought of course to be given up ... [However] it [is] possible to hang around in the space between art and political action. If one is to continue to paint or write as the political trap seems to close upon him, he must perhaps have the extremist faith in sheer possibility. In his extremism he shows that he has recognized how drastic the political presence is.
>
> (Motherwell and Rosenberg, editorial in *Possibilities*, no.1, winter, 1947/8)

Pollock's 'extremism' threatened all sorts of certainties and, for some commentators, his works attest to the limits of one development within modernism, that of abstraction, to represent experience. Here there is a paradox. Pollock's drip-paintings appear to be the antithesis of the values of capitalist industrialism. One sign of this was his use of industrial paints, enamel and aluminium in works made by the free play of all that industrialism denied – the psychophysical demands of intelligence, fantasy and initiative on the part of the worker. But Pollock's drip processes also parallel, at least metaphorically, the development in the industrialized alienated worker of the highest degree of automatic and mechanical attitudes, reducing productions exclusively to the mechanical physical aspect.

A counter-public sphere

Many historians have argued that the late 1960s produced a counter-culture – a rupture in the Cold War system of order and control. Now that we've examined some of the practices and debates of the post-war period, are we in a better position to assess that argument? One thing is clear: Cold War reconstruction and reformism just after the Second World War did not produce the same conditions in France as in the USA. Many artists, critics and intellectuals in the thirties and early forties saw the need to politicize both themselves and their work. But how they perceived the alternatives depended on which country they were in. The issues, though, were not dissimilar – debates about abstraction and realism, autonomy and political commitment, liberal-conservative industrialism and the struggle to achieve socialism. Often these debates did not lead to a clear 'either/or' but to a contradictory negotiation between theoretical aspiration and historical contingency. Such contradictions may account for the conflicting views in the politics of representation that we've examined in this chapter. For example, Rosenberg and Greenberg differed radically about the politics of Abstract Expressionism. And work by artists in the PCF was condemned or celebrated on ideological grounds both in France and in the USA, but in differing ways depending on the country.

One major area of dispute was 'autonomy'. Should art be concerned with (and preserve at all costs) its own specialized laws, issues and competencies and address an elevated élite public, actual or ideal? For some, this preserves the Utopian vision of creative human expression untainted by kitsch or political doctrine; for others, it maintains an insulated, socially exclusive and gendered art, with attendant discourse, which feeds the market in novel objects and provides state and corporate agencies with symbols to be used for whatever ideological reasons they may wish. Alternatively, should art engage with the social and cultural world at large to give expression to those issues, controversies and interests that are stifled or marginalized by dominant ideologies? For some, this preserves the power of art to engage critically with what Baudelaire called 'the transitory, the fugitive, the contingent' of the *present*, in a way that addresses a constituency for whom culture has a broader social base; for others, this is a naïve, conscience-wringing 'whine' leading to 'bad' art and special pleading.

Such disputes, with their paradoxes, some of which we have explored, arise from the reconstruction of 'culture' in the post-war years: by 1960, in Europe and the USA, it was clear that there had been a rapid option for conventional capitalist priorities. In the USA and Britain, at least, those art practices rooted in Marxist debates of the 1930s were subjected to pressures depriving them of the broad-based constituency that *seemed* a revolutionary possibility before the war. In France, as in Italy, the massive support for the Communist Party suggested that a genuine socialist audience could be created. By the mid-fifties, however, compromises, mistakes and the lure of 'Americanization' – economically and culturally supported by CIA agencies – undermined such hope.

At the end of 'The American action painters' of 1952, Rosenberg draws attention to the absence of a 'genuine audience' in contrast to the leisure-oriented class of conspicuous consumers: 'To counteract the obtuseness, veniality and aimlessness of the Art World, American vanguard art needs a genuine audience – not just a market' (p.50). In the 1930s many had felt that such an audience was a real revolutionary possibility. However, by the early 1950s this political constituency had been doubly squeezed. Capitalism had outflanked the Left by offering consumerism as an alluring alternative to collective action. It had also succeeded in caricaturing Marxism by tarring it with the Zhdanovist brush. There is a dilemma here. If there is no 'genuine audience' for an art that is claimed to give expression to the contradictory experiences of contemporary life, that art may be absorbed, appropriated and, not least, used for reactionary reasons and ends. The revolutionary intellectual or artist may be led into inadvertently colluding with the forces of order by claiming that the only way to survive such a process is to address an ideal public,

an imaginary community. Benjamin recognized this dilemma in the thirties:

> [the more precisely the revolutionary intellectual] understands his own position within the production process, the less it will occur to him to pass himself off as a 'man of mind' … The mind which believes in its own magic strength *will* disappear. For the revolutionary struggle is not fought between capitalism and mind. It is fought between capitalism and the proletariat.
>
> (Benjamin, 'The author as producer', p.103)

From one perspective, the emphasis on autonomous art and specialized esoteric criticism inevitably becomes part of the culture industry, with such criticism acting, unwittingly, as 'public relations' in a large-scale corporate undertaking. For many 'realist' artists who saw themselves as a kind of subculture in the fifties and early sixties, Pop Art (such as Rosenquist's *F-111*, Plate 100), with its use of imagery and techniques from the wider cultural world, was perceived as beginning to rupture this process. This rupture was paralleled by the civil rights and the anti-Vietnam War movements, which actively questioned and struggled with power relations and established polarities.

However, we need to be wary of claims that such a rupture was possible. All of the cultural processes involved took place within 'late' or 'developed' capitalism, a system where the economic efficiency of workers and the production of commodities are severed from all that is designated 'unproductive' – the symbolic aspects of experience and creativity with their traditional expenditures of bodily energy. Often this system is presented as the modern fascination with industrialized technology, Taylorist efficiency and Fordist processes (Plate 135). These privilege intellect and rationalization over dream, fantasy and the needs and desires of the body. John Brenkman argues that in late capitalism these severed symbolic aspects of life, which in pre-industrialized societies 'manifest themselves in forms of erotic, aesthetic and religious experience', are brought under the dominance of the economic in a managed way. This is the case with all cultural forms and practices, from 'high art' and the modern museum to soap operas and television. In a letter to Benjamin in August 1935, Adorno wrote that both 'autonomous' works of art and mass cultural forms such as cinema 'bear the stigmata of capitalism … Both are torn halves of an integral freedom, to which, however, they do not add up' (*Aesthetics and Politics*, p.123). In both of these torn halves, emphasis is placed on the private experience of the viewer rather than on social interaction. (This is an issue central to my earlier discussion of Keinholz's *The Eleventh Hour Final*, Plate 101.) Brenkman argues that late capitalism encourages individuals to see themselves as asocial, ultimate units of being (i.e. as 'monadic'):

> Through its dominant *cultural* forms and practices, late capitalism strives to sever social experience from the formation of counter-ideologies, to break collective experience into the monadic isolation of the private experience of individuals, and to pre-empt the effects of association by subsuming the discourses and images that regulate social life.
>
> (J. Brenkman, 'Mass media', p.98)

I want to go back to some of my earlier examples. From Brenkman's perspective, Fried's subjective bodily pleasure in his experience of a Caro sculpture in a commercial gallery is an instance of 'the monadic isolation of the private experiences of individuals'. This private experience is translated into a specialized terminology and given an authoritative, public place in *Artforum*'s publication of 'Caro's abstractness'. In Brenkman's terms, that text is an instance of Fried's attempt to recover an equivalent for those 'forms of erotic, aesthetic and religious experience' that have been severed by capitalism's cultural management (Art as 'salvation'). His personal experience of a particular, specialized object and commodity is then projected as authentic and potentially repeatable for *everyone*. Such private experiences are regarded by Modernists as correctives to the moral choices and pressures of everyday life. The authority of *particular* individuals is treated as an absolute, and is oppressively used to erase cultural and gender differences. Capitalism, of course,

Plate 135 Robert Mottar, photograph of the construction of One Chase Plaza, the Chase Manhattan Bank building, New York, 1959. Photograph by courtesy of the Chase Manhattan Corporation Archives, New York.

thrives on such art works and critics' judgements. These judgements, seemingly authoritative and often intimidating, sustain the process of producing novel commodities while keeping people in their passive, consumerist place.

Alternatively, the social experience of the anti-Vietnam War movement – resulting in, for example, the Los Angeles *Peace Tower*, *The Collage of Indignation*, and groups such as the AWC and WAR – led to the formation of counter-ideologies, notably feminism. One account of this experience is given by Martha Rosler. Her work moved from abstract paintings in the sixties, through anti-war photomontages during 1969–71 (Plate 136), to photography-plus-text and video pieces on social subjects such as anorexia and homelessness from the seventies onwards. She recalls that the 'oppositional' legacy of the Beat poets and the social movements of the sixties determined her practice:

> … it was feminism which burst like a bomb in my mind. That stopped me from doing abstract painting, because it was then that I realized that I really had a great deal to say and that abstract painting was in fact mute and self-mutilating …

> I read Michael Fried's essay ['Art and objecthood'] … which was a sort of terribly starchy defence of high Modernism, and he spoke of the problem of art that did not follow these

Plate 136 Martha Rosler, untitled, from *Bringing the War Home: House Beautiful*, 1969–71, photomontage, 36 x 28 cm. Collection of the artist. Photograph by courtesy of the artist and Simon Watson.

Modernist precepts as being 'theatre'. And I said 'bingo, that's it, that's right'. The art that is important now is a form of theatre, and one thing *that* means is that it has to be in the same space as the viewer ...

(M. Rosler, interview with the author, 24 November 1991)

For Rosler it was the legacy of feminism that focused on the 'importance of representation in determining and reinforcing one's position in culture', especially the 'importance of representation in cultural control'. By using photography and text (and eventually video) on social themes, Rosler was 'interested in activating an audience [as] we should all be activated as subjects of a culture that intended to make us all audience spectators rather than citizen participants'.

There are two main points to make here. The first is that in the mid-sixties we can identify the reappearance of resistance in the form of student and counter-cultural or counter-public movements. Within the space created, 'previously repressed or inarticulate needs, interests and desires find political and symbolic form, mediated by changed idioms, practices and cultural modes' (T. Eagleton, *The Function of Criticism*, p.119). In the USA this resistance was predominantly centred on civil rights and Vietnam; in France, as in other European countries, 'May 1968' was a symbolic landmark – the student revolt and general strike almost ousting the Gaullist government. The women's movement was one

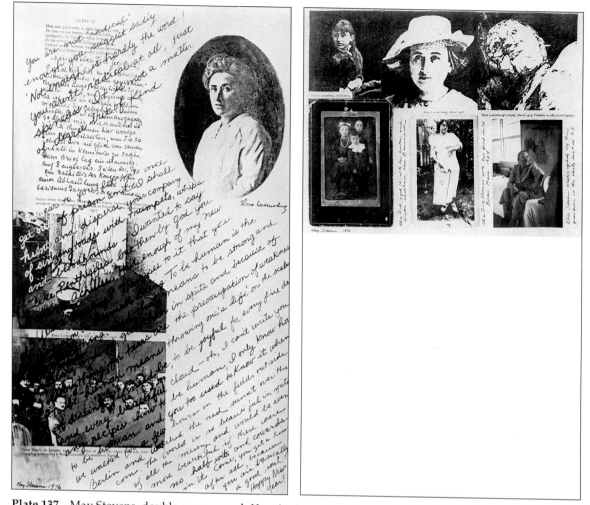

Plate 137 May Stevens, double-page spread, *Heresies*, issue 1, 1977, pp.28–9. Left: *Tribute to Rosa Luxemburg*, 1976, collage, 42 x 25 cm; it includes a letter that Rosa Luxemburg wrote from prison to a female friend in *c*.1917, a photograph of her cell and, in the centre of the bottom photograph, her murderer Runge. Right: *Two Women*, 1976, collage, 27 x 34 cm; top row from left to right: Rosa Luxemburg aged 12 and 36, and her corpse in March 1919; bottom row from left to right: Alice Dick Stevens (May Stevens' mother) aged 12 and 29, and in her sixties in the 1960s. Reproduced by permission of the artist.

example of the emergence of a counter-public sphere that had a lasting effect in transforming practices and regimes of power. Here women's collectives, magazines, sites for exhibition and a revision in the subjects and forms of expression were pursued (Plates 137 and 138).

The second point is that artists involved in civil rights and anti-Vietnam War movements actively opposed the critical and institutional fascination with, and preservation of, autonomous 'high art'. One of their strategies was to use photographic media, often with texts, and installations. Heartfield's political photomontages, especially from the thirties, were one model for practice; texts such as Benjamin's 'The work of art in the age of mechanical reproduction', first published in English in 1968, provided crucial theoretical support. Kozloff also recalls that 'forgotten' texts, such as those from the thirties by Schapiro, began to be unearthed and used as methodological resources. As we saw in

Plate 138 Vanalyne Green, Patricia Jones and Holly Zox, 'Put them all together they spell mother', produced for Events: Heresies Collective, 1983, The New Museum of Contemporary Art, New York. Photograph: David Lubarsky. Reproduced by permission of The New Museum of Contemporary Art, New York.

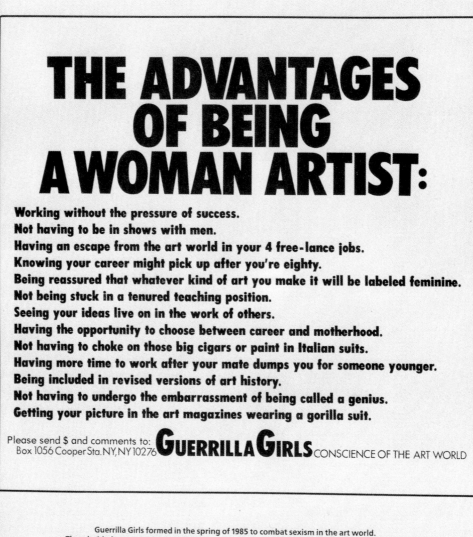

Plate 139 Guerrilla Girls, *The Advantages of being a Woman Artist, Heresies*, vol.6, no.4, issue 24, 1989, p.35.

Chapter 1, p.70, Benjamin argued that mechanical reproducibility (as in film and photography) offers a potentially democratic corrective to the unique value that bourgeois society accords to the 'authentic' work of art. The doctrine of 'art for art's sake', a modern theology, makes the work of art dependent on ritual. Once authenticity is no longer central to artistic production, Benjamin argues, the ritualistic function of art is reversed. Art begins to be based on politics, as demonstrated by Heartfield's photomontages attacking Nazism, and by Eisenstein's films in post-Revolutionary Russia.

In an era when the photograph or the photographic record of an earthwork, performance or conceptual piece can be commodified, Benjamin's text seems as much strategy as actual blueprint for a 'democratic practice'. It provided a strategic resource for many concerned with social systems (such as Haacke) and with feminism (such as Rosler, Stevens, Kelly and Spero), all of whom used what has been called the 'scripto-visual' where photographic and other images and objects were combined with texts. These were often used in collective exhibitions on women's experience, which feminists saw as marginalized in dominant cultural constructions. They criticized these constructions for being based on what Benjamin called the 'auratic' art object on set topics and themes. It's in this context that 'politics,' for those in the women's movement, revolved around experiences and topics traditionally regarded as 'unproductive', personal or too wrapped up with the 'inner speech' of dream, desire and fantasy. In this context, the work of women artists, work that connects Sherman to Kahlo (Plates 72 and 75), offered more relevant examples than those in the official canon. Much of the evidence suggests that there was a rupture in the late 1960s that allowed expression to many marginalized experiences and communities. However, the idea of the canon was still powerful even in 1987:

> Inasmuch as it reaffirms – with only occasional exceptions – male white supremacy in visual high culture, the critical canon to which we all [Buchloh, Fried and Krauss] adhere is hegemonic and monocentric. Furthermore, this canon inadvertently confirms – despite all claims to the contrary – the construction of individual œuvres and authors, and it continues to posit and celebrate individual achievement over collaborative endeavor. We are also united as critics in our almost complete devotion to high culture and our refusal to understand art production, the exclusive object of our studies, as the dialectic counterpart of mass cultural and ideological formations – formations from which the work of high art continues to promise if not redemption then at least escape.
>
> (B. Buchloh, 'Theories of art after Minimalism and Pop', p.66)

This admission was made in a three-way discussion, with Fried and Krauss, entitled '1967/1987, genealogies of art and theory'. Significantly, those landmark dates were art/cultural: they didn't register the momentous political events of 1968, but were linked to the publication in 1967 of Fried's 'Art and objecthood'. In the light of developed capitalism's absorption of the dissent of the late 1960s, turning much of it to its own purposes of commodity consumption and display, Buchloh sees belatedly that

> another function of criticism at this moment [is] to support and expand knowledge of those artistic practices of resistance and opposition which are currently developed by artists outside the view of the hegemonic market and of institutional attention.
>
> (Buchloh, p.70)

Those active in the late sixties might say that all this is a bit late (Plate 139). Many feminists and Marxists of '1968' have discovered that, despite their challenge to ideological control, capitalism encourages and thrives on the production of subcultural identities and the proliferation of difference. How to avoid, in their challenge, falling into the trap of mapping out territory, validating new objects, producing representations that only expand what the cultural commissars of capitalism construct as 'the tradition' – leaving the system intact?

References

ADORNO, T., 'Scientific experiences of a European scholar in America' in D. Fleming and
B. Bailyn (eds), *The Intellectual Migration: Europe and America, 1930–1960*, Cambridge Mass.,
The Belknap Press of Harvard University Press, 1969.

ADORNO, T., letter to Walter Benjamin, 2 August 1935, in *Aesthetics and Politics*, London, 1977
(an edited version is reprinted in Frascina and Harris, *Art in Modern Culture*).

ADORNO, T., 'Commitment', 1962, in A. Arato and E. Gebhardt (eds), *The Essential Frankfurt
School Reader*, New York, Continuum, 1985 (an edited version is reprinted in Frascina
and Harris, *Art in Modern Culture*, and in Harrison and Wood, *Art in Theory, 1900–1990*,
section VI.b.5).

ARAGON, L., *Écrits sur l'art moderne*, Paris, Flammarion, 1981.

ARATO, A. and GEBHARDT, E. (eds), *The Essential Frankfurt School Reader*, New York, Continuum, 1985.

'Arms for Europe: The top brass of the US comes up with a program to defend Europe with
revitalized European armies', *Life*, 8 August 1949, pp.26–7.

'The artist and politics: a symposium', *Artforum*, vol.IX, no.1, September 1970, pp.35–9 (an
edited version is reprinted in Harrison and Wood, *Art in Theory, 1900–1990*, section VII.c.2).

ASHTON, D., 'Response to crisis in American art', *Art in America*, vol.57, January–February, 1969,
pp.24–35.

ASHTON, D. (ed.), *Picasso on Art: A Selection of Views*, London, Thames and Hudson, 1972.

BARANIK, R., interview with the author, 24 November 1991.

BARR, A.H. jr, *Picasso: Fifty Years of his Art*, New York, MOMA, 1949.

BENJAMIN, W., 'The author as producer', 1934, in *Understanding Brecht*, translated by Anna
Bostock, London, New Left Books, 1977 (an edited version is reprinted in Harrison and
Wood, *Art in Theory, 1900–1990*, section IV.c.16).

BENJAMIN, W., 'The work of art in the age of mechanical reproduction', 1936, *Illuminations*,
translated by Harry Zohn, London, Jonathan Cape, 1970 (an edited version is reprinted in
Frascina and Harris, *Art in Modern Culture*, and in Harrison and Wood, *Art in Theory,
1900–1990*, section IV.d.6).

The Holy Bible, Revised Standard Version Catholic Edition, London, Catholic Truth Society,
Nelson, 1966.

BOURDIEU, P., *Distinction: A Social Critique of the Judgement of Taste*, translated by R. Nice,
London, Routledge, 1984.

BOURDIEU, P. and DARBEL, A., *The Love of Art: European Museums and their Public*, 1969, translated
by Caroline Beattie and Nick Berriman, Cambridge, Polity Press, 1992 (an edited version is
reprinted in Frascina and Harris, *Art in Modern Culture*).

BRECHT, B., 'On non-objective painting' in Frascina and Harris, *Art in Modern Culture*.

BRENKMAN, J., 'Mass media: from collective experience to the culture of privatization', *Social
Text*, no.1, winter, 1979, pp.94–100.

BRETON, A. and RIVERA, D. (TROTSKY, L.), 'Manifesto: Towards a free revolutionary art', *Partisan
Review*, vol.VI, no.1, fall, 1938, pp.49–53 (reprinted in Harrison and Wood, *Art in Theory,
1900–1990*, section IV.d.9).

BUCHLOH, B., 'Theories of art after Minimalism and Pop' in H. Foster (ed.), *Discussions in
Contemporary Culture*, Seattle, Bay Press, 1987.

CAMBELL, M.S., *Tradition and Conflict: Images of a Turbulent Decade, 1963–1973*, New York, Studio
Museum in Harlem, 1985.

CAUTE, D., *Sixty-Eight: The Year of the Barricades*, London, Hamish Hamilton, 1988.

CHAVE, A., 'Minimalism and the rhetoric of power', *Arts Magazine*, vol.64, no.5, 1990, pp.44–63
(an edited version is reprinted in Frascina and Harris, *Art in Modern Culture*).

CHOMSKY, N., *Language and Responsibility*, Hassocks, Harvester Press, 1979 (an edited version is
reprinted in Frascina and Harris, *Art in Modern Culture*).

CONWIL, K., interview with the author, 26 November 1991.

COX, A., *Art-as-Politics: The Abstract Expressionist Avant-Garde and Society*, Ann Arbor, UMI
Research Press, 1982.

CRANE, D., *The Transformation of the Avant-Garde: The New York Art World, 1940–1985,* Chicago and London, The University of Chicago Press, 1987.

DONDERO, G., 'Modern art shackled to Communism', *Congressional Record,* vol.95, Part 9, 81st Congress, 1st session, 16 August 1949, pp.11584–7 (an edited version is reprinted in Harrison and Wood, *Art in Theory, 1900–1990,* section V.c.14).

DONDERO, G., 'How the magazine *The Nation* is serving Communism (letters by Clement Greenberg relative to certain policies of the magazine, *The Nation and New Leader*)', *Congressional Record,* vol.97, Part 16, 82nd Congress, 1st session, 4 May 1951, pp.4920–21.

DUNCAN, C. and WALLACH, A., 'MOMA: ordeal and triumph on 53rd Street', *Studio International,* vol.194, no.988, 1978, pp.48–57.

EAGLETON, T., *The Function of Criticism: From 'The Spectator' to Post-Structuralism,* London, Verso, 1984.

FOSTER, H. (ed.), *The Anti-Aesthetic: Essays in Postmodern Culture,* Port Townsend, Bay Press, 1983.

FOSTER, H. (ed.), *Discussions in Contemporary Culture,* Seattle, Bay Press, 1987.

FOUGERON, A., interview with the author in January 1988 for The Open University, A324 *Liberation and Reconstruction: Politics, Culture and Society in France and Italy, 1943–54,* video-cassette *Art and Political Engagement, 1947–53.*

FRASCINA, F. (ed.), *Pollock and After: The Critical Debate,* London and New York, Harper and Row, 1985.

FRASCINA, F. and HARRIS, J. (eds), *Art in Modern Culture: An Anthology of Critical Texts,* London, Phaidon, 1992.

FRIED, M., *Three American Painters: Kenneth Noland, Jules Olitski, Frank Stella,* Harvard, Fogg Art Museum, 1965 (an edited version is reprinted in Harrison and Wood, *Art in Theory, 1900–1990,* section VI.b.8).

FRIED, M., 'Art and objecthood', *Artforum,* vol.V, no.10, 1967, pp.12–23 (an edited version is reprinted in Harrison and Wood, *Art in Theory, 1900–1990,* section VII.a.6).

FRIED, M., 'Caro's abstractness', *Artforum,* vol.IX, no.1, 1970, pp.32–4.

GILOT, F. and LAKE, C., *Life with Picasso,* London, Nelson, 1965.

GOLUB, L., 'The artist as an angry artist: the obsession with napalm', *Arts Magazine,* April 1967, pp.48–9.

GOLUB, L., interviews with the author, 21 December 1990 and 24 November 1991.

GORDON, M., 'Art and politics: interview with Carl Baldwin, Hans Haacke, Alice Neel, May Stevens, Leon Golub', *Strata,* vol.1, no.2, 1975, pp.6–11.

GRAMSCI, A., 'Americanism and Fordism', *Selections from the Prison Notebooks,* edited and translated by Q. Hoare and G. Nowell Smith, London, Lawrence and Wishart, 1971.

GREENBERG, C., 'Marc Chagall, Lionel Feininger, Jackson Pollock', *The Nation,* 27 November 1943, p.621.

GREENBERG, C., 'The present prospects of American painting and sculpture', *Horizon,* no.93–4, 1947, pp.20–30.

GREENBERG, C., 'The situation at the moment', *Partisan Review,* vol.XV, no.1, 1948, pp.81–4.

GREENBERG, C., 'The decline of Cubism', *Partisan Review,* vol.XV, no.3, 1948, pp.366–9 (an edited version is reprinted in Harrison and Wood, *Art in Theory, 1900–1990,* section V.a.9).

GREENBERG, C., 'The plight of our culture': Part I ('Industrialism and class mobility'), *Commentary,* vol.XV, June, 1953, pp.558–66; Part II ('Work and leisure under industrialism'), vol.XV, August, 1953, pp.54–62.

GREENBERG, C., 'American stereotypes', *Commentary,* vol.XXII, 1956, pp.379–81.

GREENBERG, C., 'The Jackson Pollock market soars', *The New York Times Magazine,* 16 April 1961, pp.42–43, 132 and 135.

GREENBERG, C., 'Modernist painting', 1961, Forum Lectures no.14, radio broadcast for The Voice of America, 1961 (reprinted in Frascina and Harris, *Art in Modern Culture,* and in Harrison and Wood, *Art in Theory, 1900–1990,* section VI.b.4).

GREENBERG, C., *Art and Culture,* Boston, Beacon Press, 1961.

GUILBAUT, S., 'The new adventures of the avant-garde in America', *October,* 15, winter 1980 pp.61–78 (an edited version is reprinted in Frascina and Harris, *Art in Modern Culture*).

GUILBAUT, S., *How New York Stole the Idea of Modern Art: Abstract Expressionism, Freedom and the Cold War*, Chicago and London, The University of Chicago Press, 1983.

GUILBAUT, S., 'Postwar painting games: the rough and the slick' in S. Guilbaut (ed.), *Reconstructing Modernism: Art in New York, Paris, and Montreal, 1945–1964*, Cambridge Mass., and London, MIT Press, 1990.

'Gurgles around the Guggenheim' (statements and comments by Daniel Buren, Diane Waldman, Thomas M. Messer and Hans Haacke), *Studio International*, vol.181, no.934, 1971, pp.246–50.

HAACKE, H., 'Catalogue of works: 1969–1986' in B. Wallis (ed.), *Hans Haacke: Unfinished Business*, New York, The New Museum of Contemporary Art and MIT Press, 1986.

HARRISON, C. and WOOD, P. (eds), *Art in Theory, 1900–1990*, Oxford, Blackwell, 1992.

HERRERA, H., *Frida Kahlo: The Paintings*, New York, Harper Collins, 1991.

HERSH, S., 'My Lai 4: a report on the massacre and its aftermath', *Harper's Magazine*, May 1970, pp.53–84.

HOBBS, R., *Robert Smithson: Sculpture*, Ithaca and London, Cornell University Press, 1981.

'Jackson Pollock: an artists' symposium': Part I, *Art News*, vol.66, no.2, 1967, pp.28–33 and 59–67; Part II, vol.66, no.3, 1967, pp.27–9, 69–71.

JAMESON, F., 'Postmodernism and consumer society' in H. Foster (ed.), *The Anti-Aesthetic: Essays in Postmodern Culture*, Port Townsend, Bay Press, 1983.

KELLY, M., interview with the author, 24 November 1991.

KLEIN, M., 'Mourning and its relation to manic depressive states', *The International Journal of Psycho-Analysis*, vol.21, 1940, pp.125–53.

KOZLOFF, M., 'A collage of indignation', *The Nation*, 20 February 1967, pp.248–51.

KOZLOFF, M., 'Art', *The Nation*, 29 April 1968, pp.578–80.

KOZLOFF, M., interview with the author, 26 November 1991.

KRAUSS, R., 'A view of Modernism', *Artforum*, vol.XI, no.1, 1972, pp.48–51 (an edited version is reprinted in Harrison and Wood, *Art in Theory, 1900–1990*, section VII.d.8).

LÉGER, F., 'Mural painting and easel painting', *Functions of Painting*, London, Thames and Hudson, 1973.

LEIDER, P., 'How I spent my summer vacation or, Art and Politics in Nevada, Berkeley, San Francisco and Utah', *Artforum*, vol.IX, no.1, 1970, pp.40–49.

LIPPARD, L., *From the Center: Feminist Essays on Women's Art*, New York, Dutton, 1976.

LIPPARD, L., *Mixed Blessings: New Art in a Multicultural America*, New York, Pantheon Books, 1990 (an edited version is reprinted in Frascina and Harris, *Art in Modern Culture*).

LIPPARD, L., *A Different War: Vietnam in Art*, Seattle, Whatcome Museum of History and Art and the Real Comet Press, 1990.

LIPPARD, L., interviews with the author, 15 December 1990 and 26 November 1991.

MEYER, K.E., *The Art Museum: Power, Money, Ethics*, New York, William Morrow and Company, 1979.

MORGAN, E.P., *The 60s Experience: Hard Lessons about Modern America*, Philadelphia, Temple University Press, 1991.

MORRISON, D., *Television and the Gulf War*, Institute of Communications Studies, University of Leeds, Academia Research Monograph 7, London, John Libbey, 1992.

MOTHERWELL, R., 'Jackson Pollock' (in 'Jackson Pollock: an artists' symposium', Part 1), *Art News*, vol.66, no.2, 1967, pp.28–33, 59–67.

MOTHERWELL, R. and ROSENBERG, H., editorial statement, *Possibilities*, 1, winter 1947/8 (reprinted in Harrison and Wood, *Art in Theory, 1900–1990*, section V.c.10).

MOULIN, R., *Le Marché de la peinture en France*, Paris, Éditions de Minuit, 1967.

MULVEY, L., 'A phantasmagoria of the female body: the work of Cindy Sherman', *New Left Review*, no.188, July/August, 1991, pp.136–50.

MULVEY, L. and WOLLEN, P., *Frida Kahlo and Tina Modotti*, exhibition catalogue, London, Whitechapel Art Gallery, 1982 (an edited version is reprinted in Frascina and Harris, *Art in Modern Culture*).

NAIFEH, S., *Culture Making: Money, Success and the New York Art World*, Princeton University Undergraduate Students, in *History: 2*, History Department of Princeton University, 1976.

NAIFEH, S. and WHITE SMITH, G., *Jackson Pollock: An American Saga*, London, Barrie and Jenkins, 1990.

O'CONNOR, F. and THAW, E., *Jackson Pollock: A Catalogue Raisonné of Paintings, Drawings and Other Works*, four volumes, New Haven and London, Yale University Press, 1978.

Orozco: 1883–1949, exhibition catalogue, Oxford, The Museum of Modern Art, 1980.

REISE, B., 'Greenberg and the group: a retrospective view': Part I, *Studio International*, vol.175, no.901, 1968, pp.254–7; Part II, vol.175, no.902, 1968, pp.314–16 (reprinted in Frascina and Harris, *Art in Modern Culture*).

ROBSON, D., 'The market for Abstract Expressionism: the time-lag between critical and commercial acceptance', *Archives of American Art Journal*, vol.25, no.3, 1985, pp.19–23.

ROSENBERG, H., 'The American action painters', *Art News*, vol.XL, no.8, 1952, pp.22–3, 48–50 (an edited version is reprinted in Harrison and Wood, *Art in Theory, 1900–1990*, section V.a.14).

ROSLER, M., 'Lookers, buyers, dealers and makers: thoughts on audience' in B. Wallis (ed.), *Art After Modernism: Rethinking Representation*, New York and Boston, The New Museum of Contemporary Art, and Godine Publisher Inc., 1984.

ROSLER, M., interview with the author, 24 November 1991.

SCHAPIRO, M., 'The liberating quality of avant-garde art', *Art News*, vol.56, no.4, 1957, pp.36–42.

SCHWARTZ, T., 'The politicization of the avant-garde': Part I, *Art in America*, vol.59, no.6, 1971, pp.97–105; Part II, vol.60, no.2, 1972, pp.70–79; Part III, vol.61, no.2, 1973, pp.69–71; Part IV, vol.62, no.1, 1974, pp.80–84.

SCHWARTZ, T. and AMIDON, B., 'On the steps of the Met', *New York Element*, vol.2, no.2, 1970, pp.3–4, 19–20.

SECKLER, D., 'Frontiers of space', *Art in America*, vol.L, no.2, 1962, pp.82–7 (an edited version is reprinted in Harrison and Wood, *Art in Theory, 1900–1990*, section VI.b.6).

SIEGEL, J., 'Carl Andre: artworker, in an interview with Jeanne Siegel', *Studio International*, vol.180, no.927, 1970, pp.175–9.

SMITHSON, R., 'A sedimentation of the mind: earth projects', *Artforum*, vol.VII, no.1, 1968, pp.44–50.

SPERO, N., interview with the author, 24 November 1991.

STEVENS, M., interview with the author, 24 November 1991.

SWENSON, G., 'The F-111: an interview with James Rosenquist', *Partisan Review*, vol.XXXII, no.4, fall, 1965, pp.589–601.

TROTSKY, L., 'Manifesto: Towards a free revolutionary art', 1938, in P.N. Siegel (ed.), *Leon Trotsky on Literature and Art*, New York, Pathfinder, 1970 (reprinted in Harrison and Wood, *Art in Theory, 1900–1990*, section IV.d.9).

TUCKER, M., interview with the author, 26 November 1991.

VARNEDOE, K., interview with the author, 12 December 1990.

WAGNER, A., 'Lee Krasner as LK', *Representations*, no.25, 1989, pp.42–57.

WALLACH, A., 'The Museum of Modern Art: the past's future' in Frascina and Harris, *Art in Modern Culture*.

WALLIS, B. (ed.), *Hans Haacke: Unfinished Business*, New York, The New Museum of Contemporary Art and MIT Press, 1986.

WEBER, M., 'Religious rejections of the world and their directions' in H.H. Gerth and C. Wright Mills (eds), *From Max Weber: Essays in Sociology*, London, Routledge, 1991.

WILLIAMS, R., 'Base and superstructure in Marxist cultural theory', *Problems in Materialism and Culture*, London, Verso, 1980.

WYE, D., *Committed to Print: Social and Political Themes in Recent American Printed Art*, exhibition catalogue, The Museum of Modern Art, New York, 1988.

MODERNITY AND MODERNISM RECONSIDERED
by Charles Harrison and Paul Wood

Modernist theory and Modernist art

In this chapter we shall review the establishment of Modernism as a paradigmatic theory and practice in the early 1960s and consider some symptoms and consequences of the apparent breakdown or abandonment of that paradigm during the later sixties and early seventies. We shall discuss some tendencies in the art of the later seventies and eighties, and conclude with a survey of some problems and questions which may be associated with the idea of the 'postmodern' in art.

Though the idea of 'modernism' as a particular quality or value in experience and culture can be traced back to nineteenth-century France, the particular resonance the term has acquired in art-critical debate owes much to the writing of Clement Greenberg and to the various reactions his writing has attracted. Though he had been publishing criticism regularly since 1939, Greenberg's influence on younger critics was at its height in the early sixties. His 'Modernist painting', first published in 1961 and reprinted in 1965, presented an ambitious body of ideas about art in a form which rendered those ideas both graspable and available for critical scrutiny. On the one hand, as the work of the Abstract Expressionists achieved public acclaim and market success, artists and critics looked to Greenberg as a source of judgements about art 'After Abstract Expressionism' (the title of an essay of 1962). On the other hand, his status as the Modernist critic *par excellence* made him a natural target for those looking to counter what they saw as the regulatory effects of Modernist priorities in both the practice and the criticism of art.[1]

It is more or less clear what we mean – or at least who we mean – when we talk about Modernist criticism. But to what extent can we talk of the establishment of a form of 'Modernist Art' – that's to say, not just modern art as retrospectively surveyed by Greenberg and by those whose views he helped to shape, but a tendency in art consistent with the criticism and intentionally sharing its priorities? The question deserves some consideration if we are properly to review the debates of the sixties, when those who most strongly objected to the priorities of Modernist criticism tended also to disparage the work of artists supported by Modernist critics.

The relations between art and art criticism are matters for open inquiry. We do not intend to suggest that if there is – or was – such a thing as Modernist art or Modernist painting, what it amounts to is a form of practice governed by the prescriptions of a critic. When we think about how art is thought about – including the ways in which it is thought about by artists – we refer both to the practice of art and to the deliberations of criticism.

[1] We use 'modernism' with a small 'm' to refer more or less neutrally to the property of being modern. We use 'Modernism' with a capital 'm' to refer to the critical tradition associated with Greenberg, a tradition in which the property of modernism is identified with a self-critical tendency intrinsic to art.

Plate 140 Morris Louis, *Saraband*, 1959, acrylic resin on canvas, 257 x 378 cm. Solomon R. Guggenheim Museum, New York. Photo: David Heald. © The Solomon R. Guggenheim Foundation, FN 64.1685.

Art is determined in a world beyond the studio, but it is also made from other art and from ideas about art. Artists need to be critics of their own work in progress, and may employ concepts of success and failure which are taken from or at least shared with those who talk and write about art. For some artists in the generation which followed the Abstract Expressionists, points of reference for a continuing practice clearly included both the work of Jackson Pollock and that conceptualization of Modernism for which Greenberg was largely responsible. There may be argument about whether or not these are the artists most worthy of attention, but this argument will be undecidable unless agreement can be reached on some set of criteria for deciding who is and is not 'worthy of attention'. What we can say with confidence is that by about 1960 the form of Modernist criticism with which Greenberg was identified seemed clearly compatible with a specific tendency in contemporary art.

This point is brought home if Greenberg's 'Modernist painting' is read with reference to works by artists in whose careers he was interested at the time this essay was written. Notable among these were the Washington-based artists Morris Louis (Plate 140) and Kenneth Noland (Plate 141), who had visited Greenberg together in New York in 1953 and whose paintings Greenberg had discussed in an article published in 1960, describing them as 'serious candidates for major status' ('Louis and Noland', p.27). The argument of 'Modernist painting' is not simply an account of the development of painting since Manet. It is also an attempt to represent that development retrospectively, in a manner which justifies and explains the contemporary paintings which Greenberg had been looking at and thinking about over a period of years. If one starts from Manet, that's to say, and if one

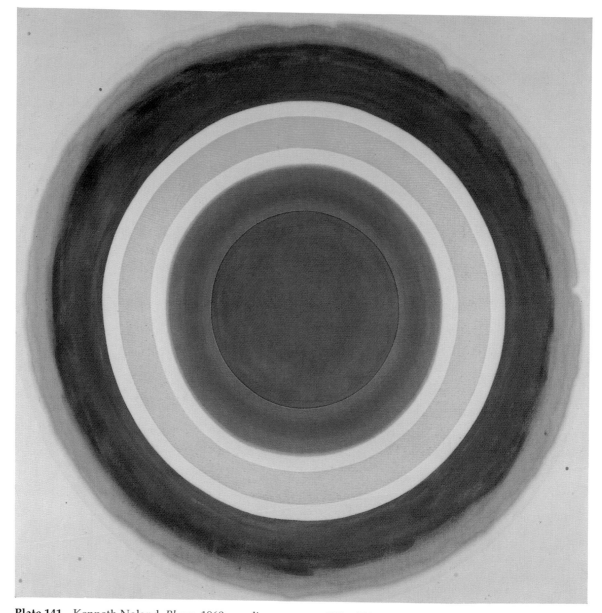

Plate 141 Kenneth Noland, *Bloom*, 1960, acrylic on canvas, 170 x 171 cm. Kunstsammlung Nordrhein-Westfalen, Düsseldorf. © Kenneth Noland/DACS, London/VAGA, New York 1993.

means to finish with Louis and Noland, then the idea of an increasing and progressive 'orientation to flatness' may serve as a kind of theoretical nexus by means of which both to bridge and selectively to *organize* the intervening developments in painting.

Louis's *Saraband* (Plate 140) and Noland's *Bloom* (Plate 141) were painted within one year of each other, and one or two years before the first publication of 'Modernist painting'. The two works are similar in many respects. Both are abstract, both are large (around two metres in height), and both are painted in acrylics. Unlike oils, acrylics will retain a high degree of saturation in a relatively liquid form (the pigment can be diluted or otherwise thinned down without that loss of brilliance in colour which would be unavoidable in oils). These are both paintings which exploit the properties of what was at the time a relatively new medium. In the mid-1950s Louis and Noland experimented together with

the effects which could be obtained by staining acrylic paints and dyes into unprimed cotton canvas. By the end of the decade, each was working in series, concentrating principally on a single type of motif – target shapes in Noland's case, and what came to be referred to as 'veils' in Louis's. In these paintings the artists' experiments were resolved into a distinctive and novel style of painting, to which Greenberg gave the label 'Post-Painterly Abstraction' – 'post-painterly' because in his view it both succeeded and contrasted with the 'painterly' style associated with Pollock, Still, Rothko and de Kooning.[2] For Greenberg, the literal identification of colour with the surface of the canvas 'conveys a sense not only of colour as somehow disembodied, and therefore more purely optical, but also of colour as a thing that opens and expands the picture plane' ('Louis and Noland', p.28). The loss of reference to the physical world, to the world of other bodies and other surfaces, is thus seen as leading to a compensating gain in the possibility of expression through the opening and expansion of the picture plane itself. Sheer size was necessarily a factor in this. In Greenberg's view Louis needed 'to have the picture occupy so much of one's visual field that it loses its character as a discrete tactile object and thereby becomes that much more purely a picture, a strictly visual entity' ('Louis and Noland', p.28).

If it is true that the tendency of modern painting – of 'ambitious' or 'major' modern painting at least – has been towards a gradual elimination of the illusion of three dimensions, then it could be said that these are paradigmatic modern paintings. Devoid as they seem to be of all that illusory space had formerly served to contain in the way of narrative, depiction and figuration, they appear to confirm the Greenbergian thesis that painting has had to concentrate upon what it shares with no other art form: its flatness, its address to 'eyesight alone'. Or at least, they may be said to confirm that thesis *so long* as they are regarded as the paintings most representative of the state of painting, most deserving of attention, most highly endowed, in fact, with aesthetic power, where the latter is seen as distinct from (though not necessarily unconnected with) moral or political virtue, normative interests and so forth. If, on the other hand, these paintings are judged to be insignificant and inferior in relation to other contemporary paintings, then either the thesis must be considered to have been undermined, or it must be held to be a thesis that – whatever claims it makes – is not really serving to pick out what's best in painting. As Greenberg himself put it in 1963, 'if these paintings fail as vehicles and expressions of feeling they fail entirely' (*Three New American Painters*). And if *none* of them succeeds, then, by implication, the thesis of 'Modernist painting' fails with them. (We might ask, of course, who is qualified to decide whether or not paintings succeed as vehicles of feeling, and on what basis they are supposed to do so. We can safely assume that the lay person who says, 'that just leaves me cold' will not necessarily count for Greenberg as a competent arbiter.)

Let's sum up. We start from a critical judgement made in about 1960 that the works of Louis and Noland are the best new paintings available to view. If we believe like Greenberg that aesthetic judgement is involuntary (see, for example, his 'Complaints of an art critic', pp.3–8) and taste 'objective' in the sense of disinterested, it should follow that the distinctive characteristics of these paintings are the kinds of characteristics we believe paintings have had to be given in order to sustain the level of quality expected of high art. In other words, they look like this because this is how paintings must be made to look *c*.1960 if they are to offer the viewer a sufficient degree of aesthetic power (or, as Greenberg expresses it at the close of 'Modernist painting', if they are to take their place in 'the intelligible continuity of taste and tradition', p.201). The task of the critic is then to explain how and why it is that these specific characteristics *are* the characteristics paintings must have in order to succeed *c*.1960. And that task will be a task of historical retrodiction, of retracing the supposed 'logic of development' by means of which these paintings may be

2 'Painterly' denotes a relatively informal style in which a high priority is placed on effects of colour and texture, as against one in which priority is placed on the form-defining properties of line.

connected to others whose status and aesthetic power are uncontroversially admitted – a category filled in Greenberg's 'Modernist painting' by the works of Manet.

What is noticeable about such writing is the close mutual implication it assumes between value judgement and historical account. The claim made by Greenberg and by those younger critics who followed him, notably Michael Fried, is that the history they construct is no more (and no less) than an attempt to perceive the tendencies and mechanisms which connect those works of art which happen to attain major status. What Modernism stands for in the criticism of art is not a particular set of judgements and preferences alone, then, nor a particular interpretation of the history of modern art alone, but rather a certain *relationship* between the one and the other. It follows that to talk of Modernist *art* is to assume a kind of practice which is governed by similar preferences and by a similar interpretation of modern art itself.

Because Modernist critics place an absolute priority upon what they view as the empirical test of quality – which they believe to be disinterested – they will also tend to distrust those approaches to art which prepare the way for reaction and response by setting the work of art within some social and historical context. Their methodology will rather be one which encourages concentration upon formal properties and effects, if necessary at the expense of attention to figurative or illustrative aspects, or of attention to the artist's recorded positions or intentions. They see this concentration not simply as a requirement in criticism but also as one determining the art under review; in other words, the modern artist who fails to accord priority to formal properties and effects will fail to produce art of the highest quality. As Michael Fried put it in a much-quoted passage:

> Roughly speaking, the history of painting from Manet through Synthetic Cubism and Matisse may be characterized in terms of the gradual withdrawal of painting from the task of representing reality – or of reality from the power of painting to represent it – in favour of an increasing preoccupation with problems intrinsic to painting itself. One may deplore the fact that critics such as Fry and Greenberg concentrate their attention upon the formal characteristics of the works they discuss; but the painters whose work they most esteem on formal grounds – e.g., Manet, the Impressionists, Seurat, Cézanne, Picasso, Braque, Matisse, Léger, Mondrian, Kandinsky, Miró – are among the finest painters of the past hundred years. This is not to imply that only the formal aspect of their works is worthy of interest. On the contrary, because recognizable objects, persons and places are often not entirely expunged from their work, criticism which deals with the ostensible subject of a given painting can be highly informative; and in general, criticism concerned with aspects of the situation in which art was made other than its formal context can add significantly to our understanding of the artist's achievement. But criticism of this kind has shown itself largely unable to make convincing discriminations of value among the works of a particular artist; and it often happens that those paintings that are most full of explicit human content can be faulted on formal grounds ...
>
> (Fried, *Three American Painters*, p.5)

The essay from which this quotation is taken was written in 1965 to introduce the exhibition Three American Painters: Kenneth Noland, Jules Olitski, Frank Stella, selected by Fried himself. In charting a line of succession from Manet to his own time – a present which included these three paintings – Fried was filling in the framework laid down by Greenberg's 'Modernist painting'. In the same year the recently-launched journal *Artforum* transferred its editorial offices from the West Coast to New York, and the new generation of 'Post-Greenbergian' Modernist critics acquired a kind of headquarters. Over the next three years Fried was to publish a series of articles in *Artforum* defending the works of the American painters Noland, Louis, Olitski (Plate 142) and Stella and of the English sculptor Anthony Caro.

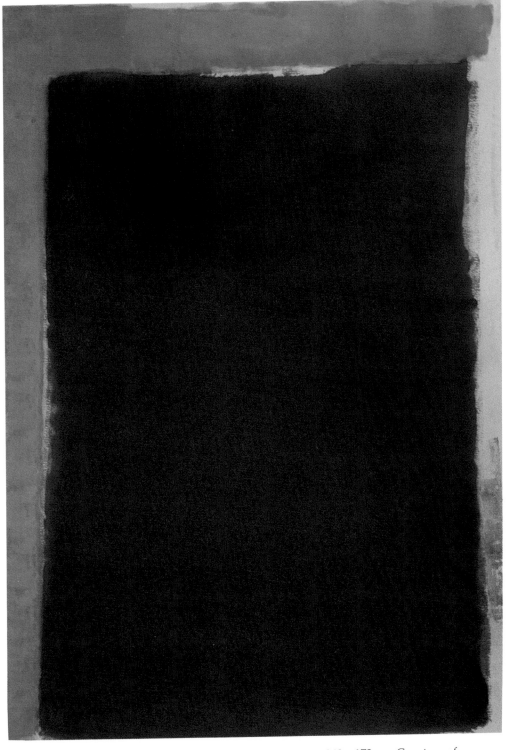

Plate 142 Jules Olitski, *Judith Juice*, 1965, acrylic on canvas, 249 x 173 cm. Courtesy of Salander-O'Reilly Galleries, New York. © Jules Olitski/DACS, London/VAGA, New York 1993.

Modernism in sculpture

If Louis and Noland may be considered paradigmatic Modernist painters, Caro appears in the criticism of the sixties as the paradigmatic Modernist sculptor. He had worked as an assistant to Henry Moore from 1951 to 1953 and for the rest of the decade had practised that form of expressive, figurative and modelled sculpture which was widespread in England and France at the time (see Plates 143 and 144). But like many English artists of his generation he had been deeply impressed by the works of the Abstract Expressionists, which were shown sporadically in London in the mid-1950s and featured in two large exhibitions of 1956 and 1959. He seems to have accepted that the work in question changed the terms of reference for all subsequent modern art and not just for painting, a conclusion reinforced by a visit to America in 1959 and by ensuing friendships with Greenberg and with Noland, his exact contemporary. In 1960 Caro completed his first surviving abstract work (Plate 145). The technique he used – welding together a selection of found steel elements – was one largely foreign to English sculptors at the time. There were clear precedents, however, in the work of Picasso, of Julio Gonzalez and, above all, of the American sculptor David Smith (Plate 146), whom Caro had met briefly on his trip to the US. The resulting configuration combined reference to Cubist collage with an echo of Noland's contemporary target paintings.

Caro's adoption of an abstract constructed style (Plate 147), which Greenberg was to call his 'breakthrough' ('Anthony Caro', p.116) has clear significance in relation to that moment of coherence of Modernist criticism with abstract painting which we discussed

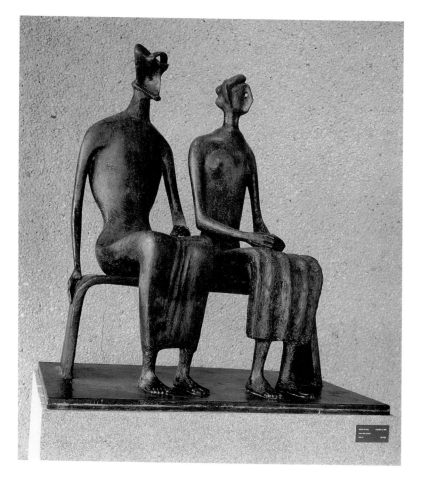

Plate 143 Henry Moore, *King and Queen*, 1952–53, bronze, 161 x 149 x 95 cm. Hirshhorn Museum and Sculpture Garden, Smithsonian Institution, Washington, Gift of Joseph H. Hirshhorn, 1966, HMSG 66.3635. Reproduced by kind permission of the Henry Moore Foundation.

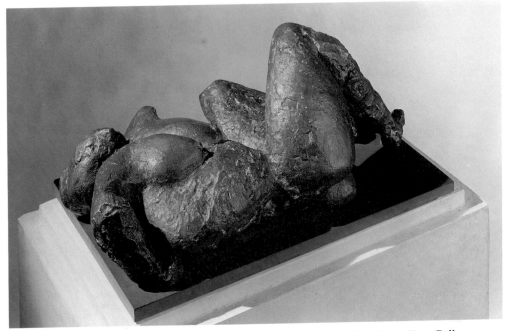

Plate 144 Anthony Caro, *Woman Waking Up*, 1955, bronze, 27 x 68 x 35 cm. Tate Gallery, London. By permission of the Trustees of the Tate Gallery.

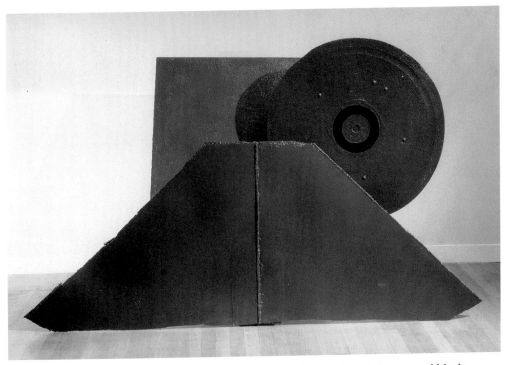

Plate 145 Anthony Caro, *Twenty Four Hours*, 1960, steel painted dark brown and black, 138 x 223 x 79 cm. Tate Gallery, London. By permission of the Trustees of the Tate Gallery.

Plate 146 David Smith, *Five Spring*,
1956, steel, stainless steel and nickel,
197 x 91 x 37 cm. Photograph by
courtesy of the Tate Gallery, London.
© Estate of David Smith/DACS,
London/VAGA, New York 1993.

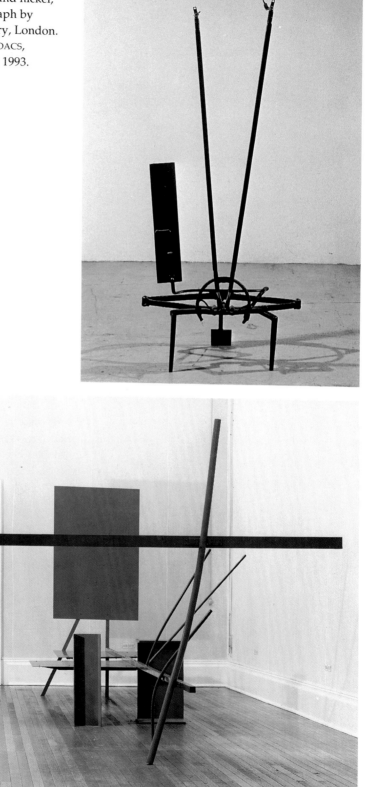

Plate 147 Anthony Caro,
Early One Morning, 1962, steel
and aluminium painted red,
290 x 620 x 333 cm. Tate Gallery,
London. By permission of the
Trustees of the Tate Gallery.

earlier. In this context two particular texts are deserving of note. The first is an essay by Greenberg on collage, originally published in 1958, shortly before his first meeting with Caro. In it he had discussed the formation of 'a new genre of sculpture' through the techniques of Cubist collage and construction:

> Construction sculpture was freed long ago from its bas-relief frontality and every other suggestion of the picture plane, but has continued to this day to be marked by its pictorial origins. Not for nothing did the sculptor-constructor Gonzalez call it the new art of 'drawing in space'. But with equal and more descriptive justice it could be called ... the new art of joining two-dimensional forms in three-dimensional space.
>
> (Greenberg, 'Collage', p.107)

The second reference is the revision by Greenberg of a ten-year-old essay on 'The new sculpture'. (The revision was made for republication of the essay in Greenberg's collection *Art and Culture*, 1961; the original version was published in *Partisan Review*, June 1949.) Among the most significant of Greenberg's additions was the conclusion that 'sculpture – that long eclipsed art – stands to gain by the modernist "reduction" as painting does not', and that sculpture would acquire the status of 'the representative visual art of modernism', so long as it provided 'the greatest possible amount of visibility with the least possible expenditure of tactile surface' (*Art and Culture*, p.140). According to the proposals which these two essays offered, what was required for an authentically Modernist sculpture was that it should be constructed rather than modelled or carved, and that it should follow the tendency of Modernist painting in abjuring the physical and refining the 'purely visual'. Given the respect in which Greenberg was then held among the English artists with whom Caro was associated, and given the desire which Caro clearly felt to open his practice to the implications of American painting, it is likely that the sculptor would have informed himself about these proposals and taken them to heart. Greenberg, in his turn, was bound to be favourably disposed to a form of sculpture which he could relate to David Smith's. Certainly, both Greenberg and Fried responded with enthusiasm to the abstract constructed sculpture which Caro produced throughout the sixties.

At the time of the technical change in his work, Caro was teaching at St Martins School of Art in London. A group of younger sculptors developed around him there, whose work and interests were for a while clearly compatible with those of the American painters. An exhibition of their work was shown at the Whitechapel Art Gallery in 1965 as one of a series of surveys under the title 'New Generation' (Plate 148). For a short while in the mid- to late sixties an apparently common abstract tendency within American painting and British sculpture was singled out as the authentic and dominant form of a transatlantic 'Modernist Art'. The tendency was supported as such by a number of committed critics for all of whom Clement Greenberg had been an influential model of the engaged writer on art.

According to the Greenberg of 'Modernist painting', abstractness as such had still not proved to be necessary to the 'self-critical' tendency of pictorial art. His point was rather that the kind of imaginary depth necessary to support figuration led to a compromising of painting's 'uniqueness' as a medium. Similarly, the development which Fried observed in his *Three American Painters* was not specifically a move towards abstraction in painting but rather 'an increasing preoccupation with problems intrinsic to painting itself' (p.5). In fact, the theoretical positions of both writers depended on the conviction that the true high art of the time was abstract art. On these grounds we may consider them as representative of a distinctly 'abstractionist' form of Modernist theory, which both responded to and found a response in those advanced forms of Modernist abstract art practised in the sixties by the painters Kenneth Noland and Jules Olitski, by the sculptor Anthony Caro, and by many other artists with less well-established careers.

Plate 148 Installation view,
New Generation exhibition,
Whitechapel Art Gallery,
London 1965. Photo: Martin
Koretz.

Critical theory and cultural agency

We have discussed the apparent coherence of a putatively 'Modernist' painting, sculpture
and criticism during the early sixties. It has to be recognized that this apparent coherence
was achieved at the expense of a series of exclusions. To put the matter another way, we
might say that to accept the principal findings of Modernist criticism in the sixties is to as-
sent to the following tenets:

1 that what matters most in art and in criticism is the pursuit and identification of qual-
 ity – that is, quality understood as an unquestionable, ineffable and self-sufficient
 measure in experience, not simply as meaning adequacy of craftsmanship or richness
 of reference to the world or effectiveness in relation to some practical end;

2 that so far as the modern period is concerned, modernism is a necessary condition of
 quality in high art (so that while there may be virtue in certain conservative forms of
 art, they will never attain 'major' quality);

3 that so far as concerns the specific period under review, the possibility of quality in
 high art is to be associated with those forms of abstract painting and sculpture for
 which the works of Noland and Caro respectively may be taken as paradigms.

In principle, it is possible to subscribe to any one of these tenets without the others. We
might believe that quality, or what we would prefer to conceive of as 'aesthetic power' is
what matters most in art, but that it is not to be found to any remarkable degree in the
works of Noland or Caro. We might believe that modernism is a necessary condition of
aesthetic power, but see it as exemplified in the work of different artists: Jasper Johns

(Plate 154) and Andy Warhol (Plate 179), for instance, artists who have both been disparaged in Modernist criticism. Or we might believe that the works of Noland and Caro are indeed remarkable, but that they are not remarkable in the way that Modernist critics have suggested. We might decide, for example, that what distinguishes them is not their expression of intense feeling through abstract form, but rather an appearance of brash modernity and synthetic technical effectiveness which they might be thought to share with contemporary Pop Art.[3] In practice those who have not been convinced of the aesthetic power of these works and of the necessity of their abstraction have rarely found any other strong reasons for being interested in them, while those accustomed to applying some other measure to art than the Greenbergian test of quality of effect have tended to see the works of Noland and Caro alike as merely symptomatic objects – symptomatic, perhaps, of a culture in which class- or gender-based preferences are dignified and mystified with the status of objective taste.

Two points should immediately become clear from any adequate review of the wider history of modern art during the later fifties and sixties. The first is that the appearance of coherence and cohesiveness associated with the abstractionist tendency is maintained at the expense of other artists and tendencies that are derogated, marginalized or simply ignored in Modernist criticism. The forms of so-called Pop Art prevalent in England from the later fifties (for example, Plate 149) and in New York from the early sixties (Plate 150) are all figurative, although their imagery is typically taken at second hand. That's to say their imagery is derived from the world of advertisements, comics, films and other forms of mass publication, where figures, objects, landscapes and so forth are already accorded a representational aspect. This derivation cannot be dismissed, as a naïve form of Modernism might suggest, simply as an avoidance of the requirement of originality. Rather, its intended function was generally to re-effect an engagement of fine art with a wider culture. The second point is that there is a considerable body of work, also disparaged or ignored in Modernist criticism, which evades any simple categorization as either painting or sculpture. A great deal of the avant-garde art of the later fifties and sixties has had to be categorized under different terms, for example, as 'assemblage' (Plate 151), as 'performance' or happening (Plate 152), or as 'installation' (Plate 153). Some of these forms will be discussed further in later sections.

In talking about Modernist criticism and its exclusions we should be clear about the relations between different forms and senses of Modernism. We understand the Modernism discussed in the previous section as the late form of a significant critical tradition, which offers a certain theorized account of the development of modern art, which is closely connected to the practice of art, and which has been informative to specific types of practice. Its representations, arguments and judgements are open to examination. But the term 'Modernism' is also used to refer to a broader, more informal and less discriminating set of attitudes towards and beliefs about modern art, and even to refer to those practices on the part of writers and institutions in which these attitudes and beliefs are given effect. Thus we might talk of a Modernist gallery or exhibition, of a Modernist curator or art historian, of a Modernist monograph or review, and in none of these cases would we have in mind the *explicit* formulation of a theoretical position. Rather, we would be implying that the ideas and values which are given effect through such 'Modernist' agencies are consistent with those expressed in the Modernist tradition of criticism, and perhaps – though not necessarily – that these ideas and values are traceable to the influence of Modernist critical theory. But we need to be careful. The forms of valuation used to facilitate the *distribution* of artistic culture are often travesties, if not outright contradictions, of those employed in the *critical analysis* of specific bodies of work. To attribute the character of

[3] Rosalind Krauss makes a suggestion along these lines in her essay 'Theories of art after Minimalism and Pop', pp.60–1.

Plate 149 Richard Hamilton, *$he*,
1958–61, oil, cellulose and collage on
panel, 122 x 81 cm. Tate Gallery, London
© Richard Hamilton 1993

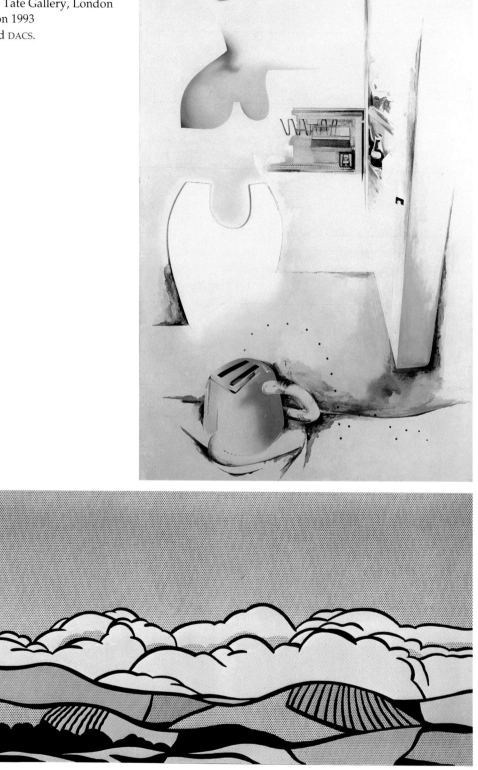

Plate 150 Roy Lichtenstein, *Sussex*, 1964, oil and magna on canvas, 91 x 173 cm. Collection of
Dr and Mrs Robert Rosenblum, New York. © Roy Lichtenstein/DACS 1993.

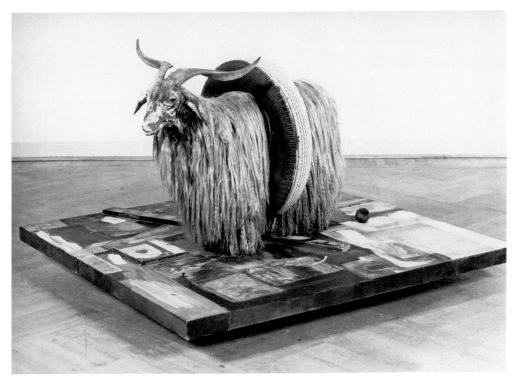

Plate 151 Robert Rauschenberg, *Monogram*, 1955–59 mixed media, 122 x 183 x 183 cm.
Moderna Museet, Stockholm, Photo: Statens Konstmuseer. © Robert Rauschenberg/DACS,
London/VAGA, New York 1993.

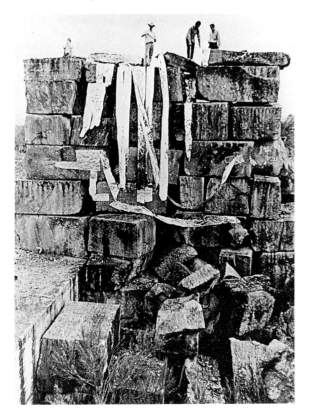

Plate 152 Allan Kaprow, *Record 11*,
Austin, Texas, 1968. Photograph
courtesy of the artist.

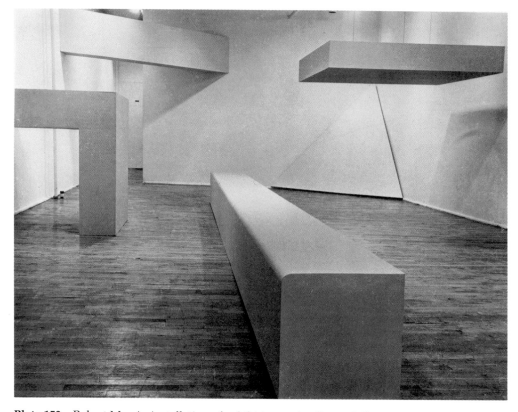

Plate 153 Robert Morris, installation of exhibition at the Green Gallery, New York, December 1964. Photograph reproduced by permission of the artist.

Modernism as a form of *cultural agency* entirely to the influence of Modernism as a form of *critical theory* would be to ignore substantial differences in the determining conditions of each. The curator of a 'Modernist' museum, for example, might have grounds on which to exhibit or acquire works of a kind that the writer of Modernist criticism would not countenance. It would be misleading, then, to form conclusions about the tendency of the criticism simply on the basis of the museum display. At the very least we would have to recognize that such displays can be revealing of other kinds of tendency – for example those bearing specifically on the management of museums, some of which may run counter to the values expressed in the critical theory.

In talking of the exclusions of Modernism, then, we need to recognize that these may be of different orders under different conditions, and may not function in the same ways in different Modernist practices. Thus, for example, if the curator and art historian Alfred H. Barr junior and the critic Clement Greenberg are both to be discussed as Modernists, there will be severe limits on the kinds of generalizations that can be offered about the Modernist representation of modern art, since the judgements and decisions to which Barr gave practical effect were by no means all of a kind that Greenberg would have endorsed. The fortunes of Jasper Johns and of the American Pop Artists are cases in point. Johns' first one-man show in 1958 was undoubtedly successful and since then he has generally been accorded a major role in the development of American art. But while both Greenberg and Fried gave serious attention to his work during the early sixties, both ended by denying it the status of 'major art'. If this disparagement did anything to delay Johns' incorporation within 'Modernist' institutions and 'Modernist' art history, it is hard to see how. The Pop artists Warhol and Lichtenstein were both established as major avant-garde

figures by the mid-sixties, despite Greenberg's stigmatization of their work as 'novelty art', undistinguished by any real 'newness' (see, for example, Lucie-Smith, 'An interview with Clement Greenberg', p.5).

There are two points to be made in this connection. Firstly, as we have already suggested, criticism in the Modernist tradition has *always* been highly selective in its account of modern art. There have consistently been 'others', forms of art viewed as avant-garde within the broad field of modern art, but continuously marginalized by Modernist criticism: the work of the Dadaists, developments in photomontage during the twenties, and Russian Constructivism, for example. This very exclusiveness is the principal characteristic by which different contributors to the Modernist critical tradition may be recognized as such and connected. Inevitably, however, different principles of selection, and sometimes of exclusion, have been at work in art history, in curatorship and in art-world commerce, even where these have been subject to the influence of Modernist criticism. Alfred Barr, for instance, was interested in Russian Constructivism in the late twenties and mounted a large exhibition of Dada and Surrealist art at the Museum of Modern Art in 1937. Many of the practices marginalized in Modernist critical theory have been incorporated into the narratives of art history and the representations of modern art institutions as a less specialized Modernist *culture* has expanded the territory of its legitimation. But it may be noted that such initiatives as those of Dada and Russian Constructivism have not generally been represented in the institutions of Modernist culture in the spirit in which they were originally undertaken: as forms of opposition and of alternative to capitalism and to its representative systems of evaluation.

The second point is that – with the benefit of hindsight – the American avant-garde itself can be seen to have been dividing or fragmenting as early as the early fifties; that's to say from immediately after that point in the later forties when various members of the small Abstract Expressionist avant-garde, notably Pollock, achieved stylistic individuality and coherence in their work. While the works of Louis and Noland and even of Caro may be seen from a Greenbergian perspective as forms of continuation of the expressive character, the improvisatory technique, and the abstractness of Pollock's work of 1947–50, other artists during the fifties – notably Jasper Johns and Robert Rauschenberg – treated the legacy of Abstract Expressionism differently, as if the very possibility of expression had been exhausted, as if colour, texture, contrast, brushstroke and so forth were no longer conceivable as 'vehicles of feeling' but had to be treated as the conventional components of manifestly artificial schemes. In *Painting with Two Balls* (Plate 154), Johns appears to parody the notion of painting as a form of virile action independent of the conventions of language.[4] Rauschenberg makes a painting, *Factum I* (Plate 155), using apparently random juxtapositions and 'spontaneous' brushstrokes to produce an original configuration; but he then makes another version, virtually the same, *Factum II* (Plate 156), thus putting in question the very notions of randomness, spontaneity and originality.

It is arguable that Johns and Rauschenberg were addressing the conditions of *vulgarization* of modern art, its legitimation as a consumable form of high culture. In turn, their own representation of this state of affairs laid claim to the status of avant-garde art. The increasing divergence of opinion and valuation discernible during the sixties between orthodox Modernist criticism and a broader Modernist culture of modern art may have had its roots in a significant divergence in artistic practices during the previous decade.

Two important questions seem to us to be raised in and by the American art of the later fifties and early sixties. The first is whether the continuing task of self-criticism, as conceived by Greenberg, was to find technical means to maintain the possibility of expression (of feeling), or whether the expressive resources of art had become inescapably

4 For further arguments along these lines see Harrison and Orton, 'Jasper Johns: meaning what you see'.

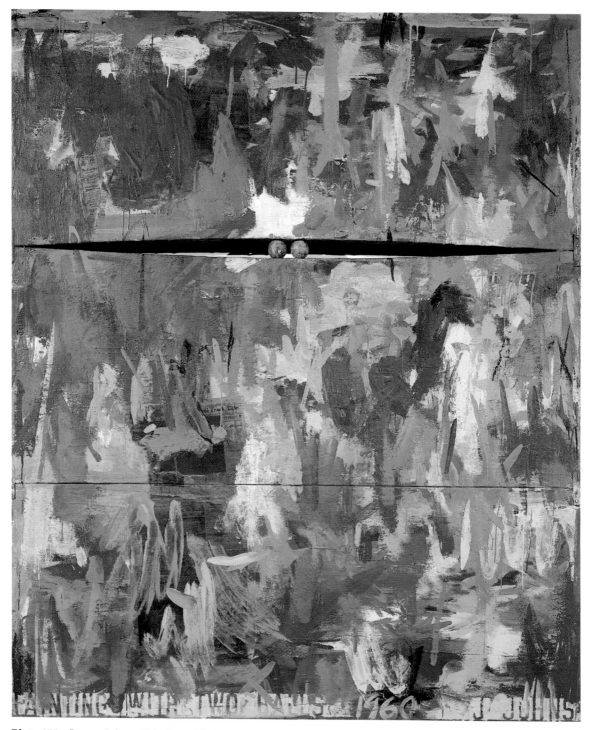

Plate 154 Jasper Johns, *Painting with Two Balls*, 1960, encaustic and collage on canvas with objects, 165 x 137 cm. Artist's collection. Photograph by courtesy of the Leo Castelli Gallery, New York © Jasper Johns/DACS, London/VAGA, New York 1993.

Plate 155 Robert Rauschenberg, *Factum I*, 1957, combine painting, 157x 90 cm. Private Collection. Photograph by courtesy of the Leo Castelli Gallery, New York © Robert Rauschenberg/DACS, London/VAGA, New York 1993.

Plate 156 Robert Rauschenberg, *Factum II*, 1957, combine painting, 156 x 90 cm. Private Collection. Photograph by courtesy of the Leo Castelli Gallery, New York © Robert Rauschenberg/DACS, London/VAGA, New York 1993.

conventionalized, so that the task of self-criticism was rather to discover adequate and practical forms of irony, negation and refusal. The second question is whether the major critical resources and possibilities of art were still to be associated with the traditions of painting and sculpture respectively, or whether these were now to be regarded as obsolete and redundant forms of specialization and thus as effective *limits* on the development of art and upon its potential relevance to the conditions of modern existence. During the sixties and later, these questions were addressed and argued over within the restricted contexts of art magazines and catalogue essays, but their various implications extended well beyond the world of art. Since the mid-sixties, wider historical and political issues have often made themselves felt within the context of artistic debate in the specific form of controversies over the status of Modernism and of its favoured technical categories.

A counter-tradition?

A distinct challenge to the authority of the 'abstractionist' account of modern art was offered in the mid-sixties by those American artists who came to be grouped together as Minimalists. (The designation is misleading in many respects, and each of the artists concerned has at one time or another tried explicitly to reject the identification. Like many such labels it has stuck nevertheless.) Donald Judd started as a painter, but by 1963 was making free-standing objects with box-like and frame-like forms (Plates 157, 158). In 1965 he wrote a review of recent developments in art, published under the title 'Specific objects', which proposed the new technical category of 'three-dimensional work' in the face of what he saw as the now inevitable conservatism of painting and sculpture:

> Half or more of the best new work in the last few years has been neither painting nor sculpture. Usually it has been related, closely or distantly, to one or the other. The work is diverse, and much in it that is not in painting and sculpture is also diverse. But there are some things that occur nearly in common ... The disinterest in painting and sculpture is a disinterest in doing it again ...
>
> (Judd, 'Specific objects', p.74)

Two years later the artist Robert Morris provided some detail to the 'Minimalist' case against painting (examples of his own work are shown in the installation in Plate 153):

Plate 157 Donald Judd, installation at the Green Gallery, New York, December 1963. Photo courtesy of the Paula Cooper Gallery, New York, photograph by Rudolph Burkhardt. © Don Judd 1989.

Plate 158 Donald Judd, *Untitled*, 1963–75, metal lath and wood with light cadmium red oil paint, 183 x 264 x 124 cm. National Gallery of Canada, Ottawa. © Donald Judd.

The trouble with painting is not its inescapable illusionism *per se*. But this inherent illusionism brings with it a non-actual elusiveness or indeterminate allusiveness. The mode has become antique. Specifically what is antique about it is the divisiveness of experience which marks on a flat surface elicit. There are obvious cultural and historical reasons why this happens. For a long while the duality of thing and allusion sustained itself under the force of profuse organizational innovations within the work itself. But it has worn thin and its premises cease to convince. Duality of experience is not direct enough. That which has ambiguity built into it is not acceptable to an empirical and pragmatic outlook …

(Morris, 'Notes on sculpture 3: notes and non sequiturs', p.25)

Morris shared with Judd a belief that one current task for a modern art was to achieve emancipation from the notion that composition involved a process of relating of parts. Both Judd and Morris tended to see the 'relational' concept of composition as a now dispensable part of the legacy of the European tradition, though as early as the later fifties the French avant-gardist Yves Klein had been motivated by a similar distaste for the relational to produce a series of 'pure' monochrome paintings (Plate 159).[5] Judd criticized Caro's work for what he saw as its 'Cubist fragmentation' (Judd, 'Complaints part 1', p.183). For

5 Klein's arguments on this subject can be found in his 'Sorbonne lecture'.

Plate 159 Yves Klein, *Monochrome blanc M69* (*White Monochrome M69*), 1958, oil on canvas, 50 x 100 cm. Musée National d'Art Moderne, Centre George Pompidou, Paris. © ADAGP, Paris and DACS, London 1993.

Morris, the new 'three-dimensional work' emerged from less artistic and less specialized processes of making and forming:

> Such work which has the feel and look of openness, extendibility, accessibility, publicness, repeatability, equanimity, directness, immediacy, and has been formed by clear decision rather than groping craft would seem to have a few social implications, none of which are negative. Such work would undoubtedly be boring to those who long for access to an exclusive specialness, the experience of which reassures their superior perception.
>
> (Morris, 'Notes on sculpture 3: notes and non sequiturs', p.29)

Morris was effectively accusing the Modernist critics of élitism. The accusation may seem justified in certain respects, but we should consider the physical objects Morris proposed to put in place of the 'exclusive' ones of the Modernists' regard: for example, *Untitled* (Plate 160), which he included in the illustrations to his 'Notes and non sequiturs' from which the above quotations are taken. Whatever this may be, it is not an object likely to have appeared immediately interesting and attractive to the uninformed lay person.

In defence of works such as these, it might be said that their appearance is not the principal point – that they are explicitly intended to frustrate that form of regard which delights in complex phenomenal effects and inventive compositional relations. Their particular identity lies rather in the processes by which they have been formed and the materials of which they are made. What Morris seems to be proposing is a shift in priorities, a change in the way we identify some object as an *art object*. Indeed what seemed increasingly to be at stake in the art-critical debates of the later sixties was whether 'art' required 'objects' at all.

Morris's 'Notes and non sequiturs' was the third in a series of 'Notes on sculpture' which he wrote between 1966 and 1969. It was published in *Artforum* in the summer of 1967 in a special issue on American sculpture. That issue also contained a long essay by Michael Fried, under the title 'Art and objecthood', which was at once a sustained attack on the ideas of the Minimalists as he understood them and an impassioned defence of the values of abstractionist Modernism. If they had not been aware of it before, readers of *Artforum* were presented with powerful evidence of a deep schism within the professional world of modern American art. So what were the issues and what was at stake?

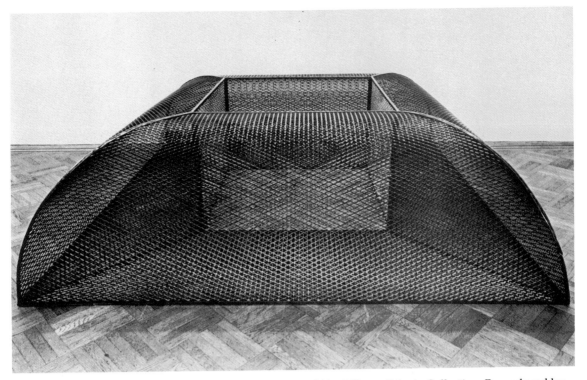

Plate 160 Robert Morris, *Untitled*, 1967, steel mesh, 79 x 269 x 269 cm. Private Collection. Reproduced by permission of the artist.

Literalism and presentness

Fried's argument is based on the distinction which he makes between two different modes of experience. In one the spectator perceives an object as that which it literally is, something existing in space and time. The experience is then of interest to the extent that the relationship between spectator and object can be invested with drama; that is to say, to the extent that that relationship can be made 'theatrical'. In the other mode of experience the spectator is engaged by a formal configuration which appears as if 'instantaneously present', so that the sense of time and place is suspended. In the former case the relations which matter are those governing the *interaction* between spectator and object; in the latter what matters are those *internal relations* which give the work of art its own identity (in the eyes of the suitably alert and sympathetic spectator).

For Fried it is this second mode of experience that is ushered in by authentic Modernist art. The Minimalists, on the other hand, are 'literalists', makers of 'mere' objects, the effects of which depend upon the setting-up of what Fried calls 'theatrical' conditions – conditions conducive to forms of physical and psychological *self*-awareness. The effect he values is that supposed *loss* of the sense of self which he associates with absorption in the enduring 'present' of the work of art. He claims that 'theatre and theatricality are at war today, not simply with modernist painting (or modernist painting and sculpture), but with art as such – and to the extent that the different arts can be described as modernist, with modernist sensibility as such' ('Art and objecthood', p.21). He breaks this claim down into three succinct theses:

(1) The success, even the survival, of the arts has come increasingly to depend on their ability to defeat theatre. ...

(2) Art degenerates as it approaches the condition of theatre. ...

(3) The concepts of quality and value – and to the extent that these are central to art, the concept of art itself – are meaningful, or wholly meaningful, only *within* the individual arts. What lies *between* the arts is theatre.

(Fried, 'Art and objecthood', p.21)

Fried's model of aesthetic virtue is a typical work by Caro, which he sees as establishing its distinct identity as a sculpture 'instantaneously', by virtue of its internal relations, its syntax, from whatever position it may happen to be viewed. In defeating the condition of theatre, the authentic work of Modernist art suspends both the sense of its literal object-hood and the engaged spectator's awareness of time as duration. Fried's conclusion is worth quoting in full.

This essay will be read as an attack on certain artists (and critics) and as a defence of others. And of course it is true that the desire to distinguish between what is to me the authentic art of our time and other work, which, whatever the dedication, passion, and intelligence of its creators, seems to me to share certain characteristics associated here with the concepts of literalism and theatre, has largely motivated what I have written. In these last sentences, however, I want to call attention to the utter pervasiveness – the virtual universality of the sensibility or mode of being that I have characterized as corrupted or perverted by theatre. We are all literalists most or all of our lives. Presentness is grace.

(Fried, 'Art and objecthood', p.23)

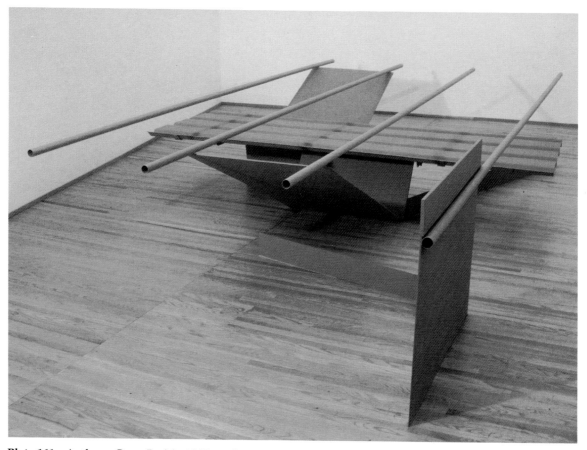

Plate 161 Anthony Caro, *Prairie*, 1967, steel painted matt yellow, 96 x 582 x 320 cm. Private collection. Photograph by courtesy of Barford Sculptures.

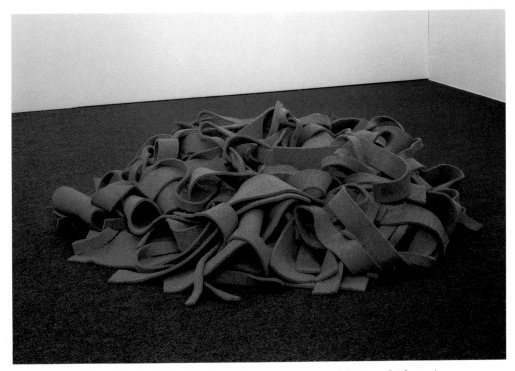

Plate 162 Robert Morris, *Untitled*, 1967–68, 264 pieces of tan felt 1 cm thick, various dimensions. National Gallery of Canada, Ottawa. Reproduced by permission of the artist.

Whatever else it may be taken to be, this is clearly a claim for the autonomy of aesthetic experience and for the centrality of that experience to the meaning of human existence. How far was Fried justified in his criticism of the Minimalists? Did he correctly diagnose an absence of aesthetic power in their work; or were the virtues of the work such that his own aesthetic prejudices simply prevented him from perceiving them?

We can explore these questions further by a comparison of specific works. When Caro's *Prairie* (Plate 161) was exhibited in London in the autumn of 1967 it was greeted by Fried as a masterpiece, the finest work of art by an Englishman since Constable (in conversation with Charles Harrison at the time). *Untitled* (Plate 162) is a work in felt by Morris. The first works in this series were also made in 1967; they initiated the artist's exploration of what he called 'anti-form' (see Morris, 'Anti-Form' and 'Notes on sculpture 4: beyond objects').

The immediate impression on first seeing *Prairie* is that the four parallel poles are hovering in the air. The rest of the structure serves to establish the conditions of this illusion. In fact one of the poles is welded to the vertical face of a standing plate, another is fixed at either end where it rests on the outward-slanting plates, thus tying the structure together, while the remaining two, in apparent contradiction of physical laws, are supported only at a single point near to one end. Stress is reduced by weighting the short ends of these poles. Close examination reveals a junction in each of them, on the longer side of the weld. This method of construction partially enables the arrangement which the work presents. But the evidence of that same method of construction is concealed beneath a uniform skin of paint. The suggestion is thus made that the junction is irrelevant to the *appearance* of the sculpture. A competent engineer could work out how the sculpture was made, and could make some deductions about how it must be put together. And yet that form of reconstruction seems somehow inappropriate to what must be the intended *effect*

Plate 163 Kenneth Noland, *Magus*, 1967, acrylic on canvas, 225 x 686 cm. Property of Mr and Mrs David Mirvish, Toronto. © Kenneth Noland, DACS, London/VAGA, New York 1993.

of the work, which is the effect of something visually complex but perceived as an indivis-ible whole. That close examination which reveals the point of junction in the poles – and thus the actual break in their apparently continuous extension – is not the kind of exam-ination which the appearance of the work invites. Another way to put this would be to say that a kind of truth to the vision or *idea* of the work has been given precedence over what has been called 'truth to materials'.[6] Of course *Prairie* is a kind of object. But viewed as a work of Modernist art, it exists to be the object of *vision* and as such to be both 'instan-taneous' and 'inexhaustible': 'instantaneous' in the sense referred to earlier – because its identity is supposedly grasped at once and as a whole by the stationary spectator – and 'inexhaustible' because of the incomparable 'rightness' of its relations. For the abstraction-ist critic this 'rightness' has nothing to do with the sculpture's establishment of any figur-ative reference – for example reference to the kind of wide-open landscape the title might suggest. On the contrary, if such a reading had to be seen as integral to the meaning of the work, the abstractionist critic would regard it as compromising to that work's identity as *sculpture*, just as Noland's contemporary and compatible works (for example, Plate 163) would be compromised in their identity as paintings were they to invite viewing as kinds of picture. (In fact, 'Prairie Gold' was the manufacturer's name for the particular paint-colour Caro selected. Though we might want to say that the name cannot now be entirely divorced from the *effect* of the sculpture, that name does seem to have been adopted far too late in the process of composition to have been determining upon the sculpture's *shape*. According to Caro's own testimony (in D. Waldman, *Anthony Caro*, p.61) the sculpture was painted blue at one stage.)

Morris's work presents a number of points of contrast. It is not composed as a devel-oping set of formal relationships between different constituents. It is all made of one material, felt, and by one process, cutting. The work simply is the result of applying that process to that material. We can make certain further deductions. For example, the fact that the strips are of different lengths and different widths suggests that the process was relatively informal and applied without mechanical regularity. In the face of this work, it would seem inappropriate to talk about the realization of a vision or about the rightness of its relations. On the one hand, what is visible is of little interest on grounds of formal ingenuity or complexity; on the other, the specific relations between the various material

[6] 'Truth to materials' was particularly associated with the Arts and Crafts movement and subsequently with the extension of its ethos into the practice of sculpture. According to this doctrine, a work made in wood ought to have a form and surface proper to that material; a work in stone ought to exhibit rather than conceal the properties of hardness, brittleness, etc.

parts are presumably subject to change. To transport the work from one viewing situation to another must inevitably be to alter the specific formal arrangement under which the spectator can come to know it. If the work is interesting as a kind of idea it must presumably be because it displaces our attention from the finished object of art to the process whereby materials take form – to just that point of interaction between intentions and materials, in fact, which *Prairie* conceals beneath its skin of paint.

Prairie has one proper visible form, which both generates and corresponds to the form apprehended by the competent viewer. Its materials exist as the materials of art, in so far as they are the bearers of that apprehended or intuited form. The components of Morris's felt piece, on the other hand, could be given an infinite number of possible forms, some of which would presumably still be forms of that work of art. In fact, we might say that to come to know the work is to sense which among the conceivable arrangements of its components would count as arrangements of the form of the work, and which would not. Does it have to take the form of a pile? Could the pieces be scattered around the room? Or around two rooms? Or around a field? Could they be hung on a line? For us to ask these questions is not just to ask what *is* the form of the work. It is also to consider the kinds of terms on which we might decide such an issue; that's to say, it is to consider the very grounds on which we single something out as 'art' or as 'work' or as an 'object'. It is perhaps also to recognize that in doing this singling out we risk making the assumption that our contemplating *selves* can be singled out from that untidy world of materials and processes within which both we and the work have our being. Perhaps the real form of Morris's felt piece is *any* arrangement of its materials, or any arrangement which fulfils one basic condition: *that it serves to pose these questions*. To see this posing of questions as a critical function of Morris's work is to offer a counter to Fried's derogation of that work as 'theatrical', and of the spectator's relationship to it as 'complicit'.

We may extract one important point from the contrast of priorities and values revealed in this comparison. Both in its early twentieth-century form, associated with such writers as Clive Bell and Roger Fry and in the later form it was given by Greenberg, Modernist theory has tended implicitly or explicitly to distinguish the values of modern art from those of scientific and technical modernization.[7] Modernism and modernity, once so closely bound together, seem to have parted company a long time ago. The experience by which art is in the end recognized and defined in Modernist criticism is the intuitive and supposedly disinterested experience of an emotional or spiritual value. The critical aspect of this value lies precisely in its being divorced from considerations of utility. For Morris, on the other hand, manufacture is the very activity by which human nature and human existence are defined. In his concept of what it is to be an artist, to apply a process to a material is to behave *naturally*, even if the materials are synthetic and the processes industrial. Art is thus defined as a kind of activity or interaction or form of change.

Given Fried's notion of the kind of experience he looks for from art, it is not hard to understand why he should derogate Morris's work as theatrical. But what if the experience of art were conceived in terms of that form of restless, questioning activity which Morris's work proposes? A work like *Prairie* might then come to be seen as conceptually fragile; as depending on highly specialized viewing conditions and on an *already* attuned and sympathetic spectator. As the type of this kind of spectator, Fried values works such as *Prairie* for their self-sufficiency; for the sensation of wholeness and abiding 'presentness' which they have to offer him. But according to one influential account of the 'postmodern condition', this sense of wholeness and completeness is the product of illusion, and the enjoyment of it is therefore in essence nostalgic. If this is indeed the form of enjoyment which Modernist art typically enables, then what will identify a work as *postmodern*

7 See, for example, Bell, 'The aesthetic hypothesis' (1914) and Fry, 'An essay in aesthetics' (1909).

Plate 164 Robert Smithson, the Great Pipes Monument (left) and the Fountain monument (right) from 'A Tour of the Monuments of Passaic, New Jersey', *Artforum*, December 1967. Reproduced from *The Writings of Robert Smithson*, 1979, New York University Press by permission of Nancy Holt.

is its presentation of the very *impossibility* of wholeness – its manifestation, in fact, of 'the absence of presence'.[8]

Is the Fried of 1967 to be read as an élitist seeking to defend the crumbling bastions of a conservative Modernism, as a kind of Canute waving his aesthetic broom at the incoming tides of the postmodern, or as a courageous defender of those irreplaceable human values which are threatened by merely sensational forms of theatricality and by fascination with merely journalistic forms of novelty? Could we reasonably see him as justified in his claim for the critical importance of the aesthetic, but as mistaken or simply too partial in his selection of those objects in which he sees the aesthetic as exemplified? (This is the assessment offered by Rosalind Krauss in her essay 'A view of modernism'.) How do our responses to questions such as these affect our responses to the art at issue, and vice versa?

1967–1972: new avant-gardes

The questions with which we concluded the previous section are open questions; that's to say they invite speculation on the issues concerned and do not require decisions between alternative positions. What is not really disputable, however, is that though painting and sculpture in the Modernist vein continued in practice, Modernist abstraction was virtually eclipsed as a resource of precedent for younger artists and as a subject of critical interest for new writers during the later sixties and early seventies, not only in America but throughout the broad field of modern Western art.

Among the other contributions to the summer 1967 issue of *Artforum* were Robert Smithson's 'Towards the development of an air terminal site' and Sol LeWitt's 'Paragraphs on Conceptual Art'. Smithson argues for a form of 'Land Art': an art which

[8] See Jean-François Lyotard, 'Answering the question: What is postmodernism?'; and Victor Burgin, 'The absence of presence: Conceptualism and post-modernisms'.

Plate 165 Sol LeWitt, *Serial Project No.1 (ABCD)* 1966–67, baked enamel on aluminium, 51 x 39 x 399 cm. Collection, The Museum of Modern Art, New York, Gift of Agnes Gund and purchase (by exchange). © 1993 Sol LeWitt/ARS, New York.

takes form through the exploration of 'sites', and which approaches the diverse resources of the natural and industrial world without prior assumptions about which materials are 'artistic' materials. His 'Tour of the Monuments of Passaic' (see Plate 164) offers an ironic aestheticization of the conventionally unaesthetic world of industrial detritus and urban sprawl. LeWitt argues that 'the idea itself, even if not made visual is as much a work of art as any finished product' ('Paragraphs on Conceptual Art', p.80; see Plate 165). This is a far cry from Greenberg's 'All that matters is results' (The Open University, 'Greenberg on criticism'). As such writings bear witness, the spare style associated with Minimalism in the years 1963–66 served as a prelude to various kinds of informal or 'anti-formal' work in three dimensions, to forms of performance, of installation and of extension into the 'expanded field' of landscapes, proposals and imaginary objects.

Land Art and Conceptual Art were to emerge during the later sixties and early seventies as quite distinct tendencies within this wider break with traditional forms of practice. At first, though, it was easier to perceive that a widespread shift of priorities had taken place than it was to discriminate between different positions. This shift was recognized in a number of large-scale international exhibitions staged between 1969 and 1972, each attempting to survey the various productions of what appeared to be a broad and cosmopolitan avant-garde.

One of the earliest of these surveys, When Attitudes Become Form, was shown in Berne, London and Krefeld between March and September 1969 (Plate 166 shows two views of the exhibition in its London showing). Besides representation of various forms of Land Art and Conceptual Art, this exhibition embraced the American anti-formal tendency with which Morris was associated (Plate 167 is an example of a work of this type by Richard Serra), the Arte Povera movement in Italy, and the work of Joseph Beuys and his followers in Germany (Plate 168).[9] One distinctive feature of such exhibitions was the invitation to artists to install their own works. In the case of those who made their works on the spot, from perishable materials or in relation to specific spaces, artists' attendance was a necessary condition of their inclusion. This bringing together of artists from several

[9] Arte Povera (Poor Art) was a specifically Italian variant of the anti-formal and putatively libertarian tendencies which mushroomed in the later 1960s; see Harrison and Wood, *Art in Theory*, p.886.

Plate 166 Installation views of exhibition When Attitudes Become Form, ICA London, September 1969.
Photos: Charles Harrison.

Plate 167 Richard Serra, *Splashing*, 1968, lead, 46 x 792 cm. Installed at the Castelli Ware-
house, New York 1968 (destroyed). Photograph by Harry Shunk reproduced by courtesy of
The Pace Gallery, New York. © 1993 Richard Serra/ARS, New York.

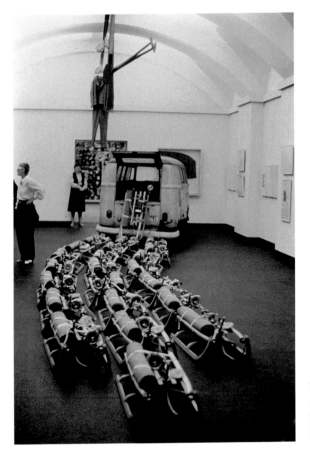

Plate 168 Joseph Beuys, *Das Rudel*
(*The Pack*), 1969, Volkswagen
Microbus with sledges (Documenta,
1983). Photo: Charles Harrison.

Plate 169 Victor Burgin, 'Any moment previous to the present moment ...', *Studio International*, July/August 1970, p.28. Reproduced by permission of the artist.

0
ANY MOMENT PREVIOUS TO THE PRESENT MOMENT
1
THE PRESENT MOMENT AND ONLY THE PRESENT MOMENT
2
ALL APPARENTLY INDIVIDUAL OBJECTS DIRECTLY EXPERIENCED BY YOU AT 1
3
ALL OF YOUR RECOLLECTION AT 1 OF APPARENTLY INDIVIDUAL OBJECTS DIRECTLY EXPERIENCED BY YOU AT 0 AND KNOWN TO BE IDENTICAL WITH 2
4
ALL CRITERIA BY WHICH YOU MIGHT DISTINGUISH BETWEEN MEMBERS OF 3 AND 2
5
ALL OF YOUR EXTRAPOLATION FROM 2 AND 3 CONCERNING THE DISPOSITION OF 2 AT 0
6
ALL ASPECTS OF THE DISPOSITION OF YOUR OWN BODY AT 1 WHICH YOU CONSIDER IN WHOLE OR IN PART STRUCTURALLY ANALOGOUS WITH THE DISPOSITION OF 2
7
ALL OF YOUR INTENTIONAL BODILY ACTS PERFORMED UPON ANY MEMBER OF 2
8
ALL OF YOUR BODILY SENSATIONS WHICH YOU CONSIDER CONTINGENT UPON YOUR BODILY CONTACT WITH ANY MEMBER OF 2
9
ALL EMOTIONS DIRECTLY EXPERIENCED BY YOU AT 1
10
ALL OF YOUR BODILY SENSATIONS WHICH YOU CONSIDER CONTINGENT UPON ANY MEMBER OF 9
11
ALL CRITERIA BY WHICH YOU MIGHT DISTINGUISH BETWEEN MEMBERS OF 10 AND OF 8
12
ALL OF YOUR RECOLLECTION AT 1 OTHER THAN 3
13
ALL ASPECTS OF 12 UPON WHICH YOU CONSIDER ANY MEMBER OF 9 TO BE CONTINGENT

countries and continents led to a rapid exchange of information and to the establishment of international networks of contact and friendship. 'Exhibition' itself became an elastic term. In some cases a well-endowed institution would assemble people, objects, documentation and films, staging performances, symposia and other encounters. In others, the catalogue was the 'exhibition', circulating works in the form of proposals, statements and descriptions. The summer 1970 edition of the English journal *Studio International* took the form of such an exhibition, under the guest-editorship of Seth Siegelaub, an American avant-garde entrepreneur. Six critics from the US, Italy, France, England and Germany were invited to select a number of artists. The artists were then

Plate 170 Daniel Buren, double page spread from his contribution to *Studio International*, July/August 1970,. © ADAGP, Paris and DACS London 1993.

allocated pages for the publication of statements or photographs, or for the realization of specially designed art works. It was a notable feature of such enterprises that they raised problems of definition. To be more precise, they drew attention to the complex relationships between artistic concept, art object and medium of presentation. The English artist Victor Burgin filled the page he had been allocated with a form of conceptual work (Plate 169). Burgin's work uses printed words as its medium and in so far as these define an object, it is one which is formed in the mind of the spectator. The concept behind the work is a concept of something such as this *as a work of art*.

We suggested earlier that the development of American art in the later fifties and sixties raised the question of the continuing centrality of painting and sculpture. The concepts of painting and sculpture were not altogether abandoned by the new avant-gardes of the later 1960s, but they were revised and extended in ways which tended to strain their relevance and authority *as* concepts. Two examples will suffice, one concerning 'painting', the other concerning 'sculpture'.

In the *Studio International* 'Summer exhibition' of 1970, the French critic Michel Claura turned his allocation of eight pages over to Daniel Buren, who instructed that they should be printed with broad stripes in yellow and white (Plate 170). In 1967 Buren had exhibited together with three other painters at the Biennale des Jeunes in Paris: each adopted a single motif as his personal hallmark, simply repeating it in one work after another.[10] Buren's motif was alternating vertical stripes of white and another colour. At the time of writing his work still takes the form of painted canvas or printed paper in white and one other colour, the dimensions and means of application varying according to the strategy adopted by the artist for different exhibitions and installations (Plate 171). The object of this work is not to be aesthetically pleasing, but to be noticed: to draw attention both to its

10 The joint statement issued by the artists on this occasion is printed in Harrison and Wood, *Art in Theory*.

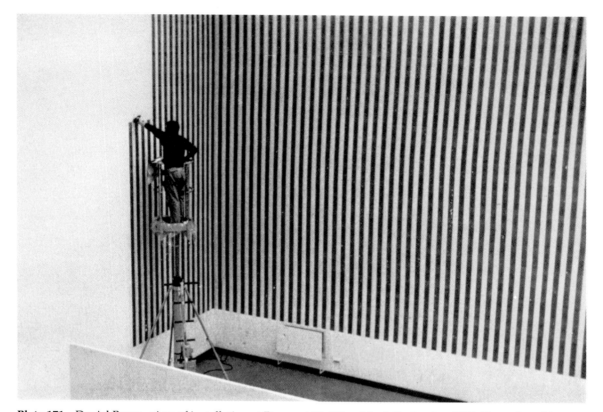

Plate 171 Daniel Buren, view of installation at Prospect 68, Düsseldorf, September 1968. Reproduced in *Studio International*, January 1969, p.47. © ADAGP, Paris and DACS, London, 1993.

own 'neutrality', its lack of formal interest, aesthetic appeal, emotional content and so forth, and to its distinctness from its 'container' or surrounding location:

> In this way, the location assumes considerable importance by its fixity and its inevitability; becomes the 'frame' (*and the security that presupposes*) at the very moment when they would have us believe that what takes place inside shatters all the existing frames (manacles) in the attaining of pure 'freedom'. A clear eye will recognize what is meant by freedom in art, but an eye which is a little less educated will see better what it is all about when it has adopted the following idea: that the location ... where a work is seen is its frame (its *boundary*).
>
> (Buren, 'Beware!', p.104)

In Modernist theory the liberating power of art was associated with the internal relations of the individual work ('what takes place inside'), and with their potential completely to engage the spectator, thus removing him or her from the contingencies of place and time into a sustained sense of 'presentness' (at least in imagination). Buren, on the other hand, proposes a total exclusion of all that might cater to the taste for an imaginary freedom. Given the absence of formal interest or variety, the only relations to which the viewer can attach any significance are those between the work and its context. It is Buren's intention that the work should thus draw attention not simply to itself but to the circumstances of its – and by implication of our – containment. He aims to recast 'painting' as a practice of theory, for 'theory and theory alone, as we all know, can make possible a revolutionary practice' ('Beware!', p.104). A conventional sense of painting thus lurks in the background of Buren's work, but only as the image of that which is to be denied and transcended.

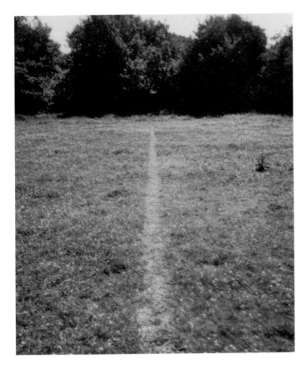

Plate 172 Richard Long, *A Line Made by Walking*, December 1967, photograph, © courtesy Anthony d'Offay Gallery, London.

A second example is furnished by the work of an English artist consistently associated with the practice of Land Art. Richard Long was using the sites and materials of the landscape to make what he referred to as 'sculpture' while still a student on the advanced sculpture course at St Martin's School of Art in London in 1967 (Plates 172 and 173). In December 1967 he 'installed' a work to the north-east of London. This consisted, in his own description, of '16 similar parts placed irregularly surrounding an area of 2401 square miles. Near each part was a notice giving the information. Thus a spectator could only see one part (no information being given to locate the others), but have a mental realization of the whole' (quoted in C. Harrison, 'Some recent sculpture in Britain', p.32).

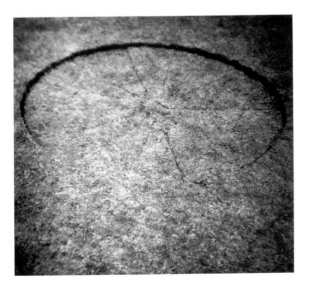

Plate 173 Richard Long, *Turf Circle*, England, 1966. Photo: Prudence Cuming Associates. © courtesy, Anthony d'Offay Gallery, London.

With the notion of sculpture as something 'realized' in the mind, Long may have capi-talized on the Modernist notion that the experience of art is essentially intuitive, but he put his work strategically out of reach of that Friedian requirement of 'presentness' which the notion normally entailed. A story current at the time serves as a kind of parable of the different aesthetic assumptions governing sculptors on either side of the break with Modernist priorities. In 1967 Caro was still a leading figure in sessions of practical criticism at St Martin's. On one occasion, so the story goes, he found himself confronted by an arrangement of twigs in the exhibition hall of the sculpture department.

> A conversation ensued, Caro: 'What's this?' Long: 'It's one part of a two-part sculpture.' Caro: 'So show me the other half.' Long: 'It's on top of Ben Nevis.' Caro: 'So how can I assess it when I can't see all of it?'
>
> (in C. Harrison, 'Sculpture's recent past', p.32)

The story may be apocryphal, but it is certainly representative of a type of conversation which took place in various art schools in Britain during the later sixties and early seven-ties. We do not mean, however, to suggest that the work of the new generation of avant-garde artists was universally confronted with a determined opposition. On the contrary. It is of note both that Long was content to advance his work under the banner of 'sculpture', and that the work attracted considerable critical and institutional support virtually from the point of its first publication and exhibition in 1968–69. Long's is an example of a type of work which was absorbed by the institutions and markets of modern culture despite its failure to look like a Modernist form of sculpture. Or rather, it was absorbed precisely because of its success in looking like something else, at a time when Modernism in its American form was coming to be seen by an emerging generation of artists, writers, curators and collectors *both* as entrenched and dominant *and* as conservative and critically exhausted. Though apparently untouched by the kind of political purpose which Buren's work declares, Long's work in the landscape shares one important characteristic with the French artist's avowedly postmodernist art: its effect depends not so much upon the in-ternal formal relations of the individual display as upon a kind of resonance established between work and setting.

Though both Buren's work and Long's establish considerable distance from tradition-al concepts of painting and sculpture, their effects are achieved through forms of display, and in so far as verbal language plays a part in establishing the meaning of that display, it does so at a 'secondary' level. In Conceptual Art, on the other hand, the inescapably linguistic forms in which art is thought about, spoken about, defined and interpreted are made the very materials of the practice of art. In some early forms of Conceptual Art, particularly those practised by the American artists Lawrence Weiner and Robert Barry, the 'works' take the form of statements (Plate 174). In Weiner's case the statements serve to describe certain material circumstances. These may either be left as unrealized possi-bilities, open to a range of interpretations from the literal to the metaphorical, or they may be realized in a specific form, which then serves as the exemplification of the statement. Weiner's contribution to the London showing of When Attitudes Become Form was *A River Spanned*. This was 'exhibited' simply in the form of a label in the gallery, which gave the title, date and catalogue number. Barry's statements, on the other hand, describe 'objects' which can be thought about, but not made or seen or defined. His contribution to the Attitudes show was 'Something which is near in place and time but not yet known to me', a work identified simply by a printed notice on the gallery wall giving that infor-mation, together with Barry's name and the date of the work.

Though they could not sensibly be conceived of either as forms of painting or forms of sculpture, it can be said of such works as Weiner's and Barry's that they still present the spectator with a form of object of contemplation – even if this object is imaginary. In the

One regular rectangular object place
d across an international boundary a
llowed to rest then turned to and tu
rned upon to intrude the portion of
one country into the other

Plate 174 A work by Laurence Weiner, from *Statements*, 1968. The Louis Kellner Foundation/
Seth Siegelaub, New York. © Lawrence Weiner.

more 'analytical' form of Conceptual Art, however, the activity of the spectator as reader
is conceived not as form of contemplation, but rather as a process of inquiry undertaken in
a spirit of scepticism. This scepticism has a specific focus upon the theoretical
assumptions of Modernist criticism and the informal assumptions of Modernist culture,
viewed as a kind of mythical system. Thus, for example, Mel Ramsden's *Secret Painting*
(Plate 175) plays upon the irony that language is both a medium supposedly distinct from
art *and* the source of information about art's content and meaning. In place of paintings,
Kosuth presents a series of photographic enlargements of dictionary definitions of words
which might occur in discussions about painting (Plate 176).

The analytical tendency of Conceptual Art is principally associated with the work of
Art & Language. The name was originally adopted in 1968 by the English artists Terry
Atkinson, David Bainbridge, Michael Baldwin and Harold Hurrell to formalize the work-
ing relations which had developed between them over the previous two years (Plate 177
shows a work produced during this period). Their publication of the journal *Art–Language*
in the following year served to attract others in England and America, including Ramsden,
Ian Burn and Joseph Kosuth (respectively English, Australian and American but all three
then working in New York), Philip Pilkington and David Rushton, then art-college
students in England, together with Charles Harrison, co-author of the present text. [11]

11 The number of those identified with Art & Language in England and America was to grow to a peak of
around thirty by 1976 before reducing to its present state: at the time of writing Baldwin and Ramsden are
still working together as artists under the name, and Harrison remains associated with them as a writer. His
writings about Art & Language are collected in his book *Essays on Art & Language,* which includes material
on the nature of the group's membership, on the Indexing project (discussed here on pp.207–208) and on the
paintings produced by Baldwin and Ramsden since 1979.

The content of this painting is invisible; the character and dimension of the content are to be kept permanently secret, known only to the artist.

Plate 175 Mel Ramsden, *Secret Painting*, 1967–68, liquitex on canvas, 122 x 122 cm with photostat 91 x 122 cm. Courtesy Galerie Bruno Bischofberger, Zurich.

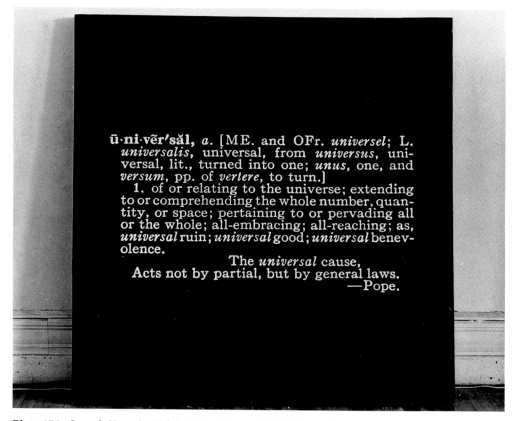

Plate 176 Joseph Kosuth, *Titled (Art as Idea as Idea) (Universal)*, 1967 photostat, dimensions variable. Private Collection. Photo: Jay Cantor. © 1993 Joseph Kosuth/ARS, New York.

Multiple meaning (polysemie) and ambiguity function as aesthetic constants. The study of 'multiple meaning' which is an aspect of structuralist research in literature, suggests many other parallels in other disciplines. The problem of multiple is of particular interest because, more than any other factor, it seems to offer the chance of establishing a distinction between linguistic structure (pure and simple) and poetic structure (language). It could be said that the common aim of the introduction of multiple meanings is to ensure that meaning itself is not dissipated. The phenomenon of multiple is kept within bounds.

The notion of semantic vagueness.

Challenged the notion of emotive and cognitive value (Richards). The problem of single meaning, which plays a considerable part when it is a matter of evaluating a contemporary document, becomes in fact 'decisive' in evaluating an ancient text.

Terms of reference.

Multiple meaning. The admittance of two or more distinct structures (that is to say of a linguistic structure proper), the language or the idiom in which the meaning is expressed.

Norberg Schulz . . . 'particular structures have a certain limited possibility for meaning: receiving contents'.

Barthes has tried to apply linguistic schemata to the visual disciplines. In Barthes' account (Rhetorique de l'image), an illustrated advertisement based on a colour picture of a food product, comprises three types of message, an encoded iconographic message and a second iconographic message (not encoded) the linguistic message being denotative and the other two connotative as are, in general, those in which the figurative element is dominant. Today Barthes affirms 'on the level of mass communication it is evident that the linguistic message is 'present' (sic) in all images in the form of title, caption or as film dialogue'.

Plate 177 Terry Atkinson/Michael Baldwin, *Title Equals Text no. 12*, 1967, photostat, dimensions variable. Private Collection.

In the 'analytical' Conceptual Art of Art & Language, it was assumed that there were no longer good reasons to countenance the typically Modernist division of labour between artist and critic, according to which the artist was supposed to be an inarticulate 'doer' on whose behalf the critic furnished intelligent meanings and explanations. It was further assumed that the maintenance of a critical practice of art must depend upon inquiry into the power of language and the authority of concepts. The understanding that forms of meaning are sustained by forms of power was given considerable substance and detail in the philosophical theory of the 1960s, and particularly in the work of Michel Foucault. If the artistic work of the avant-gardes of the later 1960s was not always informed by this theory, many of those involved were nevertheless impelled by similar forms of understanding in their reaction against the supposed authority of the Modernist observer. It was the view of those associated with Art & Language that if significant change was to be effected within the practice of art, then the initiative would have to be recovered on the terrain of language, where cultural power was invested and sustained. What was required, then, was that the practice of art should be explicitly identified with the practices of reading and writing. For the time being the problems of 'surfaces', of 'effects' and of 'appearances' would have to be left to the attention of conservative interests.

An extensive demonstration of the outcome of this project was furnished by the work *Index 01* (Plate 178), exhibited in the name of Art & Language at the international exhibition Documenta 5, held at Kassel in Germany in the summer of 1972.[12] In the centre of a large square room eight metal filing cabinets were mounted on grey-painted stands which raised them to reading height. In the drawers of the cabinets typed and printed texts were fixed to the hinged leaves of the filing system, so that they could be read in situ. The texts were the assembled contents of the journal *Art–Language*, together with other writings by

12 Documenta is an international avant-garde exhibition, held every five years.

Plate 178 Art & Language,
Index 01, 1972, texts, eight filing
cabinets and photostats,
installation from Documenta 5.
Collection Thomas Ammann,
Zurich, courtesy of the Lisson
Gallery, London Ltd.

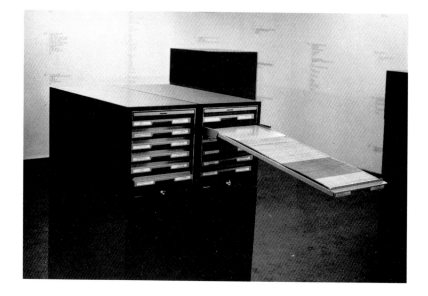

members of the group, by then some ten in number. Each of 350 separate items of text was
given an index number, and each was then read in relation to all of the others. Round the
walls of the room the results of these readings were given in the form of printed listings:
under each item all the others were sorted into one of three categories; under the sign '+'
were listed all those considered compatible in terms of attitude and argument; under '–'
all those considered incompatible; and under 'T' all those considered impossible to
compare without some transformation of the logical grounds of comparison.

Among the points to remark about this work are its disregard of all considerations of
visual appeal, or rather the deliberate adoption of a stylistic blandness such that the ex-
pectation of visual appeal is ruled out as irrelevant. Art & Language did indeed have a
distinct presence, but that presence was conveyed in part by a strategic 'neutrality' of
appearance and organization. Further points to note are the suppression of the normal
signs of individual authorship and the implicit invitation to the passive spectator to be-
come actively and critically engaged as a reader.

A simplified form of example may help to clarify the system and its implications. For
this purpose the essay-length texts are represented by straightforward statements:

Text 1 reduces to the assertion: 'I like the sculpture of Anthony Caro';

Text 2 to: 'I dislike the sculpture of Anthony Caro';

Text 3 to: 'The criticism of Michael Fried is admirable';

Text 4 to: 'Football is a matter of life and death'.

Now 1 and 2 are clearly incommensurable, so we would say that 1 '–' 2. In the light of our
discussion so far, a common-sense decision would be that 1 and 3 are commensurable, so
1 '+' 3, and 2 '–' 3. Given the frame of reference we find ourselves in, 4 has the status of a
kind of noise off, so we might assume that 1 'T' 4, and that 3 'T' 4. But what of the relations
between 2 and 4? At least in the minds of Modernism's unsporting aesthetes, both state-
ments might well be attributed to the same speaker. So perhaps 2 '+' 4. But then, would it
not follow that 1 '–' 4, and that 3 '–' 4? Is it the case that liking Caro and taking football
seriously are events in different logical 'worlds', or does one event actually tend to ex-
clude the possibility of the other within the *same* world? These are relatively bloodless
examples, but they should be adequate to suggest that the kinds of decisions we make
about the relations between one text and another can have implications for our picture of
an entire conversational, or ideological world.

Contexts and constraints

By the time of the 1972 Documenta 5 exhibition in which *Index 01* was shown, the various components of the international avant-garde had clearly diverged into distinct factions. Their varied productions of the previous five years were incorporated in this exhibition into a form of gigantic avant-garde Salon. With hindsight it might be said that this diversity provided early evidence of the incorporation of radicalism into the range of options offered by a self-consciously 'pluralistic' dominant culture. Then, however, it might just as plausibly have seemed that this diversity betokened a kind of radical victory over an entrenched orthodoxy. The French critic Jean Clay, writing in *Studio International* in 1970, began an article with the claim: 'It is clear that we are witnessing the death throes of the cultural system maintained by the bourgeoisie in its galleries and its museums. The values and the commodities which constituted it have now passed into the realm of the inessential' (Clay, 'Some aspects of bourgeois art', p.266). The kinds of relations alluded to here – economic and market relations, social and political ones – are not easily separated from more specifically artistic ones. The schisms within the avant-garde bear traces of those forms of division most acutely evident in the political sphere.

With hindsight, Documenta 5 might be said to have prefigured some of the complex shifts fully evident a few years later. By the mid-seventies it was clear that those underlying economic conditions which had sustained the growth of a diverse and cosmopolitan avant-garde were changing. Most visibly of all, perhaps, the oil crisis signalled the end of a period of expansion which had been uninterrupted for a quarter of a century. The growing political response was towards a new form of conservatism in which the Keynesian economic policies which had underwritten a multiplicity of social welfare and educational programmes (not to mention artistic and cultural innovation) were abandoned in favour of a radical monetarism. What began as spending restraint developed into real cuts in such social services. This was accompanied by a widespread ideological shift of emphasis away from the public domain towards privatization. In the developed nations, questioning of, and dissent from, inherited norms and values, which had been typical of the sixties and early seventies, met with increasingly entrenched resistance. The space for nonconformism shrank as wage restraint was insistently urged and unemployment began to rise significantly for the first time since the outbreak of the Second World War. Simultaneously, the power of the dominant culture to neutralize dissent and incorporate it into its own structures of ideological reproduction seemed to increase, fuelled not least by developments in the field of communications technology.

Differences of artistic position did not simply 'reflect' political commitments, but, in the climate of the time, the role of art within a wider culture was a matter of continual critical debate, so that artistic positions were always liable to be scrutinized for their political implications and underpinnings. In short, it was widely felt that artists should address the realities of their time: But the familiar question of *how* this was to be achieved was itself complicated by developments – both historical and artistic – since the last time art and politics had been unavoidably thrown into conjunction: that is to say, since the 1930s. There is a sense in which many of the social and political dilemmas and commitments of the thirties, which had been marginalized during the intervening decades of economic expansion, American hegemony and Cold War, began to reappear in the 1970s, ultimately to be transformed.

The 1930s and the 1970s

In the 1930s, the principal recourse for artists who had come to feel that their art should serve a wider emancipatory end lay in the adoption of some form of Social Realism (for

example, Plates 2 and 8). To the avant-garde of the seventies, Social Realism represented a technically conservative and unadventurous practice. However, what was vice in one perspective was virtue in another: the familiar appearance resulting from such conservatism had been a guarantee of popular accessibility. In relation to Social Realism, moreover, 'popular' did not mean simply 'widespread'; its specific connotation was of those social sections struggling against poverty, Fascism and other features of the capitalist crisis of the thirties. That is to say, Social Realism had carried an implicit commitment to the left – a left dominated by the communist parties, particularly by that of the Soviet Union. But none of these co-ordinates held in the new crisis of the early seventies. On the one hand, the Soviet Union had largely been dethroned as the bearer of radical virtue, having become synonymous with tyranny, bureaucracy, and social stagnation. On the other hand, the very success of the avant-garde in the post-war period had limited the potential of a technically orthodox figuration in serious art. Furthermore, those bearing the brunt of social and political struggle in this period were no longer easily assimilable to a traditional image of the working class. Both within and without the imperialist metropolis, students, women and socially marginalized people were more visibly identified with resistance to the status quo than the white working class. This amounted to a situation in which a (re-)turn to a form of traditional figurative realism was not an option in avant-garde quests for political identity and social relevance in the early seventies.

Pop art was the exception that proved the rule. Its figuration, largely based on existing mass-media representations, was already second-order. The traditional aspiration of Social Realism – to cut through to a truth behind the conventional *mis*representation – had been closed off by an art in which the principal subject *was* such convention. If Pop were to achieve any critical distance from its sources, this could clearly not be done by bypassing those sources in the name of a truth which they obscured; rather it had to be achieved through a heightened focus upon those sources themselves. This entailed looking not just at the imagery itself but at the technology by which such imagery was typically produced and disseminated. In the work of Andy Warhol, for example, repetition became a device for the parody or ironization of mass media images. Warhol's *Race Riot* series (Plate 179), for example, offered not so much the opportunity for outrage at 'man's inhumanity to man' as revealed by the incisive eye of the committed artist but something less comfortable for the spectator. For there is a sense in which traditional realism situates its exposés elsewhere; it provokes the impulse to corrective action in viewers who are not themselves caught up in the theatre of its depiction. By representing *representations* of the racist police in action, Warhol's work drew its spectator into the circle of responsibility. This diminished the possibilities for moralizing response and had the capacity to induce an uneasy passiveness in the face of one's own complicity.

Applied to the shop-worn icons of the traditional left, Warhol's silk-screen technique was capable of achieving an unsettling effect (Plate 180), voiding them of their rhetorical force by flattening the forms and misregistering the images. Doubtless such art achieved a kind of 'realism' both about the sociality of mass society and the vacancy of traditional forms of opposition. But to the extent that it did so, it was not according to the lights of a traditional 'socially committed' realism, nor in the name of realism's emancipatory drive. Warhol's version was bought at the cost of just those wishes and hopes which usually fuelled the desire to have art relate to society, break out of the avant-garde cloister and grasp the forms of the real world as a preliminary to changing them.

The situation was, if anything, more uncertain for artists of the post-Minimalist or Conceptualist avant-garde, including those already discussed, whose work had tended to be disparaged by Modernist critics. Their position was grounded in a refusal of the categories of painting and sculpture themselves, and thus of *all* possibilities of depiction, however attenuated. Artists of this persuasion who nevertheless felt the need to animate

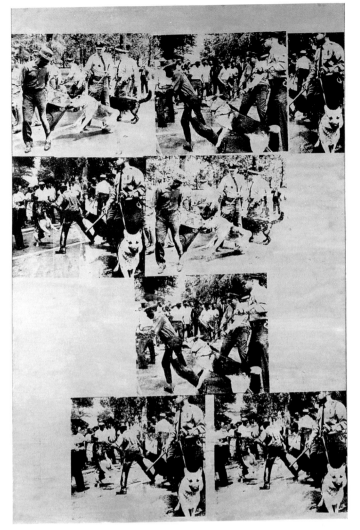

Plate 179 Andy Warhol, *Red Race Riot*, 1963, silkscreen ink on synthetic polymer paint on canvas, 350 x 310 cm. Museum Ludwig Cologne. Photo: Rheinische Bildarchiv. © The Andy Warhol Foundation for the Visual Arts Inc.

their practice with social relevance clearly had to underwrite their reference to a world beyond art by other means. In essence this meant that, in the absence of depiction, the task of referring had to be achieved by the work's structure and materials. This carried with it however a problem for the aspiration to a form of critical social address. It effectively ruled out the specific event – the strike, the battle, the workplace or domestic incident – on which such address had tended to depend in the social-realist tradition. At best the structuring principles of avant-garde work could themselves be claimed to embody the general social orientation intended by the artists.

A cursory list of such techniques includes the use of less 'hierarchical' composition, of compositional units of 'equal' status (Plates 181 and 184), of 'undifferentiated' collections of material and of 'non-artistic' materials (Plates 162 and 182), of repetitive movements in time, of industrial processes and decayed or waste products (Plate 183). The sculptor Carl Andre spoke in this vein about the interchangeability of his compositional elements, drawing a connection with his work experience in railway shunting yards.[13] Richard Serra similarly invoked his experience of working in steel mills. Robert Morris, in a passage already cited, spoke of the work as embodying 'an empirical and pragmatic outlook' and

13 See D. Bourdon, 'The razed sites of Carl Andre'.

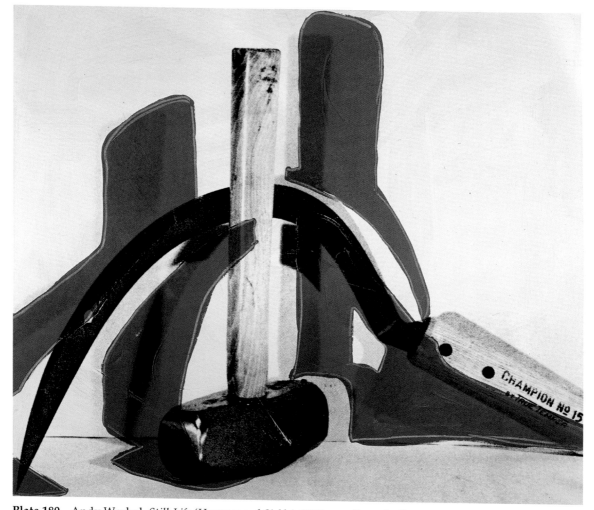

Plate 180 Andy Warhol, *Still-Life (Hammer and Sickle)*, 1976, acrylic and silkscreen on canvas, 168 x 183 cm. © The Andy Warhol Foundation for the Visual Arts Inc.

therefore as having 'a few social implications, none of which are negative' ('Notes on sculpture 3', pp.25, 29). Yet such 'implications' are notoriously unstable. For example the modular structures and wall drawings of Sol LeWitt (Plate 165) are often seen as embodying purity and rationalism (Kuspit, quoted in Krauss, 'The LeWitt matrix', n.p.). But Krauss has pointed out, to the contrary, that they might be seen as 'models of "reason" running amok, doing a kind of lunatic dance over an abyss of purposelessness' ('The LeWitt matrix', n.p.).[14] Bearing in mind the ideological investment in systems, technology, and goal-oriented planning so central in the wider American culture of that time, the critical, dissenting dimension of such work begins, tentatively, to emerge.

[14] In her discussion of LeWitt's modular structures Krauss calls attention to Beckett's *Molloy*, in which Molloy sets himself the task of thinking through a 'problem': 'how to suck sixteen stones in succession without sucking any one twice if he has only four pockets out of which to pull and into which to replace each stone'. Krauss' point is that far from embodying crystalline rationality – as Kuspit, Gablik and others would have it – LeWitt's structures in fact came closer to reproducing the kind of interminable and apparently pointless procedures in which Beckett's characters engage, in which rationality breaks down or wears thin by dint of repetition (Krauss, 'The LeWitt matrix').

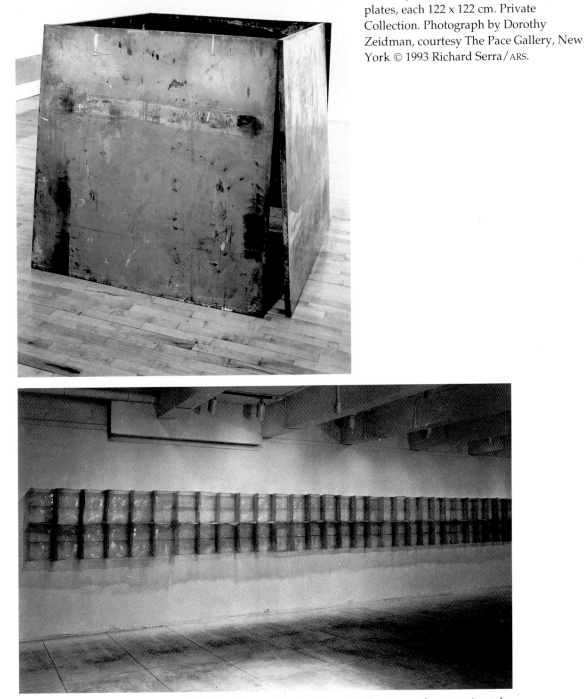

Plate 181 Richard Serra, *One Ton Prop (House of Cards)*, 1969, lead antimony, four plates, each 122 x 122 cm. Private Collection. Photograph by Dorothy Zeidman, courtesy The Pace Gallery, New York © 1993 Richard Serra/ARS.

Plate 182 Eva Hesse, *Sans II*, 1968, fibreglass and polyester resin, 5 units, each approximately 96 x 218 x 15 cm. One unit: Dr and Mrs Norman Messite, New York, one unit: Refco Group Ltd., one unit: Private Collection, two units: Whitney Museum of American Art, New York; purchase, with funds from Ethelyn and Lester J. Honig and the Albert A. List Family. © The Estate of Eva Hesse. All Rights Reserved. Photograph of five units courtesy Robert Miller Gallery, New York.

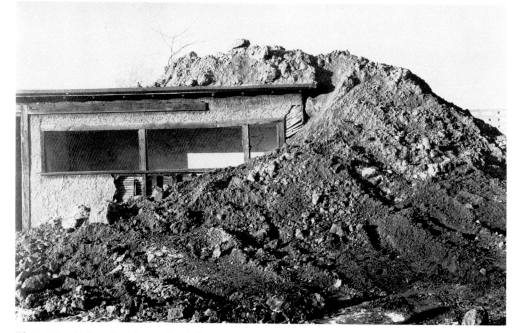

Plate 183 Robert Smithson, *Partially Buried Woodshed*, January 1970, Kent State University, Ohio, one woodshed and twenty truckloads of earth, 564 x 310 x 1372 cm. Photograph courtesy of the John Weber Gallery, New York.

It may be objected that this is an argument which opens a Pandora's box: far from being 'meaningless', strips of felt or piles of industrial waste may come to 'mean' anything – and who is to say? Due to the absence of a shared contemporary language for such reference, much relies on stipulation: this in turn clearly opens up questions of authority. Arcane or private allegories, be they of equality, resistance, survival, decay, etc., remain merely arcane and private in the absence of a mediating apparatus of interpretation. The problem follows from the fact that this work undoubtedly has its origins in a range of relatively specialized and technical refusals within the sphere of art. Yet simultaneously these refusals are inseparable from a wide, perhaps inchoate range of connotations, commitments, principles and so forth, extending into the broader sphere of social life. It is as if the avant-garde perceived in practice a point articulated theoretically half a century before by Walter Benjamin: 'Any person, any object, any relationship can mean absolutely anything else' (*The Origin of German Tragic Drama*, p.175). Benjamin was writing of the Baroque, and contrasting its allegorical consciousness with the certainties of the Renaissance. It may be that the new avant-gardes who lacked the confidence felt by Modernist critics in the exclusive powers of art did so, like their Baroque forbears, because of 'a deep rooted intuition of the problematic character of art' (Benjamin, *The Origin of German Tragic Drama*, p.176).

The supposed security of reference – the 'naturalness' – to which Social Realism had laid claim had thus disintegrated; its constituent parts were now scattered across a terrain of conventions. By the 1970s no culturally shared language was available to the avant-garde by means of which reference to the contemporary world might be secured. At any rate, the constituency to whom the new conventions *were* conventions, that is to say those to whom they were legible, was a restricted one. Whatever the new avant-garde's aspirations to social resonance, it remained precisely that – an artistic avant-garde – rather than a catalyst in any wider social context. It could even be claimed, with some legitimacy,

that its members were not so much forming social commitment as responding to a cultural climate in which commitment was expected. If this was the case, the implications for a viable notion of avant-gardism are obviously far-reaching.

The debate of the seventies

The critical controversies of the late sixties and early seventies clearly attest to conflicts over the interpretation of mute stuff – conflicts which it may initially be hard to take seriously. Nonetheless, the intent was serious enough. For Robert Smithson, Michael Fried's writing showed signs of a kind of propriety, of fear even, which rendered opposition to it a moral imperative rather than 'merely' an aesthetic one. Smithson made this point in relation to Fried's comments on Morris Louis:

> The dazzling blankness of the untouched canvas at once repulses and engulfs the eye, like an infinite abyss, the abyss that opens up behind the least mark that we make on a flat surface, or *would* open up if innumerable conventions both of art and of practical life did not restrict the consequences of our act within narrow bounds.
>
> (M. Fried, quoted in Smithson, 'A sedimentation of the mind', p.84)

For Smithson and others of like persuasion it was the duty of the adequately contemporary artist precisely to challenge such conventions and to overcome restrictions in both art and practical life. Smithson wrote: 'I am speaking of a dialectics that seeks a world outside of cultural confinement … it would be better to disclose the confinement rather than make illusions of freedom' (Smithson, 'Cultural confinement', pp.132–3).

Jules Olitski's painting (for example, Plate 142) seems to have marked a kind of frontier (there were many) between the different parts of the avant-garde. For Fried, as we have seen, his works represented a high point in the artistic achievement of their time – they were 'among the most beautiful, authoritative and moving creations of our time in any art' (Fried, 'Jules Olitski's new paintings', p.40). For Lucy Lippard, writing at the same time as Fried and in some of the same magazines, this was far from being the case. She was identified as a leading supporter of the post-Minimal and Conceptual avant-garde. For her, Olitski's work was 'visual muzak' (quoted in J. Kosuth, 'Art after philosophy', p.135). 'Muzak' was a term coined in the 1960s to describe that synthetic type of music which was then being piped into airport lounges, lifts and – significantly – supermarkets for the first time. It was the intention of 'muzak' to pacify, to lull, virtually to anaesthetize: and in the case of supermarkets the anaesthetic was intended to facilitate consumption. It performed its inconspicuous work upon inattentive but captive listeners. The charge therefore is not purely an aesthetic one. It is not that Lippard disliked Olitski's painting on the grounds that she saw too little in it to engage the attentive viewer; the wider charge being made was that Modernist art had become complicit in the very mechanisms of power against which the moral force of the avant-garde had traditionally been defined. Now that Modernism had established a form of hegemony, now that the world was dotted with museums dedicated to it – and not just in the heartlands of Western Europe and North America, but in Sao Paolo, Tehran and Tokyo; now that abstract painting could be found in prestigious shopping malls and corporate boardrooms, that claim to independence from official values which had always been the means to secure the moral ground of Modernism could no longer credibly be sustained.

A politics of modern art began to be articulated again, more explicitly than it had been for a generation. It is, of course, impossible to draw a secure connection between a B52 raid in Vietnam and an art gallery in America filled with bricks (Plate 184). Nonetheless, connections of some sort were invoked, by both artists and critics. In the summer of 1970, *Artforum* responded to the growing debate about the relationship of art to politics in the form of the symposium discussed in Chapter 2 ('The artist and politics: a symposium',

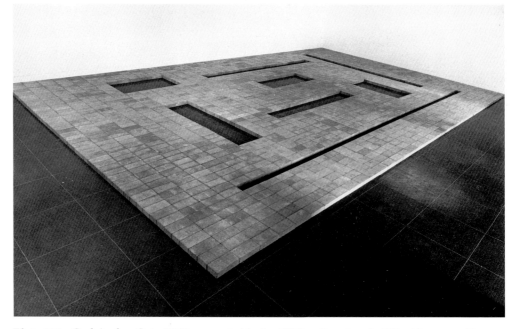

Plate 184 Carl Andre, *Cuts*, 1967, concrete blocks, 1748 unit rectangle (38 x 46 array with
8 voids of 30 units), overall dimensions 893 x 1509 x 9 cm, each unit 9 x 19 x 40 cm. Installation
in the National Gallery of Canada 31 July–4 November 1979. Private Collection. Photograph by
courtesy of the Paula Cooper Gallery. © Carl Andre, DACS, London/VAGA, New York 1993.

Artforum, p.35). Carl Andre's reply to the magazine's question was in characteristically
elliptical style: 'Given: Art as a branch of agriculture. We must farm to sustain life. We
must fight to protect life … We must be fighting farmers and farming fighters …' (Andre,
Artforum, pp.35–9). By relating the artist to a farmer, and art to agriculture, there is little
doubt that he was identifying with Vietnamese peasant resistance to the American in-
vasion. This sense of an affiliation is underlined, if not exactly explicated, by his slightly
earlier assertion: 'My art is atheistic, materialistic, and communistic' (cited in Bourdon,
'The razed sites of Carl Andre', p.107).

Andre and Robert Morris both became leading figures in the Art Workers Coalition.
By contrast Donald Judd and Robert Smithson maintained a distance from it, though in
their replies to the same *Artforum* questionnaire they made no secret of their anti-
establishment sympathies. The point was that the 'establishment', opposed by most of a
generation of Western, avant-garde artists, was both aesthetic *and* political. The
connection between the aesthetic and political establishments did not seem to need to be
made with any great cognitive thoroughness. Rightly or wrongly, it was held to be
obvious. And rightly or wrongly, bricks, felt, earth and other such materials were held to
be the adequate vehicles of a conjoint aesthetic *and* political critique.

It is another question how effective the critique was. Lucy Lippard was forced to
acknowledge, indeed was herself arguably a part of, the process of curatorial legitimation
which rapidly installed the new avant-garde in the market place. Moreover, despite the
radical enthusiasms of some of its participants, even the early When Attitudes Become
Form exhibition had been sponsored by Philip Morris Europe, a subsidiary of the
American-based multinational tobacco company (see J.A. Murphy, 'Sponsor's statement'
for When Attitudes Become Form). Such commercial sponsorship was the true harbinger
of things to come, and in its way more prophetic than the revolutionary rhetoric
surrounding some of the exhibits.

Political art

Given the relative homogeneity which Modernist critical theory had projected onto art practice in the preceding period, it is perhaps not surprising that the avant-garde in the 1970s – as it developed, so to speak, 'after' Modernism – should have appeared to be profoundly fragmented. As we have already remarked, however, a strong case can be made that modern art in America had begun to fragment almost from the moment of the consolidation of Abstract Expressionism in the early 1950s. As we have suggested, when avant-garde work in Britain and Europe is taken into acccount, it can be seen that even in the fifties and sixties Modernist 'order' had been imposed over considerable heterogeneity. That heterogeneity *became* the 'order' of the seventies. In the present compass, therefore, it goes without saying that we have to be highly selective.

Among the most significant developments in the period, viewed retrospectively, are those which sought to address more explicitly the radical social and political implications which had permeated the new avant-garde of the late sixties and early seventies. Conceptual Art, Land Art and performance works shared at least one important concern: the issue of context. Modernism, in theory at least, had been indifferent to the contingencies of the viewing situation: the point had been to shed such contingent anchorages in history. The requirement had cut two ways: as the critic strove to become a 'disembodied eye', so the artist produced objects for such an eye. In their different ways the newer forms of work, operating across the conventional divides of painting and sculpture, all called attention to context: production contexts – the material from which the work was made – and consumption contexts – the physical and institutional parameters determining access to the work of art. Initially these concerns might have been focused on, say, the gallery room itself, so that a specific work might be physically tailored to the dimensions of a specific interior space or even designed as an 'installation' for that space and that space alone. The concern with the gallery as a kind of *place* expanded to address the gallery or museum as a form of *institution*. From there it was a logical development to extend the concern of art work to other institutions and conventions comprising the social world which framed the making of art. In the radical climate of the time, it was not surprising that the major contradictions which constituted the social sphere of late capitalism should have come to motivate the production of critical art.

A range of committed practices

There were of course different shadings to this activism. New York witnessed the Artists Meeting for Cultural Change (AMCC), a revival of the defunct Art Workers Coalition, and in addition, the Maoist and Black Panther-inspired Anti-Imperialist Cultural Union (AICU).[15] A different concept of intervention underpinned the policies of the Artist Placement Group (APG), the initiative of Barbara Steveni, working in London with the artist John Latham. The objective of APG was to place artists on forms of secondment in industrial and commercial organizations, on the assumption that the perceptions and projects of the artist as an 'incidental person' in such contexts, would result in forms of mutual critical benefit.

By the mid-1970s the Art & Language group had expanded to include participants in New York as well as in England. Drawing on a mixture of Marxism and a radical English pamphleteering tradition, the English group mounted attacks on institutionalized art education through a loosely organized project dubbed 'School'. They also marked the

[15] Founded in Oakland, California in 1966, the Black Panthers took their Marxism from the ideas of Mao Zedong, Che Guevara and Franz Fanon. They were at the height of their influence in 1968 when, according to FBI statistics, 40% of young blacks supported them. They were in decline by 1971.

Plate 185 Art & Language, *Ten Postcards (Fasces)*, 1977, edition on lithographed postcards, 75 x 20 cm. Reproduced by courtesy of the Lisson Gallery.

activist pretensions of much of the rest of the avant-garde art world by pointing to uncomfortable affinities between voluntaristic left-wing idealism and the vocabulary, even the iconography, of the right (Plate 185). The New York grouping directed attention towards the operations of the art market which had come so inescapably to determine the production of art there, and published a short-lived though influential journal, *The Fox*.

Hans Haacke, the German artist based in New York had been concerned in his early work with the presentation and documentation of natural processes and systems. Such works included the documentation of birds feeding, of balloons released into the air, and the installation and subsequent tending of a patch of grass in an art gallery. His work *Condensation Cube* (Plate 186) consisted of a kind of micro-climate which functioned within a glass box according to fluctuations in the surrounding conditions. The work thus consisted in the condensation 'system' rather than, say, the dimensions or proportions of the container considered as an object. In the late sixties and seventies Haacke increasingly focused on the operation of *social* systems. The cancellation by the Guggenheim museum of a scheduled retrospective exhibition (discussed in Chapter 2) had made his work a *cause célèbre* as early as 1971. In particular however, Haacke has focused on the social system of art itself. He has concentrated on exposés of international firms which have used sponsorship of the arts as a public relations arm of their global commercial interests (Plate 187). In this way, paradoxically, Haacke was able to establish a successful career within the system which in large part provided the subject-matter for his critical activities.

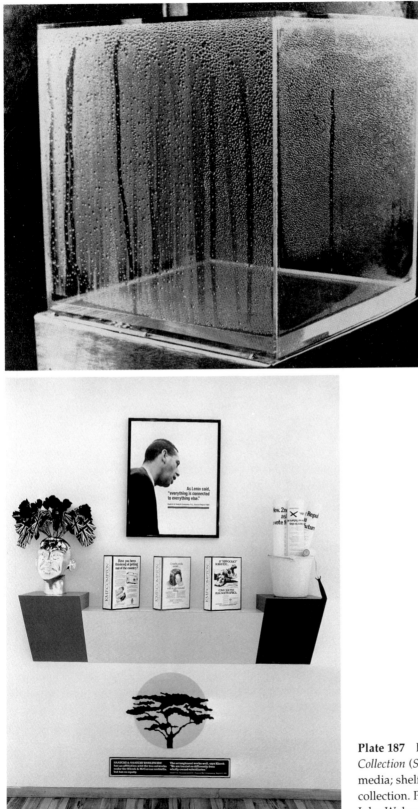

Plate 186 Hans Haacke, *Condensation Cube*, 1963–65, plexiglas, water, 30 x 30 x 30 cm. Private Collection. Photograph by courtesy of the John Weber Gallery, New York.

Plate 187 Hans Haacke, *The Saatchi Collection* (*Simulations*), 1987, mixed media; shelf 180 cm long. Private collection. Photograph by courtesy of the John Weber Gallery, New York.

Plate 188 Joseph Beuys, *Coyote, I like America and America likes me*, one-week performance, May 1974, René Block Gallery NY. Photograph by Caroline Tisdall. © DACS, London 1993.

Somewhat more Utopian forms of artistic activism were developed by the German sculptor Joseph Beuys. Using an often hermetic symbolism, derived from his own mythologized experiences during the second world war (when his aircraft was shot down on the Russian front and he was apparently succoured and restored to health by nomadic tribesmen), he promulgated a notion of 'social sculpture'. This involved elements both of installation and performance. In 1974, for example, during his second visit to New York, Beuys performed the piece 'Coyote, I like America and America likes me' (see Plate 188). In it he shared a living space, and claimed to engage in a 'dialogue' with, a coyote. According to Beuys' own testimony the coyote symbolized 'the psychological trauma point of the United States energy constellation' (J. Beuys, 'Coyote', p.141), by which he means particularly the animals and the native American people and their values, which were threatened with extinction by capitalist materialism. Other elements of the installation, the straw on which both slept, the felt blanket in which Beuys was wrapped, the wire grill separating 'performers' from audience, props such as a flashlight ('an image of energy'), a pair of gloves ('the freedom of movement that human beings possess with their hands'), and a turbine ('the echo of dominating technology: unapplied energy'), all of these were brought together to produce an allegorical acting-out of a form of emancipation. (The interpretation of the significance of the various components of the performance is drawn from Beuys' text 'Coyote'.) For Beuys, such emancipation was intended to lead from the restricted normality of a materialistic existence to the experience of a fuller creativity which, he believed, was the prerogative of all, not merely of professional artists: as he put it, 'not just a few are called, but everyone' (quoted in G. Jappe, 'Not just a few are called', p.227).

The means Beuys employed were eccentric, but in some respects he occupies a place in a familiar lineage within modern art: one in which it is not seen to be the business of the

artist to function politically in any material or organizational sense to bring about change in the world, but to do so through the example of his art. It is consistent with this idealism that Beuys should have nominated a 'Fifth International' ('I am searching for field character', p.48). This was held to have transcended what seemed to him the outworn historical materialism of the Third (i.e. Bolshevik) and Fourth (i.e. Trotskyist) Internationals. The motor of this new spiritual collective, by contrast with the Marxist stress on production, was 'creativity', and under its impulse when liberated, life was empowered to take on the quality of art. Beuys' mixture of social radicalism, shamanistic mystification and entrepreneurial skill, allied to a genuine feel for the uncanny, produced a body of work which often allegorizes the position of the artist in contemporary society. For better or worse Beuys' oeuvre had an enormous impact on art on both sides of the Atlantic. It may not be irrelevant in this respect to note that the Guggenheim Museum, which had refused to condone Haacke's brand of art and politics, in 1980 mounted the largest exhibition of Beuys' works to take place in his lifetime. Needless to say, Beuys' virtual cult of personality provoked ironic attack from collectively organized practices such as Art & Language. His aptitude for self-mythology also elicited disquiet from the critic Benjamin Buchloh, who perceived that 'the abstract universality of Beuys' vision has its equivalent in the privatistic and deeply subjectivist nature of his actual work' (B. Buchloh, 'Beuys, the twilight of the idol', p.43). For Buchloh this aestheticization of politics, by a German artist, carried historically uncomfortable overtones: Walter Benjamin, writing in the 1930s in his essay 'The work of art in the age of mechanical reproduction', had argued that the aestheticization of politics lay at the heart of Fascism and that it was in response to this aestheticization that socialists were required to politicize art.

Victor Burgin, another artist who had exhibited in When Attitudes Become Form, attempted to summarize these developments in an essay titled 'The absence of presence', which looks back to Conceptual Art and the 'defeat' of Modernism. For him, the effect of Conceptualism's 'explosion' of the art object, and the concomitant extension of attention to the institutions and systems wherein art was produced and circulated, was essentially to open up the areas of concern which art could legitimately address. For Burgin and others the feature of the newer avant-garde work which lent itself most readily to exploitation in the pursuit of relevance, was photography. At a stroke photography seemed to transcend the outmoded tradition of painterly realism, yet finally to escape the hermetic nature of so much post-Minimal art. With this idea the history of art opened onto a wider history of *representations* (Burgin, 'The absence of presence', p.20). For the artist of Burgin's persuasion, the basic historical condition of practice is that we live in a world of representations, wherein our societies, other people, even our own identities, are continually constructed, negotiated and played back to us through a range of representational systems. The task of the critical artist is to interrupt this flow of representations, to diagnose and to reveal its mechanisms, and thereby to play a part in liberating people from the range of institutions – tangible and intangible – which increasingly control their lives.

The representational system which offered itself as both tool kit and target for the new politically interventionist visual arts was advertising. In a series of works of the mid-seventies Burgin set out to turn advertising against itself. Advertising techniques, and often the subject-matter of actual advertisements too, were used to perform tasks the very opposite of those for which they were developed. Whereas capitalist advertising seeks to conceal reality behind a veil of fantasy and wish-fulfilment in order to sell products to passive consumers, Burgin attempted to use the same techniques to reveal contradictions in social reality, 'selling' ideas to people who would thereby be empowered to act upon and to change that reality.

Plate 189 Victor Burgin, *What does Possession mean to you?*, 1974, photolithographic print, 124 x 84 cm, 500 copies posted in the streets of the centre of Newcastle-upon-Tyne. Arts Council Collection. Reproduced by permission of the artist.

The early-morning mist
dissolves. And the sun shines
on the Pacific. You stand like
Balboa the Conquistadore.
On the cliff top. Among the last of
the Monterey Cypress trees.
 The old whaler's hut is abandoned now.
But whales still swim through the wild waves.
 Sea otters float on the calmer waters.
Cracking abalone shells on their chests.
 Humming birds take nectar from the red hibiscus.
Pelicans splash lazily in the surf.
 Wander down a winding path. Onto gentle sands.
Ocean crystal clear. Sea anemones. Turquoise waters.
Total immersion. Ecstasy.

TODAY IS THE TOMORROW YOU WERE PROMISED YESTERDAY

Plate 190 Victor Burgin, 'Today is the Tomorrow you were promised yesterday', one of eleven panels from *UK 76*, 1976, each 102 x 152 cm. Arts Council Collection. Reproduced by permission of the artist.

Burgin developed these ideas in such works as *What Does Possession Mean to You?* (Plate 189). The stereotypically romantic image of the sleek young couple is first of all set up and then, by the play on the word 'possession', opened up to counter-readings. These operate on two levels: gender and class relations. The stark fact of the possession of wealth and property is worked around questions of male/female 'possession'. This can imply a critique of conventional gender relations in which people are treated as property. Bearing in mind how the glamorous image of gender relationship is turned into a question of gendered oppression, it can also imply a sense in which the glamour of ownership is itself revealed as tawdry and oppressive. Both dimensions, then – the critique of gender relations and the critique of property relations – are critical with respect to the norm of contemporary bourgeois society. In other works from the same period, Burgin used similar devices to point to the realities of cheap labour, racial discrimination, poor housing and related social ills hidden behind the conventional advertising message of plenitude, harmony and consumption (Plate 190).

Class and gender

By the later 1970s, then, practices existed within the art world which were the product of a kind of tension. On the one hand, there was a traceable technical development from the avant-garde refusals of High Modernism in the 1960s: this ranged from all-over painting, to objects, to 'anti-form' and process works, the last of these often involving photographic documentation. On the other there was support for notions of social effectivity which were widely perceived to be inimical to High Modernism's claims for the autonomy of the aesthetic, and which also appeared to point in the direction of photographic work. It is important however to emphasize that a significant shift in the terms of this critical practice had taken place, relative to the tradition of the revolutionary European avant-gardes in the period before the Second World War. Two factors have been important. In the absence

of any noteworthy level of class struggle in the developed nations for much of the period after 1945, 'class' tended to be displaced as the anchorage of dissent, political or cultural. Where successful social struggle did take place it did so mostly under the rubric of anti-colonialism or anti-imperialism in, for example, Africa and South-East Asia. For our purposes, the import of these epochal struggles has been the inscription of race, or a concern with 'ethnicity', across cultural practices existing within the erstwhile imperial, developed societies. Second, and making allowance for such deceptive harbingers of change as 'students' (who much exercised both radical and conservative consciousness during the sixties), the most insistent bearer of the struggle for emancipation within Western societies has been the women's movement in its various forms. This phenomenon is not to be conflated with the varieties of intellectual feminism, significant though these have doubtless been. Rather it extends across a range of practices and campaigns from equal pay to abortion rights. The principal contribution of intellectual feminism, and in particular of cultural-intellectual feminism is that it has provided a language in which to think those practices. With considerable debts to psychoanalysis, this conceptual framework has enabled the development of a conception of human experience and human subjectivity as significantly gendered. As such the discourse of feminism offers a stark contrast to the language of class, the traditional focus of the left, which in the same period tended to stagnate. In principle no doubt the oppression of women and the plight of those subject to imperialism had always been concerns of the left, though the practice left much to be desired. But in the period after 1968 the map of their relations was redrawn. Thus far we have tended to speak of a turn to a post-Conceptual, politically left-wing art. In these years however, what the left *was* underwent significant revision.

One body of work which attracted considerable attention in this respect in the 1970s was that of Mary Kelly. Between 1973 and 1979 Kelly produced a work which has been

Plate 191 Mary Kelly, *Post Partum Document, Documentation III*, one of ten units, 1975, pencil, crayon on paper, 35 x 28 cm. Reproduced by permission of the artist.

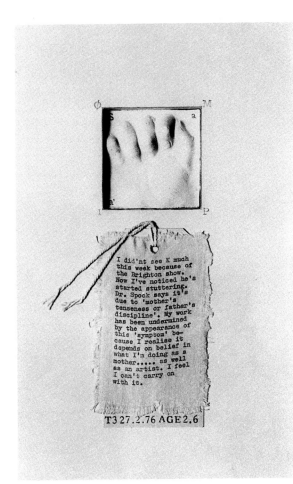

Plate 192 Mary Kelly, *Post Partum Document, Documentation IV*, one of eight units, 1976, plaster and mixed media, 35 x 28 cm. Reproduced by permission of the artist.

accorded canonical status among subsequent feminist artists: a large-scale multimedia documentation of the birth and early life of her son, titled *Post Partum Document* (Plates 191 and 192). The work is divided into six sections traversing the child's development through weaning, increasing separation from the parents, the acquisition of language, and ending with the boy being able to write his own name.

The work then, can be seen to have a dual concern: the socio-sexual development of the child and the constitution of a feminine identity on the part of the mother, through these moments in the child's development. The work itself consists of Kelly's notes and records of the process, theoretical speculations about it, which draw heavily on the work of the French psychoanalyst Jacques Lacan, and a range of documents and samples of the infant's progress. Visually, the work consists of a diverse collection of typefaces, hand-writing, fragments of cloth, chalked slates, plaster casts etc., mounted in a sequence of over a hundred 'plaques' (see Plate 192). These are internally organized, as it were 'composed', according to relatively conventional canons of graphic display in order to dramatize the impact of the various elements. The work is thus not 'about' its appearance in any significant sense. The appearance is, rather, a mutable vehicle for the advancement of a series of propositions – a point underlined by the way in which works by both Kelly and Burgin, initially presented as installations, have gone on to achieve wider renown when reproduced in book form (Kelly, *The Post-Partum Document* and Burgin, *Between*).

A critical feminist practice such as Kelly's, or indeed Burgin's own practice, sets its face against the entire range of concerns motivating Modernist painting. From such a point of view, the latter comes up for the count – if at all – only as symptomatic of the

iniquities of a world for which the former takes itself to be a partial cure. Modernist art, and the world which values it, is presumed damned: complicit in a world of sexual and racial oppression which it is the business of the critical artist to redress. As Kelly herself wrote in her essay 'Re-viewing Modernist criticism': 'Modernism is defined as a determinant discursive field with reference to critical writing since 1945' (Kelly, 'Re-viewing Modernist criticism', p.41). That is to say, the polarities are the reverse of Modernism's own: the 'autonomous' art work is reinterpreted as something merely symptomatic of the critical discourse and, by extension, of the (largely hidden) interests from which it is made. By contrast it is the intention of the new work to bring out 'the construction of a different object in the domain of criticism' ('Re-viewing Modernist criticism', p.41). In Burgin's phrase, art had become a series of strategic interventions within a widespread 'politics of representation'. It is the point of such active, critical and interventionist work to redraw the map of art's location in the social order.

The state of painting

Varieties of reduction

In the later 1970s the Western world as a whole moved definitively into a period of economic recession and political reaction from which it has, at the time of writing, yet to emerge. There have been minor recoveries within the slump, but in comparison to the steady expansion of the years of the 'long boom' after the Second World War, the spiral has been downward. In such a situation the art world found itself in a paradoxical position. Important contemporary movements and their leading figures were wedded to a mix of social radicalism and media heterodoxy but the art world nonetheless had to trade in order to exist at all. The result was a place in the market for those activities which, rhetorically at least, had been conceived in opposition to it. These included the 'documentation' of ephemeral activities and projects and the sale of photo-works and other records in limited editions. Thus the economic system of art essentially survived.

Nonetheless, from the point of view of the market the unique, hand-crafted art work remained the spectre at the feast of critical, 'post-object' art. Not for the first time, and despite many premature obituaries, painting refused to die. The manner of its survival however was complex, the status of the results ambiguous. During the 1970s Modernist painting of the kind produced by Noland and Olitski, and defended by critics like Greenberg and Fried, had declined in authority. That is not, of course, to say that its practice ceased: Noland and Olitski, and even surviving members of the first generation of Abstract Expressionists (De Kooning is the principal example) continued working uninterruptedly into the period claimed for 'postmodernism'. It is perhaps true to say, however, that of those whose work formed the focus of Michael Fried's major critical essays of the late 1960s, only Frank Stella has continued to command a place at the forefront of international art. The direction taken by his later work, however, would scarcely appear to conform to classic Modernist protocols. The artistic autonomy of *Queequeg in his Coffin* (Plate 193) is, arguably, compromised by its evocation of a literary work, Melville's *Moby Dick*. Any unity it may have is clearly unstable and, to use Greenberg's terms, it is far from 'flat', projecting as it does several feet from the wall. As an object, it inhabits a transitional zone between painting and sculpture. As a painted surface, it apparently employs 'quotations' from pre-existing types of Modernist art, as gestural brushstrokes are brought into unexpected conjunction with geometric hard-edged motifs.

Modernist painting as such failed to continue to compel widespread attention. This is doubtless in part attributable to the parallel tendency of its diminishing critical support. A

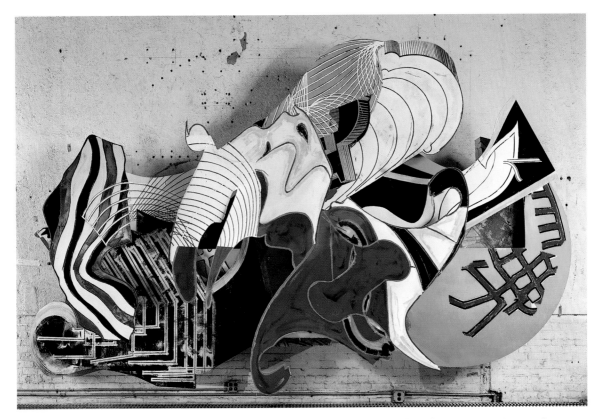

Plate 193 Frank Stella, *Queequeg in his coffin* (IRS #3, 1.875X), 1989, mixed media on magnesium and aluminium, 289 x 471 x 122 cm. Private Collection. Photo: Steve Sloman by courtesy of Knoedler & Co., New York. © Frank Stella/ARS, New York.

younger generation of committed Modernist critics failed to materialize in the 1970s. And out of the more senior of the 'abstractionist' critical pantheon, Greenberg abandoned practical criticism for increasingly Olympian bulletins on 'Aesthetics'; Fried turned to history in the shape of an account of the genesis of modernism in a dialectic of 'absorption' and 'theatricality' in eighteenth- and nineteenth-century France; and by the early seventies Rosalind Krauss had embarked on the path which by the end of the decade would lead to her influential formulation of a theory of artistic 'postmodernism'.[16] Modernist painting could scarcely sustain the loss of such powerful critical support.

Even in the climate of post-Minimal and Conceptual Art, however, some painting practices found a place. For the most part these survived and maintained a species of critical interest through their practical interrogation of certain forms and assumptions of Modernist painting. Foremost among them were the 'autographic' or gestural conventions associated with the canonical themes of self-expression and originality. By contrast, those artists on both sides of the Atlantic whose work it remains possible to comprehend as continuing both the tradition of the avant-garde and the tradition of painting – i.e. those who neither abandoned painting for 'new media' nor retreated to artistic conservatism – were motivated by an interest in painting as surface, paint as material, the work of art as a *thing* exhibited in a *place*, produced by someone whose work it was to produce such things.

Mention has already been made of the practice of the French artist Daniel Buren (Plates 170, 171), which though scarcely 'painting', still depends for its meaning on a sense

[16] See Greenberg's 'Seminars', published in various journals between 1973 and 1978; Fried, *Absorption and Theatricality*; Krauss, *The Originality of the Avant-Garde and Other Modernist Myths*.

of *not* being painting, in a context (a gallery or museum, for example) where painting constitutes a normative presence . Somewhat more conventionally, in the United States Robert Ryman methodically explored the effects of applying paint – usually white, and usually in separately applied short brush strokes – to a range of surfaces not commonly used for painting, including plastic and metal (Plate 194). These painted surfaces were then attached to the vertical surface of the wall by visible fastenings which became a declared part of the art. Working with these apparently restricted means, making marginal adjustments to the material of the support, its size, its shape, the scale of the brushstrokes relative to the whole, the density of application of the paint, and so forth, Ryman has been able to produce an apparently inexhaustible range of nuanced effects, which for all the austerity and reduction of their means, take on a paradoxically decorative quality. While this can pull against a sense of their rigour as enquiry, it may also be a way of acknowledging that they can sustain an existence as *paintings*, and not as the mere tokens of an argument.

The same can be said of a range of 'structural' paintings produced during the 1970s by the German artist Gerhard Richter. During the 1960s Richter had produced paintings based on a wide range of photographs of unremarked daily events, mass media representations, pornography, cityscapes and landscapes. At the same time this questioning of the conventional procedures of painting received a more literal formulation in the production of a series of works, continued into the 1970s. In these, separate rectangles of colour were systematically applied in enamel paint, regularly spaced over the canvas in the simplest of structures; the titles were literally descriptive of what faced the spectator: *Two Grays, One Upon the Other*; *Colour Chart*; *Twelve Colours*; *256 Colours*; *1024 Colours* (Plate 195); *4096 Colours*.

Plate 194 Robert Ryman, *Unit*, 1980, oil on canvas with metal fasteners, 66 x 61 cm. Photograph by Otto E. Nelson by courtesy of The Pace Gallery, New York.

Plate 195 Gerhard Richter, *1024 colours*, no. 350/4, 1973, lacquer on canvas, 254 x 478 cm. Hallen für Neue Kunst, Schaffhausen, Switzerland.

Richter, who has since referred to Andre, LeWitt and Ryman as among the most important artists for him in the 1970s, has also articulated that resistance to the conventions of Modernist painting which animated both his photographic and 'constructive' works. He speaks of rejecting 'the culture of painting', claiming that he would have 'nothing to do with *peinture*' – with 'painterly' painting (quoted in Buchloh, 'Gerhard Richter', p.18). His reasons bear comparison with the approximately contemporary refusal of the protocols of mainstream Modernism by the American 'literalists' like Judd, Morris or Smithson: the idea that painterly 'culture' 'stands in the way of all expression that is appropriate to our times' (Buchloh, p.18). This is not to say that Richter's works are free of ambiguity or even of visual appeal. For while on the one hand he points to the influence of Conceptual Art, he also sees his works as attempted resolutions of a problem *in painting* – namely of how to arrange colours when conventional painterly composition is no longer available: 'That's what I tried to produce, as beautifully and as clearly as possible' (Buchloh, p.20).

In England Alan Charlton embarked in the late 1960s on a series of grey monochromes, variations upon which (for example, Plate 196) have continued to preoccupy him to the time of writing. As well as varying the size of his canvases, Charlton sometimes removes holes from their centres, or notches from their corners or slots parallel to the edge. Sometimes a rectangle is placed within another 'framing' rectangle. In addition to this range of structural variations, Charlton also varies the greys he employs. What remains constant is the thickness of his stretchers: all are made from 4.5 cm deep timber. The height at which the paintings are hung on the gallery wall can also be made to vary according to the demands of the series. This points to a distinguishing feature of the project. Charlton's paintings – which frequently function collectively, as in a series of 1988 titled *Team Paintings* – actuate the space in which they and their spectator both are: that is to say they address the real space they inhabit rather than the illusionistic space internal to traditional and Modernist painting alike. Charlton's work exemplifies the argument made earlier about the formal innovations of the late 1960s embodying responses both to what

Plate 196 Alan Charlton, *Painting in Seven Equal Parts*, 1979, acrylic emulsion on cotton duck, seven panels, overall length 649 cm, each part 267 x 89 cm, 4 cm apart. Collection Stedelijk van Abbemuseum, Eindhoven. Photo: Prudence Cuming Associates by courtesy of the artist.

were perceived as the exhausted conventions of art *and* a search for different *social* standards and values. Charlton's grey monochromes stand both as things in themselves which function in space, and as allegories of equality, produced out of a working practice which owes more to the disciplines and experiences of industrial production than to the craft traditions of the studio, let alone the dilettantism which so persistently hovers in the background of 'painterly' painting. Charlton himself has recently remarked: 'I wouldn't like to represent a political stance in my work, but at the same time I could say there are certain artists who represent the right, and I would say that in that sense I represent the left' (quoted in A. Wilson, 'For me it has to be done good', p.13).

Notwithstanding Charlton's protestation of belief, it proved no easier in the 1970s than it did before – or has done since – to attach a notion of political commitment to abstract painting. At that time in the 1970s, when professions of political commitment among the avant-garde were on the whole prominently advertised, they were usually made at the expense of painting and in favour of work in the 'new' – often photographic – media. In a relatively radical political climate, to carry on painting – in however critical a form – was to swim against the tide. Yet in respect of painting, by the turn of the decade a newly powerful current was forming at the confluence of two interests. On the one hand there was a resurgent interest in a reinvestigation of the possibilities of painting after a period of its undoubted eclipse. In the history of modern art the very fact of a lack of cultivation can render an area of interest to a new generation: times change, and with them, needs. On the other hand, never to be underestimated, was the market, and a desire, perhaps even a demand, for painting. It is important to stress the distinctness of these interests, if only to offer a point of critical purchase upon the propensity of newly

hegemonic 'critical' or 'new media' artists to conflate the former entirely with the latter – that is, to view resurgent painting as *merely* the creature of the market, and as such reactionary without remainder.

New spirits

It should be borne in mind that the Modernist abstract art of the 1960s had always been critically distinct from a broad current of figurative work. Work of the latter kind (Plate 197) maintained a significant position in the market throughout the period under review and attracted continuing support from those to whom the theories and methods of the Modernist had always seemed alien and presumptuous. To such observers Minimal and Conceptual Art were altogether beyond the pale. If decline in the critical authority of Modernism meant anything to them it signified an opportunity to revert to talk of the 'human condition' – a topic methodologically excluded from Greenberg's criticism and generally treated within the discourses of Conceptual Art and its relatives as a subject of irony at best.

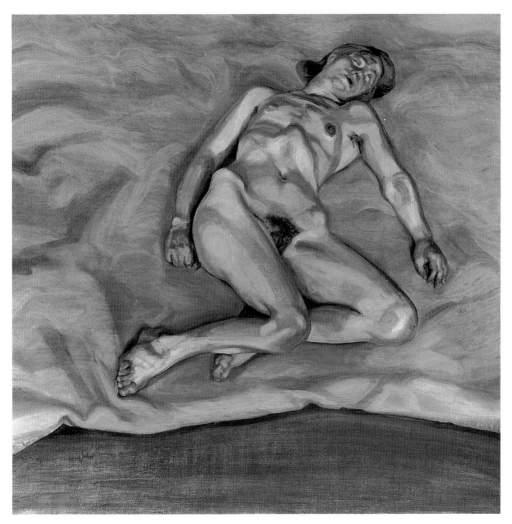

Plate 197 Lucian Freud, *Naked Girl Asleep I*, 1967, oil on canvas, 61 x 61 cm. Private Collection. Photograph by courtesy of James Kirkman by permission of the artist.

For a large and influential constituency on both sides of the Atlantic, the idea of the 'postmodern' gave new impetus to a form of persistent *anti*-Modernism. That is to say, it provided a new platform for those who had always been unhappy at that marginalization of national traditions and figurative themes which cosmopolitan Modernism effected wherever it took hold. In England during the 1980s this tendency was much strengthened; given both the relatively shallow roots of Modernism in the face of a resilient 'British tradition' in art, and the sharply conservative turn in the society as a whole, particularly after 1979. By the middle of the decade a form of born-again anti-Modernism had achieved a prominent platform in the writings of the erstwhile Marxist critic Peter Fuller and the sumptuous journal he founded with the title *Modern Painters*, a reference to the Victorian legacy of Ruskin.

It is important for the present account therefore that we distinguish between the various types of painting which have been current in the period: on the one hand what might with some justice be called a 'post-Conceptual' painting, and on the other a form of artistic retrenchment trading in the currency of 'universal' values, which interprets not merely Conceptual Art but the very Modernism of which Conceptual Art was a critique, as aberrant departures from the properly 'humanistic' calling of art.

A New Spirit in Painting was the title of an exhibition mounted in London by the Royal Academy in 1981. The catalogue's preface is instructive as to the intentions of its curators:

> This exhibition has in our eyes a programme. It is meant both as a manifesto and as a reflection of the state of painting now … During the seventies painting has continued to lose ground as 'newer' means such as photography, video, performance and environments began to dominate the great international exhibitions of contemporary art held in the United States and Europe. Surprisingly it really does seem that the last exhibition anywhere in the world to look at painting from an international perspective was held in London at the Tate Gallery in 1964 … This exhibition does not pretend to be a survey of everything that is happening … There are outstanding non-figurative paintings in our exhibition. However, it is surely unthinkable that the representation of human experiences, in other words people and their emotions, landscapes and still-lives could forever be excluded from painting. They must in the long run again return to the centre of the argument of painting. This is the central proposition of this exhibition.
>
> (*A New Spirit in Painting*, pp.11–12)

Faced by the austerity and difficulty of much post-Conceptual work it might well seem that a return to humanistic themes should enjoy considerable support. But how is such a 'return' practically to be achieved? It is one thing to wish for human reference – another to achieve it in ways which (to borrow from Fried) 'compel conviction'. One thing that any humanism requires as a precondition of its persuasiveness is a convincing account of the human subject. Universalizing arguments about the 'truly' human have buckled under the weight of new critical theories which have claimed to understand the human subject as constituted out of a variety of contingent, historical and social determinants. An understanding of subjectivity as the product of 'coding' has served to undermine the traditional assumption that identity is 'given' in some originary unproblematic unity. Wherever the necessity for such revisions is accepted, the sphere of representation must be profoundly affected. People after all are not just bodies; even theory untouched by Modernism speaks of a humanist art representing 'emotions' and 'experiences'. Yet the representation of experiences and emotions cannot but become unstable when what it means to have an experience has to be reconsidered. 'Experience' has come to be seen as the coded product of the work of social ideology, as something structured by class and gender, and by language itself. If the aim of the reinvocation of humanism is the recovery of stability – the

recovery of something shared and universal which is supposed to have been questioned and threatened – how can this be other than conservative in nature, a 'call to order' of a kind encountered in earlier phases of modern art during periods of social retreat? It seems that conventional figuration cannot do other than replay conventional misrepresentations of what it is to be human in bourgeois society. However rooted its appeal to the 'universal', conventional figuration turns out to be inescapably ideological.

Naturalistic depiction is not the only peg upon which a 'new spirit' can be hung. The austerity, intellectual aspiration and political and moral vigilance of the dominant post-Conceptual 'engaged' art of the 1970s could scarcely have been at greater variance with the antecedents of 'new spirit' painting. New spirit's most characteristic affiliation was with the Expressionist tradition. Doubtless there was an element of straightforward recidivism in the eagerness with which the market seized upon apparently self-confident and eminently saleable paintings after the thin gruel of text and photographic-documentation works. It is important, however, though not necessarily easy, to try to distinguish between the intentions of the work, and the forms in which it was most typically appropriated by the market and curatorial interests.

Julian Schnabel had been producing large, even monumental, paintings from the mid-1970s, often drawing upon Classical or biblical imagery. *St. Francis in Ecstasy* (Plate 198) was included in the New Spirit in Painting exhibition in 1981. In these works, the imagery was juxtaposed with dramatized 'expressive' surfaces, usually involving bright colour laid on with extremely large brushes: this gave an air of restlessness and dynamism to the picture. Unconventional materials were used to 'energize' the surface or to produce discordant effects: broken plates in *St. Francis*, antlers and pieces of wood elsewhere. These were often attached to equally unconventional supports – tarpaulins, or at the opposite extreme, velvet. Scale, gesture, energy, boldness, apparent conviction and so forth all serve to reinflate the sense of the artist as 'visionary': one who feels deeply, acts on impulse – yet profoundly – and offers up his insights to those who, in turn, are free enough of drab convention to appreciate the liberating message. Schnabel's work was interpreted in the New Spirit catalogue as a vigorous attempt to exude 'romance' and 'optimism'. It was said to have 'rediscovered the sheer joy of painting' in stark contrast to the preceding 'narrow, puritan approach devoid of all joy in the senses' (pp.11–12).

With these works, Schnabel experienced rapid market success in the late 1970s. His work was subsequently bought on a large scale by major private collectors such as the Saatchis, which in turn led to its acquisition by national institutions such as the Tate Gallery.[17] By the mid-1980s Schnabel was routinely being referred to in art journalism as the 'most famous artist in the world' and 'probably the most important painter since Picasso' (quoted in G. Politi, interview with Schnabel, p.51; S. Kent, 'Success on a plate'). Schnabel himself both unashamedly played up to the media image of the artist as star, yet also maintained a more reflective stance about the role of painting and the situation of the contemporary artist. As if to forestall facile condemnations of his recourse to an outmoded sense of self-expression, Schnabel remarked: 'I've always said there's no personal language; only a personal selection of language' (S. Kent, 'Success on a plate'). In this sense a painting such as *Exile* (Plate 199) might be seen as mobilizing tokens from different representational codes: Renaissance art, children's toys, a catalogue of ethnic types, real objects and painted illusions, figurative drawing, abstract painting. If this is a perception of the artist as inundated by a fund of already existing imagery and techniques out of which something newly coherent has to be won then it is characteristic of a certain 'postmodern' consciousness and must not be over-readily reduced to a retreat from criticism back into the myth of the expressive artist. It has been suggested for example that

[17] Charles and Doris Saatchi began collecting on a large scale in the 1970s; the Saatchi Gallery opened in London in 1985.

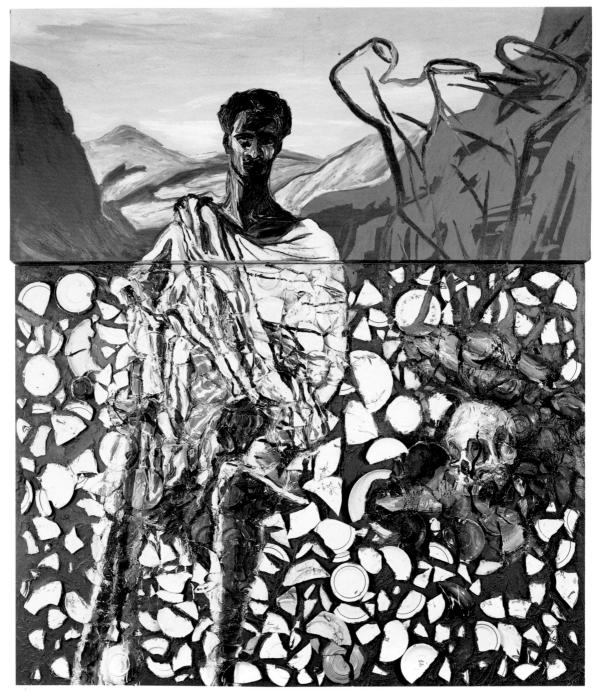

Plate 198 Julian Schnabel, *St. Francis in Ecstasy*, 1980, oil, plates on bondo, wood and putty, 244 x 213 cm.
Photograph courtesy of The Pace Gallery, New York.

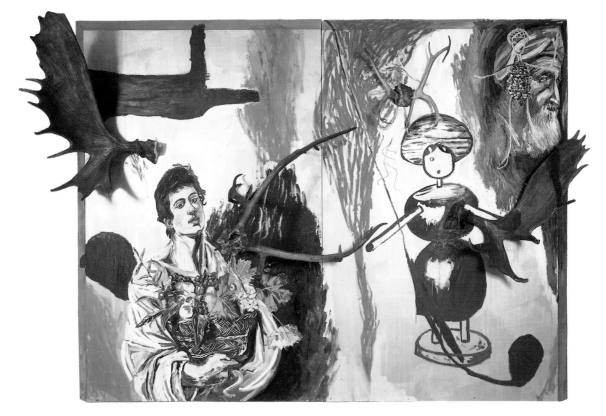

Plate 199 Julian Schnabel, *Exile*, 1980, oil and antlers on wood, 213 x 244 cm. Photograph © by Phillips/Schwab, courtesy of The Pace Gallery, New York.

Exile embodies the state of its title: 'homeless, uncertain, between languages' (S. Morgan, 'Julian Schnabel', p.4). Schnabel has also laid claim to 'a Whitmanesque notion of cataloguing things, whether materials, images, ways of working or objects … all of them as equal and on a horizontal plane' (S. Kent, 'Success on a plate'). Whatever this is, it is far from congruent with the voice of the entrepreneurs of the 'new spirit'. Much of the commentary associated with 'new spirit' painting did in fact speak of a sophisticated critical language of 'coding', 'distance', 'irony', of a knowing eclecticism within an in-escapably 'ready-made' culture. It remains an open question to what extent this tendency aped contemporary intellectual fashion before it had really faced up to the hard lessons of the much-proclaimed 'death of the Author'.

Such work thus became a focus for conflicting interpretations. Alongside his enormous success in the market place (and some related critical praise), Schnabel's work has also been the object of hostile criticism. He was censured both for self-advertisement, anti-intellectualism and 'cultural cannibalism' *and* for negativity, for relaying a message of passivity in the face of contemporary commodity culture. Irrespective of Schnabel's own acuteness, or lack of it, his painting amplified a division in the culture of modern art. It can scarcely be to its advantage that so much of the critical support for such painting – though not all – was drawn from those with a managerial interest in the health of the market. The reassertion by cultural management of an unreflective hedonism in the painting of personal experience at precisely the moment when the economy slid into crisis, and politics to the right, could hardly be clearer. From a more critical perspective, the apostrophe of a 'new relationship between image and reality through a painting of

intensive poetic force and peircing imagination' is the rhetoric of having it all made good again. In certain echelons of the art world, and not least in an American context, the 'neo-expressionism' of Schnabel and artists like him must have seemed to offer the possibility of a resumption of normal service.

A similar element of ambiguity runs through much 'new spirit' painting. It marks a rejection of that abstract Modernism whose critical force had been so compromised by its reception, often quite literally, into the corridors of power – some measure of distance from which still seems to be a condition of virtue in modern art. Yet by re-investing many of the humanist and idealist conceptions of art which Modernism at its most rigorous had foresworn, the rejection of abstract Modernism by 'new spirit' painting took a very different path from its rejection in the conceptual tradition. However much an artist like Schnabel knowingly invoked the postmodern condition of image saturation, 'new spirit' painting came additionally to stand for a rejection of the critical stance associated with Conceptual Art and its heirs. It signified more powerfully as a resumption of the authorial myths of art than a deconstruction of them. Whereas Expressionism, for all its conceptual naïveté, had historically embodied a radical impulse with respect to bourgeois society, its reappearance in the conditions of decay and confusion reigning after the break-up of the Modernist paradigm was of a different stripe: 'authoritarianism masquerading as anti-authoritarianism' (C. Owens, 'Honor, power and the love of woman', p.11).

The first generation of the New York school – Pollock, Rothko, *et al.* – had left serious problems for their successors concerning the nature of expression and meaning in art, not least those which related to issues of originality and convention. These had been obliquely negotiated by Johns, Rauschenberg and their Minimalist and Conceptualist descendants by means of a form of overt self-consciousness about problems of expression. The insouciance of 'new spirit' painting and Neo-expressionism in particular seemed to imply that these problems could be disregarded again. But *could* they be? Could work which professed to ignore its own historical conditions escape cliché?

Certainly there was a gulf between those artists who thought it could, and those who felt constrained by the limitations of previous practice; between those who, in Johns' words, 'believed painting to be a language' and those who appeared to see themselves as Robinson Crusoe. From the first perspective, part of the problem was finding ways of not repeating yourself, which seemed to demand the invention of a repertoire of devices of irony and distance. For the others, the originality of the first person utterance went unquestioned. Problems of context, redundancy and so forth, scarcely signified. 'Expressing yourself' was what modern artists did, and the more enveloping the society, the more brashly and stridently you had to do it to be heard at all.

The depth of the divide is highlighted by Alan Charlton, whose monochrome paintings acknowledge a sense of what resources are *not* available to contemporary art. Speaking retrospectively in 1991 of his somewhat incongruous participation in the New Spirit in Painting exhibition of a decade before, he commented:

> At the end of the 1970s we had reached a very strange position where the artworld was ready for something different, it was really just wanting a fashion to change. This coincided with this very conservative period of people wanting to return to old values, to things that they could understand, all of which seemed to reflect the economy of the time … I would say 95% of the artists in that show were absolutely awful and I wouldn't give any credit whatsoever to them, and for the other 5% some were artists I would respect, but on the whole I would characterize most of those artists as the enemy. But I didn't refuse the invitation to be in the exhibition because at that time I thought that the enemy was winning and that the best way to counteract this was by terrorist activity.
>
> (quoted in A. Wilson, 'For me it has to be done good', p.16)

The idea of the postmodern

Modernism always exercised its hegemony over other models of art practice. This is, after all, part of what the term 'hegemony' means. Dominant paradigms marginalize other ways of carrying on. We may take the central Modernist claim, in the Greenbergian sense of the term, to concern the autonomy of art and its 'medium-specificity' – that is, the restriction of its legitimate effects to those of its medium. By this measure it seems clear that since the late 1960s there have occurred a range of art practices which, rather than being the subordinates of a hegemonic Modernism, have in some sense occurred 'after' Modernism. Yet the first use of the term 'postmodernist' to apply to the visual arts seems to have been made by the American critic Leo Steinberg in 1972, where it was used to refer to certain art of the 1950s, particularly the mixed media 'combine' paintings of Robert Rauschenberg. Immediately, then, there is ambiguity about the scope of the term. It can be used to denote significant shifts in the priorities of the art of Rauschenberg and Johns from those of the Abstract Expressionists. It can be used to denote the distance taken by Conceptual Art, Land Art, Performance Art and related non-medium-specific work which from the late 1960s contested the high Modernist paradigm of art-making. More usually however it has been employed to refer to a range of practices from the late 1970s onwards.

Books and articles with the word in their titles do not begin to appear in an English-speaking context in any quantity until after 1980. Jean-François Lyotard's study *The Postmodern Condition* was published in French in 1979 but not in English until 1984. Jurgen Habermas's contestation of 'postmodernist' claims initially appeared, in German, late in 1980, but was not published in English until a year afterwards (Habermas, 'Modernity – an incomplete project'). It did not achieve widespread currency until its publication in the influential anthology *Postmodern Culture* (edited by Hal Foster) which appeared in England in 1985, having previously been published as *The Anti-Aesthetic* in the United States in 1983. The change is significant. By the mid-1980s 'postmodernism' had become a fashionable term in debates about art and culture: fashionable enough to sell books. The reason is probably in part related to the time taken to assimilate the initial marking out of the ground by Lyotard and Habermas. It may also have much to do with the impact of the work of Fredric Jameson, indisputably the most prominent English-language exponent of the concept, in his interventions of 1982 and 1984 – respectively *Postmodernism and Consumer Society* and the full-blown development of that thesis two years later as *Postmodernism, or The Cultural Logic of Late Capitalism*. One thing should already be clear from these titles: none of these contributions to debate about the implications of the concept is principally about art. They are concerned, to use Jameson's words, with a 'periodizing' account of cultural progression. For him, just as the productive base of capitalism has moved through different stages, from competitive capitalism, through monopoly capitalism, to multinational (or 'late') capitalism, so the terms of cultural expression have undergone epochal transformation: from what he calls 'realism', to 'modernism', and now to 'postmodernism'. For Jameson, 'postmodernism' is the new 'cultural dominant' of late capitalism.

The major early statements of a concept of postmodernism in the visual arts were by Rosalind Krauss and Craig Owens (Krauss, *The Originality of the Avant-Garde and other Modernist Myths*; Owens, 'The allegorical impulse'). Both started from an assumption that the stylistic diversity of art after Modernism (often uncritically celebrated under the rubric 'pluralist') conceals from view some underlying unifying principle: the beat of a 'different drummer from the one called style', as Krauss puts it (*The Originality of the Avant-Garde*, p.196). Both purport to deal with a change in the mode of signification of art; that is to say, not an easily specifiable shift in the appearance of art, but in the manner in which art

achieves meaning in the first place. It is natural enough when faced by the sheer prepon-
derance of the term 'postmodernism' in contemporary debate to ask the questions 'What?',
and 'When?'. These are not questions, however, which are likely to receive uncomplicated
answers. What has happened is that a web of intersecting, overlapping, occasionally con-
tradictory theses have been advanced at a number of different levels, artistic, but also
cultural, sociological, political and economic.

Given the difficulty and frequent vagueness of much of this debate, it may help if we
isolate some critical tendencies and try to relate them to vivid works of art (though, of
course, 'vividness' itself may have to be qualified). In the face of the considerable and
diverse resources of theory and analysis which have accumulated around the idea of the
postmodern, we offer a very schematic breakdown into three broad themes with regard to
which that idea has been both oriented and disputed in the field of the visual arts:

1 postmodernism as a critique of the grounds of difference;
2 postmodernism as a critique of the myth of originality;
3 postmodernism as a critique of historical narratives.

We will consider each of these themes in turn in the last sections of this chapter.

The critique of difference: class, race and gender

There is of course no sudden or qualitative shift between the art of one decade and that of
another, even if a new term does come into currency. The 'committed' art of the 1970s
became established as one of the pillars of artistic postmodernism. The major develop-
ment was a confirmation of that tendency to ignore a traditional radical focus on class in
favour of an insistent concentration on questions of gender and to a lesser extent on race.
This was conducted under the overarching rubric of 'power', a term which came into play
through the work of Michel Foucault. For Foucault power was 'secreted' by societies. It
was not something that could be escaped, via, say the libertarian gesture of revolution.
Just as for Althusser in the late 1960s 'ideology' had come to seem to be a social condition
of human life rather than merely of capitalism (see his 'Ideology and ideological state
apparatuses'), for Foucault power was a permanent condition of social life. Foucault's
perspective was conceived in opposition to what he saw as the failure of Marxism after
the defeat of 1968. On the one hand his analysis supported a focus on the local, contingent,
institutional struggle rather than on the global transformation; and on the other, by
shifting the emphasis from economic relations, such as class, to power relations between
individuals, it tended to orient concern towards hitherto neglected psycho-social areas.
Sex and power became leitmotifs of radical cultural practice in the period.

The forms of oppression associated with relations of gender have been the principal
concerns of the American artist Barbara Kruger. Kruger started her career as an art
director working on women's magazines for Condé Nast. Beginning in the early 1980s she
applied this experience in works which strongly connote advertisements (Plate 200). These
works characteristically involve the conjunction of a found photographic image, usually
printed in monochrome, with a brief hortatory or epigrammatic text, functioning
essentially as a slogan. This text frequently takes the form of white lettering, on a red
background, slashed across or bordering the image, the scale of the lettering being tuned
to that of the image so that the text never quite reads as caption to the picture, nor the
picture as illustration of the text. In addition to these graphic trademarks, Kruger often
employed the semantic device of a binary opposition running through the texts:
'We/You'. The 'We' referred to women in general, frequently in the role of victim – or
redresser of – some wrong. The 'You' tended to refer to the generality of men, personified

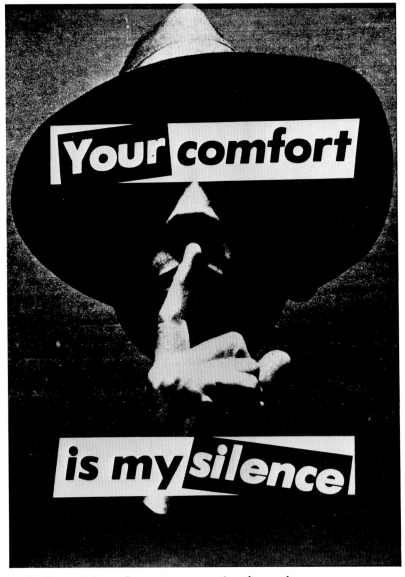

Plate 200 Barbara Kruger, *Your Comfort Is My Silence*, 1981, photograph with added text, 142 x 101 cm. Courtesy Thomas Ammann, Zurich.

in the form of the male spectator perusing the work.

Some of these pieces have appeared in relatively unconventional places for works of art: in magazines, on billboards, even on T-shirts. Others have been exhibited more conventionally in art galleries. Recently Kruger has expanded them to an environmental scale (Plate 201). Work of this kind clearly operates with a different sense of the task of art than aesthetic contemplation, which is not to say that compositional devices are not knowingly deployed as a means to the end in question. In this respect the work occupies a place similar to Burgin's 'advertisements' of the mid-seventies. The American critic Hal Foster, following the influential French semiologist Roland Barthes, has described such a conception of art as standing at a 'crossroads ... of institutions of art and political economy, of representations of sexual identity and social life'. He goes on:

> This shift in practice entails a shift in position: the artist becomes a manipulator of signs more than a producer of art objects and the viewer an active reader of messages rather than a passive contemplator of the aesthetic or consumer of the spectacular.
>
> (H. Foster, 'Subversive signs', p.99)

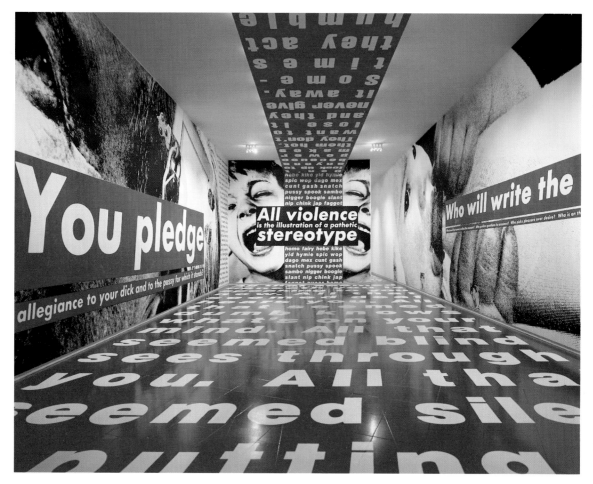

Plate 201 Barbara Kruger, installation of main room, Mary Boone Gallery, New York, January 1991.
Photograph by courtesy of Mary Boone Gallery.

That is the positive case. There are other perspectives however from which this sphere of 'engaged' postmodernist art appears more problematic. It is fundamentally predicated on a sense of its own moral security and rightness, as against the inequality and oppression it attributes to the dominant culture. The sub-cultural divisions of late capitalist society which permit the functioning of a system of committed art – its production, circulation and consumption – may simultaneously contribute to its ghettoization. There is a disquieting sense in which such work remains unconcerned by its own status within the enriched product range of contemporary culture. The culture it addresses carries on – and carries on generating materials susceptible to radical criticism. The problem arises when that which is marginal with respect to social values generally, accedes to a kind of power of its own in its own relatively restricted institutional compass. It would appear to be important for the moral character of such practices that they amount to more than the unwitting markers of cultural heterodoxy within an overarching status quo. If 'marginalization' of whatever type is reduced by those with a considerable stake in the cultural economy to a form of product identification, its virtue dwindles.

Originality and appropriation

Not all postmodernist art need fear being found in a compromising position. Some of it *courts* compromise, the better to find the limits of critical purchase. Its primary focus rests upon just those areas of life which are calculated to offend the sensibilites of the cultural activist. The salient fact of late capitalism lies after all, not in its margins. The characteristic pulse of our culture does not run through this or that radical movement, this or that style of art, even this or that political leadership. A case can be made for saying that it is to be found rather, in the commodity, in the commodification of everything, including art, and politics, and ultimately people.

The assumption that commodification is an altogether inescapable condition underlies the work of a group of artists based in New York who came to prominence in the early 1980s. Several of these artists were associated with the gallery Metro Pictures. The title itself, with its Hollywood connotations, indicates an ironic dissolution of the distinction between high art and popular culture so rigorously maintained by Modernist critics and artists. Just as 'committed' postmodernism was underwritten by the theories of Foucault and the psychoanalyst Jacques Lacan, the work of these artists owed much to the ideas of Jean Baudrillard. As early as 1973 Baudrillard had published in France a critique of Marxism under the title *The Mirror of Production*, the general ideas of which had become familiar in an English-speaking context by the end of the decade. Baudrillard's claim was that the Marxist stress on work and production as central to human social life merely mirrored the work ethic of capitalism. The 'leftover' area of aesthetic 'play' was, further-more, the other side of the same debased currency. Neither could promise emancipation. Instead Baudrillard proposed to focus on what he called 'the political economy of the sign': an emphasis upon meaning-production, information and media, which seemed to have become such a central and distinctive part of modern experience. Baudrillard was eventually to claim that reality itself had disappeared, lost behind a screen of signs. This is the condition for which the term 'hyperreality' became current in the late 1980s: a sense of living not in a world of work, production and real things, but a world of representations, of consumption, of media images, of shifting surfaces and styles, a world in which the real has dissolved into a *simulacrum*. Clearly such a description is best going to fit, in fact to be derived from, an experience of the most extreme, all-encompassing examples of contem-porary capitalism as it exists in parts of America and Japan. As its critics have pointed out, such a view is guilty of universalizing the experience of relatively few, relatively wealthy citizens of the world. It is nonetheless an experience which rubs off on very many more – precisely through the operation of the mass technologies of the spectacle. One of its effects *is* to blur the edges of fantasy and reality. It is upon such a world of 'signs' that these artists have fixed. The commodity, though a physical object, is a pre-eminent sign of our culture. Commodities don't just do; they mean.

It is from this perspective that we may usefully view Jeff Koons' act of selecting and displaying as art consumer durables, notably vacuum cleaners (Plate 202). The machines were not transformed in any way – other than by being prised loose from their normal context and subjected to display conditions of a kind usually reserved for precious objects. Haim Steinbach arranged objects bought during shopping expeditions on shelves which evoked the domestic interiors of 'middle America': juxtaposing for example light fittings, designer sportswear, mass produced mugs and primitive pots (see Plate 203). It is clear that a recurring site for scrutiny in such work has been the uneasy boundary between art and kitsch. Transgressions of the founding distinction of Greenberg's Modernism – the distinction between 'avant-garde' and 'kitsch', between 'art' and 'culture' –

Plate 202 Jeff Koons, *New Shelton Wet/Dry Triple Decker*, 1981, acrylic, fluorescent light, plexiglas, three vacuum cleaners, 316 x 71 x 71 cm. Saatchi Collection, London.

Plate 203 Haim Steinbach, *Untitled (Jugs, Mugs) 2*, 1987, mixed media, 107 x 61 x 49 cm. Courtesy of the Sonnabend Gallery New York.

became normative in much of the 'appropriation' art of the 1980s. Usually this involved elevating the products of popular culture and industrial design into the contexts of art, with a view to subverting the latter's authority. Other variations were, however, possible. The operations of avant-garde art itself became fodder for appropriation in such work as the painting of Peter Halley. His day-glo 'abstracts' seek simultaneously to ironize Barnett Newman's 'sublime' on the one hand, and to evoke a technological world of micro-circuitry and diagrams on the other (see Plate 204).[18] The painting of David Salle ranged across a broad field of signification, often seeming to ensnare its subjects and deliver them up on the surface like so many specimens, in configurations calculated to avoid both the apparent judgmentalism of Kruger and the putative hedonism of Schnabel. Salle's painting (see Plate 205) offers itself as a kind of screen, perhaps analogous to the mind, across which float disconnected images drawn from film, television, pulp fiction, in addition to avant-garde art, and which often invoke power relations, sexuality, and stereotypical identities.

The cumulative effect of such art is a sense of the inevitability of all that is done to us in the name of contemporaneity. In Steinbach's words 'The anxiety of late capitalist culture is in us in the futility we find in moralizing as a way of determining what's good or bad' (Steinbach, 'From criticism to complicity', p.49). It might be said, of this whole range of work, that one of its chief presuppositions is of culture as a kind of nature. Resistance, opposition, criticism, the staples of the avant-garde position, are frustrated in such conditions, except – and this may be the point – when reincarnated as pastiche. Late capitalism has amply demonstrated an ability to engulf anything (not least the enclaves of oppositional subcultures). Representations of 'engulfment', may just come up for the count as strategies for gaining a little space.

18 For Newman's concept of the sublime see his essay 'The sublime is now', first published in 1948.

Plate 204 Peter Halley, *Two Cells with Circulating Conduit*, 1987, day-glo acrylic, acrylic, Roll-A-Tex on canvas, 195 x 350 cm. Courtesy of the Sonnabend Gallery, New York.

Plate 205 David Salle, *Brother Animal*, 1983, acrylic, fabric and wood chair seats on canvas, 239 x 427 cm. Courtesy of the Gagosian Gallery, New York. © David Salle/DACS, London/VAGA, New York 1993.

The critique of the social subject as expressed through a focus on contradictions of class, race and gender and the critique of originality as expressed through strategies of appropriation, can be seen as variant responses by artists to the 'crisis of modernity' in the late twentieth century. They do however share a common perspective in one important regard. A key assumption of much postmodernism concerns the alleged 'death of the grand narratives' – those widespread beliefs about the potential for human social emancipation and material improvement through scientific progress which have been in place since the Enlightenment. As artistic correlates of this perspective, works of the types just reviewed share an assumption of a *dis*continuity of value with the artistic tradition of Modernism. But not all works of art 'after Modernism' have assumed such a rupture in the continuity of artistic value. Certain practices of painting, in particular, have kept the question open.

The Art & Language group increasingly turned to painting from the late 1970s. The reasons for this move are complex, but the condition into which the cluster of avant-garde options was settling at the time was one factor. Much of the critical 'new media' work had seemed to court a moral security and certitude arguably at odds with the requirement of Greenbergian (or indeed any) 'self-criticism'. For all the difference in media, it thus seemed to be in danger of replaying some of the mistakes of the social-realist tradition: assuming its own moral and political probity while 'revealing' confusion and prejudice elsewhere. Historically the condition of Cold War had been reduplicated at the level of art, in the form of the competing ideologies of a (stereotypical) Modernism and an (equally stereotypical) Socialist Realism. By forcing tokens of these two traditions into an implausible conjunction, Art & Language were able to take ironic distance from their contemporary circumstances. Their portraits of Lenin 'in the style of Jackson Pollock' (for example, Plate 206) – referred to by the artists themselves as a 'monstrous détente' – functioned as exemplifications of an ironic critical stance. However, an unexpected consequence of

Plate 206 Art & Language, *Portrait of V.I. Lenin in July 1917 Disguised by a Wig and Working Man's Clothes, in the Style of Jackson Pollock II*, 1980, enamel on board mounted on canvas, 239 x 210 cm. Collection of Jacqueline and Eric Decelle, Henonville. Photo courtesy of Lisson Gallery, London.

Plate 207 Art & Language, *Hostage XL*, 1990, glass, oil on canvas on wood, 183 x 122 cm.
Private Collection London. Photograph by courtesy of Lisson Gallery, London.

actually making the paintings, was that painting began to demand attention *as* painting. The problems of making a painting 'work', and that is inescapably to say questions of 'value', moreover of aesthetic value as distinct from moral or political value, returned to the agenda of a practice which had once seemed to suspend them. It was to be expected that this would generate criticism from those who interpret Conceptual Art's principal legacy as a simultaneous closing of the book of modern *art* and the opening-up of a 'politics of representation'. For Art & Language however Conceptual Art seemed to have offered critical leverage on an over-secure and quasi-official *culture* of art. What it did not necessarily do was absolve artists permanently from the expressive and critical demands which had traditionally been sought in art's higher genres. That is to say that, for them, such 'post-Conceptual' painting represents a continuation of the critical project, and not a reversion from it. At a time when cultural activism threatened to tip over into moral rectitude, an unexpected way out appeared in the form of the aesthetic. Viewed in these terms, such painting does not represent a flight from the critical practice of Conceptual Art to the aesthetic. Rather, it was an attempt to have the aesthetic *be* a form of critical practice (Plate 207).

Such a painting, and such a conception of the aesthetic is clearly at odds with much that has offered itself as a postmodern 'politics of representation'. It is also at odds with much that has been, and continues to be, offered as painting. Painting in its 'new spirit' manifestation, with its claims to universalism, creativity, the privileged – and mythic – insightfulness of the author/artist, plainly stands opposed to critical postmodernism, with *its* emphasis on the realities of art as a form of production, impelled to attend to the contingencies of a life in history.

The German artist Anselm Kiefer occupies an uncertain place between these contradictory possibilities. The conclusion to the catalogue of his major American retrospective of 1988 cast Kiefer as the author of 'epic elegies to the human condition' (M. Rosenthal, *Anselm Kiefer*, p.155). Terms such as 'spirituality', 'freedom', 'faith' and 'myth' abounded in the commentaries on his work. Kiefer's art has groaned under the critical burden imposed on it, of 'making the present spiritual plight of humankind the universal subject of his intensely German art' (*Anselm Kiefer*, p.7).

Yet Kiefer too has his origins in Conceptual Art, and has expressed admiration for Warhol and Duchamp. Kiefer's early work (he was born in 1945) involved 're-conquering' Europe in the guise of a Nazi by having himself photographed giving the Hitler salute in a variety of foreign locations (Plate 208). The provocative gesture was always subverted by bathetic devices internal to the photographs: standing in a bathtub, being ignored by passers-by, etc. Turning increasingly to painting in the later 1970s Kiefer evolved a powerful, even melodramatic painting which combined evocative subject-matter with an exaggerated 'modernist' emphasis on surface. During the eighties this characteristically involved the use of straw, lead, processes of burning, tearing and the writing of inscriptions, names, etc. across the surface. A key range of subjects – the artist's studio, the landscape, and architecture – was thereby used to mobilize themes of German history and German myth. In the early 1980s Kiefer produced several works derived from the extraordinary poem 'Death Fugue', written in a Nazi concentration camp in 1945 by Paul Celan (the poem can be found in Rosenthal, *Anselm Kiefer*, pp.95–6). The poem repeatedly contrasts the golden hair of a German woman (Margarete) with the dark hair of a Jewish woman (Shulamite). In *Your Golden Hair, Margarete* (Plate 209) Kiefer uses as a basis what had become a recurrent motif of his work – a blackened German landscape of ploughed earth, rendered pictorially dynamic by the high horizon and offset vanishing point. Over this signs of the two women are superimposed: the golden hair of the one represented by straw, the dark hair of the other in black paint. As in the poem the suggestion is that the two women are linked to each other, and to Germany: they constitute a 'whole', pre-Nazi

Plate 208 Anselm Kiefer, page from
'Besetzungen' ('Occupations'), 1969,
reproduced from *Interfunktionen*
(Cologne) no 12, 1975, by permission
of the artist.

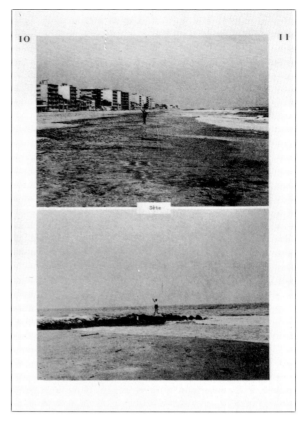

Plate 209 Anselm Kiefer, *Deine goldenes Haar, Margarethe* (*Your Golden Hair,
Margarete*), 1981, oil, acrylic, emulsion and straw on burlap, 130 x 170 cm. Private
Collection. Photograph by courtesy of the artist.

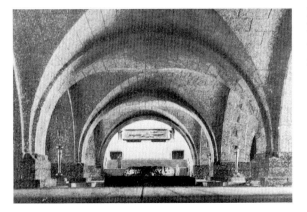

Plate 210 Wilhelm Kreis, Funeral Hall for the Great German Soldiers, in the Hall of Soldiers, Berlin, *c.*1939, from *Neue Deutsche Baukunst* (Berlin 1943).

German culture. *Shulamite* (Plate 211) takes for its basis not a token of the German landscape, but an example of Nazi architecture. A similar pictorial dynamic of palpable surface and deep recession is mobilized around an image of the Funeral Hall for the Great German Soldiers in Berlin, by Wilhelm Kreis (see Plate 210). In the painting the memorial is in effect rededicated to the victims, the 'altar' being replaced by a Jewish seven-branched candelabra whose flames flicker in the depths of a hall which itself appears to have been subject to fire.

Plate 211 Anselm Kiefer, *Sulamit* (*Shulamite*) 1983, oil, acrylic, emulsion, shellac and straw on canvas, with woodcut, 290 x 370 cm. The Saatchi Collection, London.

Such work relies on the assumption that art can intervene in history, and if not redeem it (for the Holocaust is beyond redemption) then perhaps, by allegorizing it, to offer back a past to the present. As such it remains both ambitious and deeply problematic. Perhaps it is the terms on which the past is made available which are at issue. Seen at its worst, in the validations of its uncritical admirers, Kiefer's art can be seen as reinvesting the modern tradition with those very clichés of the spiritual and the profound which, at its most rigorous, Modernist art was concerned to evacuate. Yet a case can also be made for recovering Kiefer from the bathos of his cultural legitimation. Andreas Huyssen has argued, against 'facile claims of transcendence and universality', that Kiefer's work is ambiguously bound to a 'specific cultural and political context, the context of German culture after Auschwitz' (Huyssen, 'Anselm Kiefer', p.26). Huyssen suggests that Kiefer's project has been to re-appropriate specific 'image-spaces', such as landscape and architecture, which in a German context had been 'most effectively occupied, exploited and abused' by Nazi culture. If this is indeed part of the project it is achieved to an extent by rendering the trappings of Fascism aesthetically compelling: thereby opening up the possibility for a self-critical spectator to comprehend the persistence of that fatal attraction, both subjectively within themselves and within contemporary culture at large. As Huyssen concludes:

> Here then is the dilemma: whether to read these paintings as a melancholy fixation on the dreamlike ruins of fascism that locks the viewer into complicity, or instead, as a critique of the spectator, who is caught up in a complex web of melancholy, fascination, and repression.
>
> (Huyssen, 'Anselm Kiefer', p.45)

It may be that this recognition of the role of the spectator is a key to the sense of a 'postmodernist' painting. It has been a commonplace of those forms of a supposedly 'postmodernist' art reviewed above that the Modernist spectator was passive. 'Contemplation' tends to have been seen in a very one-dimensional light by activist art. Aesthetic contemplation has been regarded as the acme of an élitism which derives its pleasures from a failure to acknowledge its own location in a nexus of inequality. 'Postmodernist' demands for an active reader as opposed to a passive viewer have been legion. It is as though the concept of 'contemplation' has been unceremoniously collapsed into 'consumption', while the spatially and temporally located viewer/reader has been construed as poised for critical action. Thus rendered, both stereotypes are fictional; they are not however groundless. Michael Fried's Modernist 'beholder' was essentially located outside space and time, in 'grace'. By contrast, much socially critical work functions as an injunction to act upon the world. But it seems that certain recent art may be working with a third term: a properly 'postmodernist' spectator, who contemplates art in time, becomes self-conscious about his or her position in the world and is led thereby to reflect upon his or her inscription in history. Such art may establish grounds for critical action; it does not however make it its business to prescribe it.

The subjects of Anselm Kiefer have been synthesized from Germany's recent historical past and her ancient, yet persistent, myths. Their treatment has equally been synthesized, both from the tradition of Academic history painting and from a Modernist tradition of attention to surface. It is perhaps less the attempted synthesis itself which renders his work so problematic as the consequences of imaginatively entering the spaces which that unstable synthesis permits. The possibility, it seems, is always biased on the side of the invitation rather than its refusal; the principal work of the painting is, as it were, performed in the service of seduction rather than resistance. It is as if its tendency toward the operatic is always poised to overpower the critical reservation it may prompt.

This balance of seduction and resistance is somewhat differently calculated in the work of another contemporary German artist, Gerhard Richter. In marked contrast to

Kiefer, Richter's subjects have been drawn from the contemporary rather than the historical German condition and his means from an acknowledgement of the ruin of Modernist metaphysics effected by Conceptual Art.

The history of modern art had been much marked by strategies of exclusion and refusal. One of the most volatile boundaries has been that between figuration and abstraction. Of course, a kind of semi-abstract, or expressively distorted figurative painting has long been a staple of middle-ground 'modern art'. But the two poles of 'pure' abstraction and 'realistic' figuration have been an illegitimate or excluded combination. Commitment to the one has precluded simultaneous commitment to the other. Or, conversely, movement from one to the other has involved an act of renunciation; for example, renunciation of abstraction for its élitism, in the name of the shared values of realism, or of figuration for its conservatism in the name of abstraction's 'promise of freedom'. Yet Richter's art, since his arrival in the West from East Germany in 1961, has been marked by a continual movement between the figurative and the abstract. Both however have been underpinned by a consciousness of the fact that painting takes place now within the broader and more pervasive visual tradition of mechanical reproduction. Thus his figurative works seem always to be rooted in a photographic image. Sometimes so too are his 'abstract' paintings. But even when they are not, their manner of production involves techniques associated with technologies of mass reproduction. The effect of this is that Richter's painting seems always to bear within it a dual address; to a history beyond art, and to a history *of* art.

Nowhere is this clearer than in two series of works made in 1988, one of which consisted of a suite of fifteen figurative paintings, titled *18 Oktober 1977* (Plate 212). This was the date of the deaths in prison, either by murder or suicide, of members of the Red Army Faction, the Baader-Meinhof group. The fifteen works, all painted in grey, were based on

Plate 212 Gerhard Richter, *Tote (Dead)*, 1988, oil on canvas from series '18 Oktober 1977', 62 x 62 cm. Reproduced by permission of the artist.

press or police photographs of members of the group, of the interior of cells, of an arrest, of a funeral. No event in the Federal Republic's recent history had been the subject of such contradictory responses. Likewise no painting in that country's brief art history proved so controversial as Richter's series.

For some on the right, by failing overtly to condemn the group, Richter condoned terrorism. For some on the left, by failing to condemn their presumed murder by the state, Richter condoned the status quo. He was also accused of a kind of dilettantism. More positively the critic Benjamin Buchloh saw Richter's intervention as a refusal of the collective amnesia with which the German state and media, abetted by the passivity of its people, had avoided the profound questions raised by the Baader-Meinhof episode (Buchloh, 'A note on Gerhard Richter's *18 Oktober 1977*', pp.92–109). Simultaneously however it marked a refusal of the prohibition on modern painting to engage with modern history. Or rather, and this is what, for Buchloh, gives the paintings their force, it refused that prohibition *while also acknowledging it*. For the gulf which opened up in the modern period between painting and history – what Michael Fried in the 1960s called reality's gradual withdrawal from the capacity of painting to represent it – cannot simply be overridden by fiat. Were that possible, the implication would be that, say, Newman, Pollock or Rothko wilfully avoided the depiction of contemporary history rather than finding themselves unavoidably in the position of working in its shadow while being unable to 'depict' it. The assumption that a 'postmodernist' painting could simply turn round and start addressing history again would effectively undermine the ethical basis of the modern tradition. Instead, for Buchloh the modern tradition was right, and those vitiated are artists producing what he calls 'polit-kitsch' (such as Kiefer).[19] Richter on the other hand, by basing paintings upon police surveillance and press photographs is operating on the different terrain of complex, nested, representation – acknowledging a world in which everything is representation, but which, for all that, never goes away. It is through a registration of the limitation of painting in the face of widespread technologies of reproduction and manipulation that Richter manoeuvres his medium and history into an oblique relationship; what sustains the project is the possibility that this very distance of painting from history is able to confer some kind of redress to a social order which trades in spectacle and amnesia. It is as if the paintings' technical qualities secure an anti-monumentality, an elusiveness, which gives them critical status against an official culture of conflicting certainties.

If these issues seem far-reaching and difficult to resolve, they are surely further complicated by the fact that at the same time as he was engaged on this difficult project – by his own admission it had lingered on as 'unfinished business' for years – Richter was also developing a new phase of the abstract painting he had been producing since 1976. Initially Richter's abstraction was based on the painted depiction of photo blow-ups of small-scale 'gestural' sketches. These works involved a kind of counter-pointing of elements from the repertoire of abstract painting: line and mass; hard edge, soft edge; smooth, brushy; amorphous form, precise form. The apparent deliberateness of this matching, the acutely self-conscious fashion in which Richter appeared to mobilize the elements of a – by now established, even historical – vocabulary, have seemed to many to point to a negative impulse in the works. Abstract art, in the rhetoric of an unreflective, curatorial form of Modernism, has been a-historical, essentialist, a terrain of absolutes, and frequently of absolute idealism. For Buchloh, once again, Richter has offered a telling deconstruction of these worn-out ideologies. He is offering a kind of non-painting, as Buchloh phrases it: 'making the spectacle of painting visible in its rhetoric, without practising it' (quoted in Buchloh, 'Gerhard Richter', p.28). That is to say, for Buchloh, Richter's mobilization of the devices of abstract painting results not so much in paintings which can

[19] 'Polit-Kitsch': a pun on 'politische' kunst – political art.

themselves compel aesthetic conviction, as in demonstrations that the desire for such aesthetic conviction is either culpable or absurd.

Yet the matter does not rest there. The philosopher of art Richard Wollheim has noted, as part of his attempt to trace the generation of meaning in art, that 'any marked surface, any surface humanly marked, will look different different ways up, so that between the different ways up preferences can form' (*Painting as an Art*, p.20). This point cryptically establishes the unavoidability of processes of evaluation in the genesis of pictorial meaning. Whatever the truth of Buchloh's claim, it does not function to close off or de-legitimize the possibility of aesthetic response to a worked surface. As remarked briefly above, when the Art & Language artists put into play their tokens of abstraction and figuration, they were unexpectedly faced by the fact that some of the resulting configurations 'worked' better than others. Likewise Richter noted of a series of grey monochromes he painted in the mid-1970s, that even though they were undertaken in a spirit of negation, of nihilism even, about the possibilities of painting, once several were complete it became possible to distinguish between them, and positive possibilities unexpectedly emerged from the debris. So it was with the later abstracts. Although Buchloh's remarks do offer a coherent critical reading, it is scarcely at one with Richter's own feelings. On hearing Buchloh's claim he responded: 'What sense would that have? That would be the last thing I'd want … I see no sense in exhibiting painting's old lost possibilities. I want to say something. I'm interested in new possibilities' (quoted in Buchloh, 'Gerhard Richter', p.28).

A painting such as *Uran 1* (Plate 213) is produced by a quasi-mechanical technique. Richter initially lays down an image, which he proceeds to paint over. The means is a large spatula or squeegee, in a process similar to silk screen printing, whereby paint is dragged across the canvas. The result is a surface of tears, scrapes and incisions through

Plate 213 Gerhard Richter, *Uran I (Abstract Painting) (688/1)*, 1989, oil on canvas, 92 x 126 cm. Reproduced by permission of the artist.

which hidden layers of colour from previous 'passes' of the spatula, show through. Often given either biblical, Classical or naturalistic titles, the paintings invite imaginative work while displacing conventional ideas of empathy and purpose. The works can be compared with Pollock's in that they raise similar questions of control and intention, and achieve a similar pictorial resolution. The volume, scale and assuredness of Richter's abstracts surely suggest that the works amount to more than demonstrations of the impossibility of painting abstractly and meaning it. Quite the reverse in fact. More unequivocally than any other contemporary work, that possibility is precisely what they demonstrate (Plate 214). As long ago as 1966 Richter spoke of painting as a 'moral action' (see C. van Bruggen, 'Gerhard Richter: painting as a moral act', pp.82–91). Painting's ethical force however resides not in the virtue of what it depicts or advocates, but in the aesthetic it embodies. Our suggestion is that this is the 'possibility' his late abstract painting investigates.

Both Richter's figuration and Richter's abstraction – or rather the two in relation – may offer support for an intriguing suggestion. Conceptual Art constituted an attack upon Modernism and in particular upon Modernism's privileging of the aesthetic. Its demonstration of the limitations of Modernism as a culture of art, however, far from absolving artists from the domain of 'aesthetic' may have made it incumbent upon them to reinvent an appropriate aesthetic for art after Modernism. Except that one cannot wilfully 'invent' an aesthetic. The logic is rather to work on, upon, or in the ruins, until the fruits of that work become subject to significant forms of aesthetic differentiation. It is as if the aesthetic did not go away; rather, it awaited reconstruction. The paradoxical precondition of that reconstruction has been a passage *through* the critique of authorship, *through* the implications of reproducibility, through, in short, the ruin of Modernism which Conceptual Art brought about.

In the face of the idealism which Modernism came to manifest and the evacuation of history from the practice of art which it fostered, extreme strategies seemed to be necessary. Faced by what many experienced as a debilitating mixture of authoritarianism and irrelevance, certain artists felt impelled to address the framing conditions of their practice, material and ideological alike. Yet in this period after the apparent terminal decline of canonical Modernism, the very qualities which it abjured came to dominate artistic debate. Modernism's evasion of the contingent and conjunctural gave way to a refusal of all but the contingent and conjunctural – interests repeatedly enunciated in the name of the gendered subject, the commodity, and the exigencies of patriarchal society. Repression however, as is well known, often brings about the return of the repressed. We would like to suggest, and we believe it to be borne out by some of the work surveyed here, that the contingency of the historical is only half the point of art. At the moment of Modernism's origin, Baudelaire noted that beauty had a dual aspect: the mutable *and* the unchanging. Clearly it would be inappropriate at the end of the twentieth century to trade in universals; nonetheless there are relatively unchanging aspects to the human condition. Other 'crossroads' exist besides the moveable feasts of 'sexual identity and social life'. The recent past has demonstrated an emphasis on difference and discontinuity after a diet of universalism. If it signifies nothing else, the breadth of interest in the idea of the postmodern testifies to a widespread dissatisfaction with the received history of the modern. Much of the work self-consciously conducted under the rubric of the postmodern has however avoided questions of value. Yet the fact of valuation remains central to diverse areas of human activity, even if the objects of valuation change.

As a critical position, Modernism has been characterized as a form of authority arbitrating over aesthetic value. The demise of the authority does not mean, however, that the problems of valuation are either solved or rendered irrelevant. In fact, though the postmodern was not an explicit concern of art criticism until the late seventies, we would

Plate 214 Gerhard Richter, *Wald (Forest) (733)*, 1990, oil on canvas, 340 x 260 cm. Durand-Dessert Gallery, Paris. Photograph by courtesy of the artist.

propose that inquiry into the *artistic* (as opposed to more broadly cultural) character of the postmodern could usefully commence at that point in the later 1960s when the virtue and authority of Modernism itself first came under sustained examination from within the actual practice of modern art. In making this suggestion, however, we do not mean to support the idea of a break with history or with tradition. The task has always been to sort out how to go on. A fixation on contingency now itself stands in need of redress. In spite of a widespread enthusiasm for a 'politics of representation', the critique of Modernism has not served to get art off the aesthetic hook so much as to point to the requirement for a less mythologized approach to questions of value. So far as art is concerned, we would suggest, the task which most matters in the end is how to maintain the *qualitative* character of production. This task is not to be confused – and in the end may not be capable of being reconciled – with the no less important task of how to maintain the *quantitative* character of production, i.e. output, in other fields. In addressing both tasks we need to learn what we can from history. We have no understanding of how to supply our material needs which is not informed by history. And we have no strong measures of value which are not furnished by the previous productions of our fellow human beings.

References

ALTHUSSER, L., 'Ideology and ideological state apparatuses', in *Lenin and Philosophy and Other Essays*, London, New Left Books, 1971, pp.121–73; an edited version is reprinted in Harrison and Wood, *Art in Theory*, section VII.d.3.

ANDRE, C., contribution to 'The artist and politics: a symposium', *Artforum*, September 1970, pp.35–9; reprinted in Harrison and Wood, *Art in Theory*, section VII.c.2.

Art into Society, Society into Art, exhibition catalogue, London, ICA, 1974.

BATTCOCK, G. (ed.), *Minimal Art*, New York, Dutton, 1968.

BAUDRILLARD, J., *The Mirror of Production*, St Louis, Telos Press, 1975.

BAUDRILLARD, J., *Selected Writings* (ed. M. Poster), Polity Press, Cambridge 1988.

BELL, C., 'The aesthetic hypothesis' (1914), in *Art*, Oxford University Press, 1987; edited version in Harrison and Wood, *Art in Theory*, section I.b.15.

BENJAMIN, W., *The Origin of German Tragic Drama* (1928), London, Verso, 1977.

BEUYS, J., 'I am searching for field character' in *Art into Society, Society into Art*, exhibition catalogue, London, ICA, 1974; reprinted in Harrison and Wood, *Art in Theory*, section VII.c.4.

BEUYS, J., 'Coyote, I like America and America likes me' (1974) in Beuys, *Energy Plan for the Western Man*, New York, Four Walls and Eight Windows Press, 1990, pp.141–44.

BOURDON, D, 'The razed sites of Carl Andre', *Artforum*, October 1966; reprinted in Battcock (ed.), *Minimal Art*, pp.103–8.

VAN BRUGGEN, C., 'Gerhard Richter: painting as a moral act', *Artforum*, May 1985, pp.82–91.

BUCHLOH, B., 'Gerhard Richter: an interview with Benjamin Buchloh', in R. Nasgaard (ed.), *Gerhard Richter: Paintings*, London, Thames and Hudson, 1988, pp.15–29.

BUCHLOH, B., 'Beuys: twilight of the idol', *Artforum*, January 1980, pp.35–43

BUCHLOH, B., 'A note on Gerhard Richter's *18 Oktober 1977*', in *October*, no.48, spring 1989, pp.92–109.

BUREN, 'Beware!', *Studio International*, vol.179, no.920, March 1970, pp.100–104; reprinted in de Vries (ed.) *Über Kunst/Artists' Writings on the Changed Notion of Art after 1965*, Cologne, DuMont Verlag, 1974; edited version in Harrison and Wood, *Art in Theory*, section VII.a.12.

BURGIN, V., 'The absence of presence: Conceptualism and post-modernisms', in *1965–1972: When Attitudes Became Form*, exhibition catalogue, Kettles Yard, Cambridge and The Fruitmarket, Edinburgh, 1984, pp.17-24; reprinted in V. Burgin, *The End of Art Theory*; edited extract in Harrison and Wood, *Art in Theory*, section VIII.c.4.

BURGIN, V., *Between*, exhibition catalogue, London, ICA, 1986.

BURGIN, V. *The End of Art Theory*, London, Macmillan, 1986.

CLAY, J., 'Some aspects of bourgeois art', *Studio International*, June 1970, pp.266–8.

FOSTER, H., 'Subversive signs', in Foster (ed.) *Recodings: Art, Spectacle, Cultural Politics*, pp.99–118 (published in an earlier form in *Art in America*, November 1982, pp.88-93); extract in Harrison and Wood, *Art in Theory*, section VIII.b.4).

FOSTER, H. (ed.), *Postmodern Culture*, London, Pluto, 1985.

FOSTER, H. (ed.), *Recodings: Art, Spectacle, Cultural Politics*, Bay Press Seattle, 1985.

FOSTER, H. (ed.), *Discussions in Contemporary Culture*, Seattle, Bay Press, 1987.

FOUCAULT, M., 'A lecture' (1976), in *Power/Knowledge* (ed. C. Gordon), pp.78–89; edited version in Harrison and Wood, *Art in Theory*.

FOUCAULT, M., *Language, Counter-Memory, Practice. Selected Essays and Interviews*, edited and introduced by D.F. Bouchard, Cornell Press, Ithaca, 1977.

FOUCAULT, M., *Power/Knowledge. Selected Interviews and Other Writings* (ed. C.Gordon), Brighton, Harvester Press, 1980.

FRASCINA, F. and HARRISON, C. (eds), *Modern Art and Modernism: A Critical Anthology*, London, Harper and Row in association with the Open University, 1982.

FRIED, M., *Three American Painters: Kenneth Noland, Jules Olitski, Frank Stella*, Fogg Art Museum, Cambridge, Massachusetts, 1965.

FRIED, M., 'Jules Olitski's new paintings', *Artforum*, Nov. 1966, pp.36–40.

FRIED, M., 'Art and objecthood', *Artforum*, vol.5 no.10, summer 1967, pp.12–23; edited version in Harrison and Wood, *Art in Theory*, section VII.a.6

FRIED, M., *Absorption and Theatricality*, Chicago, Chicago University Press, 1980.

FRY, R., 'An essay in aesthetics' (1909), in *Vision and Design*; edited version in Harrison and Wood, *Art in Theory*, section I.b.6.

FRY, R., *Vision and Design*, (1920), Pelican, Harmondsworth, 1961.

GREENBERG, C., 'The new sculpture' in *Art and Culture*, pp.139–45; first published in an earlier version in *Partisan Review*, June 1949.

GREENBERG, C., 'Collage', in Frascina and Harrison, *Modern Art and Modernism*, pp.105–8; first published as 'The pasted paper revolution' in *Artnews*, LVII, September 1958, pp.46–9; revised version printed in Greenberg, *Art and Culture*.

GREENBERG, C., 'Louis and Noland', *Art International*, vol.4 no.5 May 25 1960, pp.26–9.

GREENBERG, C., *Art and Culture: critical essays* (1961) Boston, Beacon Press, 1965.

GREENBERG, C., 'After Abstract Expressionism', *Art International*, vol. VI, no.8, October 1962; edited version in Harrison and Wood, *Art in Theory*, section VI.b.7.

GREENBERG, C., introduction to *Three New American Painters: Louis, Noland, Olitski*, MacKenzie Art Gallery, Regina, Canada, 1963.

GREENBERG, C., 'Modernist painting', *Art and Literature*, no.4, spring 1965, pp.193–201; first published in *Arts Yearbook* 1, New York, 1961; reprinted in Harrison and Wood, *Art in Theory*, section VI.b.4.

GREENBERG, C., 'Anthony Caro', *Studio International*, vol.174, no.892, September 1967, pp.116–17.

GREENBERG, C., 'Complaints of an art critic' in Harrison and Orton, *Modernism, Criticism, Realism*, pp.3–8; originally published in *Artforum*, vol.6 no.2 October 1967, pp.38–9.

HABERMAS, J., 'Modernity – an incomplete project', in H. Foster (ed.) *Postmodern Culture*, 1985, pp.3–15.

HARRISON, C., 'Some recent sculpture in Britain', *Studio International*, London, vol.177 no.907, January 1969, pp.10–33.

HARRISON, C., 'Sculpture's recent past', in T.A. Neff (ed.) *A Quiet Revolution; British Sculpture since 1965*, London, Chicago and San Francisco, Thames and Hudson, 1987, p.32.

HARRISON, C., *Essays on Art & Language*, Oxford, Blackwell, 1991.

HARRISON, C. and ORTON, F., 'Jasper Johns: meaning what you see', *Art History*, vol.7 no.1, March 1984, pp.76–101.

HARRISON, C. and ORTON, F. (eds), *Modernism, Criticism, Realism: Alternative Contexts for Art*, London, Harper and Row, 1984.

HARRISON, C. and WOOD, P. (eds), *Art in Theory 1900–1990: An Anthology of Changing Ideas*, Oxford, Blackwell, 1992.

HOLT, N. (ed.), *The Writings of Robert Smithson*, New York, New York University Press, 1979.

HUYSSEN, A., 'Anselm Kiefer: the terror of history, the temptation of myth', *October*, 48, spring 1989, pp.25–45.

JAMESON, F., 'Postmodernism and consumer society' (1982), in Foster (ed.), *Postmodern Culture*, pp.111–25.

JAMESON, F., 'Postmodernism, or the cultural logic of late capitalism', *New Left Review* 146, London, July/August 1984, pp.53–92; reprinted in Jameson's collected essays of the same title, London, Verso, 1991 (extract in Harrison and Wood, *Art in Theory*, section VIII.b.9).

JAPPE, G. 'Not just a few are called but everyone' (interview with Joseph Beuys), *Studio International*, December 1972, pp.226–8; an edited version is reprinted Harrison and Wood, *Art in Theory*, section VII.b.10.

JUDD, D., 'Specific objects', *Arts Yearbook* 8, New York 1965, pp.74–82; reprinted in Judd, *Complete Writings 1959–75*, Halifax, Nova Scotia, 1975; edited version reprinted in Harrison and Wood, *Art in Theory*, section VII.a.4.

JUDD, D., 'Complaints part 1', *Studio International*, London, vol.177, no.910, April 1968, pp.182–4.

KELLY, M., 'Re-viewing Modernist criticism', in *Screen*, vol.22 no.3 autumn 1981, pp.41–62; edited version in Harrison and Wood, *Art in Theory*, section VIII.c.2.

KELLY, M., *The Post-Partum Document*, London, Routledge Kegan Paul, 1983.

KENT, S. 'Success on a plate', *Time Out*, October 1986.

KLEIN, Y., 'Sorbonne Lecture' (1959) in Harrison and Wood, *Art in Theory*, section VII.a.1.

KOSUTH, J. 'Art after Philosophy', *Studio International*, October 1969, pp.134–7; reprinted in Harrison and Wood, *Art in Theory*, section VII.a.10.

KRAUSS, R., 'A view of modernism', *Artforum*, New York, September 1972, pp.48–51: an edited version is reprinted in Harrison and Wood, *Art in Theory*, section VII.d.8.

KRAUSS, R., 'Theories of art after Minimalism and Pop', in Foster (ed.), *Discussions in Contemporary Culture*, pp.59–63.

KRAUSS, R., *The Originality of the Avant-garde and Other Modernist Myths*, MIT Press, Cambridge, Massachusetts, 1985.

KRAUSS, R., 'The LeWitt matrix', in *Sol LeWitt* (exhibition catalogue), Oxford, Museum of Modern Art, 1993.

LACAN, J., *The Four Fundamental Concepts of Psychoanalysis*, London 1977.

LACAN, J., *Écrits*, (1977) and *The Language of the Self, Further Selections from Écrits* (1978); an edited version of Lacan's 'The mirror phase as formative of the function of the I' is reprinted in Harrison and Wood, *Art in Theory*, section V.b.7.

LEWITT, S. 'Paragraphs on Conceptual Art' *Artforum*, vol.5 no.10 Summer 1967, pp.79–83; reprinted in Harrison and Wood, *Art in Theory*, section VII.a.7.

LIPPARD, L. 'The art-workers' coalition, not a history', *Studio International*, November 1970, pp.171–2.

LUCIE-SMITH, E. (ed.), 'An interview with Clement Greenberg', *Studio International*, London, vol.175 no.896, January 1968, pp.4–5.

LYOTARD, J-F., 'Answering the question: "What is postmodernism?"', in I. and S. Hassan (eds), *Innovation/Renovation*, Madison, University of Wisconsin Press, 1983 (originally published in French in 1982); edited version in Harrison and Wood, *Art in Theory*, section, VIII a.4

LYOTARD, J.-F., *The Postmodern Condition: A Report on Knowledge*, Manchester, Manchester University Press, 1984 (originally published in French in 1979); edited extracts in Harrison and Wood, *Art in Theory*, sections VIII.a.2.

MORGAN, S., *Julian Schnabel: Paintings 1975–1986'*, exhibition guide, Whitechapel Art Gallery, London 1986.

MORRIS, R., 'Notes on sculpture', parts 1–4, *Artforum*: vol.4 no.6, February 1966, pp.42–4; vol.5 no.2, October 1966, pp.20–3; vol.5 no.10, summer 1967; vol. 7 no. 8, April 1969, pp.50–54; edited extracts reprinted in Harrison and Wood, *Art in Theory*, sections VII.a.5 and VIII.b.3.

MORRIS, R., 'Antiform', *Artforum*, vol.6 no.8, April 1968.

MURPHY, J.A., 'Sponsor's statement' for When Attitudes Become Form, reprinted in Harrison and Wood, *Art in Theory*, section VII.b.8.

A New Spirit in Painting, exhibition catalogue (ed. H. Joachimedes), London, Royal Academy, 1981.

NEWMAN, B., 'The sublime is now' (1948) in Harrison and Wood, *Art in Theory*, section V.a.10.

OPEN UNIVERSITY, A315, *Modern Art and Modernism*, TV 29, *Greenberg On Criticism*.

OWENS, C., 'The allegorical impulse. Toward a theory of the postmodern', *October*, no.12 (pp.67–86) and no.13 (pp.59–80), spring and summer 1980, reprinted in B. Wallis (ed.) *Art after Modernism*, pp.203–53; edited version in Harrison and Wood, *Art in Theory*, section VIII.b.2.

OWENS, C., 'Honor, power and the love of women', *Art in America*, January 1983, pp.7–13.

POLITI, G., 'Interview with Julian Schnabel', *Flash Art*, October/November 1986, pp.45–53.

ROSENTHAL, M., *Anselm Kiefer*, exhibition catalogue, Art Institute of Chicago, and Philadelphia Museum of Art, Chicago and Philadelphia 1987.

SMITHSON, R., 'Towards the development of an air terminal site', *Artforum*, summer 1967; reprinted in N. Holt, *The Writings of Robert Smithson*, pp.41–47.

SMITHSON, R., 'A tour of the monuments of Passaic', *Artforum*, December 1967, reprinted in N. Holt (ed.), *The Writings of Robert Smithson*, pp.52–7.

SMITHSON, R., 'A sedimentation of the mind, Earth Projects', *Artforum*, September 1968; reprinted in N. Holt, *The Writings of Robert Smithson*, pp.82–91 and in an edited version in Harrison and Wood, *Art in Theory*, section VII.b.2.

SMITHSON, R., 'Cultural confinement', originally published as a contribution to Documenta 5, 1972, reprinted N. Holt, *The Writings of Robert Smithson* and in Harrison and Wood, *Art in Theory*, section VII.d.6.

STEINBACH, H., with Koons, Levine, Taaffe, Halley and Bickerton, 'From criticism to complicity', a discussion in *Flash Art*, no.129, Milan, Summer 1986, pp.46–9; extract reprinted in Harrison and Wood, *Art in Theory*, section VIII.b.10.

STEINBERG, L., *Other Criteria*, London and New York 1972.

WALDMAN, D., *Anthony Caro*, Oxford, 1982.

WALLIS, B., (ed.) *Art after Modernism, Rethinking Representation*, New Museum of Contemporary Art, New York 1984.

WILSON, A., 'For me it has to be done good' (interview with Alan Charlton), *Art Monthly*, London, September 1991, pp.11–17.

WOLLHEIM, R., *Painting as an Art*, London, Thames and Hudson, 1987.

Index

Illustrations are indicated by italicized page numbers.